THE GHOSTS of the AVANT-GARDE(S)

THE GHOSTS of the AVANT-GARDE(S)

Exorcising Experimental Theater and Performance

James M. Harding

THE UNIVERSITY OF MICHIGAN PRESS
Ann Arbor

Copyright © by the University of Michigan 2013

Published in the United States of America by
The University of Michigan Press
Manufactured in the United States of America
⊗ Printed on acid-free paper

2016 2015 2014 2013 4 3 2 1

A CIP catalog record for this book is available from the British Library.

Library of Congress Cataloging-in-Publication Data

Harding, James Martin, 1958–
 The ghosts of the avant-garde(s) : exorcising experimental theater and
performance / James M. Harding.
 pages cm
 ISBN 978-0-472-11874-8 (hardback) — ISBN 978-0-472-02908-2 (e-book)
 1. Experimental theater—History and criticism. 2. Experimental drama—
History and criticism. I. Title.
 PN2193.E86H375 2013
 792.02′23—dc23 2012042609

To Lukas and Daniel—
Marvelous Sons.

Acknowledgments

A book that has been many years in the making owes more debts than acknowledgments can repay. I can only express the deepest gratitude to those who have been a constant source of inspiration and support at every stage of the book's development. At the most basic level, this book is an extension of the ongoing conversation about avant-garde cultures that I have been having with Mike Sell for more than a decade and a half. I hope that it makes a valuable contribution to his vision of something called "Critical Vanguard Studies." Over the course of writing this book, I have also co-edited two anthologies with Cindy Rosenthal. As rewarding as those collaborations have been in their own right, they also cultivated the kind of deep professional friendship that allowed for open and honest discussion of almost every chapter in this book. Cindy has offered insightful and supportive commentary more times than I can count. So too has my partner, Friederike Eigler, who has influenced this book as much as any other friend or colleague. I dedicated my last book to her because of the profound impact that her knowledge of feminist theory had on the arguments that I ultimately presented. Her knowledge of literary and cultural theory, her inspiring conversation, and above all her patience with me as we try to balance two academic careers are, in no uncertain terms, the central reasons why this book is finished.

But there are other reasons as well. Kimberly Jannarone has been in constant conversation with me about this project, if only because so much of it was presented at conferences where she and I were on the same panels. She is one of the smartest scholars writing today about the histories of avant-gardes, and I am grateful for her intellectual generosity and for her friendship. So too am I grateful for the friendship and insights that John Rouse has shared with me over the years. The turning point in my thinking about the avant-gardes, the turning point that led to this

book, is the direct product of my collaborations with him. I hope this work does those collaborations justice.

Large portions of this book were written and other portions revised during the 2010–2011 academic year, while I was in Berlin as a DAAD Guest Professor at the Freie Universität, Berlin. I want to thank Dr. Teresa Kennedy, my former chair at the University of Mary Washington, for helping me to obtain the leave time so that I could spend the year in Berlin working on this project. That year would not have been possible without the financial support provided by the German Academic Exchange Service, and I want to thank them for facilitating the exchange. I also want to thank Erika Fischer-Lichte for her efforts to bring me to Berlin in the first place. Large parts of my last book were written while I was on a Fulbright Teaching Fellowship, and once again Erika has been absolutely instrumental in helping me to finish a book project. I am extremely grateful to her for the support that she has extended to me, not only in helping me get to Berlin, but also through our interactions while I was there.

Coincidentally, Jean Graham-Jones was also in Berlin during part of my year there, and thus I was able to have important conversations with her at decisive moments in the final stages of the writing. While these were extensions of conversations that she and I have been having about the avant-gardes for many, many years, these Berlin conversations came at decisive moments in the book project. Her insights are greatly appreciated.

Finally, I want express, once again, my gratitude to LeAnn Fields. Her support of this project has been unwavering from the first time that I mentioned it to her, and her support of my scholarship throughout my career has been decisive to any success I might now enjoy. Her keen understanding of publishing and scholarship have been absolutely invaluable to this project, to virtually all of my other projects, and to our profession in general. It is a rare privilege to work with an editor like LeAnn. I value her frankness, I admire her savvy, and I trust her counsel.

Some acknowledgments regarding the particular content of this book are in order:

Chapter 2 is a longer and substantially revised version of the article "From Anti-culture to Counter-Culture: the Emergence of American Avant-garde Performance Events," which originally appeared in *Ereignis: Kon-*

zeptionen einies Begriffs in Geschichte, Kunst und Literatur, ed. Thomas Rathmann (Köln, Weimar und Wein: Böhlau Verlag, 2003), 243–71. Chapter 4 is a longer and revised version of the article "Exile from Alienation: Brechtian Aesthetics, the Death of the Director, and Peter Brook's *Mahabharata*," which appeared in *Modern Drama* 44.4 (2001): 416–36. The actual publication date was fall 2002. Chapter 5 originally appeared in *Not the Other Avant-Garde: The Transnational Foundations of Avant-Garde Performance*, ed. James Harding and John Rouse (Ann Arbor: University of Michigan Press, 2006), 18–40. A very small section from Chapter 6 also appears as part of "Introduction: Intersections," *Avant-Garde Performance and Material Exchange: Vectors of the Radical*, ed. Mike Sell (New York: Palgrave MacMillan, 2011).

Contents

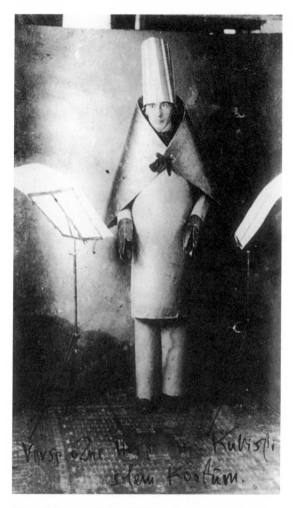

Hugo Ball at the Cabaret Voltaire, 1916.

Introduction

Avant-Garde Pluralities: An Introduction

I. Possession and Etymological Imperatives at the Cabaret Voltaire

By some accounts, Hugo Ball fell into an induced "state of possession" on a mid-July evening in 1916 and needed to be "carried onto the stage" of the legendary Cabaret Voltaire in Zurich, Switzerland.[1] In point of fact, it is debatable whether the co-founder of the Dadaist movement needed assistance because he was possessed, or simply, as he admits in his diary, because his stiff cardboard costume restricted his mobility.[2] Either way, an aura of mystique still hovers about his performance, cultivated in part by the eerie black-and-white photograph of Ball in the costume he had constructed. Reproduced many times, the photograph of Ball is one of the iconic images of twentieth century avant-garde performance. While it does not convey the striking combination of red, blue, and gold with which Ball had colored his attire, the photograph does capture Ball's haunted and distant gaze. It also captures the combination of gravity and parody in the makeshift similarity that Ball's costume bore to priestly vestments, and to what Ball somewhat problematically described as his "high, blue-and-white-striped witch doctor's hat."[3] That similarity is consistent with Ball's description of himself as "a magical bishop"—a description that positioned Ball in an irreverent cross-section of mystic, occult, Christian, colonialist, and cabaret traditions. It is from within that hybrid space that Ball performed, while possessed by whatever spirits may or may not have taken hold of him.

Whether Ball was actually possessed is less important than the fact that he was dressed for battle on a not-inconsequential field of symbolic gestures and signs. In many respects, that battle had been brewing for

some time. It was in large part a battle against the merchants and politicians of war, whose bellicose, nationalistic rhetoric had unleashed forces they could not control, forces that set massive troops into motion and propelled Europe into the First World War. By 1916, the numbers of dead and maimed soldiers were mounting, and the senseless toll of that war was all too evident. Against the backdrop of these larger horrific events, Ball was a seemingly trivial and absurd figure—standing there in his makeshift magical vestments on the stage of the Cabaret Voltaire—even among the community of exiled artists, intellectuals, and political dissidents who had sought refuge from the war in Zurich and whose ranks included none other than Vladimir Ilyich Lenin himself. Trivial though Ball may have appeared to be, the stakes in the battle that he took up were not. Indeed, they transcended the war itself and were significant enough to give Ball a lasting place in the annals of European cultural history. Although the Cabaret Voltaire was short-lived, Dada and its iconoclastic critique of culture spread quickly to Berlin, Hannover, Cologne, New York, and Paris.

That historical moment, partially constructed out of improvised cardboard vestments, can rightly be identified as the birth of an avant-garde—indeed, the birth of one of the most famously irreverent avant-gardes. There were certainly other births as well. One could cite the formation of the Italian Futurists just a few years earlier, the theatrical exploits of Alfred Jarry closer to the turn of the century, or, as critics have often done, one could go back to the early nineteenth century when Henri de Saint-Simon was among the very first to speak seriously of an artistic avant-garde and was arguing that artists ought to be at the forefront of revolutionary politics.[4] As important as groups like the Saint-Simonians are in the narrative history of the European avant-gardes, I want to suggest as a point of departure for this book that, while there is genuine intellectual value in considering a broad history of those births, it is a mistake to assume that figures like Saint-Simon set a precedent without which it is unthinkable to find Hugo Ball standing rigidly on the stage of the Cabaret Voltaire in his makeshift magical vestments. Indeed, such assumptions are intertwined with a questionable logocentrism that is still very much prevalent in scholarship on the avant-gardes and that is perhaps best exemplified in an equally problematic assumption: namely, that in order to understand vanguardism as a phenomenon, one must trace back through an etymological genealogy to the origins of the term *avant-garde*

itself and of the application of the term to describe particular artists. One might call this later assumption the "etymological imperative."

Classic examples of scholarship that follow this imperative are easy to find in histories of avant-gardism from the 1960s and 1970s, such as those by Renato Poggioli, Donald Drew Egbert, and Matei Calinescu. But the force of this imperative still resonates in the recent work of literary scholars like Richard Murphy, who, in his book *Theorizing the Avant-Garde,* is careful to note that "the earliest use of the term 'avant-garde' as applied to a progressive artist group occurs around 1825, toward the later phase of the European Romantic movements, and is associated with the followers of the proto-socialists Saint-Simon and Fourier."[5] A similar tendency is evident among theater and performance studies scholars as important as Mike Sell and as established as Richard Schechner. In his introduction to *Avant-Garde Performance and Material Exchange,* for example, Sell specifically returns to Saint-Simon and early nineteenth-century bohemians, arguing that "Saint-Simonianism and bohemianism are the two most important influences on the development of the European avant-garde tradition."[6] But perhaps the more interesting example of the tendency to follow this imperative is to be found in Schechner's prominent recent essay on 9/11 as avant-garde art, which I will be discussing at length toward the end of this book.

In the opening paragraph to that essay, Schechner literally begins his discussion by turning to the *Oxford English Dictionary.* Citing the French and military origins of the term *avant-garde,* as well as tracing its usage in English back to "the end of the fifteenth century," Schechner notes that *avant-garde* is a cognate to "*vanguard* and *van*" and "refers to being 'ahead' or 'first' in any number of circumstances." Although there is a palpable linguistic irony—or perhaps mischievousness—in Schechner's subordination of the 9/11 terrorists to the *OED,* this subordination is not unlike the tenuous linear relationship that histories of avant-gardism build between European figures like Saint-Simon and Hugo Ball. There is nothing by way of precedent set in the etymology that Schechner cites without which it is impossible to imagine the heinous events of 9/11. So at one level the obvious question that Schechner's essay raises is simple: what critical advantage does one gain by defining the events of 9/11 as avant-garde art? This is a question that Schechner himself poses. At a more basic level, however, this question begs the more fundamental question of whether the etymology that Schechner offers—an etymology that

even breaks *vanguard* into separate linguistic components—actually leads to a better understanding of vanguardism, not as a term but as a cultural-political phenomenon, against which the events of 9/11 can be measured. In this respect, the most basic question about Schechner's adherence to "the etymological imperative" is whether that adherence leads to an understanding of the dynamic surrounding the events of 9/11 that not only would justify their designation as avant-garde, but that would also open the door to considerations of how this particular form and this particular historical moment of avant-gardism necessitate new and fundamental adjustments in how cultural critics define an avant-garde as such. The choice here, I would suggest, is between a stagnant, albeit broadly defined notion of the avant-gardes on the one hand, and a fluid notion on the other that is consciously provisional and tactical with guerilla-like elusiveness. The instabilities beneath the surface value and meaning of the term *avant-garde* facilitate this latter notion.

Those instabilities always accompany the term *avant-garde,* and from a critical standpoint, I would suggest that there is much more to be gained by tapping into the resulting slippage and play than in constructing a seemingly stable etymology that subtly mystifies, and ultimately restricts, the conceptual usage of *avant-garde* as a term. To a large extent, Sell shares this same interest even though he does not say so directly. Having paid a kind of requisite service to the etymological imperative, Sell is quick to point out how "situational, how contingent and local," the influence of Saint-Simonisnism and bohemianism are in the larger economies of material exchange that have defined the avant-gardes. He notes that "if the avant-garde is a 'movement', it is a movement that goes in many different directions."[7] If it is "a moment," I would add, it is also a moment in name only. Beneath the name, it not only goes in many different directions, it also has multiple points of departure, none necessarily reliant on another. The avant-garde is always the avant-gardes, and while the constituting points of departure for one may borrow from another, one avant-garde is seldom directly contingent upon the precedents set by its predecessors. Vanguard traffic moves in pluralities. Ironically, the plural flow of this traffic is frequently at odds with the discourse coming from individual avant-gardes, and this irony returns us to this book's point of departure: it brings us back to the peculiar and solitary figure of Hugo Ball standing on the stage of the Cabaret Voltaire in his cardboard vestments and witch doctor's hat. The point of departure of this avant-garde is a moment of linguistic panic and an attempt to corral slippage

and play within an increasingly narrow and mystified etymological imperative: it is a moment of smoke and mirrors that would bury pluralities beneath a powerful illusion of unified, singular meaning.

II. Incantations, Irony, and Invulnerable Sentences:
Hugo Ball's Sound Poems

Once upon the stage, Ball recited the sound poem "Gadji Beri Bimba," which the evening program described as a "verse without words." Although critics have argued that "Gadji Beri Bimba" and other sound poems like Ball's "Karawane" are "marked by a 'senselessness' that reflects an expressive incapacity," that "repudiate[s] semantic content [. . . and that] moves toward pure sound," Ball may well have described himself as "a magical bishop" not only because of his costume, but also because his poem was not merely full of sounds, but full of sounds that performed.[8] The poem was packed with sounds of incantation and magic: *abracadabra* sounds. It was full of sounds like "the wonderfully plaintive words" that, Ball claimed, "no human mind can resist," and that came from "ancient magical texts."[9] Ball, again suggesting a state of possession, later said he "had no choice" but to deliver these sounds in "the ancient cadence of priestly lamentation" and in the "style of liturgical singing that wails in all the Catholic churches of East and West."[10] The cadence and style in the recitation gave the poem and the performance their gravity. The sounds themselves were indeed of the order of magical incantations:

gadji beri bimba glandridi laula lonni cadori
gadjama gramma berida bimbala glandri galassassa laulitalomini
gadji beri bin blassa glassala laula lonni cadorsi sassala bim
o katalominai rhinozerossola hopsamen laulitalomini hoooo
gadjama rhinozerossola hopsamen
bluku terullala blaulala looooo[11]

This sound poem went on for two additional mesmerizing verses. What force compelled Ball to adopt the priestly cadence and liturgical style is not entirely clear. The target of his lamentation and song, on the other hand, is easier to identify. He was reacting against the malleability of political discourse that allowed politicians to say one thing while doing another and to rationalize an unjustifiable war to those whose lives it ul-

timately ended. The sounds of "Gadji Beri Bimba" could not be appropriated for such cynical manipulations, and presumably they worked their spell against words that could. If Ball's performance piece strove thus toward a repudiation of "semantic content," as critics have suggested, then that repudiation was grounded in incantation—the incantation performed by those magic-laden sounds—and the incantation itself functioned as an exorcism of sorts, a battle to expel the forces that prey upon the vulnerability of words to cynical political appropriation. At the level of discourse, Ball's sound poem fought the hypocrisy of modern "European intelligence"[12] through the reduction of sound to "archetypal and magical essences."[13]

However mystified, however problematic in its notions of archetype and essence, Ball's performance of "Gadji Beri Bimba" cast a spell against cultural ideals that were all too vulnerable to the kind of appropriation that whitewashed the carnage and "slaughter" of the First World War, burying what Ball called the war's "betrayal of man" beneath a dishonest and duplicitous rhetoric of "European glory." Ball's response to this dishonest rhetoric was decisive. Although it was probably not a deliberate reference, he likened the war's political leaders to a group of demon barbers from London's Fleet Street: "They cannot persuade us to enjoy eating the rotten pie of human flesh that they present to us. They cannot force our quivering nostrils to admire the smell of corpses."[14] Ball's return to the sounds of incantation was in this regard part of a political-aesthetic search for a discourse that could not be compromised, appropriated, or manipulated. "It is imperative," Ball argued, "to write invulnerable sentences. Sentences that withstand all irony."[15] Perhaps such sentences could bring political hypocrites to silence and bring an end to an unnecessary war justified by lies and deceptive rhetoric. But such sentences, if they are possible at all, would indeed be magical, since they would have to be comprised of something other than discourse as we know it.

Combating the kind of dishonest political rhetoric that fans the flames of unnecessary wars is a noble thing in any period of history, but the dream of invulnerable sentences as the weapon for that combat is a particularly modernist fantasy—especially in the opposition that Ball builds between invulnerability and irony. Ultimately, that opposition—which masks a striking etymological imperative beneath a veil of metaphysical rhetoric—relies on a contrast between a privileged singular notion of meaning and truth, on the one hand, and the multiple layers of

meaning that irony unleashes, on the other hand. In this respect, it is not a matter of coincidence that the dream of invulnerable sentences coincided with a project that sought to reduce words and sounds to magical essences. For in the realm of discourse—be it the discourse of language or of the stage—invulnerability is a rhetorical posture rather than the place of fact and secure meaning that it pretends to be. It is a privileged and mystified category. It posits immediacy where there is already mediation, presence where there is already representation, and, above all, stability where there is already slippage and play.

In its most extreme manifestation, the dream of invulnerable sentences conceivably slips into fascist authoritarianism. This, at least, is what Greil Marcus maintains. He has famously argued that Ball's call for invulnerable sentences opens "dada to the will to power" and sounds a lot "like something that should have been written by Hitler—or Lenin."[16] Playing a provocative game of double entendre, Marcus concludes that "invulnerable sentences are death sentences." To punctuate this latter point, he adds that "'Six million exterminated' is an invulnerable sentence," claiming, "you can't argue with it." On the contrary, "Six million exterminated" is a sentence fragment, and Marcus is gaming in the darkest realms of macabre irony. In doing so, he proves that no statement of historical fact or fiction, however horrific, is ever invulnerable and safe from manipulation or irony. If, as Marcus claims, "there is a way in which" this sentence (fragment) "is dada," then I would suggest that it is so only in the echo that Marcus creates between it and Ball's incantations.

Like Ball's own performance, invulnerable sentences—and etymological imperatives—are sustained not by real magic, but by sleight of hand and by the seductive flourish of incantation. Indeed, the unity that Ball conjured forth in his performance was ultimately only a construct and representation, assembled from makeshift vestments and magic sounds that he had appropriated for that particular moment on the stage. It wasn't real magic that transpired on the stage of the Cabaret Voltaire—at least not in the paranormal sense. But it was a moment rich in irony: the irony of calling for invulnerable sentences and of seeming to strip words down to the level of pure sound, while staging an event where words and sounds are always more than they appear to be—the irony, thus, of combating irony while unavoidably producing it, and, the irony, likewise, of combating pluralities while unavoidably producing them in the ambiguities of the stage.

III. Pluralities and the Ghosts of the Avant-Gardes

One need not play along with Marcus's dark rhetorical game in order to grasp the ironies that hover about Hugo Ball standing on the stage of the Cabaret Voltaire reciting "Gadji Beri Bimba" in that combative, iconic moment in the history of the avant-gardes. It is this moment of rich irony, slippage, and play that is of interest to me—this moment that inadvertently acknowledges pluralities in the very effort to bury them beneath the misleading construct of a unified, stable discourse. There is no debate about the need to resist the deceitfulness of political doublespeak, but positing the dream of reducing sentences to invulnerable, unambiguous meaning is either equally duplicitous and manipulative, or it is simply delusional. If Hugo Ball was possessed on that July evening in 1916, I would suggest that he was possessed by the multiple layers of meaning and signification that his incantations summoned, unleashed, and ultimately failed to control. Moreover, I would suggest that in the unacknowledged pluralities that haunted that moment, the foundation for a critical discourse on the avant-gardes can be found.

I take Ball's performance both as a point of departure and as a point of contrast for this book, because, in that moment of attempting to bury pluralities beneath the semblance of a unified discourse, his performance contains a gesture that, while not necessarily setting a precedent for subsequent avant-gardes, nonetheless recurs again and again among avant-garde artists, as well as among scholars of the avant-gardes. Ultimately, I am more interested in the pluralities that Ball sought to bury and in the gesture of trying to bury them than in the unified, singular notions of meaning that Ball wanted to construct in their stead. Likewise, I am more interested in the pluralities that an overarching "theory of the avant-garde" tends to bury than I am in promoting yet another generalized theory of the avant-garde. At the very least, I see a conceptual parallel between Ball's gesture and the gesture of scholars who attempt to mold divergent avant-gardes within a unified theory of the avant-garde as such. At the most basic level, that conceptual parallel can be seen in the etymological imperative that is central not only to Ball's performance of "Gadji Beri Bimba," but to most constructed genealogies of the avant-garde(s) as well. In this regard, *The Ghosts of the Avant-Garde(s)* sides with irony and the multiple layers of meaning against which Ball struggled on that July evening in 1916. Those multiple layers of meaning—pluralities as I choose to call them—are the site and the substance of the ghosts of which I

speak. Inasmuch as this book traffics in pluralities, it does so in deliberate contrast to long-established predecessors like Peter Bürger's *Theory of the Avant-Garde.*

Pointing toward a larger conceptual strategy, the contrast here is between the construction of an overarching theory, on the one hand, and the rough negotiations within a provisionally constructed economy of critical interventions, on the other. In this contrast, the shift from "theory" to "interventions" not only calls for viewing the avant-gardes from multiple vantage points (including multiple theoretical vantage points). It also challenges the assumption that a single overarching theory can account for the diverse pluralities packed within the terms *avant-garde* and *performance* without leading to debilitating compromises or deeply problematic exclusions. Indeed, to link the avant-gardes and performance together already works in pluralities since it points toward a sphere of vanguardism that remains curiously absent from the more general theory of the avant-garde that critics like Bürger, Poggioli, and Calinescu all posited in their now-classic studies of avant-garde art and culture. Against the influential legacy of their interest in a master theory-narrative, this book pushes unrelentingly toward the numerous and the quantitatively diverse. The pluralities it embraces are multiple in kind: theories, avant-gardes, and performances. But why this emphasis on pluralities?

Some forty to fifty years after Bürger, Poggioli, and Calinescu each formulated a theory of the avant-garde, few scholars writing about avant-garde performance today fail to note at some point that it is more accurate to speak of avant-gardes than of *the* avant-garde. Such repeated acknowledgment of plurality merits much more than the kind of passing acknowledgment that ultimately reverts back to a more generalized theory of the avant-garde. The challenge is to act upon the passing note and to articulate the theoretical currents that feed it: to tease out of the shadows of the observed pluralities strategies that account for, but do not conceptually delimit, the individual particularities of the avant-gardes. Such is the project undertaken in this book. A key strategy of that project involves a concerted attack on conceptual paradigms that posit uniformity at the expense of multiplicity, that are premised upon unacknowledged preclusions, and that are sustained by what Theodor Adorno famously called "the magic spell" of "reconciliation under duress."[17] In this respect, the title of the book, *The Ghosts of the Avant-Garde(s),* refers to the multiple forms of vanguardism that haunt the selective ways in which critics have theorized the term *avant-garde.* To that end, much of this

book involves a sustained critical dialogue with Bürger's *Theory of the Avant-Garde* and with the conceptual paradigms in that work that continue to have broad, accepted currency, even among those who would speak of avant-gardes rather than of *the* avant-garde.

IV. Peter Bürger and the Parameters of Avant-Garde Studies

Considering that the German version of Bürger's book was first published in 1974, it may seem to be an odd point of focus almost forty years later, and yet this particular work (along with its English translation in 1984) continues to exercise an unparalleled influence on the shape of studies of the avant-gardes. Evidence of this influence is difficult to avoid. For example, when Jonathan Eburne and Rita Felski recently edited a special issue of *New Literary History* that addresses the question "What is an avant-garde?" not only did they argue that "for the past few decades, the study of the avant-garde has persistently circled" around issues whose "parameters" were largely set by Peter Bürger.[18] They also specifically decided to begin "the revisionist project" of their special issue with a newly commissioned essay by Bürger. In that opening essay, the editors allowed Bürger to reflect upon the critical reception of his own book, which Eburne and Felski rightly identify as "one of the principle texts in the field,"[19] This was not an altogether illogical point of departure for a collection of essays seeking to cultivate what Eburne and Felski call "a more variegated picture of the histories of avant-garde practice, one characterized by nonsynchrony, multiple temporalities, repetition, and difference."[20] Presumably, the thought here was that Bürger might have pressed toward a rethinking of the limitations of his own work. But given the revisionist goals of the overall project, it may have come as some surprise to the editors that Bürger used this opportunity to formulate a spirited reassertion of the original arguments he had laid out in 1974. At the very least, Eburne and Felski found themselves in the awkward situation of introducing Bürger's article while literally arguing against it. "The subsuming of all avant-garde movements within a single development narrative," they argue, "allots an excessive importance to the avant-garde's European origins, while condemning all subsequent forms of radical art to repetition, belatedness, and bad faith."[21] This comment not only takes aim at the underlying assumptions of Bürger's article, it applies equally to *Theory of the Avant-Garde* as well. While I strongly agree with this cri-

tique, I must note that it was purchased at an ironic price. Eburne and Felski's project resulted not only in an acknowledgment of the lasting influence of Bürger's book, but also in the placement of a reiteration of Bürger's original arguments at the center of one of the most current debates about the avant-gardes.

As for Bürger's spirited defense of his own work, there is a kind of partisan tit-for-tat in his response to critics like Benjamin Buchloh and Hal Foster that, while at times losing sight of the larger issues of "nonsynchrony" and "multiple temporalities" that concern Eburne and Felski, nonetheless evinces a crucial, if somewhat intuitive, understanding that studies of the avant-gardes are as much about the contested field of avant-garde studies as they are about the avant-gardes themselves. In this respect, Bürger's response to his critics lends credence to other essays in the special issue of *New Literary History,* such as Mike Sell's article "Resisting the Question, 'What is an Avant-Garde?'" Indeed, my own return to Bürger in this book is an emphatic echo of Sell's argument that "we cannot answer the question, 'What is an avant-garde?', until we better comprehend [. . .] the history of the field of avant-garde studies itself."[22] The two go hand-in-hand. Echoing this same sentiment, *The Ghosts of the Avant-Garde(s)* is thus based upon two assumptions: first, that to speak of the avant-gardes necessitates speaking of how the avant-gardes have been received and conceptualized in cultural criticism, and second, that in order to rigorously examine this reception, one must dive headlong into the pivotal controversies and debates that have shaped studies of the avant-gardes as a field.

Although there is much I disagree with in Bürger's specific "theory of the avant-garde," at a much more fundamental level, his decision to engage his critics coincides with my own conviction that studies of the avant-gardes ought to provoke a clear sense of the divisions that are still very much at play in the field of avant-garde studies. If that field is contested, it is contested, I would suggest, because historically the avant-gardes have inclined toward contestation at political, social, and cultural levels. While work on the avant-gardes need not be avant-garde itself, it will tend—if it pursues its subject rigorously—to court disagreement and debate, because the avant-gardes tend to be embedded in controversy and provocation. It is hard to imagine how work on the avant-gardes—work that not only takes the political and cultural provocations of vanguards seriously but that also takes the work of other scholars seriously—can avoid being spirited and partisan. At one level, then, I would suggest that

even the concepts of nonsynchrony and multiple temporalities are not mere matters of history and historiography. They are signs of how one particular faction of cultural critics—and I include myself among them—theorizes the histories of the avant-gardes. In this regard, the answer to Eburne and Felski's question "What is an avant-garde?" will always be tied to the disputes that the avant-garde provoked and that hover about the history of its reception.

With regard to Bürger and the legacy of his work, that history is marked by a profoundly influential yet false dichotomy—a dichotomy between theory and history—that resurfaces with precise clarity in the article he contributed to *New Literary History*. Accusing his critics of being "theory-phobic," Bürger claims they would have him write "a history of the avant-garde" rather than follow the dictates of theory. He notes that his critics frequently argue that *Theory of the Avant-Garde* "forces the differences and contradictions within the avant-garde movements into unifying categories," and while conceding that "there are, of course, differences between futurism, Dada, surrealism and constructivism"—differences that "a history of the avant-garde movements would have to represent"—Bürger suggests that "theory" cannot be bothered with such differences since it "pursues other goals," and thus "needs to undertake generalizations that are set at a much higher level of abstraction than the generalizations of historians."[23] Unfortunately, the appeal to necessary abstraction and generalization is not as clear-cut as Bürger seems to suggest. For the abstraction is itself a kind of magical sleight of hand. Even if one sets Bürger's highly reductive view of the work of historians aside momentarily, his response still begs the question of why the theorist needs to generalize differences and contradictions into unifying categories, rather than theorizing the significance of difference and contradiction as key paradigms for understanding the avant-gardes. But something more than issues of difference and contradiction is at stake here.

The unifying categories that Bürger posits have everything to do with the multiple histories of the avant-gardes because those categories are not mere theoretical abstractions. They are historiographic constructs intended to frame scholarly understanding of the histories of the avant-gardes in particular ways. The most widely disseminated among those categories is Bürger's distinction between what he calls "the historical avant-garde" and what he largely dismisses under the category of "the neo-avant-garde"—categories that he reaffirms in his article for *New Literary History*. If one is to speak of the enduring influence of Bürger's

work, of its foundational place in current studies of the avant-gardes, or, to follow Eburne and Felski, of the "parameters" that his work has set for subsequent studies of the avant-gardes, then one must look to categories like these. Turning a critical eye toward Bürger at this particular moment—almost four decades after the publication of *Theory of the Avant-Garde*—is not only warranted because he has once again entered the scholarly fray but because he never really left. Few writers have exercised as much direct and indirect influence on studies of the avant-gardes. This is not only true across the spectrum of disciplines where studies of the avant-gardes routinely share Bürger's anti-theatrical bias.[24] It is also true in the field of theater and performance studies, where many of his key concepts are simply taken for granted, considered so foundational that they elude critical scrutiny. An important example of the extent of this influence can be found in the uncritical borrowing of historical categories developed by Bürger in *Theory of the Avant-Garde* and later deployed by Hans-Thies Lehmann in his book *Postdramatic Theatre* (1999, 2006).

V. The Postdramatic Aesthetic Structures and the Historiographies of the Avant-Gardes

An immensely provocative and influential work in its own right, Lehmann's study plots the decline of the dramatic literary text as the focal point in theater, a decline that coincides with the late twentieth-century rise of postdramatic theatrical forms. This transition from the dramatic to the postdramatic follows an arc that roughly begins in the 1970s, according to Lehmann, and continues on into the twenty-first century. It is preceded by "the historical avant-garde" in the early part of the twentieth century and "the neo-avant-garde of the 1950s and 1960s."[25] Among the more noteworthy aspects of the "prehistory" of the postdramatic that Lehmann posits in the early part of his book are the two categories "historical avant-garde" and "neo-avant-garde," which he borrows from Bürger without attribution, and which I will be critiquing at length later on. The point here is not to be a round-about stickler for proper citation, but rather to note that the absence of attribution is actually an indication of just how widely disseminated and accepted Bürger's terms are—even in a study that would seem to involve a more nuanced understanding of those terms. I will look momentarily at some of the other examples of

this wide dissemination, but first I want to focus attention on how Lehmann's work does and does not press beyond the historiography implicit in Bürger's *Theory of the Avant-Garde.*

For Lehmann, recourse to Bürger's categories is an absolute yet unproblematized necessity. Indeed, while he argues that a discussion of the postdramatic "has to have recourse to the historical avant-gardes because here the conventional dramaturgy of unity was first disrupted," he adds in passing that this crucial necessity "cannot involve adding to the rich scholarship on this epic."[26] At the most basic level, this latter caveat is simply an open acknowledgment of how Lehmann has decided to limit his focus. But so too is it a tacit concession. It brushes over the decision not to contest the historiographic categories Bürger posited in the 1970s, categories that were contested in scholarly debates almost immediately following *Theory of the Avant-Garde*'s original publication,[27] As I will be arguing later in this book, not only have Bürger's categories shaped scholarly discourse on the avant-gardes into a reaffirmation, among other things, of Eurocentric aesthetic sensibilities, but, in the case of Lehmann's subsequent reliance on Michael Kirby's work, they also easily facilitate the transition of that discourse into a largely apolitical and formalistic analysis of avant-garde performance.

Regardless of whether one accepts or challenges the assumptions governing categories like "the historical avant-garde" or "the neo-avant-garde," avant-garde gestures tend to be socio-political formulations as much as they are aesthetic formulations, and to limit one's focus to a formalistic analysis of avant-garde gestures ultimately delivers a skewed, if not altogether sanitized, image of the avant-gardes. This is a point that Richard Schechner has emphatically rehearsed in some of his more recent writings on the avant-gardes. Although I question Schechner's own embrace of Bürger's categories, his assessment of twentieth-century vanguardism—particularly, his assessment of those avant-gardes that were influenced by European traditions—is very much in line with the notion that among the avant-gardes the aesthetic and the political walk hand-in-hand. Schechner's comments are worth quoting, if only because the disruption he associates with the avant-gardes contrasts so markedly with Lehmann's focus on the disruption of "the dramaturgy of unity":

> But it is true that the "historical avant-garde," in both its artistic and political incarnations—from, say, futurism and Dada to surrealism and the Situationists; from Alfred Jarry to Antonin Artaud to the Liv-

ing Theatre; from Trotsky to Mao, Che Guevara to Franz Fanon—
strongly advocated disruption, overthrow, and anarchy—a revolu-
tionary cathartic as prelude to a new world order.[28]

Here "disruption" is akin to political subversiveness—theater and perfor-
mance as activism, placed on a par with "anarchy." Disruption is, in this
respect, a potential prelude to "revolution" and "a new world order."
Pushing a bit beyond the contrast between Schechner and Lehmann,
however, I would suggest it is not enough to state that it was with the
"historical avant-gardes" that "the conventional dramaturgy of unity was
first disrupted," or even to state that the "historical avant-garde" advo-
cated "a revolutionary cathartic." There is a pressing need to consider the
ideological foundations of categories like "the historical avant-garde" and
"the neo-avant-garde" themselves, and in particular, there is a need to
consider how the historiography encouraged by these categories flattens
the always-contested social, political, and cultural terrains of the avant-
gardes, implying a uniform and linear sense of history, where in fact the
histories of the avant-gardes are uneven, divergent, and frequently at
odds with one another, both in terms of aesthetics and politics.

At a metaphorical level, one might legitimately argue that the critical
shift away from the historiography advocated by Bürger is a shift from a
dramatic sequential narrative toward a postdramatic historiographic sen-
sibility, and herein lies what I would call Lehmann's somewhat coinci-
dental significance for this project. If the privileging of a formalistic
analysis over a historiographic analysis has an immediate consequence for
Lehmann's handling of the avant-gardes, I would suggest that this conse-
quence lies in the lost opportunity not only to reconsider the historical
categories Bürger posited in 1974, and that Lehmann takes for granted,
but to do so in a manner that runs parallel with the structural forms
Lehmann associates with the postdramatic. The opportunity here is to
recognize the conceptual link between the structures of the histrionic and
the historical. Under the general heading of "Postdramatic theatrical
signs," for example, Lehmann identifies a "retreat of synthesis," "a de-
hierachization of theatrical means" (i.e., "parataxis"), and the embrace of
"simultaneity"—all of which are also characteristics of avant-garde per-
formance, and, more importantly, all of which are potential conceptual
models for understanding the disparate histories of the avant-gardes, or,
to recall our earlier discussion, for cultivating what Eburne and Felski call
"a more variegated picture of the histories of avant-garde practice, one

characterized by nonsynchrony, multiple temporalities, repetition, and difference."[29]

What I will be pointing toward throughout this book is a historiography of the avant-gardes that does not reconcile their differences into a greater unacknowledged synthesis or subordinate one avant-garde to another in some implied linear history or generalized theory, but rather acknowledges the simultaneous, often competing, frequently incompatible, and individually autonomous avant-gardes. Indeed, this emphasis is perhaps best foreshadowed in Lehmann's particular interest in postdramatic theater's "*deforming figuration,*" a strategy he describes as a "renunciation of conventionalized form," and which Lehmann ultimately explains by turning to Deleuze and Guattari's well-known discussions of the rhizome in *A Thousand Plateaus.* Lehmann notes:

> Gillles Deleuze and Felix Guattari have come up with the key term "rhizome" for realities in which unsurveyable branching and heterogeneous connections prevent synthesis. Theatre, too, has developed a multitude of rhizomatic connections of heterogeneous elements.[30]

Toward the end of this book, I will be developing this notion further, but I want to state in advance of my subsequent discussions of the rhizome that I see no problem with Lehmann's embrace of it as a model for the aesthetics of postdramatic theatre. But inasmuch as Deleuze and Guattari conceptualize the rhizome as a model for understanding social structures, I would suggest that it also has equal relevance for understanding how avant-gardes are configured historically in relation to one another.

VI. Paul Mann and the Discursive Economy of the Avant-Gardes

Considering the larger objectives of this book, Lehmann's problematic embrace of Bürger's historical categories is much less important than finding conceptual models that point toward alternatives to those categories. Moving in that direction, I want to acknowledge a not always visible, yet ever-present interlocutor in my larger critique of Bürger. When it comes to poststructuralist approaches to the avant-gardes, few scholars are on a par with Paul Mann, whose self-described "overheated and distasteful little book," *The Theory-Death of the Avant-Garde,* has influenced my work here in more ways than I can say.[31] Although he does not ad-

dress the issue of pluralities that is at the forefront of my own concerns, the theoretical foundations of my book and its ultimate focus on avant-garde pluralities are indebted to Mann's compelling analysis of the avant-gardes as a discursive economy.

Critics have made much of the dialectic of resistance and recuperation that Mann posits as the force moving that discursive economy, a dialectic in which the former cannot exist without the latter any more than the latter can exist without the former. As Robert Radin noted in one of the few sympathetic considerations of Mann's work, "Mann historicizes some of the 'classical' avant-gardes—impressionism, dada, futurism, abstract expressionism, pop—showing how each movement inscribes a similar set of questions, questions rooted in the binary opposition conformity/resistance. Over and over again he makes the point that the avant-garde does not represent the second term in this opposition, but rather is the means by which discourse is produced."[32] Mann is certainly not the first to challenge the long-held assumption that an aesthetics of resistance defines the avant-gardes. In fact, one of the more insightful moments in Radin's reading of Mann comes when he notes that in *The Pleasure of the Text* Roland Barthes foreshadows much of Mann's argument. This not only true with regard to Barthes's association of the avant-gardes with a "language" that, however "restive," always (already) succumbs to "recuperation." It is also true with regard to what Barthes calls "the great semiological 'versus' myth" that serves as the motor behind anti-art gestures[33]—the myth, in other words, of opposition. What interests me in Radin's discussion of Mann and Barthes is not so much the question of whether "the avant-garde represents a real antithesis or is always only a bourgeois formation."[34] It is rather the general sense that the term *avant-garde* points toward a specific kind of language and/or discursive economy.

At any number of levels, it would be difficult to overstate the importance of this shift toward an understanding of the avant-gardes as constituting a discursive economy. First and foremost, the parallels between the structures of language and the structures of avant-garde expressions demand a consideration of how the discourse of the avant-gardes, like language itself, is open to slippage and play, as well as a consideration of how this openness gives space to unexpected avant-garde expressions. Among the more significant implications of this shift is the consequent loss of a clear referent for the term *avant-garde* itself and for the accompanying discourse of the avant-gardes, a loss that not only accounts for the ever-changing and diverse forms of the avant-gardes in history but that also

opens the door to the various forms of avant-garde pluralities that I consider throughout this book. Indeed, the absence of a clear referent results in historical instances like the one that I discuss in my opening chapter, in which competing factions of the early European avant-gardes vied for control of a common avant-garde discourse, and, ironically, for the presumed advantage that this discourse conveyed as a rhetorical strategy for expelling rival avant-gardists. Here the "'versus' myth" played out in particularly vicious and personal ways, in simulated and actual legal battles between Tristan Tzara and André Breton. While this early twentieth-century struggle between Parisian Dadaists and emerging Surrealists is noteworthy because of calculated and literal attempts by figures like Breton to manipulate the language of vanguardism for their own agendas, the contradictory avant-gardes that continued to operate beneath Breton's appropriation of the "'versus' myth" highlight a slippage that surfaces time and again, not only in the discourse of the avant-gardes but also in the corresponding academic discourses that construct the histories and theory/ies of the avant-gardes.

Breton's manipulations of the "'versus' myth" may be surprising in their transparency, but such manipulations in academic discourse on the avant-gardes frequently obtain widespread acceptance because they are more subtle in the constructed oppositions that they enforce. Nowhere does this prove more true than in what is perhaps the most widely disseminated construct from Bürger's *Theory of the Avant-Garde* that I mentioned in my earlier discussion of Han-Thies Lehmann, i.e., the distinction between what he calls "the historical avant-garde" and "the neo-avant-garde." Lehmann's uncritical appropriation of those terms is but a small example of one of most established historiographic constructs shaping current histories of vanguardism. To get some sense of how established this distinction between the "historical" and "neo" avant-gardes has become among scholars, one need only look at publications like Günter Berghaus's *Theatre, Performance and the Historical Avant-Garde* (Palgrave, 2006) and David Hopkins's edited volume *Neo-Avant-Garde* (Rodopi, 2006), and there are many other examples as well. I develop a substantial critique of these two categories over the course of the second, fifth, and seventh chapters of this book, but I want to preface that critique with some preliminary reflections on how Bürger's distinction between the categories subtly reproduces the "'versus' myth" that Barthes describes in *The Pleasure of the Text*. Anyone familiar with Bürger's work knows that his use of the categories "historical avant-garde" and "neo-

avant-garde" has less to do with documenting avant-garde gestures in different historical moments than it does with positing a distinction between an ostensibly genuine avant-garde ("the historical") and its subsequent imitators ("the neo"). Here the "'versus' myth" and the myth of originality converge.

VII. On The Selective History of the Historical- and Neo-Avant-Gardes

That this distinction between "the historical" and "the neo" reproduces the "'versus' myth" can be seen in the spirited defenses of "the neo-avant-garde" by prominent critics such as Benjamin Buchloh. His book *Neo-Avantgarde and Culture Industry* (MIT, 2003), for example, explores a rich collection of experimental artists and gives the lie to Bürger's reductive dismissal of the post-war avant-gardes as mere repetitions of the European avant-gardes from the 1920s and 1930s. Indeed, Buchloh's earlier review of Bürger's book takes Bürger to task for constructing a "fictitious moment of [. . .] origin." That fiction, Buchloh argues, is embedded in "a binary opposition": the opposition of "the [supposedly] 'genuine' original versus the 'fraudulent' copy."[35] Much of Buchloh's criticism pivots on presenting a compelling case that there is nothing fraudulent or repetitive about the "neo-avant-garde." Yet, what is surprising about Buchloh's reading of Bürger is that, for all the insightfulness of his critique, the end result is not a rejection of the operative binary of the "'versus' myth" but rather a recuperation of the very categories that produced the problem in the first place. Although he effectively counters Bürger's dismissal of "the neo-avant-garde" and is far less restrictive in his understanding of "the historical avant-garde," Buchloh still conceptualizes the avant-gardes within distinct and uniform categories of history. The pluralities of the avant-gardes are actually a lot messier.

What categories like "the neo-avant-garde" obscure beneath the rhetoric of historical specificity are the mechanisms—indeed, the negotiations—of hybridity that are always the substance of avant-garde expressions, always an indication of the uneven historical trajectories in which the avant-gardes participate and reside, as well as the rough signs of avant-garde pluralities. In the second chapter of this book, I argue that it is not enough to note that the so-called "neo-avant-garde" was never about reproducing earlier gestures of the European avant-gardes. The

moments of what I call American "hybrid vanguardism" in the second chapter's discussions of Black Mountain College are in this respect less about recuperating "the neo-avant-garde" than they are about the pluralities of avant-gardism more generally. While the post-war American avant-gardes are certainly better characterized for their hybridities than dismissed for their ostensible repetitiveness, the larger point is that the so-called "historical avant-garde" was always already embedded in the pluralities of hybrid vanguardism as well—a point that I develop from a global perspective in chapter five. Placed against the backdrop of this notion of hybridity, the binary "original/repetition" emerges as a construct of a deeply problematic discursive economy that not only replicates the "'versus' myth" of the avant-gardes, but also, as I point out in chapter five, reinforces Eurocentric cultural prerogatives as well. Yet these are not the only cultural prerogatives reinforced by Bürger's, or even Poggioli's, *Theory of the Avant-Garde*.

VIII. Avant-Gardes and the Gendered Genealogies of the Artist as Producer

Constructing categories such as "the historical avant-garde" and "the neo-avant-garde" are by no means the only way in which Bürger's theory reinforces a highly selective narrative history of the avant-gardes. In many respects, these categories are secondary to his more general thesis that avant-garde expression is manifested in a critique of the institution of art. Yet this thesis is also the product of what I will be arguing in chapter three is a highly problematic historiography. Much of that historiography overlaps with the theories of Bürger's predecessor, Renato Poggioli, whose own book *Theory of the Avant-Garde* is no less problematic than Bürger's in the genealogies that it constructs. A consideration of the gendered underpinnings of Bürger's and Poggioli's theories offers a compelling illustration of this very point. As I argue in chapter three, it is not merely the institution of art that reflects a gendered bias. The vanguard critique of that institution itself perpetuates the bias as well—at least as it has been conceptualized in the theories propagated by Poggioli and Bürger.

There is perhaps no better example of this critique of the institution of art than the radical questioning of the role of the artist as producer. The classic example of this questioning is, of course, Marcel Duchamp's *Fountain* (that infamously inverted urinal). Yet when one considers the

historical foundations critics have proposed for this questioning, its selective and gendered underpinnings quickly become apparent. This is especially true in the genealogy constructed by Poggioli. A pivotal link in that genealogy is the debt that, according to Poggioli, the avant-gardes owe to early nineteenth-century romanticism. "The hypothesis of historical continuity between romanticism and avant-gardism now seems irrefutable," Poggioli argues in *Theory of the Avant-Garde*. He then concludes, "there is not the shadow of doubt that the latter would have been historically inconceivable without the romantic precedent."[36] Within the slippage and play of the discourses of the avant-gardes, such sweeping assertions of historical uniformity and genealogical continuity are subject to more than the mere shadow of doubt. The real question is what such claims obscure in the shadows that they themselves generate. Mike Sell, for one, has questioned the underlying orientalism that accompanies genealogies like the one constructed by Poggioli;[37] it is certainly hard to get around the Eurocentrism of Poggioli's claim. But even within the cultural boundaries of Europe, his argument is questionable in terms of its gendered assumptions. It is those assumptions that I address in the third chapter because of their visible currency within scholarship on the avant-gardes.

A key aspect of the continuity that Poggioli proposes lies in a rejection of institutionalized culture by the avant-gardes—a rejection of the "academic public" and "professional culture" by romantics and avant-gardists alike. This same argument is echoed in Bürger's claim that the "historical avant-garde" is defined by its critical rejection of the institution of art. A pivotal example of such rejections can be found in challenges to the traditional notion of the artist as producer.[38] What I would suggest is striking about this genealogy is not that there has been little question of the inseparable link Poggioli proposes between romanticism and vanguardism but rather that there has been little questioning of what the feminist critique of romanticism might mean for the avant-garde as it is conceptualized by theorists like Poggioli and Bürger. That critique has radically destablized scholarly understanding of romanticism, leaving the asserted continuity between romanticism and avant-gardism on very shaky ground. This point is all the more striking when one considers that the questioning of the role of the artist as producer and the feminist critique of romanticism converge in one of the most enduring works of romantic literature: Mary Shelley's *Frankenstein*, a work that has also had amazing currency in avant-garde circles.

As I argue in chapter 3, Shelley's work has enjoyed a particular appeal

among avant-garde artists like Andy Warhol and the members of The Living Theatre, both of whom produced experimental adaptations of the *Frankenstein* narrative that include a substantial reflection on the role of the artist as producer. But as I note in my discussions of Warhol and The Living Theatre, the actual history of *Frankenstein* as a literary text begins with the erasure of Shelley as its author. This erasure was not part of a critical gesture challenging the role of the artist as producer, as was the case, for example, when Marcel Duchamp signed "R. Mutt" on that inverted urinal, when Warhol claimed artistic ownership of the film *Andy Warhol's Frankenstein,* or when Julian Beck claimed authorship of the published script of The Living Theatre's collectively created version of *Frankenstein.* On the contrary, the original, anonymous publication of *Frankenstein* was one of the limited opportunities for Shelley, as a woman, to have her work taken seriously in the early nineteenth century. The larger point here is that the ties linking the avant-gardes to romanticism are not merely bound to the long history of rejecting institutionalized culture. They also link seemingly standard tropes of the avant-garde, such as gestures that question the role of the artist as producer, to a culture of male privilege that historically has maintained a restricted and gendered economy.

What becomes clear in chapter three's more detailed discussions of Warhol's and The Living Theatre's adaptations of *Frankenstein* is that the discourses of the avant-gardes never occur in isolation. They are always situated within a network of overlapping discursive economies that constantly intersect with and interrupt avant-garde expressions. It would be difficult to overstate the extent to which such interruptions run against the grain of the teleological rhetoric of the term *avant-garde* itself: that is, against the idea of the avant-garde as an unfolding linear continuity. Indeed, I would suggest that an indispensable strategy for theorizing the avant-gardes beyond the lure of their own rhetoric is to seek out instances where those moments of interruption unsettle the seemingly established theoretical paradigms of avant-garde expression and open them to the pluralities of concurrent and multiple significations. Such instances are not difficult to find, particularly when one recognizes that as a discursive economy the avant-gardes are given to the same kinds of slippages in signification that literary theorists and poststructuralist critics began exploring in language and literature a few years prior to Bürger's 1974 publication of *Theory of the Avant-Garde.*

IX. Reading Avant-Gardes Against the Grain

Even at this historical juncture, which many might describe as "post-theory," the need for this strategy is nonetheless pressing. The tendency among critics has been to see the broad theoretical implications of avant-garde gestures without bringing the implications of critical theory to bear on the conceptual foundations of avant-garde gestures themselves. Arguments, for example, that the avant-gardes challenge the institution of art, that they question the role of the artist as producer, or even that they initiate innovation through a rejection of textual authority are consistently based upon a largely uncritical but ever-present embrace of a generalized notion of intentionality that critics implicitly ascribe to the avant-gardes. This is also true of studies as deeply versed in poststructuralist thinking as Mann's *Theory-Death of the Avant-Garde*. Indeed, for all its radical rethinking of the theory-logic of the avant-gardes, Mann's book is nonetheless committed to a project of explicating the dialectical dynamics that keep the avant-gardes moving—and, I might add, that keep them moving with the same kind of uniform singularity posited by Bürger. Rather than exploring the interruptions and ruptures that highlight the unruly, uneven, and frequently irreconcilable pluralities of the avant-gardes, Mann keeps their rhetoric and their accompanying intentionality intact. What is lacking in theories of the avant-gardes is thus a strategy that consistently reads avant-garde works against the grain—not merely against the grain of the rhetoric of the avant-gardes but also against the grain of the implied or even expressed intent of avant-garde artists.

The latter half of this book addresses that lack from an increasingly global perspective. One of the consequences of this shift to a global perspective is the slippage it generates in the very idea of "the cutting edge"—a slippage I discuss at length in chapter five, where I note that the avant-gardes never move into an empty space but are always entangled in the rough edges of cultural exchange and appropriation. Although much of the argument in chapter five is focused on cultivating a sense of avant-garde pluralities by countering the Eurocentric conceptions of the avant-gardes and by acknowledging their transnational foundations, one of the significant examples of the avant-gardes' rough edges can be found in the debates about cultural exchange and appropriation that erupted around Peter Brook's production of *The Mahabharata* in the late 1980s. Indeed,

that production is of particular importance, as I argue in chapter four, because it provides a near-textbook example of how one might read the works of the avant-gardes against the expressed intent of the artists who produced them, or, in the case of Brook, against the expressed intent of their directors. What is of interest to me in that chapter is not what Brook says he attempted in *The Mahabharata,* but rather what the production does against the grain of Brook's assertions about it. Working within the discourse of critical theory, the chapter thus seeks a parallel between what Roland Barthes called "the death of the author" and what I call "the death of the director." Just as Barthes famously argued that the death of the author removes "the limit on the text" and liberates it from the restrictive notion of a "final signified,"[39] so too does "the death of the director" open any given performance to multiple significations.

Moving from what Barthes calls "the death of the author" to what I call "the death of the director" is a logical extension of a widely disseminated argument from critical theory. But the point of this extension goes well beyond a rehabilitation of Brook's production of *The Mahabharata* from the passionate debates in the late 1980s and early 1990s, debates that centered largely on Brook himself and on his presumed intentions. The extension points toward a central theoretical issue in the debates about the avant-gardes. If "the death of the author" removes the limits "on the text," and if, correspondingly, "the death of the director" opens performances up to multiple significations, what kind of limits are removed— what kind of pluralities open up—one might legitimately ask, with the often-announced death of the avant-garde? Of course, unlike Barthes's announcement of "the death of the author," announcements of the avant-garde's death have historically aimed not to remove limits but rather to impose them, and to impose them in a uniform, terminal sense. Eulogies for the avant-garde tend to be restrictive, invested in a "final signified," and committed not to plurality, or to the *avant-gardes,* but to a uniform sense of the avant-garde. I want to suggest, as a point of contrast, that those eulogies can be read against the grain of this intent. I would suggest that juxtaposing the eulogies with Barthes's pronouncement of "the death of the author" might precipitate just enough slippage so that "the death of the avant-garde" flips and becomes a sign for the no-longer restricted, for the plural and for the diverse—a sign, in short, for the avant-gardes.

Exploring the unlimited spaces and pluralities of the avant-gardes necessitates conceptual models that, first of all, preserve the decentered nature of vanguardism rather than subsuming diversity beneath constructed

uniformity. As I point out in chapter six, it is only with the presumption of uniformity that the restrictive rhetoric of eulogies for the avant-garde can function. Yet such presumptions are consistently based upon a hasty generalization, and, I might add, upon a fundamental misunderstanding of the experimental character of the avant-gardes. While eulogies may legitimately lament the demise of a particular avant-garde, the demise of the one is in no way tantamount to the demise of the many. Rather than conceptualizing the avant-gardes with such sweeping terminal uniformity, I want to build upon my earlier discussion of Lehmann and suggest here—as I do in greater detail in chapter six—that one of the most powerful alternatives to this problematic logic can be found in the conceptual model of the rhizome that Gilles Deleuze and Félix Guattari explore in their book *A Thousand Plateaus*. What is of particular interest in their discussion of that now famous metaphor of non-linear thinking is that the decentered rhizomatic structures they posit as an epistemological model also provide an ideal model for conceptualizing how one avant-garde may decline or die without endangering the whole of the avant-gardes. Beyond this model, however, I would suggest that the very notion of the death of the avant-garde is based largely upon a problematic glorification of success over experimentation.

Inasmuch as the avant-gardes are associated with experimentation, instances of demise, failure, and even defeat are arguably signs not of the death of the avant-garde but, ironically enough, of its continuing vitality. They are part of the experimental process. Some experiments succeed; others fail. Most importantly, the avant-gardes are constituted not in the successes or the failures—not in the rise or the decline—but in the experimental gestures leading potentially to either outcome. In this respect, eulogies for the avant-garde are arguably signatures of a concept of vanguardism that is only partially theorized, and, as I explain in chapter six, they are signatures of a history of the vanguards that is only half-written. The central argument of chapter six is thus not only that the death of the one does not equal the death of the many, but also that the history of the vanguards will always be half-written and half-theorized until it is also written from the perspective of the unsuccessful and the vanquished. It is this call for a history of the vanquished vanguards that serves as a segue into the book's final chapter and that chapter's implicit consideration of how one might understand the political dimensions of the theoretical parallels between Barthes's death of the author and the frequent pronouncements of the death of the avant-garde.

X. Afterlife and Vanguard Ghosting

At one level, it really doesn't matter whether one speaks of the individual death of a specific avant-garde or of the categorical death of the avant-gardes as such. Announcing the death of any or all of the avant-gardes as a conclusion rather than as a beginning—as a limit rather than as a release—begs the question of whether there is an afterlife to the avant-gardes. For Barthes, the death of the author is an opening. So too, I would suggest, is the death of an avant-garde. But here, I am speaking of a very different kind of death, one that opens up possibilities of unexpected, surprising, and haunting moments of signification: the kind of death that liberates the avant-gardes as a discursive economy. I am speaking of a very different kind of historiography as well: one that is not only open to "a more variegated picture of the histories of avant-garde practice," or to moments of "nonsynchrony, multiple temporalities, repetition, and difference," but is also open to historical grafting, non-linear recontextualizations, and temporal parataxis. To be blunt, it is a historiography open to the stealing of one historical moment for the purposes of another. To speak in this regard of an afterlife is, of course, a figurative gesture, and one perhaps articulated from within the discourse of the avant-gardes and from within the logic of collage. But it is this kind of figurative gesture that can serve as a lens for focusing attention on the coded political signs that circulate within the discursive economy of the avant-gardes and that haunt it from outside the boundaries of intention, habit, and convention. What shall we make of those moments when new historical and political contexts seize or take possession of previous avant-garde gestures, compelling them, as it were, to speak in defiance of etymological imperatives or to speak as Hugo Ball did in the retooled anachronisms of an "ancient cadence of priestly lamentation"?

One could speak of the appearance of those coded political signs as moments of guerilla appropriation of discourse (harkening back to battles between Tzara and Breton), but there is too much that is calculated in appropriation. In the final chapter of this book, I am more interested in moments that unexpectedly give voice to the restless victims of history and that seek redress for them. I call these moments "vanguard ghosting" because the voices they facilitate are always only vaguely present and always plausibly deniable, like ambiguous allusions and provocative equivocations that are both present and absent at the same time and that, nonetheless, have everything to do with how discourses perform. As I

point out in my discussions of Julian Beck's idiosyncratic reading of Artaud and The Living Theatre's subsequent productions of *The Brig,* a political/aesthetic sensitivity to vanguard ghosting is a pivotal element in how avant-gardes read and conceptualize culture. So too, I would argue, is vanguard ghosting a potentially pivotal strategy for critics who would shift understanding of the avant-gardes in radical directions that move beyond the trappings of intent and convention, in directions that are as boldly experimental in the political connections they accommodate as they are non-linear in the historiographies they construct. Moreover, vanguard ghosting is a pivotal strategy for critics who would conceptualize avant-garde works in ways that preserve the pluralities of the avant-gardes, and in ways that do not lose sight of them as elements within a functioning discursive economy of signs.

The notion of avant-garde pluralities that unfolds over the course of the seven chapters of this book is inseparable from the sense of the avant-gardes as a discursive economy that I have discussed in this introduction. It is also inseparable from my unending fascination with how discursive economies perform. In this respect, the notions of performance that I examine in this book are also multiple. Just as one can speak of the languages of the stage, so too can one speak of the discourses of performance and of the various economies in which those discourses function. One can speak as intelligently of the discourses of performance as one can of the performances of discourse, and I would suggest that the avant-gardes are remarkable not only in their abilities to speak of and to both discourse and performance, but also in their abilities to activate both in ways that are radical in terms of experimentation and political orientation. Whether one speaks of hybridities and hybrid vanguardism; of genealogies and gendered exclusions; of the death of the author, the director, and the avant-garde; of rough edges and rhizomes; or of the vanquished vanguards and vanguard ghosting, the avant-gardes have proven time and again to be inexhaustible in their abilities to disrupt conventional understandings of the discourse that ostensibly defines them. It is in the provoked slippage of the discourses of the avant-gardes where the avant-gardes perform.

CHAPTER 1

Avant-Garde Rhetoric

Show Trials and Collapsing Discourse at the Birth of Surrealism

> "Far be it from me, even today, to set myself up as judge."
>
> ANDRÉ BRETON

> "For me, the life of Barrès represents the history of France"
>
> TRISTAN TZARA

I. The Rhetoric of the Avant-Gardes

While cultural historians may disagree about where the modernist period begins and ends, there is widespread consensus that, across the spectrum of the arts, the European modernist period is marked by a self-conscious exploration of the forms of artistic expression. If this exploration is the source of modernism's most significant innovations, so too is it a signal of the pervasive sense of exhaustion that dominates the period—a sense that places innovation not as an end in itself but as an often desperate attempt to salvage extant cultural meanings from forms that seem no longer capable of sustaining them. In this respect, the staging of Western modernism was frequently tied to a fundamental search for untapped and fresh venues of theatrical expression, and staging modernism was thus consistently intertwined with a basic rethinking of the very language that constituted the stage. The serious interest that experimental artists developed in athleticism, and in circus, cabaret, and variety shows during the early decades of the twentieth century, for example, was as much a part of the rethinking of the language of the stage as it was an indication of a sense that the tropes of bourgeois theatre had become moribund, clichéd and vacuous, and that consequently they were no longer capable of serving as

purveyors of truth—regardless of whether that truth was metaphysical, aesthetic, or political in nature, and regardless of whether, as a category, "truth" itself was ultimately suspect.

Great sources of theatrical revitalization emerged from the interest that experimental artists showed in these popular cultural venues, thus facilitating a kind of double-dipping that not only capitalized on what Christopher Innes has called "the theatre's intrinsic connection to physical reality and social existence,"[1] but that also moved performance toward the teeming immediacy of the social masses. But even here the staging of Western modernism was more than merely an exercise of theater thinking about itself. Characterized though modernism's experimental stages may have been by the ideological guise of a forward-looking, self-reflective, and radical exploration of new modes of performance, those innovative explorations were almost always haunted by a conservative shadow. They were, in short, modernist precisely because they were engaged in a seemingly last-ditch effort to recover values that the exhausted structures of Western culture put at risk. Whether those values actually existed beneath, above, or somehow beyond the languishing wasteland of their current forms of expression was not the issue. The historical European avant-gardes staged modernism by appropriating unconventional theatrical venues in an attempt to secure values that the governing assumptions of the avant-gardes' own rhetoric took for granted and perpetuated.

Generally speaking, these assumptions were more visible than the underlying contradictions that sustained them. But there are particular moments in which circumstances exposed the inner workings of the avant-gardes' gestures at recovery and thereby offered a glimpse at contradictions buried beneath their powerful, forward-looking discourse. Indeed, such moments reveal a contradictory dynamic that, I want to suggest, was a defining—albeit sorely under-theorized—trope of the early twentieth-century, European and performative avant-gardes. The Paris staging of *The Trial and Sentencing of Maurice Barrès by Dada*[2] at the Salle des Sociétés Savantes in May of 1921 arguably initiated such a moment. Appropriating as it did the legal structures of the courtroom in a gesture aimed at securing political and cultural values from a perceived corruption and demise, the Barrès *Trial* falls well within the parameters of the modernist stage, and it served as the point of departure for the fleeting infatuation with legal constructs that swept the Parisian avant-gardes in the early 1920s. This infatuation ran its course over the next two years, beginning with the Barrès *Trial,* continuing with the failed Congress of Paris and

"the trial" of André Breton at the Closerie des Lilas, and culminating with a series of actual lawsuits that followed the production of Tristan Tzara's *Soireé du Coeur à barbe*. Indeed, *The Trial and Sentencing of Maurice Barrès by Dada* marked the beginning of a circuitous chain of events that, rather than propelling the vanguards forward, served as the catalyst for a telling implosion of the avant-gardes' rhetoric beneath the weight of contradictions they could no longer mask.

In the historical accounts of *The Trial* and other accounts of the events surrounding it, those contradictions tend to be overshadowed by a fascination with the bitter rivalry between Breton and Tzara that by 1921 had spilled over into the public sphere. In fact, by May of that year, the rivalry between Breton and Tzara was so pronounced that many critics cite *The Trial* as a breaking point between Paris Dada and an emerging Surrealist movement, and rightly, I think, critics argue that at one level *The Trial* was little more than a ruse for Breton to put Dada, and hence Tzara, on trial, and ultimately to put the antics of both to rest once and for all. But inasmuch as *The Trial* functioned as a ploy for Breton to break with Tzara and Dada, the mechanisms of that ploy were torn between the contradictory pull of two competing rhetorical strategies. *The Trial* was, I want to suggest, a project seeking to disguise a Janus face, looking backward and forward simultaneously in gestures that performed seemingly radical critiques of authority, while subtly and ironically re-inscribing it. On the one hand, *The Trial* was openly committed to a backward-glancing project of recovery and preservation, i.e., to a project of rescuing youthful, revolutionary ideas from the aging, increasingly reactionary, and nationalistic hands of the writer Maurice Barrès. In this respect, *The Trial's* instigators singled out Barrès primarily as an example through which to illustrate a more general project of salvaging what they perceived to be valuable cultural and political ideals from forms or messengers deemed no longer capable of carrying out their mission.

On the other hand, *The Trial* was deeply embedded in the forward-looking, rectilinear narrative logic of the avant-gardes, i.e., in the ostensible project of breaking with tradition and heralding in the new. Yet inasmuch as this logic was directed against Tzara and Paris Dada, *The Trial* did little more than appropriate the vanguards' anti-traditional rhetoric, employing it to justify a petty struggle within the ranks of the avant-gardes themselves. Rather than marking a grand rupture with the past, that struggle involved a rhetorical gesture from Breton that strategically placed notions of the past and tradition in much closer proximity, imply-

ing that in the short time since Tzara's much-anticipated arrival in Paris after leaving Zurich in late 1919, Dada's radical iconoclastic postures were already exhausted and old hat.

One measure of the profoundly seductive lure of that rhetorical gesture can be found in the resonance it has enjoyed among cultural critics and historians. A good explanation for that resonance is evident in Matthew Witkovsky's recent characterization of the logic Breton employed in orchestrating *The Trial:*

> The trial was [. . .] an ambitious attempt to isolate an issue that could potentially affect the avant-garde much more than rearguard turncoats such as Maurice Barrès. Having helped to steer Dada in Paris toward a street-level confrontation with society and aesthetic convention, Breton felt moved to ask whether this engagement was genuine or sustainable. What if one passed from revolutionary opposition to the forces of reaction, abandoning a posture that had no inherent constancy or force of impact in the world? What if one kept a facade of avant-gardism while changing one's message, simply to retain an audience that was at bottom solidly nationalistic and bourgeois?[3]

Breton's articulated fear of moving from revolutionary to reactionary sentiment, and his fear of having one's message devolve into a mere "facade of avant-gardism" seem like legitimate concerns. But situated as they are within the temporal framework of such questions about whether a particular form can sustain, or will ultimately lose, its access to some vague presumption of authenticity (or genuineness), these same fears situate Breton's break with Dada within the linear logic of a highly suspect modernist aesthetic. Simply put, this logic assumes a point at which "engagement was genuine" prior to its demise. It assumes a point of authenticity in which the forward-looking discourse of the avant-gardes is not *always already* a facade. It assumes a point at which the representational tropes of the avant-gardes actually connect in some essential way with their referents, rather than connecting and sustaining one another within a self-perpetuating economy of signs. In short, it assumes that the discourse of the avant-gardes actually represents rather than produces meaning. As profoundly seductive as this logic initially may be (and Witkovsky distills it into a powerfully intoxicating form), the specter of a lost authenticity is a potent call to arms that is almost always a ruse. It promises to reinstate not only what it cannot deliver, but a state that never existed in the

first place. Indeed, this promise is simultaneously both the operative dynamic of the avant-gardes themselves and their ever-present facade. They are one and the same. With regard to the avant-gardes, there is nothing more genuine—so to speak—than the facade itself.

Understanding the avant-gardes pivots on a willingness to crack open the fissures in the facade in order to examine what it protects and accommodates. What, in this regard, is most amazing about Breton's decision to abandon Dada in order to avoid "a facade of avant-gardism" is that this decision masked a fundamental contradiction. Breton's clamorous admonishments to abandon Dada in order to remain "genuine" and in order not to succumb to the forces of reaction ultimately facilitated the embrace of a discourse that—far from being a step forward and away from reactionary sentiments—placed him, as we shall see, squarely within the parameters of sentiments that encouraged nationalistic and bourgeois proclivities. The significance of this contradiction, I want to suggest, is its revelation that behind the rhetorical facade the struggle between Breton and Tzara was, in fact, less about a genuine and sustainable vanguard than it was about dominance and authority. Despite pretensions to the contrary, the struggle was more about who would control the discourse of the avant-gardes as a valuable cultural commodity than it was about the illusory task of maintaining that discourse as an objective system of seemingly authentic representation. It was about usurping the means of representation, rather than about who was actually positioned at the front line of the vanguard, because "the front line" proved to be nothing more than a rhetorical construct, a product of the avant-gardes' own discourse.

The influence of this construct has been profound, for it has largely dictated the reception that *The Trial* has enjoyed among cultural critics and historians. While this experimental bit of theatre certainly marked the factious divisions among the Parisian vanguards (and in particular the rift between Tzara and Breton), the tendency to view *The Trial* as a milestone in a forward evolution from Dada to Surrealism follows a narrative that Breton himself had a heavy and biased hand in constructing, and it overshadows some fundamental lessons that the Barrès *Trial* and its aftermath offer about the mechanisms of the avant-gardes more generally. Above all, the contradictory trajectories of *The Trial* itself (its forward and backward gestures), as well as the internecine struggles within the ranks of the avant-gardes that provided a context for the Barrès *Trial*, expose the ease with which the discourse of the early European avant-gardes lent it-

self to appropriation and manipulation. There is no small irony in this moment of exposure, especially given the acute sense of disillusionment with cultural expressions that swept the European avant-gardes after those expressions had been appropriated to motivate the senseless carnage of the First World War (captured best, perhaps, in the frequently-cited grotesque image of German soldiers going off to the front with works by Goethe in one hand and a rifle in the other). But the lesson here is that both cultural and anti-cultural expressions possess nothing inherent that counteracts or resists manipulation or appropriation in the public sphere.

Nowhere is that susceptibility to manipulation more evident than in the political aesthetic formula that heralds the advent of the new by strategically defining the old and defunct, and that positions certain artists at the vanguard through a calculated, and at times biased, delineation of what constitutes the front lines of experimentation, innovation, and progress. While there is nothing inherently pernicious about such ideological jockeying, neither is there anything particularly novel in Breton's use of *The Trial* as a tool for purging the ranks of the vanguard according to the dictates of his own formulated orthodoxy for the cutting edge. All of us seek to define the terms of the debates in which we have something at stake, and Breton was no exception, particularly with regard to the personal ambitions that motivated his attempts to cast Dada as defunct and to use the Barrès *Trial* as a mechanism for casting himself both as the leading man and as Dada's clear successor in an always forward-looking history of "the avant-garde." What concerns me here, however, has less to do with Breton's heavy-handed definition of the old and new vanguards than it does with the tendency of historians to uncritically absorb such calculated jockeying into their own discourse. The resulting uniform and linear notion of the history of avant-garde performance has since become an enduring myth. Indeed, I would suggest that we will only really begin to understand the avant-gardes when we recognize that concepts like "the cutting edge," "front guard," "rear guard" and "front lines" are merely metaphors generated by the rhetoric and ideology of the avant-gardes themselves.

Embedded in the very notion of "a vanguard," this highly mystified baton-passing conception of the history of the avant-gardes has obscured recognition of a crucial dynamic that belies both the avant-gardes' frontline pretensions and their often celebrated breaks with the past. Like the Janus-faced currents of *The Trial,* that dynamic is grounded in cultural contradiction, and despite the anti-authoritarian sentiments associated

with the avant-gardes, their primary modes of expression center on notions of authority and control. The forward movement of which they speak is expansionist as much as it is innovative, and is propelled by an ideological performative that cloaks appropriation, usurpation, and recycling in the guise of originality.

Much of this book coalesces around the argument that the current of this dynamic runs though virtually all of the histories of the numerous Western avant-gardes that the twentieth century produced, particularly the European and American avant-gardes. But amid those histories we can find various moments where particular historical circumstances provide us with a fleeting glance at this dynamic laid bare. The rivalry in the early 1920s between Tzara and Breton, which ultimately splintered the Parisian avant-gardes into Dada and Surrealist camps, offers precisely such a moment. Beneath the apparent baton passing from Dada to Surrealism that historians have constructed around the rivalry between Tzara and Breton lies not a moment of linear progress, but of significant implosion—a moment that has yet to be theorized, particularly with regard to the way in which, amid Breton's unsuccessful attempts to bury Dada, that implosion exposes not merely a self-perpetuating façade, but also an alarming susceptibility of the discourse of the avant-gardes to appropriation. That susceptibility is not only evident in Breton's unsuccessful attempt to relegate Dada to the past in *The Trial*, but became even more pronounced in his subsequent effort to cast Dada aside while trying to convene what he called the Congress of Paris. Ironically enough, these two efforts were matched by what amounted to an inversion of their beginning in a raucous, impromptu, and symbolic trial of Breton at the well-known Parisian café, the Closerie des Lilas, and then finally, in the actual court filings that followed Tzara's *Soireé du Coeur à barbe* a year later. Those events are the focus of this chapter.

II. Prosecuting Dada at The Trial of Maurice Barrès

Coming on the heels of a series of Dada provocations, *The Trial and Sentencing of Maurice Barrès by Dada* marked a significant shift in tone in the activities of the Paris vanguards of the early 1920s. The Barrès *Trial* was largely the brainchild of André Breton and Louis Aragon, while Tristan Tzara, who had spearheaded many of the Dada events in Paris up to that point, was a reluctant participant. Much to the audience's bewilderment,

The Trial was a mostly solemn affair and did not traffic in the wild irreverence that Parisians had come to expect from Dada events. Based upon a relatively simple conceit, *The Trial* was a staged show trial of the French nationalist writer Maurice Barrès. Ostensibly, the aim of this trial was to hold the now arch-conservative Barrès accountable for having abandoned the revolutionary ideas he espoused in his early writings. But the Barrès *Trial* had two other related objectives. The most important was an argument by analogy that sought to associate Dada and Tzara with Barrès's shift from radical to reactionary, and to use this analogy to relegate Dada and its adherents to the past, thereby paving the way for what ultimately became Surrealism. From its very inception, the Barrès *Trial* was thus constructed in contradiction: adopting the role of defender of Barrès's early revolutionary sentiments, it looked backwards in order to look forward. By implication, it did the same with regard to Dada, complimenting the Janus backward/forward glance with a rhetorical sleight of hand that equated Barrès's conscious rejection of his revolutionary beginnings with what Breton tacitly suggested was Dada's exhaustion of its revolutionary potential. By implication, conscious rejection and exhaustion of form were folded into a single idea. The question of whether Dada actually had exhausted itself was taken for granted and never addressed.

With its constructed analogy between Barrès and Dada, *The Trial* allowed Breton to position himself as defender of Barrès's earlier revolutionary sentiments. By implication, though never explicitly stated, he was also positioned as the defender of what amounted to an essence of Dada that the movement's current forms presumably could no longer sustain. This product of a modernist aesthetic set up a second level of contradiction within the Barrès *Trial*. The backward/forward glance heralded the new, ironically enough, as the defender of something that did not change. It was a peculiar bit of logic: if the new was thus not "the eternal," at the very least it was, in a manner of speaking, a return to an unchanging "sameness." Arguably, framing the entire proceedings as a trial gestured toward alleviating the strain of these contradictions, lending the argument by analogy an air of legitimacy, by framing it in a legal discourse whose chief governing assumptions included the notions of unbiased authority and objective truth.

Having appointed himself as president of the tribunal, Breton presided over *The Trial* with all the solemnity and detachment befitting the office of an actual tribunal president—a president who not only expected a guilty verdict against Barrès but who also expected to sanction the ac-

cused with the death penalty (even though that sanction would be carried out in name only). The symbolism here was hard to mistake: seeking a capital sanction against Barrès was, by extension, symbolically calling for the death of an avant-garde that stood in much closer proximity as a rival, and that stood in the way of what Breton believed to be the next wave of vanguard artists. This too had its own peculiar twist of logic, since it is not entirely clear why calling for the death of an avant-garde was necessary if it was already moribund and exhausted as a form. But apparently, Breton considered Dada to be a significant obstacle to the next wave because the unflattering analogy he drew between Barrès and Dada's adherents was both insulting and vicious. A champion of the right, Barrès was a personification of pretty much all of what the leftist followers of the Parisian vanguard opposed. He was an easy target, and associating him with Dada bordered on libel.

An immensely successful literary figure, who leading up to the outbreak of the First World War had abandoned his early liberal convictions and become an influential arch-conservative, Barrès today has the infamous notoriety of having been a genuine proto-fascist. He openly described himself in the twenties as a "national socialist," and was "rabidly anti-Semitic."[4] He embraced a brand of patriotism that was nothing short of belligerent, saber-rattling chauvinism. Yet as President of the League of Patriots, and as a respectable bourgeois, Barrès also had a large following, and many of his supporters showed up at the trial. Indeed, the announced trial completely filled the Salle des Sociétés Savantes. Yet there was one unmistakable absence: the defendant. Barrès was present at the trial in name only. Despite having "been summoned to appear at his 'trial'"—a trial incidentally that had no legal authority whatsoever—Barrès left Paris suddenly at the time of the trial and under pretenses questionable enough that Breton and his circle could boast that "they were responsible"[5] for his cowardly absence.

In his stead, Barrès was represented by a storefront mannequin that was literally vacuous and hollow, and thus was an ideal personification of established forms no longer capable of sustaining vital cultural meaning. Mannequins had often found their way into Dada events, suggesting the vacuity of all sorts of social institutions. The most famous example, perhaps, was John Heartfield and Rudolf Schlichter's *Preussischer Erzengel* (Prussian Archangel), the mannequin with a pig's head, which was dressed in a WWI German officer's uniform and hung from the ceiling at the First International Dada Fair in Berlin in June 1920. Given *The Trial*'s

argument by analogy, however, this time things were different. The association of Dada with Barrès and hence with his mannequin surrogate suggested that Dada itself was empty. Indeed, the suggestion, ironically enough, marked a significant reversal. It was not the anti-authoritarianism of the avant-gardes that indicted social institutions (like the military), but rather the appropriated structures of the judicial system that indicted an avant-garde. At the time, this reversal went largely unnoticed—except perhaps by Tzara himself. But considered in retrospect, it was a portent of what would become Breton's repeated appropriation of conservative and even reactionary forms in his efforts to displace Dada and position himself at the head of the Parisian vanguards. It was thus the first clear omen of how susceptible the discourse or facade of avant-gardism was to appropriation. It was also the first indication of the increasingly reactionary undercurrents that would consume Breton's efforts to position himself at the forefront of the Parisian vanguard. In this respect, the nationalistic and arch-conservative profile of Barrès functioned as a kind of smokescreen that distracted from the reactionary undercurrents to Breton's own actions.

The vacuous image of the mannequin contrasted sharply with the unexpectedly grim and sober tribunal, which included a judge, two assistant judges, the prosecution, and two counsels for the defense—all of whom appeared in "white smocks and clerical caps (red for the defense and black for the prosecution)"[6] and all of whom, following Breton's lead as judge, treated the proceedings with the utmost seriousness. The tribunal was accompanied by "a phalanx of witnesses" who testified "to the public danger of the accused."[7] Among their ranks Benjamin Péret provoked outrage among Barrès's supporters in the audience when he "appeared as the Unknown Soldier dressed in a German uniform"[8] and testified in German. Aside from that provocation, which was a little too dark to be funny, Tzara stood as the lone sardonic voice in an otherwise somber evening. He mounted a spirited, if wildly unconventional, defense against the analogy that Breton sought to establish. Indeed, he challenged the entire proceedings.

In contrast to the other witnesses, Tzara ridiculed the process and its participants, hurling insults and invective with grand equity in all directions. Much to the chagrin of Breton, Tzara did not stop at denouncing Barrès, whom he described as "the biggest pig" and the most "antipathetic" piece of "rabble [produced] in Europe since Napoleon." He followed this denunciation by appealing to Breton directly: "You will agree

with me, Sir, that we are all nothing but a pack of fools and that consequently the little differences—bigger fools or smaller fools, make no difference."[9] To the delight of the audience, Tzara then suggested that he might be a little less of a "bastard"[10] than all of the rest, and when—according to some accounts—Breton asked, exasperated, whether "there was anyone whom he respected," Tzara replied, "Well, I myself am really a charming fellow."[11] More to the point, Tzara denounced the entire process. He told everyone to "shit" on the defense, and categorically stated that he had "absolutely no confidence in justice, even if that justice is enacted by Dada."[12] He proved impossible to pin down to serious answers, and joking through the rest of the questions, he ended his testimony with a song that admonished: "Eat chocolate / Wash your brain / dada / dada / Drink water." After having made his way through the song's three stanzas, Tzara sang the chorus one final time. Altering the final line, he told everyone to "Eat beef," and then exited the stage with aplomb. Indeed, he marched entirely out of the theatre and into the streets, slamming the door behind him and stealing the show.

In his openly sarcastic resistance to the seriousness with which the trial progressed, Tzara (rivaled only by the vacuous dummy himself) may have been the lone person living up to the expectations of the audience who "knew Dada by reputation" and whose boisterous presence lent a certain redundancy to the banner that Péret had hung above the stage. The banner read, "No one is supposed to be unaware of Dada."[13] Yet in direct contrast to Tzara's antics and to audience expectation, Breton, never departing from his self-appointed role as president of the tribunal, solemnly presented those on the stage and those in the audience with an eight-count indictment of Barrès. The result of this indictment came only as a partial surprise. As was to be expected, following the unflattering testimony of numerous witnesses, Barrès was ultimately convicted. He was sentenced *in absentia* to twenty years hard labor—in spite of the fact that both the presiding judge (André Breton) and the "counsel for the defense" (Louis Aragon) had called for the death of the defendant.[14] Given the parallels that Breton had sought to establish between Barrès and Dada, there was, in fact, a certain consistency in this sentence. *The Trial* had hardly procured the death of Dada either. After all, when Tzara tired of the pretentiousness, he simply walked out the door.

What Tzara left behind was an event that, under the guise of breaking with the past and heralding the new, embraced a discourse grounded in tradition and precedent. Appropriating the discourse of the court in or-

der to move the Parisian vanguards forward was once again to don the Janus face, and it skirted dangerously close to a path that ironically ran parallel to the one for which Barrès was now on trial. The charges against Barrès were vaguely stated as "crimes against the security of the mind" and Breton and Aragon in particular sought to prosecute Barrès for having implicitly renounced, in his shift to the far right, the revolutionary power that the young Surrealists attached to earlier works like *Un Homme libre* (A Free Man) and *L'Ennemi des lois* (The Enemy of Laws). Although Breton later claimed that his primary desire for the trial was "to determine the extent to which a man could be held accountable if his will to power led him to champion conformist values that diametrically opposed the ideas of his youth,"[15] the charges themselves are telling. Vague though they may have been, they implicitly envision a world in which once-existent values are no longer secure—and in which, as Marx and Engels famously stated, "all that is solid melts into air" and "all that is holy is profaned."[16] In this context, the discourse of the court had a primarily conservative function. Allied here with a notion of "security," it attempted rhetorically to enforce conformity to values situated in the past, rather than articulating new values that would direct the present toward the future. Beneath the facade of avant-gardism, *The Trial* was thus embedded in a discourse that cultivated conformity and that did so under the aura of establishing, indeed to securing, objective truth and order.

Whether this *Trial* was avant-garde or Dada in anything other than name is debatable. Whether the legal discourse of the court, upon which Breton relied, actually lived up to its mandate and delivered objective truth, order, and security is debatable as well—and not just because it was stripped of its state-sanctioned context. Indeed, with regard to the Parisian vanguards, this latter question, as we will see, would become increasingly debatable in the months that followed *the event*. But at a more immediate level, both of these questions address core issues about *The Trial* itself. The charges that Breton read against Barrès at *The Trial* directed similar questions at Barrès and ultimately at Dada. Among the laundry list of charges against Barrès, the central charge was that he had "failed to live up to his mandate."[17] In its most concise articulation, this was precisely the charge that Breton wanted to extend to Dada as well. But inasmuch as that charge referred to Barrès's gravitation toward the more conservative institutional structures of French society, the charge was more applicable to the organizers of *The Trial* than it was to Tzara or to Dada more generally.

When all was said and done, and *The Trial* was concluded, Breton was left in the peculiar situation of having appropriated two opposing discourses for the single purpose of redirecting the Parisian avant-gardes on a course where he stood at the helm. Oddly enough, his appropriation of the discourse of the court was always already a facade, for without the authority of the state behind it, the legal pretensions of the Barrès *Trial* amounted to hollow symbolism. The case against Barrès was just so much talk, and the case against Dada was tenuous at best. Along the way, however, Breton had proven something else: the discourse of the avant-gardes not only lent itself to appropriation, but could also provide the semblance of radicalism for gestures that, in fact, embraced conformist values. Though this was not the case he made against Tzara, it ended up being the case that Breton's case against Tzara finally made against Breton. Susceptibility to appropriations was not limited, of course, to the avant-gardes, and perhaps that is why it is still possible to hear Tzara slamming the door on the proceedings that he had denounced. If Tzara had no faith in justice, even Dada justice, it is not only Breton who proved in the years to come that he had a little too much faith in it, purging the ranks of the Surrealists time and again of artists whose heterodoxies might suggest if not the exhaustion of Surrealism then an unwelcome competition and rivalry. History is peppered with countless examples where the legal structures of the court, even when backed by the state, have not lived up to the court's mandate.

III. Congressional Recess and Impromptu Café Courts: The Trial of André Breton at the Closerie des Lilas

Tzara's exit from the theater into the streets and the open spaces of the public sphere was less a retreat than it was a pivotal provocation aimed, this time, at a very new target. Amid the legendary irreverent antics of Paris Dada, it is easy to miss the rather seismic shift in tactics that accompanied Tzara's departure from the Salle des Sociétés Savantes, a shift from *epater les bourgeois* to *epater les avant-gardes*. Indeed, as a provocation, Tzara's exit into the streets was as much a signature of the avant-gardes as it was a mark of the new divisions among their Parisian ranks. Moreover, that exit set the stage for the second act in the dramatic rivalry that had only begun to unfold at *The Trial*. For if no one else recognized the shift in tactics, André Breton certainly did. The close of *The Trial*, while lead-

ing to a vacuous but nonetheless guilty verdict against Barrès, had left Breton empty handed. At the sentencing not only did the tribunal inexplicably reject the death penalty in favor of a lesser sentence of twenty years of hard labor for Barrès—which, given the tribunal's lack of real authority, made no more sense than a death penalty—but, more importantly, insofar as the death of Dada had been the actual target of the evening's pretentious and somber events, Dada had escaped scot-free. It was very much alive in the streets, having dodged the rhetorical cutting edge of a self-appointed vanguard executioner's guillotine.

In fact, for Tzara, the streets proved to be nothing short of a level playing field in which his uncompromising Dadaist stance set in motion what may very well have been the European avant-gardes' first instance of self-reflective deconstruction. Outside of the confines of the Salle des Sociétés Savantes, Tzara not only escaped Breton's staged attempt to associate him with the likes of a right-wing bellicose nationalist like Barrès. The escalating rivalry that emerged between Tzara and Breton also radically destabilized the vanguard/rearguard binary that had been the linchpin of Breton's prosecutorial logic. That same logic undergirded the new set of tactics that Breton adopted in the months following *The Trial*. For if Dada proved to be too elusive to prosecute, then Breton sought instead to symbolically legislate the movement into relative irrelevance, heralding in the new vanguard by convening what he called the Congress of Paris. As Mark Polizzotti has noted, Breton's planning of the Congress marked a more decisive and "conscious break" with his Dada affiliations than *The Trial* itself.[18]

While *The Trial* amounted to an attempt to usurp the reins of an event orchestrated under the auspices of Dada, the Congress of Paris, by contrast, was conceptualized as an event that would subsume Dada and every other contemporary movement or "ism" beneath a larger, forward-looking paradigm. So "on January 3, 1922, a note in [the journal] *Comoedia* announced an 'International Congress for the Determination and Defense of the Modern Spirit,' or 'Congress of Paris,' scheduled for late March,"[19] and thus with no intentional irony in sight, Breton undertook plans for a Congress that un-apologetically positioned himself at the vanguard of the vanguards. There, "by grouping Dada with all the other 'isms' under study, he hoped both to explore new territory and to consign Dada—and Tzara—to the intellectual junkyard once and for all."[20]

Although the announcement cited a long list of diversely inclined artists, groups, and movements, the Congress of Paris did not seek to unify

them under a single reductive idea—at least ostensibly. The Congress organizers, according to Breton, had no intention of working "to create a new intellectual family and to tighten the bonds that many will judge illusory."[21] The goal of the Congress was not to plot a common direction forward; it was to identify what needed to be left behind. Under the leadership of Breton, the promoters of the Congress thus sought "to reactivate avant-garde solidarity against what the promoters [. . . vaguely] designated as the 'guardians of order' and their 'so-called return to tradition.'"[22] It was a grandiose scheme. But there were two sides to these efforts to reactivate avant-garde solidarity. At one level, these efforts signified that the Congress's objective was nothing more than to build a coalition united only in its forward-thinking opposition to moribund mainstream cultural traditions. At another level, however, the "defense of the modern spirit" had a wicked undercurrent that potentially threatened any and all participants. Beyond a general opposition to mainstream traditions, the defense of the modern spirit was also conceptualized as a defense against regression, retrenchment, and backsliding among the artistic communities that would participate in the Congress—a defense, in short, against a path that presumably followed the turncoat trajectory of Maurice Barrès's own career. This meant that over the course of the Congress, any individual, group, or movement might be singled out for supposedly having lost its edge, and for having succumbed to regressive or reactionary proclivities.

If there were reservations about the Congress's objectives—and Tzara's reservations were profound—they centered on a legitimate concern about giving anyone the authority to serve as arbiter for the calculated reactivation of avant-garde solidarity the promoters called for in their announcement of the Congress. As the poet Georges Hugnet was to write a decade later, "as a matter of principle, what confidence could be placed in the members of this committee, so disparate and for the most part so unfriendly to Dada?"[23] Smelling a rat, Tzara refused the invitation to participate outright, writing publicly to Breton:

> I consider that the present apathy resulting from the jumble of tendencies, the confusing of styles, and the substitution of groups for personalities . . . is more dangerous than reaction I therefore prefer to do nothing rather than to encourage an action that in my opinion is injurious to the search for the new, which I prize so highly, even if it takes the form of indifference.[24]

It is not entirely clear whether Tzara calculated his decision as an attempt to sabotage the Congress as a whole. In his classic *History of Surrealism*, Maurice Nadeau was later to recall that for Tzara the Congress was "a stage already transcended: 'Dada is not modern', he had said, it being understood that Dada repudiated a modern art as well as traditional art, and art itself."[25] Whether this repudiation was a matter of philosophical principle or a personal jab at Breton is less important than the sequence of events that it set in motion. Nadeau suggests that "Tzara's abstention caused the collapse of Breton's attempt" to organize the Congress.[26] For Breton, Tzara's decision, like his earlier exit from the Salle des Sociétés Savantes at *The Trial*, amounted to a provocation. Breton immediately responded.

Fearing, somewhat irrationally, for the security of the Congress proceedings, he took measures against potential Dadaist sabotage of the event itself, "including the 'strict regulation of the right to speak [and allowing] police intervention in the case of willful disturbance'."[27] Somewhere amid the paranoia that motivated these precautions, Breton and his cohorts failed to recognize the irony of using police protection to reactivate avant-garde solidarity against the "guardians of order." That irony came back to haunt Breton. Above all, these gestures arguably opened Breton to charges very similar to those that he had orchestrated against Barrès. Inasmuch as the charge of "crimes against the security of the mind" pivoted, according to Breton, on "the extent to which a man could be held accountable if his will to power led him to champion conformist values that diametrically opposed the ideas of his youth,"[28] Breton's own will to power (i.e., his pursuit of a leadership position within the Parisian vanguards) had led him in very short order directly toward the kind of authoritarian and conformist proclivities for which he had criticized Barrès—proclivities that would become even more pronounced, as we shall see, when he used the machinery of the Congress to go after Tzara in particular. Second, these gestures gave Tzara a rather stunning license, which he utilized with a profoundly effective sense of irony. For they not only opened the door for a radical inversion that led directly from *The Trial and Sentencing of Maurice Barrès by Dada* to what in popular parlance was called "the trial of André Breton" at La Closerie des Lilas, but they also set a precedent for Tzara to use the police to forcibly expel Breton, Desnos, and Péret when they assaulted—indeed, broke the arm of—Pierre de Massot while he was participating in Tzara's *"Coeur à barbe,* or 'the evening of the bearded heart' on July 6, 1923 at the *Théâtre Mi-*

chel."[29] In fact, the destructive pandemonium at the *Théâtre Michel* led to formal charges, and to Tzara's taking Eluard to a real court of law.

The initial security measures taken by Breton in preparation for the Congress were really only the beginning of his adoption of decisively rearguard strategies in his frantic efforts to "reactivate avant-garde solidarity" in the name of a new vanguard. The telling moment in these strategies was to come in a slightly veiled public attack on Tzara shortly after he had rejected Breton's invitation to participate in the Congress. Following Tzara's rejection of Breton's invitation, a statement appeared on February 7, 1922, in *Comoedia,* which, though signed by the Congress's governing committee, was clearly instigated by Breton. The published statement specifically "denounced the intrigues of 'a publicity-mongering imposter . . . A person known as the promoter of a "movement" that comes from Zurich, who it is pointless to name more specifically, and *who no longer corresponds to any current reality'*."[30] This attack on Tzara not only confirmed Tzara's own suspicion that the Congress was a rhetorical set-up to relegate Dada to the past, but it also situated the Congress so squarely within the most reactionary sentiments of Parisian society that Barrès himself would now, conceivably, have been a welcome participant. The French press had long characterized Dada "as an empty mystification and a German-Jewish seditious plot,"[31] and the echoes of this same xenophobic anti-Semitism in Breton's statement were palpable enough to torpedo the Congress altogether. Indeed, such echoes in the statement generated a scandal that ultimately led to the Congress being supplanted by the impromptu trial of Breton at La Closerie des Lilas.

Perhaps some measure of just how dangerous that subtle anti-Semitic rhetoric was can be found in the fact that Tzara, who was Jewish, limited his own retort to the simple observation that "an 'international' Congress that reprimands someone for being a foreigner has no right to exist."[32] Other members of Paris's artistic and intellectual community, who inclined toward leftist politics, were not as soft-spoken, and in this respect, they were following a major cultural precedent. Contemporaries like Matthew Josephson, for example, argued that the terms Breton used in "assailing Tzara (a Romanian Jew) as a *foreigner* [. . .] suggested the xenophobe and the anti-Dreyfusard."[33] It is hard to imagine that among Parisian intellectuals, Josephson was alone in thinking about Breton's comments in relation to the lingering fallout from the infamous Dreyfus Affair.

The effects of that scandal loomed large over French politics. At the

very least, Josephson's argument highlighted the political minefield into which the latent anti-Semitism of Breton's comments led him—a minefield that was still active. Two decades earlier, Paris had split into leftist and rightist factions amid the scandal that erupted when it was revealed that a young Jewish artillery captain by the name of Alfred Dreyfus was falsely accused and convicted of treason in a case largely motivated by a nationalistic anti-Semitism. Indeed, in one of those serendipitous quirks of history, the trumped-up charges against Dreyfus—as if setting the stage for the French press's later characterization of Dada—implicated him in what it characterized as a German-Jewish seditious plot. At the time of his conviction, an anti-Semitic press fueled the case against Dreyfus, even after exonerating evidence emerged. It was not until Emile Zola published "J'accuse," his famous open letter to French President Félix Faure, that this shameful act of injustice was brought to public light, discrediting the judicial system and the Faure government. Indeed, Zola's letter ultimately caused the ruling government to collapse. It took a subsequent presidential pardon to free Dreyfus, since the courts proved incapable of exonerating him at a second trial, in which, despite the presentation of exculpatory evidence and despite having previously been denied due process, Dreyfus was found guilty a second time. Shortly after Zola published "J'accuse," he had to flee to England to avoid being brought up on charges of libel against the military. He only returned to France after Dreyfus was finally pardoned.

At one level, this same narrative was being played out again within the Parisian vanguards. Not only did the Congress's committee disassociate itself from Breton's comments, but they also turned to the press, and in an open letter somewhat reminiscent of Zola's open letter to Faure, they "now accused Breton of having issued his public statement assailing Tzara without their authorization, and of having done this in the spirit of a 'narrow nationalist' and 'reactionary.'"[34] In that same letter of accusation, the Congress committee members, which included the artists Fernand Léger, Robert Delaunay, and Amédée Ozenfant, Jean Paulhan and Roger Vitrac,[35] withdrew their support for the Congress and "called for a general hearing to be held on February 17 at the Closerie des Lilas."[36] If this letter did not in itself signal the collapse of the Congress's governing board and ultimately the collapse of the Congress itself, it at least set the stage for the event that did. The announced hearing at the Closerie des Lilas attracted wide attention among Parisian intellectuals, who saw in the event an important opportunity "to take a stand, quite literally, in

public" and thus pass what Mike Sell has called "the true test of the active citizen after Dreyfus, particularly if he claimed to be in the vanguard."[37] The hearing was quickly dubbed "the trial of Breton," since "Breton was invited to appear at this meeting, and in effect stand trial."[38] Although before going to the hearing, Breton reportedly told Picabia "that he would show his detractors 'just who they are dealing with',"[39] he was hardly prepared for what awaited him at the Closerie des Lilas.

It was not just in his polemic against Tzara that Breton had misjudged his audience. He also misjudged the overwhelming mood of the roughly one hundred artists and intellectuals who awaited him on February 17th.[40] It did not help that he arrived at the Closerie des Lilas with a prepared statement, which offered his accounting of "the previous weeks' events, [and] which when presented 'had the look and tone of a police report.'"[41] Breton had dismissed the significance of his own comments as an "unfortunate circumlocution" that was "regrettably equivocal," and in one of those peculiar instances of blaming the victim, he even implied that Tzara himself had orchestrated the hearing. "It goes without saying," Breton argued, that Tzara "seized upon" the circumlocution in order "to accuse me (in circles that largely surpassed Dada's, and included a number of elements that until then he had claimed to despise) of 'nationalism' and 'xenophobia'."[42] Despite Breton's continued efforts to vilify Tzara for a situation that was largely his own creation, what awaited him at the Closerie des Lilas was outrage, not at an "unfortunate circumlocution," but at the kind of published assault that, when left unchecked, had cultivated an environment for instances of gross injustice similar to those suffered by Dreyfus and that, unbeknownst to those who were at the Closerie on February 17th, 1922, would bring a murderous sweep across Europe in the coming years as the dark shadow of fascism descended. The profound irony of the hearing was thus that it called Breton to account for a willingness to use (indeed, to encourage) a dangerous and reactionary rhetoric as a strategy for positioning himself at the head of the Parisian vanguards. This was the same Breton who, nine months earlier, had staged a mock trial of the once-radical Maurice Barrès, holding him accountable for championing conformist values in his own "will to power."[43]

If Breton was caught off guard by the hearing, perhaps it was because it bore so little resemblance to the trial that he had orchestrated the previous spring. In contrast to the rather pretentious solemnity that governed *The Trial and Sentencing of Maurice Barrès by Dada*, the hearing at the Closerie was the site of pandemonium. "Never in my experience," Mat-

thew Josephson reported, "were words of such passion and flame hurled at each other by men without coming to blows. (If they had been Americans, they would have butchered one another.)"[44] Indeed, the raucous hearing had all of the hallmarks of what might legitimately be described as the spontaneous eruption of the perfect Dada storm—a storm that, rather than disrupting the bourgeoisie, exposed the internal contradictions of the Parisian vanguards instead. In this respect, Breton's attempts to hold Tzara responsible for the events at the Closerie were more of a signal of his growing animosity toward Tzara than a response to Tzara's own actions. Tzara's role in the hearing was primarily that of a provocateur who willingly and effectively rode a storm that erupted around him. Unlike Breton, Tzara was apparently at home in the chaos, and it was here that the contradictions in the Parisian vanguards surfaced. Just as the solemnity that marked *The Trial* contrasted diametrically with the pandemonium of the hearing at the Closerie, so too did the figures cut by Breton and Tzara. Josephson recalls that "Breton spoke in rolling periods in his own defense; while Tzara, leaping to the attack, fairly screamed in his high voice, talking so fast that I could not follow him."[45] On the surface the contrasting performances of these two forceful personalities suggest a struggle between the discourse of reason and the discourse of high-pitched revolt, if not of hysteria. But on the evening of February 17, at the corner of the Boulevard du Montparnasse and the Avenue de l'Observatoire, where the Closerie de Lilas stands, the contrast marked a wide "collision of opposites"[46] at the point of a collapsing discourse.

Some seven months later in Germany, Tzara suggested as much in a lecture that he gave on Dada. Subtly referencing his earlier arguments against participation in the Congress of Paris, Tzara reaffirmed his sense that "Dada is not at all modern," and that it is grounded in "indifference."[47] He spun the factious divisions of the previous months into the very essence of Dada, by arguing that a "characteristic of Dada is the continuous breaking off of our friends. They are always breaking off and resigning."[48] Most important of all, Tzara described Dada as "the point where the yes and the no and all the opposites meet, not solemnly in the castles of human philosophies, but very simply at street corners, like dogs and grasshoppers."[49] Roger Cardinal, in an insightful reading of this very passage from Tzara's lecture, has suggested that the "collision of opposites" and "the image of the urban intersection" to which Tzara refers conjure up "the conditions of a certain *avant-garde* exploitation of the disruptive and the haphazard," an exploitation that he suggests is typical

of a broad range of avant-garde movements. "The startling inventions of Cubism, Dada, Surrealism and other later movements," Cardinal argues, "have this in common, that they thrive upon the dismantling of the codes and divisions by which consciousness ordinarily regulates experience."[50]

As intriguing as Cardinal's reading of Tzara's comments is, I would suggest a temporally more specific referent to "the yes," "the no" and the meeting of opposites on "street corners." I would suggest that the referent is "the most tempestuous verbal brawl" that Matthew Josephson had "ever seen,"[51] the verbal brawl that was the hearing at the Closerie de Lilas. Not only does this suggestion bring Tzara's meeting of "opposites" in line with the other historical registers of his lecture, but suspending Cardinal's broad characterization of avant-garde movements also has the advantage of shifting focus away from the popular, generalized perception of the avant-gardes as code-breaking agents at the forward edge of culture and change. Consequently, it also presents the opportunity to consider more fully the implications of a historical moment in which, far from being aloof agents dismantling the codes that regulate experience, the avant-gardes displayed their own reliance on—indeed, their subservience to—a discursive code whose own legitimacy was contingent upon a set of oppositions that it represented as operative but that it proved incapable of sustaining.

If nothing else, the "verbal brawl" at the Closerie de Lilas exposed the constructed nature of those oppositions, and thus disrupted their ability to mask the contradictions seething beneath the surface of the discursive logic of the Parisian vanguards. Yet this exposure also has far-reaching implications for cultural criticism like that exemplified in Cardinal's reading of Tzara's "Lecture on Dada." The disruption at the Closerie hearing exposes more than the contradictions in the discursive codes of the Parisian vanguards. Used as a standpoint from which to survey critical perceptions of the avant-gardes more generally, this disruptive historical moment brings into view the extent to which criticism like Cardinal's otherwise insightful reading of Tzara's lecture is entangled in the linear logic of the avant-gardes' own rhetoric, and entangled particularly in the constructed front- and rearguard opposition that is as defining to the conception of an *avant-garde* as "yes" and "no" is to the conception of volition. Nowhere is this entanglement more evident than in Cardinal's positioning of each of the vanguard movements that he cites (Cubism, Dada, Surrealism, etc.) both as the agent of and as the agent beyond the dismantling of the conceptual codes that regulate experience. Each move-

ment is thus, by implication, always already at the forward position of a linear historical narrative.

While in one respect Cardinal's characterization may be consistent with the stated forward-looking objective of the Congress of Paris, "to reactivate avant-garde solidarity against [. . .] the 'guardians of order' and their 'so-called return to tradition,'"[52] it is, in a far more important respect, fundamentally at odds with the events that transpired at the corner café where the "trial" of Breton took place, amid the screaming cacophony of participants and observers. Far from being an edifying example of forward-looking solidarity, the unruly hearing at the Closerie led Matthew Josephson to exclaim, "the Revolution is devouring its sons!"[53] That exclamation found a perverse echo of its allusion to the French Revolution when, nine months later, in Spain, Breton, who was still stinging from the rebuke he had received at the Closerie, delivered a lecture to the Barcelona Dada Group, in which he "denounced Tzara's actions during the Congress of Paris" and told the Barcelona Dadaists that "it would not be a bad thing to reinstate the laws of the Terror for things of the mind." He proclaimed this without identifiable conscious irony, in what, like the Congress itself, was billed as "an overview of the 'characteristics of modern evolution and what it consists of'."[54]

If, in the early planning of the Congress of Paris, artists like Hugnet and Tzara had expressed legitimate concerns about giving any one person or group the authority to serve as arbiter for the calculated reactivation of avant-garde solidarity, such a proclamation from Breton—especially following the hearing at the Closerie—was close to a realization of their worst nightmares. For the laws of Terror precipitated the Reign of Terror during which the French Revolution devoured its sons. Though it is a bit of a stretch to see the Closerie hearing as a microcosm of that experience of late eighteenth-century carnage, Josephson's exclamation is worthy of consideration if only because it stands in such marked contrast to the linear discursive logic of the avant-garde itself. A revolution that devours its own progeny obviously has lost sight of the future in its effort to sustain itself. Such self-destructive circularity and the image of stagnation it suggests is more than an apt metaphor for what the hearing at the Closerie exposed. It also signals a discourse collapsing beneath the weight of its own contradictions.

Breton's biographer, Mark Polizzotti, has characterized the hearing at the Closerie des Lilas as "a distorted replay of the Barrès trial," since "Aragon acted as defense council" to Breton, and since Tzara once again found

himself as a witness for the prosecution.[55] But given the air of redress that filled the hearing at the Closerie, particularly redress of a latent anti-Semitism, the hearing might more accurately be described as a kind of dissonant mash-up of the Barrès trial and the Dreyfus Affair. To be more precise, the event was caught in its own contradiction of attempting to be both trial and anti-trial. It was a replay of the Barrès trial against the backdrop of subtle, but unmistakable, contextual allusions to a public scandal that had indicted the very integrity of the judicial process—a scandal that had revealed the extent to which, far from working within the realms of referential objectivity, legal discourse, like the discourse of the avant-gardes, was susceptible to appropriation. On both counts (i.e., the Barrès Trial and the Dreyfus Affair), Breton stood under fire. Inasmuch as the hearing at the Closerie des Lilas replayed the Barrès trial, the distortions of that replay tended to vindicate Tzara's earlier assertion that he had "absolutely no confidence in justice, even if that justice is enacted by Dada."[56] The lingering cultural residue from the Dreyfus Affair provided the rationale for that lack of confidence. Arguably, it also provided the rationale for the vote of no confidence that Breton received at the end of the hearing—a vote that ended his plans for the Congress of Paris then and there.

Ironically, the basis for that vote was both consistent with the indictment that Breton had previously leveled against Barrès, and consistent with the spirit of the Congress of Paris itself, combating, as it did in its repudiation of Breton, the social currents that the Congress was supposed to oppose. Breton had not lived up to his mandate. In this respect, effectively shutting down the Congress was tantamount to defending precisely that for which the Congress stood. To be forward looking was, in effect, to leave behind a project that, rather than furthering the cause of progressive ideas and countering "the guardians of order," ultimately demonstrated how susceptible the rhetoric of "avant-garde solidarity" was to appropriation and manipulation. This was especially true for Breton and those in his closest circle. If *The Trial* had ended in disappointment, Breton's plans for the Congress of Paris ended in disaster, positioning him not at the head of a grandiose defense of a progressive modern spirit, but rather, at a point of contradiction in which vying for a vanguard position was fueled by an unsuccessful defense of indefensible, reactionary sentiments. Arguably, the Congress of Paris collapsed thus under the strain of a vanguard/rearguard binary that Breton ultimately could only sustain by borrowing from the latter in order to secure

his position at the former. The greater irony, however, lies in the implications of this untenable vanguard/rearguard binary. To be forward-looking is, in effect, to leave it behind. This may not position one at the vanguard, but it does open the possibility of understanding the avant-gardes beyond the frame of their own rhetoric.

IV. "Leaving Everything: Court Summons from a Bearded Heart"

The contradictions that the hearing at the Closerie des Lilas exposed continued to haunt the Parisian vanguards for almost a year and a half after the collapse of the Congress of Paris. These contradictions played out initially in subsequent polemical publications by Breton and Tzara. Polemic boiled over into physical altercation "on July 6, 1923 at the *Théâtre Michel*," when Breton and his friends not only physically assaulted participants in Tzara's *Coeur à barbe* (Bearded Heart) soirée, but also damaged the theatre as well.[57] That moment of open warfare between the emerging Surrealists and the remaining Dadaists brought the rivalry between Breton and Tzara back to court—this time an actual court—with Breton's friends held liable for the damage they had done to the *Théâtre Michel*. They answered the suits brought against them with countersuits, and the ultimate result was a stalemate.

These post-Congress events coincided with Breton taking every opportunity he could to discredit Dada, even pronouncing it dead. In Spain, he announced the death of Dada to the Barcelona Dada Group (whom he did not convince).[58] Prior to his trip to Spain, Breton had attempted once again to cite the performance of *The Trial* as heralding Dada's death. In a short polemic entitled "Apres Dada" (After Dada) that Breton published just a month after the hearing at the Closerie des Lilas, he asserted that "Dada, very fortunately, is no longer an issue and its funeral, about May 1921, caused no rioting."[59] Such comments arguably qualify Breton as an early spokesman for what Mike Sell has aptly called "the Eulogist School of Avant-Garde Studies."[60] Although I will discuss this notion of "a Eulogist School" at some length in the seventh chapter of this book, some initial comments are warranted here. Not only is there a direct connection between Breton's announcement of the death of Dada and his divisive manipulation of the Congress of Paris, but this combination—proclaiming the death of one avant-garde while ostensi-

bly promoting "avant-garde solidarity"—reminds us of Sell's basic point: "most eulogies of the avant-garde are ultimately eulogies for the unity of truth and art embodied, supposedly, by a specific moment or movement in avant-garde history."[61] While Sell's comments can be understood as suggesting that eulogies for the avant-garde are a kind of lament for the passing of one form of experimental discourse at the cusp and birth of another—hence making any categorical pronouncement of the death of *the* avant-garde absurd—there is a more provocative reading of Sell's claim. Breton's actions suggest—and this is consistent with Sell's argument—that eulogies for the avant-garde tend to be a ruse: they use a grand proclamation of the death of one form to mask the disunity and contradictions in the discursive economy of the very group that has appointed itself as the vanguard's coroner.

When these pronouncements pit one faction of the avant-gardes against another, they may perpetuate the avant-gardes' forward-looking rhetoric, but beneath that rhetoric disunity and contradiction are both a point of departure and a destination. Indeed, theorists like Paul Mann have argued that far from being part of a process of forward moving, linear evolution, "the death of the avant-garde is not its end but its repetition."[62] Nor does the pronouncement by one faction of the avant-gardes' death position the pronouncers at the forward point of a progressive edge. In *The Theory-Death of the Avant-Garde,* for example, Mann notes that while "Breton was [. . .] anxious to bury Dada so that the world could move on to surrealism," Dada itself demonstrated that "the avant-garde is never so far *en avant* as at the moment of death, the moment when it catches up with and cancels its own future."[63] Tzara had argued as much in his "Lecture on Dada," maintaining that Dada was characterized by friends "breaking off and resigning," and claiming that he himself was "the first to tender his resignation from the Dada moment."[64] If Mann characterizes such moments of breaking off and resigning as "a kind of *sepukku,*" or contradictory suicide, that affirms Dada's "negative spirit" and enacts "an anti-aestheticism so rigorous that it must destroy itself before it becomes an institution,"[65] the counterpoint of Dada's contradictory gesture was the self-inflicted death that Breton generated in his attempt to bury Dada. If the avant-garde died, Mann contends, "it put itself to death by continually articulating itself within the discursive economy of the cultures it claimed to subvert."[66] In this respect, Breton's repeated assertions that Dada was dead not only did as much to resurrect Dada's viability as to bury it, but these assertions also

came from within a discursive economy that was itself fatal to the very notion of a vanguard.

In terms of aesthetics, that fatality was nowhere so pronounced as in Breton's polemical essay, "After Dada" [*"Apres Dada"*]. Despite the linear narrative suggested by its title, and despite Breton's concluding assertion that he was positioning himself in "the fight [. . .] as far forward as possible,"[67] the essay is remarkable for its embrace of a decisively conservative aesthetic posture in its assault on Tzara. Reading "After Dada" against the backdrop of the Barrès *Trial* and the failed Congress of Paris, one would be hard-pressed not to wince at the disingenuousness not only of Breton's statement "far be it from me, even today, to set myself up as a judge," but also of his characterization of Tzara's opposition to the Congress of Paris as "wrongfully attacking one of the most *disinterested* undertakings ever put under way"[68] (my emphasis). More remarkable still is Breton's attempt to discredit Tzara by returning to aesthetic categories that the Parisian vanguards had eschewed under the influence of Dada.

Endeavoring to strike a substantial blow against Tzara, Breton claimed to have letters from "Schad and Huelsenbeck," which allowed him to "inform the readers of *Commoedia* that M. Tzara had nothing to do with the invention of the word 'Dada'," and also that "he probably had very little to do with the writing of the *Dada Manifesto 1918*."[69] These were odd charges to bring against someone whose sense of authorship involved taking a pair of scissors, cutting words out of a newspaper, shaking them up in a bag, throwing them on a table, and calling the results a poem,[70] and against someone who was not adverse to announcing a manifesto and then going on stage "merely [to] read a vulgar article taken out of some newspaper."[71] As to the word "Dada," its "invention"—if that is what one would call it—was always so contested, with multiple figures taking credit for its coinage, that there is probably no single better example of how the avant-gardes challenged the bourgeois category of authorship to which Breton appealed in his opening salvo against Tzara. In fact, echoing the very notion of chance poetry, Tzara himself claimed only to have "found the word Dada by accident in the Larousse dictionary."[72] In Breton's "Apres Dada," Tzara's interest in spontaneity and chance were thus discarded in favor of a reassertion of cultural authority, authorship, and, oddly enough, a hint of traditional family values.

Amplifying the rhetoric of his attack, Breton claimed that "the paternity" of Tzara's *Dada Manifesto 1918* really belonged to "Max Serner" (his

name was actually Walter Serner) and thus he, Breton, could no longer allow Tzara "to go on using with impunity the papers of those whom he robbed."[73] Not only did Breton's claims prove to be incorrect,[74] but also, ironically, he was now making accusations of theft against a figure whose work was largely significant for its provocative suggestion that literature was one big swindle. Breton's accusations, particularly his reference to paternity, were met with scathing ridicule the very next month in the publication of Le Coeur à barbe by Tzara and George Ribemont-Dessaignes, in which Ribemont-Dessaignes derided the recently collapsed Congress of Paris as the "modernisthumus of Panama" and characterized its committee members as "bandits" styled after "the American cinema," who for fear of one another were running around with "guns in their pockets." He mocked Breton's "Apres Dada" mercilessly, announcing with biting sarcasm that "Dada [was] searching for his father," only then to ask whether this is all that Commoedia can come up with to say.[75]

Describing Ribemont-Dessaignes as "one of the most wickedly corrosive voices in the Le Coeur à barbe journal," the art historian Arnauld Pierre also suggests that "alongside the contemporaneous Congrès de Paris project, the Coeur à barbe seems mischievously obstructionist."[76] Since plans for the Congress had already collapsed by the time the journal went to press, I would suggest that Ribemont-Dessaignes's contributions to the journal were less obstructionist than they were indicative of a crucial strategy for engaging the factional divisions within the Parisian vanguards that the collapse of the Congress had brought to a head. The entire journal was laced with subtle but acerbic rebuttals to Breton's attacks—even when those attacks appeared to take on the air of having risen above the vindictive fray, as was the case with Breton's article "Lâchez tout" ("Leave Everything"), which was published shortly before Le Coeur à barbe.[77] Polizzotti notes that Breton "had drafted a long diatribe against Tzara," but at the last minute decided instead to publish "Lâchez tout," which Polizzoti describes as "a celebrated call to arms" that took "an essentially personal quarrel to a higher, philosophical ground."[78] Ironically, that call to arms echoed Dada's indifference, urging readers to:

Leave everything.
Leave Dada.
Leave your wife, leave your mistress.
Leave your hopes and fears.
Drop your kids in the middle of nowhere.

Leave the substance for the shadow.
Leave behind, if need be, your comfortable life and promising
 future.
Take to the highways.[79]

But for all its seeming ascent to a higher philosophical ground, "Lâchez tout" offered a prescription from which Breton exempted himself, having moved three months earlier into a two-bedroom studio with his wife Simone at 43 Rue Fontaine, the address he would keep for the rest of his life. Breton wasn't leaving anything, except ostensibly Dada—and even here there were few statements more Dadaesque than a call to leave Dada behind. As Tzara himself had argued in his "manifesto on feeble love and bitter love": "the true dadas are against Dada."[80] Indeed, the ironies of Breton's call were not lost on Tzara and Ribemont-Dessaignes.

In the *Le Coeur à barbe* journal, they included a stinging rebuttal to Breton's essay "Lâchez tout." The rebuttal, which has largely been overlooked, took the form of a short poem. It also bore the title "Lâchez tout" and specifically targeted Breton's new-found bourgeois domesticity, using it to expose the hollow rhetoric of his philosophical call to leave everything. Reducing Breton to an image of "bad breath" and "flowery hair" and identifying him with those "who cry of not being able to love," the poem placed the sentiment of "Lâchez tout" right at his doorstep. It alluded to the brothels at the "Place Pigalle"[81] nearby, and mocking Breton's attempt to take the philosophical and moral high ground, the poem playfully suggested that one catches a cold moving from "hell to heaven"[82]—a vague but unmistakable reference to the "sordid staircase"[83] leading from the cabaret "Le Ciel and L'Enfer" (Heaven and Hell) to Breton's apartment, which was located four flights above the cabaret.

The poem "Lâchez tout" in *Le Coeur à barbe* was attributed mysteriously to "the Officer." At one level, the reference to a guardian of order in this otherwise anonymous attribution played with the contradiction of asserting author-ity even as the vagueness of the author undermined author-ship. At another level, however, the image of an officer returning Breton's admonishment ("leave everything") to his own doorstep was not only a good example of the chickens coming home to roost; it was also a portent of things to come. Indeed, "the Officer" provided a subtle reminder of the police officers Breton had planned to employ as a safeguard against a potential Dada sabotage of the Congress of Paris, and this reminder surfaced once again in July of the following year, this time in

physical form, when Tzara had police waiting in the wings at Paris's final major Dada event, the Soireé *du Coeur à barbe* that he directed at the *Théâtre Michel*. Ruth Brandon has suggested that "evidently Tzara expected trouble. Before the show, he let it be known," in what she describes as a "most un-Dada fashion, that anyone interrupting would be thrown out."[84] But I would suggest that this announcement, which carried a clear sarcastic echo of Breton's own earlier announcement, was a quintessential Dada gesture of provocation, one directed at Breton himself and his friends from the *Littérature* Group—all of whom (including Breton) were further provoked by the fact that, while "free tickets were being handed out to 'all the Americans [. . . Tzara] knew'," they had to pay 25 francs for their seats.[85]

The *Soireé du Coeur à barbe* started as a mixed media event that ultimately turned into a brawl. It began with musical works by Erik Satie and Darius Milhaud. It included films by Hans Richter and Man Ray. It also included poems by Philippe Soupault and Paul Eluard (the latter of whom was in the audience) that were used without permission and that, much to Eluard's displeasure, were followed by poems from Jean Cocteau whom Breton and his friends viewed as an outright enemy. Concluding the evening's program, Tzara staged a revival of his piece *Le Coeur à gaz* (The Gas Heart) with cardboard cylinder costume designs by Sonia Delaunay, but by that time the audience had what it had been waiting for. Provocations had given way to altercations, physical assault, and police intervention. Had it not been for one final climatic round of fights, *Le Coeur à gaz* would have been little more than an afterthought to the mayhem that Tzara's Dada Soireé provoked. Interestingly enough, however, the trigger for the evening brawl did not come directly from Tzara but rather from a proclamation read by Pierre de Massot.

Having Massot on the stage was no insignificant bit of orchestration. Indeed, I would suggest that it was a provocation in and of itself, for Massot "had been Breton's faithful lieutenant during the Congrès de Paris preparation" and "had recently written a slighting article about Tzara in the Belgian review *Ça ira* referring to him as 'that little Rumanian Jew'."[86] In this respect, Massot was a physical reminder of all that went wrong with the Congress of Paris. His own anti-Semitic tendencies recalled the scandal created by Breton's attack on Tzara, and since he originally had assisted in the planning of the Congress itself, his presence on the stage was a genuine reminder of all those who originally had lent their support to the Congress, only then to abandon the project and Breton at the

Closerie hearing. If Massot's presence on the stage was not reminder enough, then the not-so-subtle inversions in his proclamation proved to be incendiary enough to ignite the whole explosive situation.

Those inversions struck at the heart of Breton's premature obituaries for Dada. Breton had conceptualized both *The Trial of Maurice Barrès* and the Congress of Paris so as to bury Dada. Massot's proclamation turned those obituaries on their head. It systematically announced the death of prominent figures of the avant-gardes, citing them by name and then listing them "dead on the field of honor" ("mort au champ d'honneur")[87] Among others, the list included Marcel Duchamp, Francis Picabia, André Gide, and Pablo Picasso. When Massot announced the death of Picasso (who was in the audience), Breton shouted "That's enough" and rushed the stage. Using his walking stick as a weapon, he physically assaulted Massot, breaking his arm. Ostensibly, Breton was defending Picasso's honor, but clearly the tumultuous history of the past year was at play in this moment and in those that followed.

True to his word, Tzara signaled to the police, and in a kind of forced inversion of Tzara's own exit from the Salle des Sociétés Savantes at *The Trial of Maurice Barrès,* "the police arrived and threw Breton, Aragon and their accomplices out into the street."[88] Inasmuch as the ejection of Breton by the police gave a strong dose of his own medicine to the one person who was not only *not* adverse to using police security for his own events, but who in the years to come would make a habit of ejecting artists from the Surrealist movement, there was enough poetic justice in Tzara's signal to the police that one could have called it an evening and gone home. But after the police had forcibly removed Breton, the show resumed, and when *Le Coeur à gaz* began, Eluard (still in the audience and still steaming about the unauthorized use of his poetry and about the ejection of Breton) decided to follow Breton's earlier lead and pursued a thuggish course of his own. He created enough of a disruption that Tzara came out on the stage to restore order. Eluard then jumped onto the stage himself, where he slapped Tzara and René Crevel, "before he was grabbed in turn by a band of stagehands and severely beaten."[89] He ended up in the orchestra pit.

It is not entirely clear whether Eluard was thrown or fell into the orchestra pit, but when he landed, he broke a number of footlights (those symbolic markers of the modern stage). This not only added additional damage to a theater that had already been trashed amid the altercations provoked by Breton and his circle, but it also put Eluard in a position of

liability that in short order ended the Parisian vanguards' infatuation with legal discourse. It was left at a dead end and a stalemate. Tzara sued Eluard for 8,000 francs to cover the damages. Eluard in turn submitted a countersuit to the court, holding Tzara responsible for the beating he had received by the stagehands whom Tzara had employed. Polizzotti notes that both of these cases "lasted nearly a year, replete with lawyers and court dates, before ultimately fading away."[90] In fact, neither suit ever came to trial, for Tzara discovered that Eluard had taken Breton's prescription to "leave everything" and departed, since the court costs alone would have financially ruined him and his wife, even if they had prevailed in court.[91]

Tzara left Paris as well, and in his own way called the bluff on Breton's admonishment. At one level, this was not a problem, since by 1923 Dada was anything but dead. It had gained enough momentum to become an international movement, and Tzara moved freely in Dada circles across Europe. This situation has led critics like Matthew Witkovsky to argue that as an artistic form Dada is essentially nomadic and that the events surrounding *The Trial* show that "the lasting value of Dada [. . .] is that it keeps recurring in new places and unforeseen guises."[92] This characterization of Dada is fair enough. But what it never really considers is how the events surrounding the hearing at the Closerie des Lilas turned both Breton's prosecutorial theatrics at the *Barrès Trial and* his quasi-legislative agenda for the Congress of Paris on their heads and revealed an authoritarian, reactionary undercurrent in his efforts to seize the vanguard baton. Far from heralding the advent of the new, these efforts recycled the all-too-familiar, echoing some of the most egregious sentiments for which Barrès had been singled out and symbolically prosecuted in May of 1921. In short, what Witkovsky leaves unaddressed are the implications that the conflict among the Parisian vanguard had for the discourse of the avant-garde. It is easy enough to recognize the nomadic quality of Dada. More difficult is to recognize how the events surrounding *The Trial* exposed the extent to which the discourse of the avant-gardes was in its own respect nomadic, floating so free that it could easily be appropriated to provide a facade of radicalism even for reactionary social currents.

From Anti-Culture to Counter-Culture

The Emergence of the American Hybrid Vanguardism

> I try to discover what one needs to do in art by observations from my daily life. I think daily life is excellent and that art introduces us to it and to its excellence the more it begins to be like it.[1]
>
> JOHN CAGE

> Perhaps every avant-garde ends in affirmation because it begins in negation. If that is the case then the anti and its recuperation are not adversaries; recuperation is not simply the defeat of negation; rather both are functions of the same dialectical apparatus operating at the most basic levels of the discursive economy.[2]
>
> PAUL MANN

I. Introduction: Optimism in John's Box

Acknowledging in 1981 the immense debt that her dance work owes to the aesthetics articulated by John Cage, Yvonne Rainer nonetheless characterizes Cagean aesthetics as a kind of "Pandora's Box."[3] "It is not my intention to force the lid shut on John's Box," Rainer says (playfully inverting sexual stereotypes associated with the myth of Pandora), "but rather to examine certain troubling implications of his ideas even as they continue to lend themselves to amplification in art-making."[4] While Rainer is careful to acknowledge Cage's insight into the "conceptual precedents for methods of nonhierarchical, indeterminate organization," this interest in the "troubling implications of his ideas" leads her to question Cage's embrace of these precedents as a strategy for what Cage describes

as "an affirmation of life, not an attempt to bring order out of chaos nor to suggest improvements on creation, but simply a way of waking up to the very life we are living which is so excellent once one gets one's mind and one's desires out of its way."[5] Rainer comments that such a notion of art could only come from "a man born with a sunny disposition," for if anything the methods of nonhierarchical, indeterminate organization are, according to Rainer, most helpful in awakening us not "to this excellent life," but rather, "to the ways in which we have been led to believe that this life is so excellent, just, and right."[6] Yet, as critical as Rainer is of what she calls the "goofy naiveté" of Cage's sense of life's excellence, she hardly advocates an outright rejection of Cage or an ultimate rejection of the inherent optimism of his philosophy. On the contrary, she would shift our attention from (Cagean) metaphysics to political ideologies, thereby providing a critical discourse that acknowledges Cage's tremendous impact on American avant-garde performance without simultaneously suppressing socio-political questions like "*Whose* life is so excellent and at what cost to others?"[7] Implicit in the discourse proposed by Rainer is an acute awareness of the questions of ideology and gender elided in Cage's philosophies, an awareness visible in Rainer's inversion of the myth of Pandora, as well as in her reference to Cage's "sunny disposition." As important as this shift from a focus on metaphysics to a focus on ideology is in reaffirming the long-standing connection that the avant-gardes have had with political aesthetics, the discourse proposed by Rainer is disappointing only insofar as she does not really follow through on the discursive shift that she initiates. But at the very least, Rainer tentatively provides us with a compass for a critical remapping of Cage's contribution to the history of American avant-garde performance, one that takes into account its complex ideological terrain.

In that remapping it would be a mistake to reduce the underlying optimism in Cage's theories to a mere illumination of the metaphysical beliefs emanating from his Buddhist convictions. The shift in focus from metaphysics to ideology does not void, but rather, changes the point of emphasis in the optimism expressed by Cage. Indeed, that optimism—which as an American phenomenon can be traced at least as far back as Emerson and Thoreau—belongs more to the political traditions that gave rise to the second wave of American avant-garde expressions, than it does to Cage's particular interest in Eastern metaphysical philosophies. It played a crucial role in forming the direction that the American avant-gardes took just as European avant-garde artists began to flee Europe in

the 1930s and arrive on the American shores. Consequently, having some greater sense of the larger American context of Cage's optimism and its relation to the rise of a second wave of American avant-garde performance is a crucial prerequisite for understanding the ideological and gendered underpinnings of Cage's contribution to the American avant-gardes.

II. An Intersection of Avant-Gardes

When the fascists came to power in Europe, they had little tolerance for the anti-authoritarian, anti-institutional, and anti-cultural sentiments associated with the European avant-garde performance community. Their response was to repress avant-garde theatre and to persecute its members. Consequently, many European avant-garde artists sought asylum in the United States, where they were able to continue their artistic work under the auspices of educational and cultural institutions, and where, in collaboration with American artists and intellectuals, they evolved with a new sense of purpose. The repressive measures of a Europe intoxicated with fascist ideology thus marks the end of what now is frequently called the historical avant-gardes, or to be more specific, their progressive European factions. The migration of those avant-gardes toward the American continent (in the form of artworks, ideas, and individuals) marks the beginning of a fundamental evolution in the experimental traditions of American avant-garde theatre. Ironically, the collaboration between European exiles and American intellectuals and artists infused the overt nihilism of the European avant-garde traditions with a strident American optimism.[8] In its hybrid American form, this emerging avant-garde community developed with a much clearer sense of alternatives to the cultural forms it opposed than the Europeans had, and in many respects, this hybrid avant-garde displayed a resourceful ability to learn the lessons faced by "even the most negative anti-artists," namely that emphatic aesthetic negations and radical anti-cultural sentiments "are trapped in conversation with the culture they wish to leave behind" and "with the order . . . [they seek] to destroy."[9] Though still quite anti-authoritarian, the new hybrid American avant-garde thus began to actively involve itself with counter-cultural, rather than anti-cultural, projects.

The shift from "anti" to "counter," from "absolute opposition" to "enacted alternative," laid the foundation for a distinctively American avant-

garde performance tradition—which I characterize here as *hybrid vanguardism*—and it cleared the path for the larger, counter-cultural currents with which that tradition is associated. To characterize these performance practices as hybrid vanguardism is, at one level, to blur the lines between the European avant-gardes and what is perhaps the most widely recognized strand of experimental performance practices that took shape in the American post-war cultural milieu: practices that critics have associated with "the Duchamp-Cage Aesthetic."[10] Characterizing these practices as hybrid vanguardism acknowledges the debt that one American avant-garde owes to its European predecessors, and it also acknowledges a variety of avant-garde practices that emerged, coexisted, and intermingled in the post-war era, but the term is primarily intended as a critical alternative to the characterization of the American avant-gardes as a "neo-avant-garde," a characterization that critics like Peter Bürger have used to dismiss the American movement as an attempted resuscitation or repetition of the radical anti-cultural provocations of the historical European avant-garde. Hybrid vanguardism, by contrast, denotes a substantially-evolved wave of avant-garde practices that emerged from a stew of imported European avant-garde influences simmering within the growing ambivalence that American artists like John Cage began to express toward "the Abstract Expressionist belief that the true sources of art were in the artist's psychology, subjective expression, and creative process."[11] Inasmuch as that ambivalence manifested itself in a renewed interest in the spectator's contribution to the creative process (following, in this respect, the lead set by Marcel Duchamp), the accompanying aesthetics of American hybrid vanguardism, whether consciously or not, implicitly underscored the socio-political context of the spectators themselves as a decisive element in the production of art. Since the cultural and political contexts of Europe and the United States were so vastly different, this acknowledgment drew a fundamental line between the work of the European and the American avant-gardes. Inasmuch as the reception of a work constitutes the work itself, the differing cultural identities of European and American spectators produced two very different conceptions of avant-garde practices.

Such demarcations play an equally important role across the diverse cultural and political landscape of the United States itself, for just as there was no uniformity in the cultural identities of European and American spectators, neither was there uniformity in what we can only provisionally label as the cultural identity of American spectators. As we will see

momentarily, the particular construction of that identity at Black Mountain College, for instance, is pivotal to understanding, among other things, the gendered underpinnings of Cage's work. But for the moment, it is important to recognize the sense in which the notion of American hybrid vanguardism runs counter to the well-known dismissals of the so-called neo-avant-garde by Peter Bürger, and also to Hal Foster's provocative defense of the neo-avant-garde in *Return of the Real*. Rather than arguing, as Foster does, that the neo-avant-garde is the first to actually achieve the critique of the institution of art that Bürger attributes to the historical (European) avant-gardes, I'm using the term *hybrid vanguardism* for the American context in relation to the critical aesthetic voice that unfolds within nontraditional "counter" institutions, or within an emerging (albeit precarious and vulnerable) counter-culture.

This distinctly American adaptation of avant-garde practice was as much a product of institutional contexts that were consciously positioned as alternatives to the mainstream, as it was a product of specific individuals willing to modify the legacy of the historical European avant-gardes in response to the demands of their own historical and cultural setting. Indeed, such modifications may very well have been unthinkable without the patronage provided by nontraditional institutional structures like Black Mountain College, the New School for Social Research, or even (a few years later) the Judson Church. With regard to the experimental redefinition of performance by individual artists working within these counter-institutional settings, probably the most pivotal figure during this period of migration, collaboration, and evolution was John Cage.[12] This was in no small part the result of Cage's early instrumental role in championing the (then-untranslated) writing of Antonin Artaud and the work of Dadaists like Kurt Schwitters.[13] More importantly, it was the result of the profoundly influential, personal rapport that he was able to establish with Marcel Duchamp, whose *readymade* aesthetics not only found an important echo in Cage's embrace of found sounds, but were thereby also framed within the temporal structures of composition that revealed their performative undercurrents. No less significant in this regard was Cage's involvement with two counter-institutional environments, the New School for Social Research and Black Mountain College, both of which were crucial sites for redefining avant-garde expression— indeed, for cultivating hybrid vanguardism—in a post-European context.[14] Not only did that involvement literally position Cage as the mentor for many individuals who would later become the leading figures in

the Happenings and Fluxus events of the late '50s and '60s, but it also provided the context for what is widely regarded as his defining contribution to the post-war experimental theatre traditions that Michael Kirby called the "New Theatre" and Richard Kostelanetz called the "Theatre of Mixed Means." While Cage's classes on composition at the New School functioned as a meeting ground for people like Alan Kaprow, Dick Higgins, Al Hansen, and George Brecht, his affiliation with Black Mountain College set the stage for the now-legendary, short, untitled mixed media piece that he orchestrated for the college community in 1952.

Widely viewed as the prototype for the "happenings" that would emerge later that decade, Cage's untitled performance piece at Black Mountain conceptualized performance within a chance operation format, accommodating what Cage later described as a "simultaneous presentation of unrelated events," and established what Michael Kirby identified as a generative combination of "indeterminate nonmatrixed performing in a compartmented structure that made use of an expressive spectator-performance relationship."[15] Descriptions of this piece are about as numerous as the inconsistencies among the recollections of those who were present for the performance of it, but roughly, the event unfolded along the following lines. The audience's seats were arranged in four triangles, the points of which implicitly and ironically directed attention toward a central space frequently not the focal point of a performance. The actual performances—by Cage, Merce Cunningham, David Tudor, Charles Olson, Mary C. Richards, Robert Rauschenberg, and an uninvited dog—incorporated a wide variety of mediums and drew the audience's attention in different directions (toward the ceiling where films and/or slides were projected, toward the walls where Rauschenberg's work was displayed, toward the seating where Olson was planted, toward a ladder where Richards read poetry, or toward the floor, or by other accounts again toward another ladder, where Cage gave a lecture on Zen or read from the works of Emerson and Thoreau[16]). Though these individual parts of the program were each limited to a specific span of time, they often overlapped, and the audience repeatedly needed to forego the attention demanded by one performance in order to concentrate on another.

The exact particulars of Cage's untitled piece have proven to be less important than its structural organization, which, it is worth noting, was strongly indebted to the formal structures of collage, and was thus its own kind of hybrid form. Critics have long argued that this organization

functioned as a prototype for the happenings, and that it marked a more general turning point in the course of American experimental theatre after the Second World War. If Kirby and Kostelanetz were at the forefront of such arguments, their views found a ready echo two decades later in the arguments of RoseLee Goldberg and Mary Emma Harris, for example, who directly link the chance operational format of Cage's piece with the happening-related events of the late fifties and sixties.[17] While the metaphysical underpinnings of Cage's aesthetics may encourage this scholarly emphasis on the structural dimensions of his untitled event—an emphasis, incidentally, that in practical terms has reduced the particulars of the event into a question of style—this approach has consistently overlooked the political and ideological foundations of the event itself, and inasmuch at those foundations are not only directly related to but actually constitute the spectator-performance relationship, it is rather amazing that little if any consideration is given either to understanding the extent to which the Black Mountain College setting was necessary for the event's cultural significance or the extent to which the setting of Cage's piece can inform us about the nature of American avant-garde performance practices and provide insight into what I have called American hybrid vanguardism.

III. Black Mountain, Counter-Culture, and the American Context

Whatever role Cage's orchestration of independently-evolving components may have had in foreshadowing the structure that many of the happenings and Fluxus events would adapt over the next two decades, his untitled piece bore a strong conceptual affinity with the institutional structures of Black Mountain College. Indeed, the piece echoed the structures of the institution itself at a level unaddressed in the social and theatrical histories of the arts at Black Mountain. Even Martin Duberman's comprehensive account of Cage's untitled piece overlooks the extent to which Cage's claim that the event was "unintentional . . . a purposeless, anarchic situation which nevertheless is made practical and functions" can be read as a reference to the value that the event had within the college's curricular structure.[18] On the contrary, Duberman maintains that

by establishing rigid time brackets for each participant, and by scheduling the event for a particular time in a particular space (the dining hall), Cage had superimposed an intentional structure of considerable proportions, and to that extent had limited *some* of the possibilities for random development.[19]

Even if one takes for granted Duberman's assertion that the imposition of "an intentional structure" may have limited some "possibilities for random development," that imposition, inasmuch as it paralleled the institutional limitations imposed by the college itself (i.e., the structuring of the daily lives of students and faculty), arguably did as much to promote the development of possibilities otherwise unimaginable as it did to "limit possibilities for random development." Indeed, Black Mountain College was founded on the (proto) counter-cultural presupposition that, given the dominant trends in the American social mainstream, random un-orchestrated activities would inevitably always remain within the already familiar, the habitual, and the conventional, unless otherwise situated in an environment that was itself structured in opposition to the status-quo. In short, the "purposeful purposelessness"[20] of a work like Cage's would remain impotent purposelessness unless buttressed by an institutional structure that orchestrated collective resistance and thereby facilitated otherwise unobtainable alternatives.[21]

This sentiment advocating the need for, and indeed the possibility of, orchestrated, institutionally-maintained forms of social resistance antedated Cage's arrival at Black Mountain. As a matter of fact, such sentiments were in circulation prior to John Andrew Rice's founding of the college in 1933, having already found an earlier and powerful voice in the philosophies of John Dewey. It is hardly an exaggeration to argue that Dewey's philosophies loom large over Black Mountain College. His *Democracy and Education* (1916) looms over virtually every experiment in education in the twentieth century, at least every American experiment. But Dewey took particular interest in Black Mountain, visited it twice in 1934–35, "and soon after his second visit accepted an offer to become a member of its Advisory Board."[22] Coincidentally, this acceptance roughly coincided with the publication of his seminal contribution to the philosophy of aesthetics, *Art as Experience* (1934). Whether Dewey's work on aesthetics and the subsequent interest he took in Black Mountain College are directly related is not really the issue. Regardless of whether Dewey recognized it, Black Mountain College constituted a living nexus of his

philosophies of education and art, especially as these philosophies overlap in an emphatic call for an alternative site of artistic expression and experience, a site that consciously runs counter to the cultural mainstream.

That call echoes throughout the entire twenty-three-year history of Black Mountain College, and when considering Cage's seminal 1952 untitled piece in light of the confluence of interests that generated American hybrid vanguardism, both Dewey's philosophy of education and his philosophy of art are indispensable. They are crucial to understanding the counter-cultural context of Cage's untitled piece, as well as the hybrid aesthetics it implicitly espoused. To associate Dewey's philosophy with a notion of counter-culture is thus more than merely an assertion—albeit a defensible one—that his arguments in *Democracy and Education* are probably the first articulated signs of the disaffection that would later become widespread on American college campuses during the 1960s. Indeed, the point of such an association is to underscore how much the Black Mountain College setting of Cage's untitled event provided a profoundly significant social purpose to Cage's "purposeless play," and thereby immediately transformed the event into a moment that Cage could genuinely describe as "purposeful purposelessness."[23]

Inasmuch as Dewey's philosophies help us to flesh out the undercurrent of socio- political dimensions of Cage's untitled event (or at least the socio-political context facilitating that event), they go a long way toward establishing the critical foundation that Yvonne Rainer seeks in her call for a discourse that can acknowledge the significance of Cage's aesthetics without sacrificing an illumination of their unspoken political commitments. But there are a number of questions that emerge from that foundation, not the least of which confronts the very notion of a counter culture with the question, "counter to which culture?" Specifying this question even further, we might ask: if resistance to the dominant trends in the social mainstream necessitates the magnified force of an institutional structure, what trends does that structure resist and what trends does it continue to reinforce? Important in this regard is the recognition that such questions by no means challenge the presumption that an institutional structure may very well serve a vital and absolutely necessary role in building a wedge against the habitual and conventional behaviors encouraged in society at large. This is especially true of educational institutions like Black Mountain College, that clearly aimed to engage society at the level of ideology and to cultivate a critical consciousness among the individual members of the Black Mountain College community before

they could be absorbed into the social mainstream. In this respect, the college was very much in tune with the mission that Dewey assigned to the university vis-á-vis the social realities that students would later face as they entered into the workforce. The social and political dimensions underlying Cage's untitled event were thus primarily defined along material, economic lines. As important as this definition was, it unfortunately paid little, if any, attention either to the ideological affinities between capitalism and patriarchy or to the mutual support that the two offer each other.

Yet inasmuch as Black Mountain College espoused the educational philosophies popularized by writers like Dewey, the "purposeless play" of Cage's chance operational event gained a profoundly significant political purpose as an integral part of curricular structure consciously designed as an alternative to the emerging ideological hegemony of American corporate culture. As part of his strategy for combating a pedagogy that fosters instrumental reason, Dewey aims specifically at seizing and cultivating alternative spaces that can serve as a hiatus from the pervasive, unavoidable market logic of the social mainstream. For Dewey, these spaces are simultaneously of both pedagogical and aesthetic value. While market logic would largely dismiss them as ultimately purposeless, Dewey maintains that such spaces are (for that very reason) absolutely essential to intellectual growth and to artistic expression—both of which he specifically associates with a notion of "play" that has not been "perverted" by a need for recuperation and distraction from reified drudgery.[24]

Not only does Dewey argue that it is the business of schools to set up environments where "plays, games, and constructive occupations" (like Cage's event at Black Mountain) are more than mere "agreeable diversions" from "factors concerned with technical production and marketing of goods,"[25] but on a more general scale, he argues in *Art as Experience* that all artistic expression is like drama, in that it "requires a stage, a space, wherein to develop and time in which to unfold."[26] Whether viewed from the perspective of education or art, the space and the time to which Dewey refers both run counter to a social tide that, without mounted resistance, will erode their potential critical force. "Where there is no administration of objective conditions, no shaping of materials in the interest of embodying the excitement," Dewey argues, "there is no [artistic] expression."[27] While that consciously administered environment may very well have been anathema to the anti-institutional dispositions of the European avant-gardes of the early part of the twentieth century, it was a requisite cornerstone to the counter-cultural strategies of the emerging American avant-gardes in the post-war era.

The question haunting such counter-cultural agendas is whether facilitating viable alternatives to the mainstream necessitates a full-scale *engagement* with or a negation of the mainstream *in toto*. As is the case with virtually any philosophy dealing with notions of reified consciousness (either by name or implication), Dewey's philosophies of education and art pivot upon a belief that consciousness is contingent upon material reality. For most materialist philosophies, this contingency leads to the logical conclusion that if reified consciousness is the product of material reality, the structures of that reality must be radically altered if reified consciousness is to be averted. Such, for example, are the views of Lukács, who seeks not a counter-culture, but a revolutionary culture that circumvents reified consciousness through a radical and complete restructuring of the social order. But in Dewey's philosophy, the circumvention of reified consciousness follows an alternative—and, one might add, a distinctly American—path. Consciousness, in Dewey's view, is as contingent upon diverse spatial realities as it is upon material, economic arrangements. Thus, by embracing a substantially less uniform or pervasive conception of the material social order, Dewey clears a conceptual path for cultural currents that can run counter to the dominant cultural mainstream and that can potentially rupture the indoctrinated logic of capitalism.

This spatial conception of the social fabric, which is by no means unique to Dewey, had profound implications for avant-garde practice as it blended into the American milieu. While the radical nihilism of the European avant-gardes inclined, however ineffectually,[28] toward full-scale negations, avant-garde practice—refashioned by artists like Cage, who practiced their art in environments strongly influenced by Dewey's philosophies—followed a new set of strategies.[29] In short, the radical, revolutionary edge of the European avant-gardes gave way to a vigilant, affirmative defense of specific sites of blossoming alternative cultures. Sites like Black Mountain College offered a respite from the pull of otherwise seemingly irresistible social currents, but at a conceptual level, the logic of work like Cage's gestured toward a similar kind of respite.

IV. Cage's Affirming Vanguardism

Exploring that logic necessitates, first of all, a recognition that the affirmative undercurrents of Cagean aesthetics are as much a product of an expressed political strategy as they are a product of Cage's metaphysical con-

victions. Rather than concurring with the Dadaist need to use negation as a springboard for its own existence, or endorsing the Russian Futurists's anti-traditionalism, which found perhaps its most concise articulation in Mayakovsky's statement, "I write *nihil* on anything that has been done before,"[30] Cage's work shifts the avant-garde equation from the negative to the alternative, in other words, from anti-culture to counter-culture. In the case of Cage, this shift entailed a simultaneous embrace of American academic settings, an embrace that was manifested in his support of counter-institutional contexts like Black Mountain College and the New School for Social Research, under whose auspices he was, in turn, able to coordinate his own artistic activities. That reciprocal support, so radically different from the Futurist desire to destroy "academies of every kind,"[31] cultivated a multilayered form of hybrid vanguardism, blending art and academics, combining American and European traditions, and emerging from the interaction of artist and spectator (a very specific kind of spectator). Distinctly American in hue, the counter-institutional context of Cage's 1952 performance piece at Black Mountain, for example, colors not only his work, but also the attitudes of the audience/participants who were indispensable to the success of Cage's piece.

In this respect, Cage's untitled event represents, among other things, a decisive evolution in the aesthetic precedent set by the work of Duchamp. It was Duchamp, of course, who first maintained, "All in all, the creative act is not performed by the artist alone; the spectator brings the work in contact with the external world by deciphering and interpreting its inner qualifications and thus adds his contribution to the creative act."[32] But whereas Duchamp's notion of the spectator in such claims is hardly specified, Cage's piece pivots as much on the calculated specificity of his audience at Black Mountain as it does on the intentional structures governing the chance operations of the untitled event itself. In both respects, Cage's piece reverberates with subtle political undertones. Indeed, Cage was well aware of how the role of the institution in America distinguished the American avant-gardes from the European avant-gardes. On this point, he was quite explicit, especially when it came to responding to criticism that implicitly challenged his institutional affiliations. Cage dismissed those critiques which he claimed represented an outright misunderstanding of the American cultural context:

> The situation is different and has been different for many years in the U.S. from what it is in Europe. The people in Europe who concern

themselves with art are for the most part not students [. . .] but are rather the people who have the leisure to pay attention to art. Therefore, Europe considers itself more cultivated than the U.S., which is considered by Europe to be a little far away from tradition and culture, and to be a little bit barbarian.

Well, what is happening in the U.S. is this: When you get a job in society and enter in the economic-political structure of capitalism, you no longer have any time for art. You're not interested in art any longer; only a few people are. The people who are interested in the arts are the students. Therefore, if I make a tour in the U.S., I go from university to university.[33]

Echoing the opposition that Dewey builds between education and market logic, Cage, with his identification of students as the most receptive of US audiences for avant-garde activities, begins to map out the calculated terrain of a hybrid American avant-garde tradition. Following the anti-capitalism of the European avant-gardes, while strategically abandoning their rejection of the academy, Cage points toward a tradition that is far more diverse in its influences and expressions than those who characterize the American avant-gardes as a "neo-avant-garde" repetition would have us believe.

As Cage implicitly admits, the use of academic institutions as enclaves strategically organized as alternatives to the economic-political structures of capitalism is a crucial part of the American avant-garde traditions. However generative scholars may rightly consider Cage's 1952 untitled event to have been in the history of the American avant-gardes, the very possibility of its orchestration is indebted to the counter-cultural foundations of Black Mountain College as an institution. Those foundations helped to facilitate avant-garde expression, and they're a far cry from the "ersatz culture" that Clement Greenberg characterized as the absolute antithesis of avant-garde expression in his classic essay "Avant-Garde and Kitsch" (1939). Whereas that "ersatz culture," or "kitsch," is an ideological commodity structure that uses what Greenberg calls "the debased and academicized simulacra of genuine culture" in order to maintain a sentimental connection between the masses and market place, the counter-cultural (and ultimately avant-garde) underpinnings of Black Mountain were clearly positioned as an alternative to the market logic of the cultural mainstream.[34] One could easily have expected Greenberg to argue similarly in his 1971 essay "Counter-Avant-Garde," the very title of which

suggests that Greenburg might have moved in the direction that I have been arguing here. But despite statements like "opposites, as we know, have a way of meeting" and "'academic' is an unhelpful term unless constantly re-defined and re-located," Greenberg—who, early on, perhaps did more than any other critic in championing avant-garde art in America, and who even taught a summer session at Black Mountain—was incapable of superseding a strict division between experimental art and academic institutions or of recognizing how fundamentally the terrain of avant-garde practice had changed in the thirty years separating "Avant-Garde and Kitsch" and "Counter-Avant-Garde.[35]

If Cage's embrace of academic institutions wasn't enough to distinguish the American avant-gardes from European avant-gardes, then a reevaluation of the aesthetics of negation served to differentiate them. Indeed, the strategic shift initiated by artists like Cage struck right at the heart of the emphatic aesthetic negations and radical anti-cultural sentiments of the European vanguard traditions. Nowhere is that shift more evident than in Cage's own articulation of his aesthetic agenda, which might very well qualify as the quintessential example of Paul Mann's claim that "every avant-garde ends in affirmation because it begins in negation," as well as his assertion that in the avant-gardes the affirmative and negative "are functions of the same dialectical apparatus."[36] Implicitly responding to the dialectical trappings of negative *engagement*,[37] Cage takes up the affirmative in a 1961 interview with Roger Reynolds, touting it as a viable alternative to the unavoidable problems of aesthetic negation:

> I have decided that it is frequently difficult to know how to steer one's course in social situations; and I've decided to use this as a kind of compass: To make affirmative actions and not to make what I call negative, or, you might say, critical or polemical actions, even when the thing being criticized or fought against is patently evil. In other words, I shall not attack the evil but rather promote what seems to me to be what I call affirmative.[38]

These comments give voice to Cage's lifelong search for a path around the inverse identification with the cultural mainstream that plagued the negative aesthetics of the European vanguards. With this embrace of affirmation, Cage signals a dialectical shift in the direction that the avant-gardes would take in their post-war American context. Stripped bare of its nihil-

ism, the avant-garde gesture promoted by Cage no longer even coincides with the style of antagonism ("acting by negative reaction") that Renato Poggioli contrasts with the most extreme forms of nihilism ("destructive, not constructive labor") frequently manifested in European avant-garde gestures.[39] Indeed, in Cage's refusal to make "negative" actions and in his intention "not to attack evil but rather [to] promote . . . [the] affirmative," he presupposes a path of already existing but overlooked alternatives. In this respect, it is not a matter of coincidence that Matei Calinescu cites the example of Cage to substantiate his assertion that "the unifying principle of the two main aspects" of the post-war avant-gardes—i.e., their "intellectualism and anarchism"—is "their common *antiteleological* drive."[40] Cage's aesthetics grasp at the already present rather than toward the future.

While scholars might debate the political viability of Cage's decision to promote the affirmative, they cannot simply dismiss it as a form of naive complacency. On the contrary, the course mapped out by Cage suggests the need to rethink the broader implications of the extent to which the European avant-gardes' negative aesthetics repeatedly reaffirmed the authority of the very social order they set out to oppose. Those implications may lead to a reevaluation of numerous political agendas, but at the very least, Cage's embrace of an aesthetics of affirmation suggests a political strategy that, while problematic if understood as a mere extension of his metaphysical convictions, may very well offer a tactic for battling a social order at a level that does not locate the goals of this battle in an unspecified and potentially indefinitely deferred future.

Inasmuch as Cage's comments presume an untapped, already existing space for radical, experimental art, the political dimensions of his work pivot on the assumption that vying against the social whole is a costly distraction. Such struggles, in Cage's opinion, merely waste time that could otherwise be devoted to cultivating neglected space that already exists.[41] This emphasis on cultivating space that already exists permeates Cage's entire aesthetic and is visible not only in his exclusive promotion of "the affirmative," but also in his art's radical transformation of the category of silence—a transformation whose obvious affinity with the underlying precepts of feminist and queer historiographies Jonathan Katz explored in his classic 1999 essay "John Cage's Queer Silence; Or, How to Make Matters Worse" (*GLQ* 5.2). Beyond Katz, not even Rainer appears to be aware of the need to shift the focus of discussion from Cagean metaphysics to the political ideologies of Cagean silence.

The affinity of Cage's work with feminism and queer studies pivots on Cage's argument that silence as an aesthetic category is a social convention. Silence, Cage argues, is a construct rather than a reality; it is a product of a tradition teaching us not only to disregard, but to no longer even perceive sounds and noises that do not reaffirm cultivated auditory aesthetic values—values that are themselves a matter of convention, neither universal nor transcendent. It is at this juncture that one finds a clear segue into the coded political ideologies of Cagean aesthetics. Arguments that would attune us to sounds we have learned not to hear find a ready echo not only in the feminist rethinking of the absence of women's voices in cultural histories, but, as Katz notes, also in the queer rethinking of the coded silences of homosexual cultural in the 1950s. Scholars working along these lines have repeatedly advocated a vigorous reexamination of the discourses of cultural history that presume silence rather than listening for the work of women artists and of gay and lesbian artists.

While Cage's transformation of silence gives some indication of how far his promotion of the affirmative extends into the political sphere, that same transformation is at the defining crux of his work as avant-garde.[42] In this respect, the parallels that his aesthetics share with the underlying precepts of feminist or queer historiographies situate cultural historians at an important crossing in the course that they've plotted for understanding the significance of Cage's contribution to the traditions of American avant-garde performance. First and foremost, I would suggest that for far too long scholars have failed to recognize that Cage's radical redefinition of silence carries an implicit appeal for those whose work has been silenced in the histories that scholars write. Indeed, critics and historians have an important role to play here. Given Cage's interest in universities as sites for his work, scholars (including cultural critics, theater historians, and performance theorists) are part of his audience, and the audience—as the critical body to whom the work is addressed—by Cage's own admission plays as much of a role in determining the work's significance as Cage himself does. To recognize the gendered implications of Cage's work is thus a legitimate extension of the aesthetic principles that Cage embraces. Secondly, how the audience as a critical body is constituted depends largely on its material circumstances, and if there are clear parallels between Cage's redefinition of silence and feminist and queer historiographies, there are equally similar parallels between that redefinition and the precepts underlying Black Mountain as an institution.

While the cultural histories that are attuned to questions of gender

and sexual diversity may echo Cage's redefinition of silence, Cage's re-definition echoes, in turn, the underlying philosophical goals of the Black Mountain educational community in general and Dewey's philosophies of education and art in particular. For just as Cage promotes spaces be-tween tones (silence) in order to excavate an avant-garde aesthetic notion of noise otherwise elided by the conceptual habits of regressive hearing, so too does Dewey promote educational and creative spaces like Black Mountain in order to excavate a notion of play otherwise elided by the conceptual habits of reified consciousness. And just as the avant-garde qualities of Cage's experiments pivot on the affirmative promotion of the alternative spaces between tones, so too did the avant-garde possibilities of his 1952 untitled piece pivot on the counter-cultural space that Black Mountain occupied in relation to the social mainstream.

What the redefinition of silence has to do with the performative his-tory of the American avant-gardes can be garnered from the parallels that Cage himself saw between his work as a composer and his eventual defi-nition of that work as a form of theatre. Indeed, Cage's own concerns with theater—concerns that are the direct result of his preference for noise over tonality—did not lead to performances modeled as negations of recognizable social structures. Rather, Cage modeled and admired per-formances that highlighted overlooked and neglected social experiences—performances akin, as he argues, to the effect that the indeterminate structure of happenings ought to potentially have on their audience/par-ticipants. That encounter, he readily agrees would amount to "the ulti-mate educational experience."[43] If that type of experience could, for ex-ample, cultivate an institutional context facilitating counter-cultural venues for women artists, it would also contribute substantially to recov-ering the inadvertently neglected contributions that women have made to the history of American avant-garde performance.

V. Cage, Performance, and Anti-Authoritarianism

Clearly, there are potential problems with a blanket analogy equating the (un)silent spaces between tones with the counter-cultural, institutional spaces advocated by Dewey's philosophies of education and art.[44] But if one looks for a bridge linking Cagean aesthetics with the political under-currents of Dewey's philosophy, it is to be found in the socio-political context looming not just in the background of Cage's work, but also in

the background of much of the experimental artistic work in the United States during the early 1950s when Cage orchestrated his untitled event at Black Mountain College. As Moira Roth noted in 1977, Cage and his colleagues (Cunningham, Rauschenberg, and Johns) all came to prominence during the darkest years of the Cold War when US domestic and foreign politics were under the spell of McCarthyism. In this chilling political context, an exploration of how silence is not really silence, I would argue, is hardly the product of the neutral "aesthetics of indifference" that Roth attributes to Cage's circle. Indeed, in the late forties and early fifties, knowing where and how to speak was a matter of political survival, and the political witch hunt against the left was merely one reason for this necessity.

While Roth is largely correct in her assertion that "the *machismo* attitudes proudly displayed by the Abstract Expressionists were [. . .] countered by the homosexuality and bisexuality permissible and even common among" those affiliated with the Duchamp-Cage aesthetic, her arguments are marked by little, if any, expressed awareness that, like the public embrace of radical political ideologies, the open expression of alternative sexual identities in the fifties was not (and unfortunately is still not) without risk.[45] David K. Johnson has recently made a profound case for this very point in his book *The Lavender Scare: The Cold War Persecution of Gays and Lesbians in the Federal Government.* Johnson notes that McCarthy "was the first major politician to publically suggest that there were homosexuals in the government and that they posed a risk to national security," and also that the homophobic panic that McCarthy stirred up led in 1950 alone to "the dismissal of some six hundred federal civil servants," which was almost "double the rate for those suspected of political disloyalty."[46] While homophobic panic was writ large across McCarthyism, it was also writ large across US society in the 1950s more generally. At one level, the history of homosexuality in the United States is a history of subtle expression beneath compulsory discretion or, in other words, a history of silence that in fact is not really silence at all but a coded form of expression. Camp is perhaps one example of such expression, but it is also an example of a gesture toward alternative spaces where the expression of homoerotic desire can exist safely beneath the currents of the social mainstream: an affirmation rather than a negation.

Amid the coded silences of the 1950s, Black Mountain had a very special character, particularly evident in the summer of 1952, when Cage, Cunningham, Rauschenberg, and Tudor had clearly recognized Black

Mountain College as a site receptive to both their artistic and personal interests. On an artistic level, Cage's circle began to consider the theatrical implications of Cage's compositional techniques and to seriously work with the forms of what later became known as "the theatre of mixed means," the definitive example of which was Cage's event later that summer. On a more personal level, however, Cage's circle apparently also engaged in an exploration of their own sexual identities that caught the attention of their colleagues. Martin Duberman tells us, for example, that while exploring the theatrical implications of Cage's work, Cage himself, Raushenberg, and the others ventured down "sexual bypaths [. . .] that disconcerted [Charles] Olson, Joe Fiore and Dan Rice, men who shared a stereotypic, almost truckdriver view of 'masculinity'."[47] Disconcerted though their other male colleagues may have been, the fact was that at Black Mountain, Cage's circle had discovered a social context that, unlike the American social mainstream of the 1950s, would accommodate their radical explorations in both art and sexuality.

These very different explorations may not be as distinct as they first appear, for at a conceptual level they converge in the theory of performance that grew out of the Duchamp-Cage aesthetic and that blossomed in the ready echo that aesthetic found in the philosophical principals governing Black Mountain as an institution. Decisive in this regard was the interest that Cage's circle took in Duchamp's performative construct, Rrose Sélavy. The issue here is not merely that Duchamp's cross-dressed performance fit well within what Amelia Jones calls "the gay kitsch of neo-Dada and pop," but rather that this "fit" had less to do with any essential characteristic of Rrose Sélavy, per se, than it did with the constructed reception that Duchamp's alter ego received within Cage's circle.[48] Indeed, with regard to sexual politics, the post-war American avant-garde reception of Rrose Sélavy gave her a progressive hue that she arguably lacked in the 1920s. Inasmuch as Rrose Sélavy served "as a symbol of new sexual and artistic freedoms and flexibilities," that function, before affirming anything else, thus reaffirmed the fundamental precepts of Duchampian aesthetics that gave spectators an equal role in creating a work of art.[49] It is worth pausing momentarily to consider what this reaffirmation of Duchampian aesthetics means for the performative gesture so often associated with Duchamp's act of cross-dressing.

For the role that Cage and his colleagues had in constructing Rrose Sélavy as a symbol of new sexual and artistic freedoms was also a performative act, one that not only characterized gender as a construct, but that

also coincided with a movement among the avant-gardes toward a defini-
tion of performance in which the boundaries between performers and
spectators no longer hold. In this respect, Rrose Sélavy was no less a
performative construct of Cage's circle than s/he was of Duchamp. In the
created persona, which, as Duchamp argued, was true of all artistic cre-
ations, artist and spectators converged in a collective act of creation.
Whatever progressive political potential this character possessed was con-
tingent upon a community capable of actively realizing that potential in
acts of interpretive construction. In this particular case, that community
was constituted by Cage's circle, but for the enactment of the new sexual
and artistic freedoms that Rrose Sélavy represented, Cage and his col-
leagues needed an equally receptive community.

 If a redefinition of performance was subtly evident in the post-war
American avant-garde reception of Rrose Sélavy, then it was even more
pronounced in the direction that Cage took Duchamp's aesthetics as he
adapted them to his theories of composition. Drawing upon the aesthet-
ics governing Duchamp's interest in *found objects,* Cage began working
with what one can describe as found sounds, sounds that were often
discovered amid presumed silence. *4'33"* is perhaps the most famous ex-
ample of this aesthetic, structured as it was around three movements dur-
ing which the pianist David Tutor sat in front of a piano without playing
a note, while an increasingly restless audience filled the composition with
chance sounds—sounds they created, thus undercutting their passive role
as spectators. Decentering the authority of the composer, the random,
chance sounds from the members of the audience (a unexpected cough,
a squeaking chair, an anxious sigh, even a heckle) all contributed to the
composition itself. Yet in many respects, the audience's creation of *4'33"*
limited the piece through their own limitations of what they were actu-
ally prepared to contribute.

 However open this audience might have been to the experimental
arts, the concert hall venue for *4'33"* reinforced what was clearly the audi-
ence's expectation that they could maintain their conventional status as
passive consumers, even though the piece itself moved them in precisely
the opposite direction. Their restlessness at Tutor's inactivity was indica-
tive both of a struggle to maintain that passive status and of an increasing
discomfort with the unconventional mode of performance that *4'33"*
facilitated in its deferral of Cage's authority and in its use of the audience
as active agents and performers. What is significant in this regard is not
just that *4'33"*'s use of *found sounds* had both musical and theatrical im-

port, but that it had social import as well, radically redefining the audience as it moved them into the role of creators. Yet that same social import is what distinguished *4' 33"* from Cage's untitled event at Black Mountain later that same year. If *4' 33"* pivoted on thwarting the audience's reluctance to become active agents in the piece, Cage's untitled event at Black Mountain unfolded before an audience fully cognizant of the larger socio-political implications of their involvement. Cage recognized those implications as well, situating them as a central aspect of his own aesthetic.

The social underpinning of Cage's deference to the audience is, in fact, indicative of a larger preference for indeterminacy and for a decentered mode of performance that not only subverts the hierarchies of authority governing traditional theater, but also subverts hierarchies of authority in general. Cage articulated his agenda to Roger Reynolds in no uncertain terms:

> Most people mistakenly think that when they hear a piece of music, that they're not *doing* anything, but that something is being done *to* them. Now this is not true, and we must arrange our music, we must arrange our Art, we must arrange everything, I believe, so that people realize that they themselves are doing it, and not that something is being done to them.[50]

Such arrangements reverberate from Cage's music through his notions of theatre into the chance operational format of his untitled performance piece at Black Mountain. Responding to the comment that the untitled piece was well received by the college audience, Cage told Richard Kostelanetz, "that was a very good situation at Black Mountain College."[51] Indeed it was a good situation, for as a performance piece aiming to de-center the authority of the producer by subverting the passive, receptive role of the audience, Cage's untitled piece could not have been better housed. The audience was already schooled in a radical resistance to passivity prior to Cage's arrival. This schooling was the cornerstone of Black Mountain as a counter-cultural institution; "doing" rather than "being done to" was its mainstay.

One might debate Black Mountain's imperfections in terms of realizing the ideals toward which it aspired, but there is little question about the extent to which its founders shared Dewey's distaste for one-sided authoritarian structures that reduced students to mere consumers or pas-

sive recipients of knowledge. Taking aim at educational traditions that cultivated rigid class divisions inside, and later outside, the classroom, Dewey advocated the creation of educational environments, like the one attempted at Black Mountain College, where both students and faculty had "an equable opportunity to receive and to take from others," and where the result of "a large variety of shared undertaking and experiences" was the (at least temporary) supersession of the master-slave dialectic that dominated higher education and, by extension, the market-logic of American society as well.[52] This contempt for class divisions remained with Dewey throughout his life. At the very least, it resurfaced two decades later when he published *Art as Experience* around the same time that he agreed to serve on the Board of Advisors to Black Mountain College. Just as he had opposed the traditionally passive and subservient role of the student in higher education, and just as Duchamp had rejected the spectator's passive role, Dewey rejected characterizations of aesthetic experience that cast the perceiver in a passive role. Foreshadowing Cage's similar arguments by almost three decades, Dewey argued that the audience for any work of art inevitably participates in an "intimate union of doing and undergoing."[53] As was the goal with a de-centered structure of authority in education, the heightened participatory role granted to the audience/perceiver in Dewey's aesthetics was essentially conceived as an implicitly subversive and fundamentally liberating gesture.

For all intents and purposes, this characterization of the audience is lifted almost directly from the pages of Dewey's *Democracy and Education*, where twenty years earlier he had outlined his ideal educational environment as one in which students learn from a simultaneous process of "*trying*" and "*undergoing.*"[54] It is little wonder, then, that Dewey showed interest in Black Mountain College. Its student body was comprised of individuals who by their very willingness to come to Black Mountain signaled an inclination to participate in the *trying* and *undergoing* that Dewey had mapped out in his philosophy of education. Given the school's emphasis on "hands-on" training in the arts, the students, furthermore, were, arguably, comparably predisposed to the "doing and undergoing" outlined in *Art and Experience* (and that was later demanded by the structure of Cage's performance piece). Nominally at least, the institution was also organized around a decentered notion of authority that ran counter to the market-logic of the cultural mainstream. That organization precariously positioned Black Mountain as an institution at the front-guard of a counter-cultural agenda that gestured (however

quixotically) toward a decentered notion of culture. It also repeatedly left the college in financial straits or in what might be called the vulnerability of the vanguard.

An important lesson to be learned from Black Mountain's embattled, short-lived history in the counter-cultural vanguards is thus that one cannot overestimate the difficulty of maintaining an anti-capitalistic, quasi-anarchistic community in the American socio-political landscape. But beyond the financial impracticality of its principled anti-capitalistic sensibilities, Black Mountain College, however fleeting its own existence might have been, provided an influential model of American vanguardism that, in its wide embrace of political / cultural dissidents, not only countered political repression, but also cultivated the hybrid forms that are perhaps the quintessential examples of what I have been calling American hybrid vanguardism. Before Black Mountain provided an institutional setting for Cage's avant-garde performance piece and a shelter for the exploration of sexual identity he (arguably) pursued beneath his embrace and de-coding of silence, the college had already established itself as a haven for those who found themselves at odds with a wide variety of mainstream political currents. This mission was part of the college's founding inspiration, and a comparable mission was carried over from Europe by the early members of the college's faculty, who were also seeking place of respite from political persecution.

VI. Avant-Garde in Exile: Bauhaus at Black Mountain

By the time of Cage's arrival, Black Mountain was close to completing its second (and final) full decade as an experimental institution that from its very founding had not only been a haven for the experimental arts, but had also served as a refuge for members of the European avant-garde community who had fled fascism.[55] Though I do not want to underplay the distinction Cage draws between European and American contexts for experimental performances, Black Mountain College's favorable predisposition to Cage's piece was not merely the result of the students generally being, by Cage's own account, the only student body in America whose interest in experimental art had not been eclipsed by the exhausting demands of a market economy. The positive reception that his work received was also, in part, the result of the college's long-standing connection with a very specific branch of the European avant-gardes, namely the

Bauhaus.[56] Whether the product of conscious choice or of coincidence, the untitled piece at Black Mountain College thus implicitly positioned Cage's activity under the auspices of an exiled fragment of a European avant-garde that had first-hand experience of political intolerance.

That Black Mountain College curried European and American experimental traditions into a hybrid form is well known. The relevance of that mix to the rise of the American post-war avant-gardes, on the other hand, has largely remained unaddressed, even though most scholars recognize that American experimental performance owes a great debt to the first wave of European avant-garde activity. If the "neo-avant-garde," as Peter Bürger has maintained, in contrast to the "historical" European avant-garde, has identifiable—and to Bürger's mind questionable—institutional affiliations that compromise its critical force, then Cage's untitled piece is doubly damned. Not only did the piece rely on the institutional setting of Black Mountain, but the college itself, which Kostelanetz has called an "American Bauhaus," bore the indelible stamp of affiliation with the only movement within the European historical avant-gardes to have a clear institutional foundation.[57] As Kostelanetz notes,

> unlike Futurism, Dada, and Surrealism, informal conglomerations of like-minded artists, the Bauhaus was an education institution possessed of clearly articulated purposes, particularly the fusion of art with craft, the artist with technology, and artistic design with daily life.[58]

This institutional structure is noticeably overlooked in Bürger's account. In its affiliation with the Bauhaus, Black Mountain College is thus a powerful illustration of how narrowly developed Bürger's notions of both the European avant-gardes and the American avant-gardes are, particularly with regard to questions of the institutionalization of art. For the history of the Bauhaus runs counter to Bürger's narrative, situating institutional activity squarely within the historical avant-gardes and thus setting a precedent for the kind of avant-garde activity that occurred at Black Mountain College.

At Black Mountain, that activity was cultivated by an admirable versatility in the avant-garde tone established by Bauhaus figures like Josef Albers, who left fascist Germany in 1933 to accept the position that John Andrew Rice had offered him when the college was just opening its doors. Albers, a veteran of the first wave of the European avant-gardes

and a victim of National Socialist policies, became one of the most influential figures in the college—second perhaps only to Rice—and the two men found common ground in an agenda that ultimately, though probably not deliberately, laid the foundation for the counter-cultural practices of the American avant-gardes. First of all, although associated with the educational institution of the Bauhaus, Albers, like Rice, consciously moved the college in a decisively counter-institutional direction. As Mary Emma Harris has noted, the two men "shared a genuinely anti-academic spirit, and they were equally adamant in their conviction that the 'academicians' should never dominate the college."[59] Although Rice's anti-academic spirit was probably attributable to a lingering bitterness from having been denied tenure at Rollins College, Albers's anti-academic spirit was arguably a much larger signature of the avant-garde traditions that he helped to forge, and which, considering the treatment he received from the fascist bureaucrats of Hitler's Germany, were grounded in first-hand experience of the difference between institutions per se and institutions as repressive, ideological state apparatuses.

Furthermore, Albers, though still working within the broad framework of the Bauhaus, was by no means interested in either repeating its previous accomplishments or in rigidly maintaining its traditions, for the former meant stagnancy and the latter meant a linear-narrative notion of history that he and Xanti Schawinsky (also from the Bauhaus) had both questioned. More about the importance of their questioning of linear notions of history will follow momentarily, but first it is worth noting that there is perhaps no better sign of the new direction Albers was taking than the title of the article in which he expressed these ideas. Published a year after *Art as Experience,* and directly echoing Dewey's most recent work, Albers's 1935 article by the same name argued:

If we review what is being done now, what directions our art studies take in relation to the past, the present, also the future, the answer is clear: We over-accentuate the past, and often are more interested in drawing out a continuous line of historical development than in finding out which of certain art problems are related to our own life, or in getting an open mind for the newer and nearer and forward-looking art results of our period.[60]

Not only was Albers fundamentally interested in the grand experimental endeavor of building counter-cultural institutions that were consciously

positioned as alternatives to the mainstream, but, as his distinction between "drawing out a continuous line of historical development" and being open to the "newer and nearer" indicate, he was among the very first to begin modifying the legacy of the historical European avant-gardes to respond to the demands of the new historical and cultural context in America. Such modifications were the crucial prerequisite to what would become a distinctly hybrid American avant-garde aesthetic.

On both counts, Albers helped to lay the foundation for a notion of American avant-garde activity that is far more dynamic than Bürger's categorically dismissive conception of the neo-avant-garde as a kind of institutionalized repetitive inauthenticity.[61] Indeed, that foundation survived Albers's eventual departure from Black Mountain College, setting a tone that continued to reverberate, even though his departure meant, according to Duberman, that "Black Mountain became for the first time since the days of its inception—and in an important sense, for the first time ever—a decidedly American, and a decidedly radical environment."[62] It is debatable whether that radical American environment, which ultimately sponsored Cage's performance piece, would have been possible without the early direction set by Albers. But one thing is clear: the radical American environment that Duberman describes was the fertile counter-cultural ground out of which post-war American avant-garde performance emerged. Even though by 1952 their work had literally taken Albers and Cage in substantially different directions, both men shared an enduring conviction—contrary to what Bürger would have us believe about the neo-avant-garde—that experimental art specifically must *not* repeat or "over-accentuate the past."[63] For just as Albers "sought to dispel the idealization of the European tradition both in his teaching and in his own art," Cage, as if already responding to arguments that Bürger had not yet formulated, was consciously circumventing artistic provocations previously committed, and, as Marjorie Perloff has noted in contrasting Cage's and Bürger's theoretical conceptions of (neo) avant-garde endeavors, Cage was particularly seeking "not to do again what Duchamp already did" but to do "something else."[64]

While it was largely Albers whose Bauhaus affiliations set the European avant-garde context for Cage's performance piece, it was Xanti Schawinsky who, in his short two-year stay at Black Mountain, transplanted a notion of performance that was derived from his work with Oskar Schlemmer at the Bauhaus and that arguably only came to fruition with Cage's piece.[65] Meshing well with Dewey's philosophical calls for

alternative spaces of both pedagogical and aesthetic value, Schawinsky's notion of performance proclaimed that the "experience of space is the fundamental adventure of man." In exploring that experience, he built upon his work at Bauhaus, where he had sought "to arrive at concepts of the theatre through educational means."[66] Although Albers ultimately criticized Schawinsky for being too indebted to Schlemmer, that debt, at least in terms of aesthetics, had important correlations with Black Mountain College's abandonment of the traditionally passive role assigned to the student. For just as Duchamp, Dewey, and later, Cage, sought to subvert that passive role of the audience / perceiver in aesthetic experience, Schlemmer too concludes his classic essay "Man and Art Figure" with the claim that the new theater depends "upon the inner transformation of the spectator" and "is doomed to remain Utopia so long as it does not find intellectual and spiritual receptivity and response."[67] Helping the theater to find precisely such a receptivity and response was arguably one of the most significant aspects of the performance at Black Mountain as a socio-cultural event within a counter-cultural institution where substantial efforts "to arrive at concepts of the theatre through educational means" had preceded Cage's arrival.

Schawinsky's pursuit of theatrical concepts though educational means—which Cage would later characterize as an essential mixture for his own experimental work in America—led to performances at the Bauhaus and Black Mountain College that are significant as more than just precursors to Cage's untitled piece. At Black Mountain these performances were, as Harris has observed, "among the first American presentations of what was later to become known as 'performance theater'."[68] More importantly, at a crucial turning point in the history of the avant-gardes, these too, like Cage's later work, were part of a vision of "a world without boundaries, no part more central than any other"—a vision that extended a subtle but profound legitimacy to later avant-garde practice.[69] In their structure, these performances were based upon a logic that consciously refused to establish hierarchies and that de-centered conventional narrative structure. Schawinsky, for example, specifically characterized the proto-Happening-like structure of *Olga-Olga* (performed in 1927 at Bauhaus, Dessau) as an example of "equilibristics," in other words, as an example of the use of "the things of daily life in reference to the imagination without giving an answer to anything."[70] Although in many respects, pieces like *Olga-Olga* and *Spectodrama* (performed at Black Mountain in 1937) foreshadow the chance operational format of Cage's

performance work, they are significant less as precursors to Cage than as proposed models for understanding narrative and history.

VII. Decentering the Narrative History of the Avant-Gardes

Like Albers's admonishment against becoming obsessed with drawing "continuous line[s] of historical development," Schawinsky's embrace of the non-hierarchical idea of "equilibristics" and his abandonment of causal narrative structure in his performance pieces are both by-products of an underlying philosophy allied with the logic of radical juxtapositions and diverse hybridities rather than that of uniform linearity. While this philosophy gave shape to the specific aesthetic models that emerged at Black Mountain College, I would suggest that it also has broad-reaching implications for how one might conceptualize the histories and theories of the avant-gardes more generally. That is certainly part of the suggestion in Albers's admonishment, and the philosophical underpinnings to Schawinsky's aesthetics are consistent with Albers's point of view. Both stand in marked contrast to the sequential and universalized notions of the history of modernism and of the avant-gardes that govern the theories posited by critics like Peter Bürger and Benjamin Buchloh. The latter, while otherwise profoundly critical of Bürger, still maintains that the linear distinctions Bürger draws are "sound." Indeed, Buchloh argues that Bürger's distinction between "the historical avant-garde" and "the neo-avant-garde" will serve "as an obligatory model for anyone working in the history of modernism."[71] If by "obligatory" Buchloh means influential enough to merit attention, then my own arguments here and throughout this book attest to the insightfulness of claims that Buchloh made back in the mid-1980s, but if, on the other hand, by "obligatory" and "sound," he means that "the historical avant-garde" and "the neo-avant-garde" are accurate as historical categories, then this chapter and the chapters that follow are very much at odds with his arguments, and are allied instead with the philosophical tendencies evident in the aesthetics of Albers, Schawinsky, and ultimately Cage as well. In this chapter, I have repeatedly pointed to what I have been calling *hybrid vanguardism*. Later in the book, I will introduce what I call the *rough edges of the avant-gardes*, and even later, I will discuss the avant-gardes' *rhizomatic structures* and *horizontal* and *vertical* tendencies. What unites all of these concepts is not

only that they refuse to conceptualize the avant-gardes' evolution as a uniform process, but also that they acknowledge that each moment in any vanguard's evolution is the product of an encounter and negotiation with some other form. Like the avant-garde at Black Mountain College, each and every avant-garde is grounded not in originality or authenticity but in hybridity—in multiple hybridities. In this respect, Bürger's "historical avant-garde" is no more or less original than the "neo-avant-garde" he dismisses as repetitious. The histories of the avant-gardes are like the decentered narratives of Schawinsky's performance pieces: counter-linear and embedded in multiple, concurrent juxtapositions and negotiations. And this is the problem with Bürger's *Theory of the Avant-Garde:* it privileges one strand of those negotiations at the expense of all others.

Ironically enough, a critical framework for decentering the historical narratives of the avant-gardes predates Bürger's arguments. Kostelanetz, for one, speaks in *Theatre of Mixed Means* of four great avant-garde movements, and, though it is clearly not Kostelanetz's intention to offer a precedent for the institutionally-facilitated avant-garde activity at Black Mountain College, he nonetheless achieves precisely that in specifically acknowledging the fundamental institutional nature of the Bauhaus. The Bauhaus provides a particularly rich example of vanguard activity that is not only cultivated within institutional structures, but also occurring within the nebulous boundaries of what Bürger calls "the historical avant-garde." Indeed, Kostelanetz cites an example that locates institutionality within the very period of the avant-garde that Bürger cites for its anti-institutionality. Not only did that precedent set the stage for the counter-cultural institution that became Black Mountain College and for avant-garde experiments like Cage's 1952 untitled event at the college, but similar arguments can be made about the event itself as a generative work in the rise of American hybrid vanguardism. Just as Cage's untitled event demanded an often contradictory and consciously-incomplete mode of perception, so too do the histories of avant-garde performance demand a substantially less uniform and consequently more dynamic notion of the avant-gardes, which in turn lays the foundation for an equally less uniform notion of the American avant-gardes, especially as the performance traditions of those avant-gardes took shape in the hybrid forms that emerged from the migration of European avant-garde artists to the American cultural scene. Those traditions took a variety of forms as they crisscrossed the historically determined national borders of

the early post-war era—not only from Europe to the US, but the other way as well. The Hungarian critic Miklos Szabolcsi pointed to precisely such a dynamic some three years prior to the original publication of Bürger's book in 1974.

Though not specifically concerned with theatre or performance, Szabolcsi was among the first to advocate understanding the term "avant-garde" as a historical category rather than as a description of an "attitude" or "disposition," and he was also among the first to resist an omnibus usage of "avant-garde" to account for what was in fact "a group of currents, [and] a set of schools" rather than "one specific school or one single current."[72] Formulating an argument that Bürger reaffirmed three years later, Szabolcsi maintains that "the first great wave of the avant-garde" subsided in the mid 1930s (with the rise of fascism). But he was also quick to acknowledge the existence and rise of a "neo-avant-garde," which, "following the armistice," emerged in Europe from a "quick but superficial revival of the first avant-garde wave" and from "a modified and strengthened version of the earlier avant-garde . . . freshly arrived from the United States."[73] Though Szabolsci only mentions the American modification and reinforcement of the historical avant-gardes in passing, the American reception of the European avant-gardes at places like Black Mountain College is a cornerstone not only for the emergence of a hybrid European avant-garde, but for an American counterpart as well, each evolving out of a distinct set of currents and each subsequently pursuing a course distinctly its own.

As might be expected, navigating the crosscurrents of these evolutions has resulted in the plotting of one course at the expense of others, or, more precisely stated, it has resulted in the positing of one discourse at the expense of others, which in turn has encouraged scholars to assume silence when in fact we've often turned a deaf ear to a rich variety of experimental expressions—expressions, for example, that occur well outside of the American or European continents. In this respect, Cage's legacy would admonish us not only to be attentive to the alternative spaces where such expressions are to be found, but also to be vigorous in the cultivation of such spaces so that elided expressions will be heard. While understanding this charge as a political rather than a metaphysical undertaking may run counter to Cage's own convictions and intent, the charge is not his alone. Like the works of art accounted for in his aesthetics, this charge has been constructed as much by Cage's audience as by Cage himself, and while Rainer may chastise Cage, for example, for neglecting

questions of gender in the aesthetic discourse he forges, that same discourse not only accommodates the inclusion of gender into our critical terminology, but it behooves us as co-authors to make the addition ourselves. Only such a strategy will ultimately achieve the aspiration that Rainer alludes to in her call for an assessment that recognizes Cage's immense importance to the American avant-gardes, while also undertaking a consideration of whose voices have been unjustly neglected.

Critique of the Artist as (Re)producer

Warhol, The Living Theatre, and *Frankenstein*

> As a whole "Frankenstein" is the perfect foil for The Living
> Theatre's peculiar talents. I don't think there is anyone in the cast
> that really knows how to speak as an actor. Given a sentence,
> they sound dreadful. But each and every one of them know what
> to do with their body and their larynx. Give them a contortion
> and a howl and they can really perform.
>
> GLENNA SYSE[1]

I. Scars, Erasure, and History: An Introduction

During an interview with Laticia Kent in September of 1968, just three months after Valerie Solanas nearly killed him, Andy Warhol offered what at first blush would seem to be a contradictory assessment of the disfiguring effect that Solanas's act of violence had on his body. "It's sort of awful, looking in the mirror and seeing all those scars," he initially confided to Kent, yet he then supplemented his comments with the incongruous judgment: "The scars are really beautiful."[2] While it may not have been a conscious distinction, the contrast Warhol drew here between the "awful" and the "beautiful" subtly reaffirmed the radical sense of immediacy that was so much a part of his own aesthetics. In the contrast between the "awful" and the "beautiful," Warhol differentiated between the represented effects of violence in a mirror and the manifested effects of violence in the actual scars across his reassembled body. Whereas the former was disparaged as a representation ("awful"), the latter was embraced for its tangible immediacy—an immediacy, in this particular instance, offering conclusive evidence of a past, and now absent, violent act that was nonetheless indexed by its present visible effect. Indeed,

within three short months, that effect had become so much a part of Warhol's everyday experience that he could lay claim to it in much the same way that he did to Brillo boxes, Campbell soup cans, and any number of items from "the iconography of everyday life."[3] In their seeming immediacy, Warhol's scars became a kind of paradigmatic found object. While he was not the author of them, they were nonetheless his. Made part of his body in the violence perpetrated against him, Warhol's scars were, as his alter ego "B" would later describe them in *The Philosophy of Andy Warhol*, "the best things you have because they're proof of something. I always think it is nice to have the proof." Of course, proof isn't worth much unless one can do something with it, as "B" reminds Andy when he suggests, "I think you produced *Frankenstein* just so you could put your scars in the ad."[4]

If truth and proof go hand and hand, however, "B's" comments were a bit of a stretch. Those weren't really Warhol's scars in the movie ad—they weren't even real scars—and he no more "produced" *Andy Warhol's Frankenstein* (1974) than he did the scars that marred his own body. But laying claim to *Frankenstein* had a lot to do with those scars, both the ones running across the movie ad and the ones running across his own body. Implicitly positioning himself as the producer of scars, of reproductions of scars, of an English romantic novel, and of a cinematic adaptation of that novel—none of which he actually produced—Warhol once again added his voice to that chorus of avant-garde artists who, by signing their names to work they did not produce, questioned the very idea of the artist as producer. *Frankenstein* offered a particularly important opportunity in this regard for a number of reasons, not the least of which was that in lending his name to the film made by his friend Paul Morrissey, Warhol not only associated his own disfigurement with what in Western popular culture is arguably the paragon of scarred bodies, but by so doing he personified avant-garde aesthetics in allegorical terms that would be accessible to the social mainstream. Baron von Frankenstein's nameless creature, as an experimental product of the scalpel's cutting edge, is quintessentially avant-garde. As an amalgam of discarded body parts, he is himself an animated assemblage of found objects, and in addition, as a subject appearing without a history, he embodies an avant-garde break with history. Most important of all, the Frankenstein narrative was a staple of popular culture—as were countless other subjects of Warhol's work—which, when appropriated as art, could simultaneously challenge the elitism feeding the conventional understanding of art and literature.

Particularly in this latter respect, Warhol's interest in *Frankenstein* was but one example of the widespread and intense fascination that various avant-gardes had with the *Frankenstein* narrative in the late 1960s and early 1970s. Indeed, Warhol was by no means alone in recognizing the vital link that *Frankenstein* offered between the experimental aesthetics of the vanguard and the popular cultural preoccupations of the social mainstream. His involvement with the production of the semi-pornographic *Andy Warhol's Frankenstein* (1974) not only followed his own nearly fatal encounter with violence, it also followed a decade of at least six Frankenstein films and at least three major adaptations of the narrative for the stage—most notably O'Brien and Sharman's *Rocky Horror Show* (1973) in London and The Living Theatre's productions of *Frankenstein* (1965) in Venice and Berlin during its exile in Europe. While all of these productions responded in one way or another to the increasingly lucrative trend of marketing violence as erotically charged entertainment, there is nonetheless much room for reflection on the rich magnetism that the *Frankenstein* narrative held for avant-garde factions as divergent in their political-aesthetic inclinations as Warhol and The Living Theatre. Despite the significant political chasm that separated Warhol and The Living Theatre, their shared interest in the *Frankenstein* narrative linked them both to the legacies of the late romantic period in which Mary Shelley penned her tale of the experimental scientist Victor Frankenstein, who sutures together a creature from found and stolen body parts.

Critics have long argued that the avant-gardes owe a substantial intellectual debt to romanticism.[5] But none have really explored how problematic that debt is with regard to the patriarchal legacies that it injects into the conceptual discourses *of* and *about* the avant-gardes. In this respect, the interest that Warhol and The Living Theatre shared in the *Frankenstein* narrative offers a unique opportunity to examine not only the debt that the avant-gardes owe to romanticism, but also the gendered economies that this debt sustains. The opportunity here is all the greater since the history of the *Frankenstein* narrative as a cultural artifact stretches from the romantic period on through the twentieth century. While that history begins with the publication of Shelley's novel in 1816 and includes countless adaptations of the narrative for the cinema and stage over the next two centuries, the history of *Frankenstein* is also haunted by Shelley's vexed relationship with the patriarchal structures of romantic literary culture. Indeed, there is a noticeable overlap in the work of Warhol and of The Living Theatre with regard to this haunting.

I would suggest that the overlap can tell us much about the avant-gardes more generally, particularly with regard to their historical ties to the patriarchal foundations of romanticism.

The path to those foundations, inasmuch as it journeys through Warhol's production of *Frankenstein* as well as The Living Theatre's production of *Frankenstein* is a complicated one. The narratives of both productions are idiosyncratic enough that providing an overview of them is a necessary prerequisite not only to assessing the ways in which they are both deeply committed to a common set of assumptions about the avant-garde and its aesthetic strategies, but also to assessing the ways in which those assumptions have sustained fundamentally patriarchal tendencies in some of the most basic categories associated with avant-garde practice. From a practical standpoint, this means that the following discussion is divided into three major sections: an overview of the productions themselves, an assessment of both productions' reliance on a common set of avant-garde strategies, and a critique of the assumptions governing those strategies—a critique that demands a fundamental reassessment of some of the most basic aesthetic categories associated with the avant-gardes.

II. Overview of Productions

By the mid-twentieth century, adaptions of *Frankenstein* barely resembled the narrative originally penned by Mary Shelley in 1816. Indeed, the narrative (like the creature whose story it tells) literally had taken on a life of its own in the popular cultural imaginary where it was cobbled together from multiple adaptations in literature, theater, and, above all, cinema. A century and a half of adaptations thus gave Warhol and The Living Theatre a wide range of possibilities for constructing their own version of Shelly's tale and positioned their adaptations within a tradition where broad license was the rule, rather than the exception. Indeed, the two productions drew upon such a diverse mélange of material that, particularly in the case of The Living Theatre's production, it was often difficult to identify any direct connection with Shelley's *Frankenstein,* other than the construction of the Frankenstein creature out of disparate parts and cultural fragments.

Andy Warhol's Frankenstein is probably better remembered for its calculated use of semi-pornographic imagery and 3D technologies than for its narrative. But of the two adaptations, Warhol's narrative was arguably

the more recognizable because it drew heavily on the most famous Hollywood versions of *Frankenstein*—James Whale's two films *Frankenstein* (Universal Pictures, 1931) and *The Bride of Frankenstein* (Universal Pictures, 1933)—both of which included defining performances by Boris Karloff as the creature. The Warhol film playfully combined the conceits of these two films, producing an idiosyncratic narrative in which Victor Frankenstein (played by Udo Kier) is a scientist obsessed with the simultaneous construction of both male and female creatures whom he plans to mate, thereby initiating the creation of a "perfect Serbian race." As was the case in the Whale films, the Baron works in a modern laboratory and is accompanied by an incompetent assistant (played by Arno Juerging), whose name "Otto" riffs on the character that first appeared as "Fritz" in Whale's *Frankenstein,* and then as "Karl" in *The Bride of Frankenstein.*

Neither the laboratory, nor the female creature, nor the assistant was a part of Shelley's original narrative. But Fritz / Karl quickly became a stock character in Hollywood horror films, and Warhol's character Otto is a kind of parodic homage to the character Whale added to the original narrative. Despite the character's seemingly minor role, the addition of Fritz / Karl to the *Frankenstein* narrative was no small matter. The addition of this new character altered the ideological dimensions of Shelley's narrative by generating a significantly different account of the creature's antisocial and violent behavior. That shift is evident in the pivotal role Fritz plays in the plot of the first Whale film—specifically when Fritz goes to a medical laboratory to procure a brain for the creature and ends up inadvertently supplying the Baron with a criminal brain. The basic structure of this part of the narrative, which implies that the creature's violent actions are the product of a congenital abnormality rather than a revolt against injustice, recurs both in the Warhol film and in The Living Theatre's production. Momentarily, I will consider its larger significance, but first, more about the narratives of Warhol's and The Living Theatre's productions.

In one of many subsequent parodies of the above-mentioned scene, Warhol's *Frankenstein* replaces the search for a brain with a campy search for a head that leads Frankenstein and his assistant Otto to a bordello where they lie in wait just outside of the exit. Their plan is to hide in the bushes with a large pair of extendable scissors, decapitate a young male with strong sexual appetites as he leaves the bordello, and then use the head to create a creature capable of procreating a new race. This plan runs amok when, rather than getting the head of a virile servant by the name

of Nicholas (played by Joe Dallasandro) who is having an affair with the Baron's wife,[6] Frankenstein and Otto end up decapitating Nicholas's friend Sasha, a celibate and sexually squeamish theology student. As Joan Hawkins has noted, "in a scene reminiscent of the bungled brain theft in James Whale's *Frankenstein* (in which Fritz accidentally chooses a 'criminal brain' for the creature), the Baron and Otto mistake which of the two brothel patrons would best suit their plans."[7] Sasha's head gives the Baron's creature absolutely no visible libidinal drive. The creature is despairing and suicidal. Viewing himself as an abomination, he kills the Baron, rips his own body apart, and thus thwarts Frankenstein's plans to create a Serbian master race.

If Warhol's film adaptation seems far afield from Shelley's original narrative, The Living Theatre's adaption strayed even further from the novel and from all but the most rudimentary elements of Whale's film as well. Both the novel and the Hollywood films served primarily as a "springboard for action"[8] rather than as the narrative basis for adaptation. In many respects, the Frankenstein narrative was subordinate to The Living Theatre's three-act exploration of how Enlightenment projects have repeatedly caused additional suffering in their efforts to end it. The Frankenstein narrative, which could be summoned merely by vague suggestion and allusion, thus served as an easily accessible metaphor for the problematic that The Living Theatre addressed. The piece contained virtually no dialogue. From a technical standpoint, it was notable for its innovative use of a three-tiered scaffolding that was constructed out of iron pipes, ropes, ladders, nets, slides, and other objects and that formed fifteen cubicles in which the individual members of the troupe frequently and simultaneously performed different actions.[9] The edifice served at times as a museum of torture or an execution chambers, at times as a structural representation of the Frankenstein creature himself, and at times as a prison block.

The Living Theatre's production opened with fifteen actors in street clothes sitting in front of the edifice, facing the audience and meditating in a concerted and apparently sincere effort to levitate the performer Mary Mary.[10] When this quasi-spiritual effort ended in failure (as it did every time they performed the work), a torrent of simulated political violence began, which was portrayed as the source of much suffering. The performers simulated the execution of Mary Mary in one of the cubicles, leading in turn to the graphically-simulated execution of all but three of members of the troupe: Julian Beck, who then assumed the role of Victor

Frankenstein, and two other performers who served as his assistants. At the end of this cycle of execution, Beck began repeating the question "How can we end human suffering?" He accompanied "the ghost of Paracelsus"[11] in a tour of the cubicles of the scaffolding where the bodies of the executed were strewn. As he did so, he responded to the brutal violence all around him by using the bodies of the executed victims to construct what became the Frankenstein creature. When at the conclusion of this tour Frankenstein screamed "Turn the Creature on," the corpses in their cubicles began to "quiver and shake and make weird sounds, moving into positions that formed a twenty-foot-high figure,"[12] which critic Margaret Croyden described as "a stunning but horrifying configuration formed from the arrangement of the actor's bodies hanging from the poles of the scaffolding."[13]

If the initial implication of the first act was that scientific advancement might be able to end the suffering the audience had just witnessed, the second act took a more skeptical attitude toward scientific endeavors. The bodies that previously constructed the Frankenstein creature were replaced by a string of lights hung from the scaffolding, this time in the shape of what doubled as giant versions of the creature's head and an outline of a huge phrenology chart. The promise of scientific advancement thus symbolically fell prey to the biases and prejudices of pseudoscience. The composite image of the creature's head as a phrenology chart suggested a kind of determinism reminiscent of Hollywood narratives like Whale's *Frankenstein*, in which an abnormal brain is presented as the source of the creature's violent behavior. Once established visually on the stage, this image of pseudo-science became the object of a sustained critique.

Against the backdrop of the towering phrenology chart, one of the members of the cast assumed the role of the Frankenstein creature himself and, in this role, gradually revolted against the pseudo-scientific determinism represented in the image behind him. In the final act of the production, this same actor—still playing the creature—made his way to the center of the scaffolding, while the rest of the troupe transformed all the remaining cubicles into individual jail cells where they were incarcerated. Through a visual transformation of the scaffolding, they thus likened the pseudo-sciences of phrenology to a kind of prison. At the center of this prison, the creature instigated a massive jail break[14] that not only enacted a revolt against the previous pseudo-scientific image, but also equated the creature's own fate with the fate of the collective. The crea-

ture's body was, in short, the body politic. Indeed, the production ended with a final visual transformation of the scaffolding that underscored this latter point. The attempted jail break culminated in a simulated catastrophic fire that consumed the escaping prisoners, who then rose "from the dead, and with their 'charred' bodies create[d] once again the configuration of the Creature," by hanging from the scaffolding as they had done in the first Act.[15] The reconfigured creature on the scaffolding and the image of it raising its "arms to the heavens" while signaling "through the flames"[16] ended The Living Theatre's performance of *Frankenstein* with a cry against injustice. It seemed designed to provoke the audience into a revolt against injustices they themselves had encountered as members of society. But the cry that concluded The Living Theatre's performance of *Frankenstein* also reflected the sense of immediacy that the group believed could radicalize the body politic by first revolutionizing the theatre. That sense of immediacy drew heavily on the theories of Artaud, and the final images of The Living Theatre's production gestured toward the theatre he envisioned.

III. *Frankenstein* and Strategies of the Avant-Gardes

The Living Theatre's gesture took the form of a visual citation of a key phrase in Artaud's call for a new kind of theater, capable of delving beneath the "surface of fact," extending beyond a mere "dallying with forms," and conveying a visceral sense of immediacy comparable to that experienced by "victims burnt at the stake, signaling through the flames."[17] Crucial to this vision of an immediacy where one no longer dallied with forms was the embrace of a language for the theater that was not bound by the abstract representational quality of the spoken or written word. The closing scene of The Living Theatre's production certainly moved in this direction, at least in terms of the sheer intensity of the spectacle it presented and in the actual image of the creature signaling through the flames. But whatever intensity The Living Theatre achieved in their performance, the gesture toward Artaud's vision of theater and the realization of that vision were two entirely different matters. The Living Theatre's closing gesture was, in fact, less of a realization of Artaud's vision than it was an echo of the vision itself—an echo remarkable more for what it rejected than for what it realized. Rather than producing gestures of immediacy, The Living Theatre chose a path of negation that is argu-

ably typical of avant-garde gestures generally and of Artaud's vision specifically. The logic at work involved seeking immediacy through artistic rejection—a rejection of "dallying with forms," for example. Pivotal in this regard was a rejection of traditional categories of artistic production, particularly those associated with literary production (e.g., "textual authority" and "authorship").[18] Such rejections resonated playfully with Frankenstein's rejection of traditional categories of reproduction. Andy Warhol's production of *Frankenstein* was marked by similar rejections as well. Indeed, the refutation of textual authority and authorship in The Living Theatre's production of *Frankenstein* was echoed in the rejection of conventional artistic production and of the notion of the artist as producer in Warhol's *Frankenstein*. For both The Living Theatre and for Warhol, an objection to the artist's privileged status as author and/or producer was, at the most basic level, evident in the merely nominal relation that their adaptations had to Shelley's novel. But beyond that, the rejection of traditional categories of artistic production took a decisively self-reflective turn in both works. That turn was most evident in the way that both projects played the concept of individuality against collective enterprise.

Both adaptations were collective endeavors that, when placed in the public sphere, were attributed to specific individuals: Warhol and Julian Beck. Yet these attributions were of such openly questionable legitimacy that they carried with them an aura of ambiguity and parody. Writing about Warhol's dubious and limited involvement with *Andy Warhol's Frankenstein,* for example, Hawkins notes, "it's not clear what, if anything, [. . . Warhol] provided besides funding and inspiration." (This is true not only for *Frankenstein* but for any of the Morrissey films where Warhol is cited as producer.)[19] Still, Hawkins adds, the film was nonetheless Warhol's—at the very least, "in the sense that everything produced by members of the Factory was somehow Warhol's."[20] If, in calling his studio "the Factory," Warhol highlighted the extent to which commodity production and artistic endeavor were blurred in bourgeois conceptions of art and artists, The Living Theatre's constant flirtation with bankruptcy in their rather uncompromising resistance to commodification tended to highlight the same argument from the opposite end of the economic spectrum.

While Warhol's *Frankenstein* took shape in the Factory, The Living Theatre's *Frankenstein* took shape, as Julian Beck recalled, "in Velletri, Italy, where we had holed up in a big house some one gave us for a month while we were out of work."[21] In that house, the members of The Living

Theatre spent three weeks experimenting with ideas through a process that Beck characterized as an exhausting, "monster making orgy," which left everyone "feeling limp and helpless."[22] Amid the company's state of exhaustion, Beck took the opportunity to slip away, "hid[ing] for two days," during which he reportedly distilled the group's experiments into a semi-coherent form and wrote what is called the Velletri "Frankenstein Poem." That poem, which Lawrence Ferlinghetti published in *City Lights Journal* the following year, became a rough score for the piece that The Living Theatre premiered in Venice, in late September of 1965. Although the poem and its related material, entitled "Munich Scenario" and "Venice Synopsis," all appeared in *City Lights Journal* under Beck's name, Kenneth H. Brown[23] undercut this attribution in the very positive review of the Venice production that he wrote for the same issue of Ferlinghetti's journal and that served as an introduction to Beck's contribution. Indeed, Brown opened his piece with the assertion that *"Frankenstein* is a theatre experience developed by a commune of players from an unwritten script that was later ascribed merely as a formality."[24]

Around the same time that Brown's piece appeared, Saul Gottlieb[25] published a comparably favorable review of *Frankenstein* in a piece called "The Living Theatre in Exile" that he wrote for *TDR*. Whereas Brown asserted that there was no written script for the work, Gottlieb maintains that the piece "does have a script, which was written by the Becks [i.e., by Julian Beck *and* Judith Malina] after months of study, discussion and improvisation."[26] Yet even these comments are undercut by Gottlieb's introductory assertion that *Frankenstein* was "the result of the collective authorship of an entire company working deliberately with the concepts of Artaud."[27]

Just as the Frankenstein creature appeared as a singular subject comprised of disparate body parts, so too, the work that bore Warhol's name and the work that bore Beck's name were in actuality composite products of the contributions of many. Inasmuch as those contributions were never masked, the seams holding Warhol's aesthetic authority together as artist and producer, and the seams holding Beck's literary authority together as poet[28] and playwright, were not only visible, they were an immediate, calculated, and constant reminder of the work that was displaced and/or erased in the assertions of authority and agency that Warhol and Beck appeared to make. Indeed, that reminder was an integral part of the aesthetics governing the work of these two men. For Warhol, such moments constituted a calculated parody and subversion of

his role as artist and producer, and they link him, at least partially, to Dada predecessors like Duchamp. For Beck, such moments constituted a calculated subversion of his role as poet and playwright and they link him and The Living Theatre to the theories of Artaud.

Beyond a general critique of the artist's privileged status as author and producer, links to predecessors like Duchamp and Artaud serve as important reminders of the broad avant-grade traditions embraced by mid-twentieth century American experimental artists like Warhol, Beck, and the members of The Living Theatre. In many respects, those traditions converged in their adaptations of *Frankenstein,* and they did so in ways that offer telling insights into the assumptions that, beneath the "surface of fact" (to borrow Artaud's phrase), governed the avant-gardes' basic rethinking of artistic production as such. While the adaptations of *Frankenstein* by Warhol and The Living Theatre may be more remarkable for what they rejected than for what they realized, the two arguably worked from within a surprisingly common set of assumptions governing those rejections. Indeed, one need not look too far to see the link between Warhol's interest in Duchamp's use of found objects and The Living Theatre's interest in Artaud's embrace of a visceral immediacy. In the critique of artistic production, "the found" and "the immediate" come from the same conceptual terrain. Both enjoy a privileged status as presumably existing within the realm of the primary, the fundamental, and the non-representational. And I would like to suggest here that it was not a matter of coincidence that in the specific productions of *Frankenstein* by Warhol and The Living Theatre, this privileged status found safe harbor within the borders of popular culture.

For Warhol, those borders were common territory, and they gave shape to one of the most celebrated aspects of Warhol's aesthetics: what Arthur Danto, in his classic discussion of the 1962 "Brillo Boxes," characterizes as Warhol's "celebration of the commonplace"[29]—a celebration that coincided with a late twentieth century conceptual relocation of the notion of found objects. In contrast to the deliberately arcane and aesthetically bland quality of Duchamp's readymades, Warhol's "Brillo Boxes" and a whole host of other artifacts that he found and presented as art were, Danto argues, consciously "mainstream," and represented a "celebration rather than a criticism of contemporary life."[30] Moreover, Danto maintains that for Warhol (and Pop) it was essential that the artifacts and images he found for his works belonged to "the iconography of everyday life" and were "so familiar that 'stealing' them was impossible."[31]

This question of found objects and the impossibility of theft has particular relevance to *Frankenstein,* especially since the scientist constructs the creature from stolen body parts. I want to discuss the question of found objects and theft at length momentarily, both with regard to the plot of the narrative and with regard to the history of Shelley's work of fiction as a cultural artifact. But first, it is important to note that there is perhaps no better example of material literally belonging to what Danto calls "the iconography of everyday life" than the material that Warhol and also The Living Theatre drew upon in their adaptions of *Frankenstein.* In their critique of artistic production and of the artist's privileged status as author and producer, Warhol and The Living Theatre bridged Artaud's theories of performance with what is arguably the quintessential source of "the iconography of everyday life": a Hollywood cinematic tradition of adaptations that, in terms of disregard for textual authority, could rival even the finest anti-cultural/anti-textual gestures of the avant-gardes. For both productions, that cinematic tradition became a found object in its own right.

It was not just that The Living Theatre's work included specific instances where such bridging was identifiable—say, for example, in the closing images of their production, with the creature's signaling through the flames carrying a double citation. Not only did it allude to Artaud, as I mentioned before, but, importantly, it also alluded to the closing scene of Whale's Hollywood *Frankenstein* (1931), when the creature, played by Boris Karloff, waves frantically from a burning windmill amid the flames that ultimately consume him. But in terms of spectacle alone, the abundance of gore and the excessiveness of grossly and violently mutilated bodies that littered the Hollywood adaptations of the Frankenstein narrative suggested links to Artaud's theories. The 3-D format of *Andy Warhol's Frankenstein*—a format that at one level gestured toward completing the eclipse of theatre by the cinema—certainly took the excessiveness of the cinematic spectacles to new extremes. As Albert LaValley has noted, the abundance of gore in Warhol's film not only recalled "the excessive and often ludicrous ends of Jacobean tragedy but also some of the truth in excess that Artaud found in that dramatic form."[32] While the spectacle of excess in Warhol's 3-D format culminates in the illusion of guts and gore spilling out across the audience—as the tagline promised, the film "Brings the Horror Off the Screen . . . And Into Your Lap"—The Living Theatre more directly disrupted the audience's passive position, with actors climbing over the auditorium seats and repeatedly simulating the

violent pursuit, apprehension, and ultimate execution of individuals who, in a synoptic reign of terror, found themselves recast from the role of executioner into that of victim.[33]

Not coincidentally, The Living Theatre conceptualized this pouring out into the audience much in the same way that LaValley characterized Warhol's 3-D movie. Indeed, Beck associated the opening cycle of violence in The Living Theatre's production with Artaud's "Theatre of Cruelty" and conceptualized the spilling out into the audience as a kind of intense, visceral immediacy akin to the notion of found objects in the non-representational physicality that it presumably offered. The act of spilling out into the audience was, Beck argued, the first salvo of "a work in the tradition of Artaud's concept of a non-literary theatre which, through ritual, *horror and spectacle* might become an even more valid theatrical event than much of the wordy theatre of Ideas which has dominated our stages for so long."[34] The underlying assumption here was that in spilling out into the audience and transgressing the invisible but accepted boundaries separating performers and spectators, the members of The Living Theatre would move from the realms of dramatic presentation into moments of direct, unmediated confrontation. Such confrontations presumably would cut beneath what Artaud called the "surface of fact," and access something presumably more immediate than fact itself, the effect of which would radicalize members of the audience.

IV. Operative Assumptions of an Avant-Garde

Conceptually at least, the belief in a fundamental immediacy—like that which The Living Theatre embraced in their extension of Artuad's theories—has almost always had strong ties to a whole host of humanistic assumptions about essence, authenticity, and truth. Those same assumptions have enjoyed wide currency in the social mainstream beneath the protective guise of "common sense." Under this umbrella, they have accommodated not radical but rather commonplace prescriptive conceptions about gender, race, and class, among other things. The Living Theatre did not escape the trappings of these assumptions from the mainstream—in part because their production had taken a decisive turn toward the popular mainstream in its use of Hollywood versions of *Frankenstein* as a frame. They were certainly not alone in this regard. Warhol's "iconography of everyday life" circulated within the same econ-

omy. Indeed, as far as Warhol's aesthetics were concerned, one would be hard-pressed to separate his "celebration of the commonplace" from a tacit affirmation of popular but deeply problematic notions of "common sense." It was thus not just in the trajectory of their aesthetics that The Living Theatre and Warhol followed similar paths. In that trajectory, neither The Living Theatre nor Warhol could discard the problematic baggage that comes with positing "the un-mediated" as an ideal—regardless of whether that ideal takes the form of a presumed immediacy of action or of a presumed neutrality in discovered, commonplace artifacts from everyday life.

The irony of this inability is that in their productions of *Frankenstein* both The Living Theatre and Warhol presented narratives that suggested radically different conceptual possibilities from their own aesthetics. The found objects that are central to the tale of Frankenstein's creature—the body parts that give the creature substance and form—are artifacts of history rather than objects of immediacy. They are never neutral, never solely "found," and never immediate. In the narratives of both productions, immediacy as a concept is little more than an ideological veil obscuring both a history of repression and a repression of history. Even the rapid sequence of executions in The Living Theatre's adaptation of *Frankenstein*—the sequence Beck described as "a work in the tradition of Artaud"—played out a history of repression followed by a repression of that same history. The executions provided parts for the twenty-foot creature The Living Theatre constructed on their three-story scaffolding, thus representing countless dissidents who had been persecuted for their political nonconformity and criminalized for purposes of ideological expediency. At one level, then, their execution, dismemberment, and ultimate incorporation into the creature's frame were emblematic of a repressive incorporation of the disaffected into the body politic and of an assimilated, political uniformity achieved only under duress.

As an allegorical trope, this portrayal complicated the notions of immediacy that were a crucial component of The Living Theatre's aesthetics. The immediacy of the creature's body vied against the displaced historicity of the individual body parts that gave him form. The individual cubicles of The Living Theatre's scaffolding, where one execution after another had transpired, were in this respect a constant reminder that each of the seemingly discarded, found, or stolen objects of physical anatomy that made up the creature's structure had a unique, albeit erased, history all its own. Directly following the scene when the members of The Living

Theatre spilled out into the audience, the twenty-foot creature thus emerged not as a tool of non-representational immediacy but as a representation of a historical artifact, an artifact that was always already mediated. The actual physical immediacy of the individual members of The Living Theatre was challenged by the theoretical implications of the historicity of the creature's body. In fact, there are similar suggestions of this historicity in Warhol's *Frankenstein* as well, particularly at the end of the film when Nicholas, the stableboy, encounters the male creature who possesses the head of Nicholas's murdered friend Sasha. In the ensuing exchange between the two figures, it is Sasha, oddly enough, and not the newly formed creature, who addresses Nicholas—the last historical traces of his former identity speaking out against the animated physical structure of which he involuntarily has become a part, and which, in a quasi-suicidal moment, he decides to destroy by mustering up enough volution from his previous existence to literally rip his newly sutured body apart, spilling 3-D guts and gore into the audience one final time. If the earlier 3-D images of guts and gore spilling out onto the audience evoked what LaValley called Artaud's "truth in excess," here they evoke not a sense of immediacy or truth, but rather, a graphic return of repressed historicity in the creature's literal deconstruction.

In light of such moments, the creature's scars, which are the only parts of his body that he can claim as uniquely his own, become, in no uncertain terms, a disturbing and hideous record of erasure. They are the seams of a living history constructed by eliding the history of others. Yet the image of Warhol's creature ripping apart the seams of his newly constructed body is more than a fictional gesture of reasserting a historical order that Baron von Frankenstein's experiments have disturbed. Beyond the image of the creature deconstructing itself, this scene carries implications that challenge both Warhol's and The Living Theatre's casual appropriation of the Frankenstein narrative as if it were so commonplace—so much a part of the public domain—that "stealing . . . [it] was impossible." There are, in other words, important parallels to be drawn between the residual history obscured by the creature's construction and, for example, the residual history obscured by the productions of *Frankenstein* by Warhol and The Living Theatre—a history that is directly connected to Mary Shelley, her novel, and the gendered cultural politics of romanticism. If the creature is produced only at the expense of the history of others, it is worth asking at whose expense Warhol's and The Living Theatre's adaptations of *Frankenstein* were produced. Indeed, the

question is not just at whose expense their adaptations were possible. I would suggest the need to question even further, to also ask at whose expense their critiques of the artist as producer and/or author comes.

Ultimately, these basic questions about the productions of *Franken-stein* and about the critique of artistic production have as much to do with the avant-gardes in general as they do with Warhol or The Living Theatre in particular. While there is a compelling analogy to be drawn between the residues, on the one hand, of Sasha's identity literally deconstructing the creature of whom he has been made a part, and the residues, on the other hand, of Shelley's novel *Frankenstein* metaphorically ripping at the seams of these two adaptations, the issue in this analogy involves more than merely giving Shelley more of the credit that she is certainly due. Her status as a female author seeking venues for her work within the patriarchal cultural structures of romanticism is, to draw the analogy more precisely, like the voice of Sasha (the trace of repressed history), both in terms of the historical ties that critics have cited between the avant-gardes and romanticism and in terms of the key aesthetic categories of avant-garde expression that these ties reinforce. Indeed, Shelly's troubled relation to romanticism is a stark reminder that the historical ties connecting the avant-gardes to romanticism are only maintained by the history that they repress.

Contrary to what one might expect, it was not so much the use of Shelley's novel as it was the embrace of popular cultural forms like Hollywood films that situated the adaptations of *Frankenstein* by Warhol and The Living Theatre in the historical currents that scholars cite when linking the avant-gardes to romanticism. A few years before The Living Theatre mounted their production of *Frankenstein,* for example, Renato Poggioli, who was one of the most prominent historians to trace the lines of continuity "between romanticism and avantgardism,"[35] noted that the romantics not only encouraged "the cult of novelty and even of the strange" long "before it became typically avant-garde"[36] but that the avant-gardes also echoed the romantics in their interest in the general public and in the popular cultural mainstream. Indeed, for the romantics, and later for the avant-gardes as well, these two lines of continuity converged in what Poggioli identifies as a common strategy to subvert established notions of taste and cultivated artistic sensibilities.[37] But whether coming from the romantics or the avant-gardes, this interest in the commonplace, the public, and the popular lent tacit support to basic assumptions about gender that have long had wide circulation within the

cultural mainstream. If the embrace of *Frankenstein* and its spin-offs in popular culture by avant-gardists like Warhol and The Living Theatre highlighted a continuity between romanticism and avant-gardism, so too did that embrace expose a contiguous patriarchal undercurrent linking the romantics to the avant-gardes, one that historians like Poggioli and his successors have never really acknowledged.

It is worth remembering that as a movement romanticism was by and large a project that affirmed male cultural prerogatives. Scholars of early nineteenth-century culture have been arguing precisely this point for some time. In "Romantic Quest and Conquest," for example, Marlon Ross has argued that "romanticism is historically a masculine phenomenon," in which the romantic, "self-conscious search for poetic identity" blurred with a project of "masculine empowerment."[38] It is not difficult to understand how appeals to popular opinion figured into this project, for popular opinion has long supported such empowerment in the public sphere, clearing the way for male prerogatives by reinforcing notions of gender that relegate women to domestic spaces, away from the open economies to which men have had ready access. Not only did this division between the public and domestic spheres reinforce the privileged social advantages that men have historically presumed to be a natural birthright, but it also sustained a system that consistently absorbed the labor of women without remuneration.

The injustices of this kind of patriarchal system have profound implications for avant-garde aesthetics. This is especially true with regard to the avant-garde critique of artistic production and variations of that critique, such as Warhol's celebration of the commonplace and his use in that celebration of objects presumed to be "so familiar that 'stealing' them was impossible." The more one considers the economies of such a system, the more difficult it becomes to assume that wide dissemination and popular cultural familiarity preclude the possibility of theft. When it comes to objects and cultural artifacts produced by women, these conditions have historically signified theft and appropriation rather than the neutrality that Warhol's aesthetics assume. Indeed, with regard to its own history within the economies of print (and celluloid) culture, Shelley's *Frankenstein* underscores time and again how blurred the boundaries between the found and the appropriated are with respect to works produced by women.

When *Frankenstein* was first published, it didn't even have Shelley's name on it. Although, generally speaking, it is hard to steal what no one

claims, in this particular case anonymity was more a matter of necessity than choice. The anonymous publication of *Frankenstein* was one of the few avenues open to Shelley if she wanted her work to be taken seriously by her male peers. But in practical terms, that anonymous publication, which was a direct response to the cultural assumptions regulating gender during the Romantic period, nominally removed her from the material processes of production, and invited a kind of appropriation that could easily be passed off as merely embracing what appeared to be freely given to the public domain. Appropriations of *Frankenstein* in literature and in the theater followed quickly after publication of Shelley's novel. As Albert LaValley has noted, "in the 1820s, even before Mary Shelley's authorship was widely known, there were several [theatrical] productions playing simultaneously in London."[39] Not only do these appropriations trouble the lines of continuity between romanticism and avant-gardism, but the circumstances of the appropriations also raise troubling questions about the idea that one could challenge the role of the artist as producer by presenting ostensibly found objects, images, or ideas as newly produced works of art. However provocative it might be as an artistic gesture to sign one's name to something one did not produce, it clashes with a gendered history, of which Shelley is merely a prominent example. Against the backdrop of avant-gardists questioning artistic production by signing what they did not produce, there is the long, often unacknowledged history of women not being able to sign what they did produce. In this respect, the very notion of the artist as such, like the category of authorship, proves to be a highly gendered category. Amid this engendering of the artist, found objects are a lot like the body parts used to construct Frankenstein's creature. Frequently, they turn out to be stolen goods.

Inasmuch as artists like Warhol conceptualized their art in aesthetic categories that, on the one hand encourage a self-reflective critique of the artist as producer, and yet, on the other, elide serious consideration of how the very categories of artist, producer, and found objects are grounded in gendered exclusions, they fall in line with a tradition that has consistently positioned the avant-garde critique of the institutions of art within a subtle affirmation of patriarchal prerogatives. This same tradition governed the adaptation of Shelley's *Frankenstein*. But as an object of interest to the avant-gardes, *Frankenstein* proved to be as unruly as the creature whose story the novel tells. The historical contexts of the novel ultimately challenge many of the governing assumptions of the much-celebrated critique of the institution of art by avant-garde artists. Run-

ning directly counter to the break with the past that this critique purport-edly represents, the historical residues associated with the publication and reception of Shelley's novel highlighted a line of continuity between romanticism and avantgardism that ran not through their common aes-thetic goals and objectives, but beneath them, in the deep, erased history of aesthetic categories that cultural historians have overlooked and that have long been implicated in the repression of women.

If this effect challenged the underlying assumptions of the critique of the artist as producer, so too did it challenge The Living Theatre's fascina-tion with Artaud and his visionary interest in a non-literary theater. In-deed, the history of *Frankenstein* as a published text in the male-dominated literary economy of nineteenth-century England is a simple reminder of what Artuad's theories leave unaddressed in their rejection of literary cul-ture. For all its cries of "No More Masterpieces!," Artaud's non-literary theater still functions within a privileged economy of men, subtly affirm-ing the patriarchal traditions of literary culture. Not only does Artaud negate that culture *in toto* without problematizing the exclusions that were an integral part of its construction in the first place, but even the crucial metaphors of that negation are cast in gendered forms. This is, for example, especially true of Artaud's famous visionary theories of the plague, which he offers as an antidote to a moribund literary culture. Even here, Shelley's novel provides a profoundly important point of con-trast that highlights the gendered underpinnings of Artaud's vision. In the narrative of the novel, it is worth recalling, Victor Frankenstein's mother (Caroline Beaufort) "dies unnecessarily because she feels obli-gated to nurse her favorite Elizabeth during a smallpox epidemic." Far from being a metaphor for a visceral performative contrast to literary theater, the image of the plague/epidemic in *Frankenstein* emerges thus as a symbol of "a sexual division of labor," where "masculine work is kept outside of the domestic realm" and contagion results not from a pro-found performative immediacy but from a prescriptive, gendered prox-imity—in other words, from fulfilling "a patriarchal ideal of female self-sacrifice."[40] In what easily serves as a romantic metaphor for the gendered underpinnings of the avant-garde cult of the new, the male figure, e.g., Victor Frankenstein, ventures off into the uncharted topographies of hu-man exploration and experimentation, while the female is bound, indeed falls prey, to a plague-ridden domestic space. In Shelley's narrative, the plague is a domestic phenomenon that quarantines, restricts, and ulti-mately removes women from the public sphere.

In contrast to the idea of a non-literary theater and its related challenge to the notion of authorship as such, the specter of Shelley's *Frankenstein* looms as a disturbing reminder of how gendered the notion of authorship has been in Western society. For even amid innovative adaptations like those by Warhol or The Living Theatre, there is always the disruptive fact that the history of *Frankenstein* as a cultural narrative begins with the erasure of its author, not in an Artaudian gesture of anti-textuality, but in a self-effacing, pragmatic concession to publish the novel anonymously, so as not to jeopardize its success within a market that generally presumed that the literary arts—similar to the scientific laboratories of Victor Frankenstein—belonged to the domain of men.[41] Placing productions like those of Warhol and The Living Theatre in their own historical contexts, one might ask, furthermore, how it is that even after the early history of the novel became well known, subsequent avant-garde adaptations of *Frankenstein* offered little critical self-reflection on the implications that Shelley's anonymity might have for the avant-gardes' own notions of artistic production.

Perhaps the answer to this question might illuminate the more enduring and arguably least-discussed link between romanticism and the avant-gardes. Beyond the blurred boundaries between the found and the appropriated, beyond the privileged gendered conceptions of authorship itself, the critical perspective articulated in Shelley's novel highlights what is perhaps the most significant oversight among the many parallels that Poggioli and other critics have drawn between romanticism and avant-gardism, an oversight that centers on the problematic concept of genius. Not only did that concept play a central ideological role in the male-centered aesthetics of romanticism, but it is arguably also the central functioning aesthetic category in the avant-gardes' use of found objects and in their related critique of the artist as producer. Indeed, the very foundation of this latter critique is grounded in the assumption that what makes an artist is not technical skill but rather the gifts of artistic sensibility and insight.[42] Even if, with regard to the avant-gardes, such abilities might be better characterized as a good sense for provocation, the point remains: critics have either left the source of such sensibilities unaddressed or have tended to represent them as an implied product of birth rather than of socialization. It is hard to dispute that historically such notions of innate artistic sensibility and superior insight have fed into a larger concept of genius. It is worth noting in this regard that within the period of romanticism such notions, implicitly tied as they were to pro-

phetic foresight, prefigured the forward-looking tendencies of the avant-gardes. Donald Egbert has noted, for example, that "many romantics had long regarded the artist as the original genius and prophet-hero *par excellence.*"[43] Nonetheless, this notion of the artist "as genius and prophet hero" largely remained a gendered category in romanticism and for the avant-gardes.

Against the backdrop of the romantic cultural category of genius, Shelley herself sketched an image in her novel not of genius but of delusory grandeur: a thinly veiled metaphor of the male romantic artist in the guise of a scientist whose visionary obsession, far from affirming genius, culminates in the creation of havoc, destruction, and violence—all of which are primarily directed against women. In its critical portrayal of the male romantic project, Shelley's novel thus articulates what in some respects might be considered the most enduring, if not the definitive, critique of the notion of the artist as genius—a critique that in the larger context of nominal adaptations of Shelly's narrative by figures like Warhol becomes all the more striking because of the critical bridge it builds between romanticism and the avant-gardes. It is, in fact, a bridge that forges an alternate route for our understanding of the avant-gardes.

Shelley's novel not only sets the avant-gardes' questioning of the role of the artist as producer into critical relief. In doing this, her work encourages scholars and historians to consider how, for all of their radical questioning of the artist as producer, the avant-gardes continued to embrace a notion of genius that had its grounding in eighteenth-century aesthetics. The history of Shelley's text would suggest that this tendency has direct historical connections with the unequal social construction of gender. And it suggests the need not only to question the role of the artist as producer, but to do so in a manner that simultaneously exposes the bourgeois, patriarchal notions of genius lurking in the shadows of the avant-gardes.

Brechtian Aesthetics and the Death of the Director in Peter Brook's *The Mahabharata*

I. Prelude to Culture Wars

In an effort to capture some sense of the significance that the radical shifts in literary and cultural theory during the 1980s had for studies of avant-garde performance, one could do a lot worse than to frame the decade with the publication of Richard Schechner's *The End of Humanism* in 1982 and the subsequent publication of Schechner's *The Future of Ritual* in 1993. Indeed, the writing of these two books roughly coincided with the beginning and end of a decade that played out against the backdrop of the increasing influence of poststructuralism and that produced a sustained critique of Western cultural assumptions. Both books have a profound significance for how scholars conceptualize the avant-gardes. If the first book proclaimed the end of humanism, as Rebecca Schneider notes, before poststructuralism would make such claims *"de rigeur,"*[1] *The Future of Ritual* is clearly committed to the models of performance studies that were shaped by the poststructuralist critique of Western humanism, by the related emergence of postcolonial studies, and by the often fierce debates about interculturalism that coincided with that emergence. With regard to the avant-gardes specifically, these two books also mark a significant shift from Schechner's claim at the beginning of the decade that "the avant-garde," having run its course, was now in "decline," to his later assertion that avantgardism had devolved into one theatrical "style" among many. As I will be arguing in the sixth chapter of this book, it is more accurate to state that particular models for understanding the avant-gardes were in decline by the end of the '80s. But more about that later. By the end of the decade, Schechner was certainly looking for new models. In *The Future of Ritual* he began testing them, tentatively asserting the idea of "five avant-gardes" and then suggesting that perhaps there

were none.[2] Most importantly, he rejected the idea of talking about "the avant-garde" in general, and famously suggested instead that it would be better to speak of "the historical," "the current," "the forward-looking," "the tradition-seeking," and "the intercultural" avant-gardes.

While one cannot help but applaud the pluralization of "avant-garde," Schechner's list of different avant-gardes are, for the most part, merely different possible trajectories within a conception of avantgardism still unified by his implied collective dismissal of the avant-garde as merely one style among many theatrical styles. In fact, Schechner does little more than differentiate avant-gardes according to temporal qualities. Whether an avant-garde is "historical," "current," "forward-looking," or "tradition-seeking" is, I would suggest, more a question of nuance than it is a marker of the kind of categorical differences among avant-gardes that one might make in distinguishing, for example, the historical configurations of the military, the political, and the cultural avant-gardes—all of which have historical, current, forward-looking, and tradition-seeking factions within their ranks. The one anomaly in Schechner's list is, of course, "the intercultural avant-garde," and this avant-garde occupies a unique status in that Schechner gives it a definition that transcends style. "Intercultural performances occur across an enormous range of venues, styles, and purposes," he observes. Following this observation, he then offers an intriguing, albeit somewhat idiosyncratic, explanation of what aligns intercultural performance with the avant-gardes: "What is avant-garde," he argues, "is when the performance does not try to heal over rifts or fractures but further opens these for exploration."[3]

To some extent, this explanation, which moves the notion of intercultural performance into realms of the avant-gardes, is a subtle but important coda to the rebuttal Schechner wrote to an extremely unflattering critique of his work that Rustom Bharucha published in 1984, the same year, coincidentally, that the English translation of Peter Bürger's *Theory of the Avant-Garde* appeared. In that critique, Bharucha took Schechner to task for advocating "cultural tourism" and for what he perceived to be Schechner's callous appropriation of rituals from "other" cultures "simply to be used in an arbitrary way."[4] In his rebuttal, Schechner understandably rejected this accusation of arbitrariness as a gross oversimplification of his work (particularly as a practitioner), but that was not really the point. While Bharucha framed his criticism as a concern with what he called "*the ethics of representation,*" the potential broader dynamics of this

concern fell prey to what was arguably Bharucha's more pressing agenda in singling out Schechner in the first place: Bharucha's assertion of a narrowly prescriptive view of ritual practice that cast the cultural exchanges between East and West as a struggle for the preservation of the sacred against the onslaught of the profane. It is hard to miss this subtext in Bharucha's argument. Invoking a sense of religious privilege that was blurred with anti-colonialist discourse, Bharucha demanded that Schechner and others defer to his belief that rituals "are inextricably linked" to their "spiritual contexts"[5]—a belief that Bharucha reiterated in his later reply to Schechner's published rebuttal. There Bharucha complained again that "Schechner does not address the question of faith when he defends the transportation of rituals from one culture to another."[6]

For his part, Schechner responded not by yielding to Bharucha's call for deference to the narrowly defined prerogatives of the faithful, but by reminding Bharucha that "cultural influence," particularly in the late twentieth century, "is not a one-way street,"[7] and by arguing, so to speak, that the Indian traffic on that street hardly resembled a caravan lining up uniformly behind Bharucha's view of Indian ritual and theatrical practice. Indeed, Schechner cited a long list of Indian theater practitioners who, he argued, "probably have nothing in common except their passion for understanding and using in their own ways the rich, detailed, and multiple traditions of Indian performance."[8] Accusing Bharucha of being "profoundly patronizing," Schechner noted again "this is not a one-way street," and reminded Bharucha that "there is a flourishing 'modern theatre' (Euro-American influenced) in India."[9] Schechner returned to the image of the street once again at the end of his rebuttal: "And, as I have emphasized, it is a two-way street. To think only of 'Western interpretations' is to distort the process of history. The exchanges go far beyond India-America: they are worldwide, multicultural, and multivocal."[10] Three times in his short rebuttal, Schechner turned metaphorically to the street, and at an important level, these references to the street pointed Bharucha back to the original essay with which he had taken exception, Schechner's "From Ritual to Theatre and Back." In that essay Schechner's theorizing is positioned at the crossroads of what he would later call the intercultural avant-garde—an avant-garde that experiments with cultural exchange rather than regulating mystified conceptions of cultural integrity. Schechner argues not only that "tourism is a two-way street," but that, as a consequence, "it was logical" that the traffic of cross-cultural

exchange "should be felt first in the avant-garde."[11] The question, of course, is what kind of avant-garde? A possible answer to this question can be found by returning to the streets.

Given that Schechner's rebuttal addressed, among other things, Bharucha's pointed criticism of The Performance Group's production of *Mother Courage,* it is hard not to see in Schechner's repeated references to the street not only an allusion to his own earlier writings but also a more subtle allusion to Brecht's classic essay "The Street Scene." In that essay, Brecht famously argued that the key principles of epic theatre could be found among the strategies of provisional demonstration used by someone recounting events he or she had witnessed on the street: "one essential element of the street scene," Brecht argues, "lies in the natural attitude adopted by the demonstrator, which is two-fold; he is always taking two situations into account. He behaves naturally as a demonstrator, and he lets the subject of the demonstration behave naturally too. He never forgets nor does he allow it to be forgotten, that he is not the subject but the demonstrator."[12] If the allusion to the avant-garde traditions associated with Brecht's notion of the street scene was too subtle to be registered in Schechner's own repeated references to the street, those traditions were identifiable in the striking similarity between the passage cited above and the arguments that Schechner cited at the end of his rebuttal to Bharucha. There Schechner reiterated what he, in a "keynote address at the 1983 Calcutta conference" on "Indian Dance Tradition and Modern Theatre," had already argued. Amid the unavoidable exchanges between cultures and traditions in the modern world, the fear of "cultural imperialism" was indeed legitimate, he argued, but there were important alternatives to exploitation. Speaking as a Westerner, Schechner espoused a notion of interculturalism that bore a strong affinity to Brechtian aesthetics. "In learning about the Other we also deepen our grasp of who we ourselves are: the Other is another and a mirror at the same time. We learn about our own aesthetics when we study the dance of another place and/or time."[13] Just as Brecht had argued that the demonstrator in the street scene "is always taking two situations into account," so too did Schechner argue that intercultural performance practitioners are always positioned in a doubled situation, mirroring their own aesthetics when working with material from others.

Against the backdrop of the heated and at times deeply personalized debate between Bharucha and Schechner, it is easy to lose sight of how closely tied this Brechtian notion of intercultural performance is to

Schechner's later definition of the intercultural avant-garde in *The Future of Ritual*. When at the conclusion of his rebuttal to Bharucha, Schechner initially reiterated his claim that "the Other is another and a mirror at the same time," Bharucha then suggested the claim was idealistic, pointing out that "the implications of interculturalism are very different for people in impoverished, 'developing' countries like India, and for people in technologically advanced, capitalist societies like America,"[14] Although the exchanges between Schechner and Bharucha did not go through another round, Schechner was arguably attentive to the concerns that Bharucha expressed about interculturalism. His subsequent assertion in *The Future of Ritual* that intercultural performance becomes avant-garde when it "does not try to heal over rifts or fractures but further opens these for exploration" is, in this respect, an important amendment to his Brechtian-influenced notion that "the Other is another and a mirror at the same time." Indeed, a mirror does not hide but rather shows the rifts and fractures in all their detail. In doing so, it invites further exploration in a typically Brechtian fashion—the kind of exploration that engages history and *the ethics of representation* in profoundly dynamic and critically self-reflective ways. It is this kind of exploration, to follow Schechner, that is central to the notion of an intercultural avant-garde.

As dynamic as this notion of the intercultural avant-garde may be, it is worth pausing to consider one of the major problems that it leaves intact. In simplest terms that problem centers on issues of presumed authority and intentionality: the presumed authority and intentionality of avant-garde performance. While struggles for cultural authority over particular texts and rituals, or struggles over the appropriation of them from one culture by another, are certainly a part of the larger context of this problem and of how I want to discuss it in the remainder of this chapter, I also want to suggest a more pointed consideration in that discussion—one that distinguishes the notion of an avant-garde from avant-garde performances as such: a consideration, in short, that distinguishes a practitioner's intent from the assessment of a performance itself. The issue here is thus not so much the assertion of an assumed cultural authority over particular texts or particular rituals in a way that would question the political or ethical legitimacy of an experimental adaptation of them—the kind of assertion, for example, that is at the core of Bharucha's critique of Schechner's work. The issue is rather the relation of individual avant-garde artists to individual works of avant-garde performance: the relation, for example, of Schechner as a director to a work like *Dionysus*

in 69. The issue that I want to address concerns what I would suggest is a peculiar double standard in the theories of avant-garde performance.

That double standard has everything to do with how readily critics accept the legitimacy of an avant-garde's questioning of textual authority and authorial intent and thereby grant a broad experimental license to avant-garde practitioners. In the previous chapter on *Frankenstein,* I examined how gendered the dynamics of that acceptance tend to be. Here I want to push in a different direction and question how, despite granting broad interpretive license to avant-garde artists, critics tend to tacitly accept something akin to authorial intent when considering the relation of an avant-garde artist/practitioner to the performance pieces that he or she produces. But if critics accept a fundamental distinction between an author and a text, to what extent, it behooves us then to ask, should critics and historians assume a fundamental correspondence between what a practitioner does and what a work does? Since this question arises, in part, out of a consideration of the exchanges between Bharucha and Schechner, it can be refined even further to focus specifically on the extent to which critics and historians should assume a correspondence between what an experimental director does and what his or her work does. Although this bit of fine-tuning could certainly lead to a further consideration of Schechner's work as an international director, there are perhaps more important opportunities for the kind of consideration that I am suggesting. Peter Brook's production of *The Mahabharata* especially comes to mind. Indeed, there is a strong case to be made that the exchanges between Bharucha and Schechner in the mid 1980s were merely a rehearsal for the larger battle that would be waged at the end of the decade around Brook's controversial production—a battle fully immersed in the double standards that I want to challenge in this chapter.

II. (Re)Citing Battle Lines

Certain to be counted among the many flashpoints in the cultural wars of the late 1980s, Peter Brook's *The Mahabharata* occupies a unique and ultimately illuminating position in the history of avant-garde theater and performance criticism. Stained by the lingering residues of its producer's gross and well-documented cultural insensitivities, Brook's *The Mahabharata* became a kind of pariah shortly after its premier.[15] That stain marks the history of the piece's reception and has resulted either in a

consistent blurring of the production with its producer or in an implicit call to boycott its performance as a way to hold Brook accountable for his indefensible behavior while he was in India, researching the production. In either case, scholars have been unable or unwilling to move beyond considerations that are based on an equation of Brook's production with Peter Brook the person. While from a political standpoint such equations initially may be understandable, from a theoretical perspective they not only have been problematic from the very start, but they also have inadvertently elided profoundly significant political ramifications in Brook's *The Mahabharata,* ramifications that only become visible if critics make a clear break between Brook and his production. Though I have suggested the need for such a break in the opening section of this chapter, ultimately the justifications for the break are to be found in the arguments of critical theory and poststructuralism. Deconstructive in their larger implications, those arguments are by no means an apology for Brook's personal politics or a reaffirmation of the expressed intentions of his adaptation. Nor are they an attempt to separate aesthetics and politics or, more specifically, an attempt to build an opposition between critical theory and cultural politics. On the contrary, a consideration of Brook's *The Mahabharata* within the context of critical theory and poststructuralism illuminates political undercurrents in Brook's adaptation that not only run directly counter to his own intent as a producer, but also run directly counter to the political and philosophical underpinnings of his critics.

To claim that Brook's production has political implications running counter to his expressed intent may initially seem to reaffirm the views of those critics who argue that Brook's liberal humanistic agenda ultimately results in regressive and hegemonic cultural politics. While at one level, the following arguments do in fact reaffirm such criticisms of Peter Brook the person, at a more fundamental level they are concerned with the manner in which the dynamics of Brook's *The Mahabharata*—irrespective of, indeed contrary to, the problematic humanistic underpinnings of Brook's stated objectives—pivot upon an identifiable Brechtian political aesthetic. As I will show, the political dimensions of that aesthetic are manifested in the piece's self-reflexive scrutiny of the processes of representation, in its profound questioning of notions of textual and cultural authority, and in its implicit, radical critique of identity politics. At the same time, the presence of this Brechtian aesthetic in *The Mahabharata,* inasmuch as it runs counter to Brook's directorial intent, raises fundamental questions about the intersection between Brechtian technique

and poststructuralism. Indeed, my basic underlying assertion is that Brook's *The Mahabharata* ultimately illustrates how little critics have recognized that the intersection of Brechtian aesthetics with poststructuralism severs Brechtian technique and its concomitant political effects from a necessary dependence upon the conscious political intents of a playwright or director. Within a theory of avant-garde performance, this severance suggests the need, more generally, to challenge the moments in criticism where the lines that would otherwise distinguish an artist and his or her work begin to blur.

Although not likely the product of conscious design, the overlooked political dimensions of Brook's *The Mahabharata* are closely tied to the work of those who, at a time when other critics were taking Brook to task, were seeking to unite the arguments of poststructuralism and deconstruction with the legacies of Brechtian theatre.[16] Such efforts were not the only trends to develop as critical theory began to alter the course of theater studies in the mid and late 1980s, and that is part of the reason why scholars have not brought the combination of critical theory and Brechtian aesthetics to bear on analyses of Brook's piece. Such an explanation is at least implied by Una Chaudhuri's "Working Out (of) Place" which plots the increasingly hostile response to Brook's *The Mahabharata* along an arc parallel to the growing influence of Edward Said's pivotal study *Orientalism*. Chaudhuri presents a convincing case that Brook's piece fell prey to the changing political landscape "when intercultural performance shifted its grounds in Western liberal humanism and began to be recontextualied within the burgeoning critical discourse [. . .] of postcolonialism."[17]

In addition to this historical context, Chaudhuri takes two important steps beyond the impasse that has dominated the critical discussion of Brook's piece. First, she explicitly calls for an assessment of Brook's *The Mahabharata* that does not pivot on a "personal denigration" of Brook himself.[18] Second, in discussing the problems that Brook's international cast had with the English language, Chaudhuri suggests, in passing, a Brechtian quality to Brook's production that she unfortunately does not fully explore. Rather, she characterizes the actors' strained use of English as "a kind of Brechtian effect in a non-Brechtian context."[19] One can only speculate as to why Chaudhuri does not pursue this idea further, but even this passing reference to the Brechtian effect of Brook's production opens an important avenue for a reevaluation of *The Mahabharata*. Ultimately, that critical avenue not only leads well beyond a "personal denigration"

of Brook the person, but it also takes critical discussion beyond a fixation on directorial intent and lays open a Brechtian undercurrent of Brook's adaptation.

If the poststructuralist reassessment of Brechtian theatre has taught us anything, it is a reaffirmation of the basic principle that Brechtian contexts do not generate Brechtian effects so much as Brechtian effects create Brechtian contexts. The crucial question looming at the end of Chaudhuri's article is whether the effect she so aptly identifies is merely a byproduct of a unique but interesting coincidence or rather an example of a larger pattern of theatrical effects which, when combined, cast a decisively Brechtian hue across Brook's controversial adaptation of India's national epic. The stakes in this question go well beyond a simple quantitative enumeration of theatrical effects that one may (or may not) characterize as Brechtian. It is not the tally of effects that counts but the context that those effects create, regardless of whether that context coincides with directorial intent.

My goal here is not so much to attribute a Brechtian intent to Brook as a director as it is to identify the Brechtian elements in his production and to consider the myriad ways that those elements not only subvert Brook's expressed intent as a director, but subvert the underlying assumptions of his critics as well. The Brechtian context created by these techniques—specifically by the techniques of estrangement and interruption—radically inverts what critics have presumed to be the piece's implicit regressive politics, and it does so primarily because the regressive politics associated with Brook's production have more to do with Brook's expressed intent than with the dynamics of the production itself. Indeed, the Brechtian dimensions of Brook's adaptation transform what has been perceived to be an instance of cultural appropriation into a process that insistently reveals, rather than reproduces, the conditions of appropriation, a process that repeatedly "remind[s] us that representations are not given but produced,"[20] and that offers a politically significant "critique of representation as such."[21]

The problem is that such Brechtian reminders tend to run counter to the most prominent statements Brook has made regarding *The Mahabharata,* statements that, in their consistency with the "evolving spiritual quest at the center of . . . [Brook's] research and performance" in the 1980s, tend to suggest a humanistic agenda or intent seldom associated with Brechtian fare and also at the center of poststructuralism's most radical critiques.[22] It is difficult to square a Brechtian critique of representation as

such with Brook's comment that in *The Mahabharata* he intended to "suggest the flavor of India," while celebrating a work that "carries echoes for all mankind"[23] (a comment, it is worth noting in passing, similar to Schechner's statement to Bharucha that when looking at a wide variety of cultural performances, "the flavor of each is what interests me"[24]). Such sentiments have justifiably incurred the ire of critics because at the very least they accommodate, if not directly support, the kind of rationalized humanistic gloss that historically has provided cover for the most crass instances of cultural hegemony.[25] Inasmuch as such statements express Brook's intentions, they well merit the bitter criticism they have received.

Nonetheless, to the extent that Brook's piece has served (on a small scale) as a point against which to articulate a critical postcolonial discourse, that point of departure is based upon the assumption of a one-to-one relation between Brook's expressed liberal humanistic philosophies and the aesthetic principles governing his production of *The Mahabharata*. The assumption is that those humanistic philosophies shape an intent that in turn is identifiably manifested in Brook's production.[26] Yet it is precisely with regard to Brook's statements of intent—indeed with regard to intentionality in general—that the coordination of critical theory and Brechtian aesthetics is particularly important. Critical theory not only provides a line of inquiry that moves beyond the *ad hominem* attacks on Peter Brook's personal politics (however justifiable those attacks may be), but, more importantly, it also highlights the need to separate the discussion of intent from actual effect. This is as true of Peter Brook's expressed intent as it is of the intent that critics like Gautam Dasgupta presume to be an inherent part of India's national epic when they criticize Brook's adaptation with arguments like "One should not, under cover of universality of theme or character, undercut the intrinsic core of how *The Mahabharata* characters function within the world of which they are a part."[27] From the perspective of poststructuralism, it is as problematic to speak casually of "echoes for all mankind" as it is to speak of the "intrinsic core" of any text. With regard to the Brechtian context of Brook's *The Mahabharata*, then, the issue is not so much about what Brook intends or the presumed intent of the original *Mahabharata*. Rather, the issue is what theatrical techniques and effects Brook's production actually employs and what context those techniques and effects create.

Chaudhuri has already mentioned one of those techniques, namely the Brechtian quality of the strained use of English in productions outside of France.[28] This use of English was the direct result of Brook's deci-

sion to use an international cast with diverse cultural and racial backgrounds. That decision generated an even more obvious example of Brechtian aesthetics than the one mentioned by Chaudhuri. The international cast led to numerous instances of cross-casting; Brook even described his doubling of Maurice Benichou in the roles of Ganesha and Krishna as a deliberate "distancing effect."[29] In the late 1980s, Brook was certainly not alone in using these techniques. Interestingly enough, when Caryl Churchill employed them in *Cloud Nine* around the same time, critics praised her use of doubling and cross-casting as "graphic example[s] of the Brechtian spectatorial triangle" that presents "the character-as-socially-constructed to the spectator in a very literal way."[30] Although these techniques have never really been acknowledged in any significant way in the reception of Brook's *The Mahabharata*, one would be hardpressed to argue that Brook's use of cross-linguistic and cross-racial casting does not function in a manner similar to Churchill's use of it, regardless of intent. Indeed, the cross-linguistic, cross-racial, and cross-cultural castings of Brook's production all comply with what Walter Benjamin has famously called "the first commandment of epic theatre": that "'the one who shows'—that is, the actor—'shall be shown'"[31]—a commandment that has clear affinities with Brecht's notion of the street scene.

Without specifically naming it, Brook's actors were well aware of the underlying role that this so-called Brechtian commandment played in Brook's production. Vittorio Mezzogiorno, the Italian actor who played Arjuna, specifically noted that Brook was concerned with the monumental cultural differences separating his actors from their Indian characters and that Brook did not want them to adopt a Stanislavskian approach through which they would "fully inhabit [. . .] an imaginary character."[32] As Mezzogiorno notes in an interview with Martine Millon, Brook did not want to impose on an actor "a culture to which he doesn't belong." On the contrary, the goal was for the actor to incorporate "the Indian world solely by impressions from the perspective of his own culture, his own temperament, his own sensations."[33] For many the reliance on such unreliable impressions was indicative of the production's failure as a whole.[34] But combined with the linguistic idiosyncracies and instances of cross-casting, the production's reliance on impressions of India garnered from the perspectives of actors coming from various cultural backgrounds not only multiplied the "disparate elements"[35] in the performance, but also tended to underscore a classic mechanism of Brechtian theater, what Brecht called the "not . . . but." This mechanism, as Brecht explained,

required actors to perform in such a manner that what they were actually doing would "at all essential points discover, specify, imply what [they were] not doing."[36] In Brook's *The Mahabharata,* this use of the "not . . . but" repeatedly and at multiple levels underscores for the audience the Western social construction of images of Indian culture, people, and literature. Within the Brechtian context of the production, Brook's infamous reference to "a flavor of India" thus ironically inclined toward an acknowledgment that an accurate representation of India or of *The Mahabharata* was not so much to be expected of the production, as was a critical aesthetic scrutiny of the processes of representation themselves. To echo Schechner's comments once again: "the Other is another and a mirror at the same time." As if in anticipation of Rustom Bharucha's criticism that "one cannot separate the culture from the text"[37] (i.e., cannot separate India from *The Mahabharata*), the subtle presence of the Brechtian "not . . . but" in Brook's adaptation implies that culture is not so much located in texts as it is in readers; it implies that one cannot separate one's own culture from the reading of a text.[38]

On a larger scale, such Brechtian undercurrents have had the critical function of a sword with two edges, not only cutting against the grain of Brook's liberal humanistic philosophies, but also against the grain of the assertions of critics like Dasgupta, who argues, for example, that "there is no dramatic or epic kernel to *The Mahabharata* outside of its theological value system" and that *The Mahabharata* "is nothing, [and is] an empty shell" if it does not address the "deeply-ingrained structure of ritual beliefs and ethical codes of conduct intrinsic to its [Indian] audience."[39] Obviously, these criticisms intend to underscore the cultural blindness of Brook's humanistic worldview, despite Brook's assertion that a close regard for the Indian traditions of *The Mahabharata* "was never a goal."[40] Inasmuch as Dasgupta's concerns are positioned as a critique of that humanistic worldview, they coincide with "key operations of deconstruction and post-structuralism" that inform postcolonial theory, and that, as Janelle Reinelt has noted, Brecht incidentally anticipated.[41] Yet while Dasgupta's critique of Brook may find common ground with a poststructuralist (and Brechtain) critique of humanistic philosophies, a fundamental divide finally separates the two. In his critique of Brook, Dasgupta criticizes one set of absolutes by imposing the authority of another, in this particular instance by imposing a religious authority that echoes Bharucha's references to the "cosmic context" of *The Mahabharata* and to the "ritual status" of its characters.[42]

Since these appeals to religious authority situate the arguments of Dasgupta and Bharucha within a closed metaphysical system, deference may be the best and only response to their concerns. These concerns are ultimately couched in a matter of faith, and so finally exclude themselves from debate. (This was the very problem with Bharucha's critique of Schechner.) Nevertheless, Dasgupta and Bharucha, in weighing Brook's production against its loyalty to the theological and ritual structures of *The Mahabharata,* have measured the work against a standard that is incommensurable with the theater that Brook's production of *The Mahabharata* exemplifies, especially with regard to its Brechtian underpinnings. Nowhere is the nature of this theater more evident than in Brecht's own comments on the relation of theater to ritual practice. To understand the former, Brecht argues, it is absolutely necessary to distinguish it from the latter:

Theatre may be said to be derived from ritual, but that is only to say that it becomes theatre once the two have separated; what it brought over from the mysteries was not its former ritual function, but purely and simply the pleasure which accompanied this.[43]

Brecht's distinction between the mysteries associated with ritual and the pleasures associated with theater has profound implications for our understanding of Brook's production of *The Mahabharata.* Not only do Brecht's comments anticipate poststructualism's rejection of logocentrism in favor of what Derrida has called a "non-theological space," but they also herald the emergence of that theatrical space as a locus of *jouissance* and pleasure.[44] The pleasure of the theater to which Brecht refers ultimately embraces a notion of "performance whose only authority is in the performance itself,"[45] rather than a notion of performance whose authority resides in "sacred texts."[46] As a precursor to subsequent poststructuralist theories, Brecht's notion of pleasure also locates meaning in slippage and in the play of theatrical signifiers rather than in a logocentric reading of *The Mahabharata* that would be legitimized by a strict adherence to the authority of an absent and presumably authentic ritual practice, however diverse or pluralistic that practice may be.

Inasmuch as Brechtian pleasure is located in the realms of performance, it has a dual relevance for Brook's adaptation of *The Mahabharata.* First there is the issue of *The Mahabharata*'s rich ritual traditions. With or without their underlying metaphysical presuppositions, those traditions

contribute importantly to "an image of a social order"[47] within which an Indian cultural identity may repeatedly be imagined and re-imagined, while nonetheless remaining secure and while retaining a specific social framework that provides it with a guarded meaning and significance. But even at the level of social and cultural identity, Brecht's distinction between the mysteries of ritual and the pleasures of the theater tends to delineate between the ritual traditions of *The Mahabharata* and Brook's adaptation of *The Mahabharata* for the theater. If, as Bruce McConachie argues, the function of ritual, once its metaphysical underpinnings are bracketed, is to legitimize and secure a meaningful cultural identity, then the Brechtian distinction between ritual and theater suggests that a very different agenda is at play in Brook's adaptation. That this agenda is positioned—in a quintessentially Brechtian fashion—as at odds with the notions of identification and identity will become clear momentarily. But as a point of transition, it is worth noting that Brecht's distinction between the mysteries of ritual and the pleasures of theater lays the foundation for a conception of interculturalism that is not grounded in the humanistic philosophical absolutes that shadow Brook's own commentary on his adaptation of *The Mahabharata*.

Some sense of that conception is evident in W. B. Worthen's subtle challenge to the specter of (in)authenticity that haunted the enactment of Ndembu rituals in Victor Turner's anthropology classes. Questioning Turner's own depiction of those classroom enactments as "highly artificial" and "inauthentic," Worthen suggests that Turner's performances be viewed not as reenactments or representations but as intercultural performances with a dynamic all their own. Challenging Turner's reading of his re-enactments of ritual practices in his own classroom, Worthen argues:

> At the moment that this performance becomes truly intercultural and intertextual—when, we might say, the rituals of NYU and the Ndembu finally deconstruct one another, subvert notions of authorized performance altogether—it loses its value for Turner, precisely because that "authentic" other disappears from view, is replaced by a performance whose only authority is the performance itself.[48]

Just as Brecht locates the advent of theatre in a departure from the logocentric mysteries of ritual, Worthen locates intercultural performance in a departure from the belief in an absent, legitimizing authenticity. For Worthen, intercultural performance is thus not a site "of interpretation"

or "of echoing meanings which already exist elsewhere" but rather, in an obvious echo of Brechtian theory, a site "where the ways in which meaning is produced can be interrogated, inspected, performed."[49]

There is also the issue of the infidelity of Brook's production to the presumed authority of *The Mahabharata* as a text whose status critics have not only depicted as sacred but also as a crucial element in Indian cultural identity.[50] Here, the Brechtain notion of pleasure coincides with a subtle but important distinction between representation and the Brechtian technique of *quotation:* that is, between an adaptation measured against a repressive lack of accuracy that its representations cultivate, and an adaptation measured against the thought-provoking interruptions its *quotations* achieve. While the former measurement serves as a reassertion of a repressed cultural identity and as a focal point for a legitimate, although problematic, struggle for control of the discursive foundations of identity politics, the latter (a Brechtian strategy) aims at obstructing identification in order to achieve a calculated moment of critical and political reflection. If viewed exclusively as an attempted representation, Brook's adaptation is clearly open to charges—like those articulated by Dasgupta—that it exemplifies a contemporary specter of "Orientalism" and thus follows the precedent that was set by scholarship in the eighteenth and nineteenth centuries and that granted the West the prerogative of representing the East according to the West's own ideological presumptions. From this perspective, Brook's adaptation of *The Mahabharata* is but another example of the Orient not being "allowed to represent itself."[51] Yet viewed as an instance of Brechtian *quotation,* Brook's adaptation takes on a much more complicated and complicating dynamic. For "Orientalism" pivots on the assumption that when the West represents the East, the former represses the latter by attempting to pass the representation off as authentic and accurate. Yet the Brechtian *quote* does nothing of the sort. Inasmuch as Brook's adaptation quotes *The Mahabharata,* it constantly calls attention to the mechanisms of its representations, repeatedly interrupting and subtly undermining their credibility with the audience. From this perspective, Brook's adaptation of *The Mahabharata* interrupts to expose rather than merely to reproduce the mechanisms of contemporary "Orientalism."

Such interruptions are central to Brechtian *quotation,* but for *quotation* to serve as an effective strategy of displacement, alienation, and ultimately critical and political reflection, it must simultaneously also interrupt the context of the material it cites. As Benjamin suggests, "quoting a

text implies interrupting its context."[52] In Brook's *The Mahabharata,* this latter aspect of Brechtian *quotation* pushes us well beyond the "Western humanist" commitment to multiculturalism that critics like Chaudhuri have argued motivates Brook's "massive displacement" of *The Mahabharata*'s "very insistent [Indian] context."[53] On the contrary, Brechtian *quotation* adds a profoundly deconstructive undercurrent to those displacements.[54] For it tags the underlying assumptions of Brook's harshest critics with a contradictory shadow. Against the backdrop of categorical charges that Brook betrays *The Mahabharata*'s "deepest meanings"[55] and of bitter criticism that his adaptation falters because it displaces and fails to confront "the meaning (or meanings) of *The Mahabharata* . . . within their own cultural context,"[56] a reading of those same cultural displacements as examples of Brechtian *quotation* ultimately questions and demands a rethinking of the identity politics upon which these criticisms of Brook's work are based. As instances of Brechtain *quotation,* Brook's displacements of *The Mahabharata*'s cultural context thus exemplify a fundamental technique of estrangement that not only permeates the whole of Brook's adaptation but that consistently interrupts the processes of identification (for both Eastern and Western audiences), and so leads us out of what Chaudhuri has called "the essentialist trap of identity politics," that is, out of a policing of "ethnic representations . . . [to] keep them contained within the narrow confines of a prescriptive group identity."[57]

Although there is a great potential for slippage between the concept of identification that Brechtian *quotation* interrupts and the concept of identity that functions as the modifier of "identity politics," recent assessments of the Brechtian method suggest an important area of overlap between the two concepts, which radically alters the polarized dynamic that has characterized Brook's production and its reception. As is widely known to those familiar with Brechtian theory, the interruptions generated by *quotation* result when an actor narrates his or her role rather than attempting—through, say, a Stanislavskian method—to lay the foundation for empathy and for an identification between actor and character or actor(s) and audience.[58] In his book *Brecht and Method,* Frederic Jameson takes issue with the accepted view that the Brechtian technique of *quotation* is positioned as a mere refusal of the identifications upon which the dominant theater of Brecht's day relied. Moving in a critical direction that highlights the conceptual overlap in the "identification" interrupted by Brecht and the "identity" contained in identity politics, Jameson suggests that the stakes in Brecht's *quotations* pivot on a much more funda-

mental recognition that the "notion of 'identification' is one of the most problematic and unexamined concepts in the arsenal of sociological cliché," and he implicitly argues that Brecht's resistance to "identification" is in fact a radical precursor of the decentered notions of the self that later surface in poststructuralist theory:

> Brecht's positions are better read not as a refusal of identification but, rather, as the consequences to be drawn from the fact that such a thing never existed in the first place. . . . [T]he quoting of a character's expressions of feeling and emotion . . . is the result of a radical absence of the self, or at least the coming to terms with a realization that what we call our "self" is itself an object for consciousness, not our consciousness itself: it is a foreign body within an impersonal consciousness, which we try to manipulate.[59]

If the interruptions by Brechtian *quotation* ultimately imply, as Jameson contends, that the self is a manipulable object of consciousness rather than consciousness itself, then identity and identification begin to lose their mystified, logocentric, and unified aura of authority, and the issue that emerges from the radical displacements of cultural context in Brook's *The Mahabharata* is not whether the adaptation misses the "deepest meanings" of the Indian epic or whether it fails to confront those meanings within "their own cultural context." The issue is about the very notion of "deeper meanings" as such.

In the reception of Brook's adaptation, that construction, bound as it is to notions of authenticity and authority (both with regard to textuality and identity), falls well within the parameters of a high modernist aesthetic, the vigilant maintenance of which ironically pits Brook's critics and Brook himself in a struggle over ideological territory that the Brechtian undercurrents of Brook's adaptation interrupt and deconstruct. While the distancing techniques of cross-linguistic and cross-racial casting reinforce these interruptions, the interruptions are primarily the result of an undercurrent strategy of *quotation* that makes strange and, more importantly, disrupts identification with the actual narrative of *The Mahabharata*. In Brook's adaptation, this strategy of disruptive quotation is probably best exemplified in the massive displacement and interruption that occurs when Krishna, resorting to the third person at the beginning of the great final battle, circumvents the metaphysical dialogues of the *Bhagavad Gita* and simply tells everyone instead that "he spoke for a

very long time."[60] Similar but less significant interruptions occur when Krishna, without further clarification, advises Arjuna to "act, but do not reflect on the fruits of the action,"[61] and when "Yudhisthira is prevented from entering Heaven" because his companion is a dog—even though it is never made clear that in the Hindu tradition the dog is a sign of pollution.[62] Interrupted from the context of their "Hindu ritual universe," these estranged *quotations* of *The Mahabharata* provoked puzzled laughter from Western audiences and impassioned denouncements from Indian critics.[63] In short, they effectively alienated both Western and Eastern audiences and thwarted their ability to identify with the events unfolding before them.[64] Furthermore, the theatrical context created in place of the cultural context, with its interrupting *quotations,* radically scrutinized the construction, representation, and manipulation of identity as a social and political concept.

The consequences of this scrutiny work as much against Brook's humanistic commitment to multiculturalism as they do against the identity politics pursued by his critics, exposing the fundamentally conservative, indeed restrictive, foundations not only of Brook's humanistic universals but also of assertions of identity as such. For the liberal humanistic philosophies motivating Brook's adaptation—philosophies that are also tied to the aesthetics of high modernism—depend upon the presumption of fundamental moments of identification across the centuries and across cultural boundaries: "echoes for all mankind" is, in fact, nothing short of a codified assertion of a unified, immutable notion of the self with which everyone, regardless of time, place, or culture, presumably can identify.[65] The undercurrent of Brechtian interruptions of Brook's production recontextualizes these "echoes," shedding their guise as an affirmation of an immutable notion of the self and exposing their potential as a manipulable tool of hegemonic rhetoric. At the same time, however, these same Brechtian undercurrents, inasmuch as they interrupt the Indian and Hindu cultural contexts of *The Mahabharata,* also erode the authority of the identity that Brook's critics have constructed as a critical response to his adaptation.

Both the seams of that constructed identity and its grounding in the aesthetic presumptions of high modernism are evident in the almost entirely dismissive attitude these critics display toward the popular cultural manifestations of *The Mahabharata* in Indian society, in addition to its elevated status as a sacred text and as a source of ritual structure. For all the discussion of the gaps, exclusions, and cultural displacements of

Brook's adaptation, and for all the complaints about his irresponsible handling of the diverse meanings and manifold ritual practices associated with *The Mahabharata,* there is, among Brook's critics, virtually no acknowledgment extended to *The Mahabharata*'s kitsch-ridden currency in low cultural expressions like comic books and Indian television serials. The closest we come to such an acknowledgment is Bharucha's expressed displeasure with "Ramanand Sagar's serialization of the *Ramayana*" and his (Bharucha's) puzzling assertion that because Indians have internalized *The Mahabharata,* their experience of "a television serial of the *Ramayana,*" however "synthetic, tacky, [and] sticky in the worst tradition of Hindi films" it may be, leads them to transform "this representation into a deeply spiritual experience."[66] At one level, the reinscription of an authentic spirituality across a "synthetic" and "tacky" secular experience of *The Mahabharata* is absolutely necessary if Bharucha is to maintain the integrity and authority of an Indian cultural identity violated by Brook's adaptation. The alternative is to acknowledge that even *The Mahabharata,* prior to Brook's "mishandling" of it, plays both sides of Brecht's distinction between ritual grounded in mystery and theater grounded in pleasure, slippage, and *jouissance.* Ironically, the very authority to take Brook to task for what he excluded in his adaptation necessitates the exclusion of cultural forms and experiences of *The Mahabharata* that would, if not legitimize, then at the very least be indifferent to Brook's free-handed adaptation.

Where the undercurrent of Brechtian *quotations* in the adaptation leads then is toward a fundamental shift in critical perspectives. They move in a direction where the stakes hinge not on a conception of representation as a product (or end-in-itself) that can be assessed according to its authenticity or authority but rather where performance builds upon repeated moments of illuminated self-referentiality and where a critical examination of representation as such begins with an exposure of one's own social and cultural positionality. While one might complain that we do not get India in Brook's *Mahabharata,* the Brechtian dimension of this adaptation would suggest a different point of critical focus, one that ultimately moves beyond the actual boundaries of theater. What Brook's adaptation thus provides, however inadvertently, is a profoundly rich reflection on precisely how difficult it is to represent India in the larger mediums of Western culture. One passing example of the far-reaching extent of that difficulty can be found right at the center of the chorus of voices expressing dismay and contempt for the insensitive way that Brook

handled his project. I refer here to a piece called "The Aftermath: When Peter Brook Came to India," which contains the edited transcripts of an interview that Phillip Zarrilli and Deborah Neff conducted with the director Probir Guha (the director for The Living Theatre in Calcutta) in August of 1985, shortly after Brook's production premiered. The interview amounted to the first in a series of scathing critiques of the disparity between the claims to universal humanism apparently underlying Brook's *The Mahabharata* and the now infamous disregard that Brook showed toward his Indian hosts while in India researching his project. Following Zarrilli's lead, later accounts of Brook's trips to India, like the searing criticisms articulated by Bharucha and Hiltebeitel, repeatedly underscore the extent to which Brook's insensitivity was despicable not so much because of the condescending way he dealt with Indians who were trying in good faith to assist him but because his insensitivity toward them had damaging effects on their relations with their friends, professional colleagues, and respective communities.[67] But even Zarrilli, who in 1985 was going against the grain in exposing Brook, quickly found himself confronting similar accusations of insensitivity and usurpation in the way that he went about facilitating the exposure.

Shortly after publishing Zarrilli's interview, *TDR* followed up with a piece called "More Aftermath," in which the Indian dancer Avanthi Meduri bitterly accused Zarrilli of a hypocritical sleight of hand and of having manipulated Guha with questions so leading that they made Zarrilli his spokesman. Meduri argued that Zarrilli had thereby usurped Guha's voice and thus had created another instance of victimization.[68] It was a telling and in many respects underestimated moment, which precipitated a pointed but defensive response from Zarrilli (not unlike Richard Schechner's earlier response to Bharucha's critique of his work). Its significance in the overall reception of Brook's *The Mahabharata* lies, first of all, in the way that Meduri's critique of Zarrilli illustrates how easily, if not unavoidably, critics from the West can be caught unawares by the cultural presumptions of their own discourse. Second, and more important, Meduri's critique underscores how utterly crucial an openly acknowledged self-conscious awareness of one's own social and cultural positionality is as a prerequisite to expressions on behalf of another culture.

This need for an expressed acknowledgment of one's social and cultural positionality is especially true when a particular representation might be haunted by the specters of a colonial legacy. In relation to epic theatre, John Rouse has noted:

Through the self-referentiality of its elegant design and comically exaggerated acting, Brecht's theatrical interpretation draws attention to its own situation of enunciation, subverting the ideological presentation of interpretation as the simple reflection of reality.[69]

While the legacies of colonialism may very well haunt Brook's own work, the identifiable Brechtian undercurrents of the adaptation give conscious voice to a form of intercultural representation that utilizes numerous techniques of alienation to highlight the piece's own cultural positionality and to draw "attention to its own situation of enunciation."

Given his-oft cited references to humanistic interpretations of literature, the extent of Brook's conscious involvement with Brecht is certainly open to debate. But it is worth noting that twice in his discussions of the particulars of his production, Brook mentions the use of "distancing effect[s]" and "Brechtian techniques."[70] The latter of these two references occurs specifically within the context of a discussion of the character Vyasa, who, following Indian tradition, occupies the position of author and narrator in the adaptation. As a figurative construct, however, Vyasa is also the single most important element for understanding the confluence of Brechtian technique and critical theory underlying Brook's adaptation of *The Mahabharata*.[71] First of all, the use of a narrator is a mainstay of Brechtian strategies of interruption and alienation, and it thus adds to the Brechtian context of the production as a whole. So while Brook's use of Vyasa coincides with Indian traditions, it simultaneously interrupts those traditions and undermines their authority. Secondly, and perhaps more importantly, Vyasa's own self-conscious role as an author—in particular, his admission that there are elements in his poem that are lively, uncontrollable, and beyond his intent—not only coincides with some of the most basic precepts that critical theory has contributed to our understanding of what an author is, but Vyasa's admitted lack of authorial control ultimately also lays the foundation for understanding the contradictory relation that Brook's liberal humanistic philosophies have to the insistent Brechtian undercurrents of his production.

That foundation, as will become clear in a moment, rests on a parallel between the limited authority that Vyasa as an author has over his material and the limited authority that Brook as a director has over his production. Since the rich history of *The Mahabharata* encompasses diverse textual and performance traditions, it is perhaps appropriate that these parallel limitations are framed within a larger, reciprocally illuminating

dynamic between text and performance. To some extent, Vyasa thematizes that very dynamic even as he concedes the limitations of his own intent as an author. Vyasa's concession is clearest in the moments directly following his most decisive intervention in his own narrative, i.e., when he suddenly appears in his own poem and uses his power as author to stop the Kauravas from murdering Yudhisthira. In the memorable scene that follows, Janamejaya, the young ruler to whom the poem is told and who accompanies Vyasa when he intervenes in his poem, then asks Vyasa why, if he can stop this crime, he cannot stop the pending war. Vyasa's answer, "some acts a word can check; others nothing can stop,"[72] acknowledges a fundamental limitation of word and text in the world of *The Mahabharata*. But since Vyasa is the author of that world, his answer finds a subtle parallel with the limited authority that a text can exercise over performance. In short, Vyasa concedes that he is the author of events he cannot control, regardless of his intent—events with a life of their own that he must finally accept.

Combined with the Brechtian undercurrents of Brook's adaptation, the implications of Vyasa's concessions have to be counted among the least explored, yet pressingly relevant, aspects of Brook's handling of *The Mahabharata*. They position the Brechtain undercurrents of Brook's adaptation at a crucial crossroads with poststructuralist theory. By highlighting the uncontrollable and autonomous relation any performance has to whatever we might deem to be the intent of any text or author, Vyasa's comments strike at the very foundation of the critiques of Brook for his infidelity to an elusive textual authenticity and for not adhering to the authorial or even cultural intent of *The Mahabharata*. All three of these issues—textual authenticity, authorial intent, and cultural intent— have less to do with adaptation than, to borrow phrasing from W. B. Worthen, "with the way that we authorize performance [and] ground its significance."[73] In this respect, Vyasa's acknowledgment that his work generates events beyond his control suggests, first, that the poem as a text is much more than—and by no means subordinate to—the poet's own intent and, second, that his words (his text) cannot ultimately restrict the events or performances they generate. Vyasa thus acknowledges the existence of complementary, parallel realms of slippage and *jouissance* that place the former textual realm in a dynamic, but not authoritative, relation with its performative counterpart. These coexistent realms of slippage and *jouissance* comprise the fundamental condition of *The Mahabharata* itself prior to any adaptation one might venture today: a text that

is without stable authorship and that is the source of abundant theatrical and performative traditions.

Such qualities resonate well beyond Brecht's distinction between the mysteries of ritual and the pleasures of theater. Derrida's reflections on Artaud's anti-theological theater, for example, use this notion of coexistent realms of *jouissance* as the cornerstone of an argument for a liberation of performance from "an author-creator who, absent and from afar, is armed with a text and keeps watch over, assembles, regulates the time or the meaning of representation."[74] Like Brecht's distinction between ritual and theater, Derrida's argument posits this liberation as the basis for performance that, grounded in immediacy, is its own authority, and "is not a representation" of a previously existing text.[75] It hardly could be otherwise. As Derrida notes, the imitative and reproductive dimensions of textuality itself give rise to a slippage and play in signification that make impossible an adequate representation of a text on the stage. But rather than concluding that performance is thus a poor representation of an inexhaustibly rich literary textuality, Derrida argues that the impossibility of representing the dramatic text throws the theater back upon its own resources, giving rise to an equally inexhaustible (visual) economy of signs, as well as to a space, as Vyasa tells Janamejaya, where words do not have the power to check or stop.

The implications of Derrida's arguments are by no means limited to a liberation of performance from the authority of the text. Even though these arguments tend to offer Brook's controversial adaptation a certain degree of cover, they only do so by simultaneously subverting his authority as director. The logic of that subversion is relatively transparent. As signifying systems, the languages of the stage not only play upon but also parallel the play and pleasure of the written word. Just as any text is more than its author, so too (arguably) is any performance more than its producer or director. In fact, when poststructuralism would teach us that Vyasa's acknowledged limitations are merely the plight of any author, that very lesson has direct relevance to our understanding of the signifying nature of performance. While it may be true, as Worthen has deftly argued, that performance as a concept coincides with what Roland Barthes "means by a text," and that performance is to the "material text" (the physical, printed page) what "text" is "to the authorial work," performance, irrespective of its relation to a piece of literature, also moves from a stage of directorial work into an autonomous field of signification.[76] Authorial intent, inasmuch as it can be reliably identified, is a component

but certainly not the completion of any text, and if it is true that every author must contend with the subtleties of a written language the meanings of which cannot entirely be contained by the intent of the author, is not the same true of directors and their manipulation of the languages of the stage? As sympathetic as one might be to the legitimate criticism leveled at Brook both for his arrogant cultural insensitivity as a visitor in India and for his naive liberal humanism as a motivating force behind his directing, those very critiques tend to have a blinding effect on the multiple ways in which Brook's production of *The Mahabharata* defies containment within the intent of its director, and thus serves as a critical irritant rubbing against the very attitudes Brook embraced in putting his production together.

Severed from analyses that measure Brook's *The Mahabharata* against the problematic intent of its producer, the adaptation falls back upon its own resources. It is there that the Brechtain undercurrents of Brook's piece rise to the surface of the production and carry it in a decisively different critical direction. One need not look far for a theoretical accounting of this shift in critical currents. By slightly modifying Barthes' famous argument that the death of the author is the beginning of the text, one begins to get a very different sense of performance than has dominated the critical reception of Brook's adaptation, a notion of performance that equates the beginning of a production with the death of the director, thereby shifting the critical focus from the director to the audience. The logic of this shift is found in the final passages of Barthes' seminal essay "The Death of the Author." There he presents the following argument:

> A text is made of multiple writings, drawn from many cultures and entering into mutual relations of dialogue, parody, contestation, but there is one place where this multiplicity is focused and that place is the reader, not, as was hitherto said, the author. The reader is the space on which all the quotations that make up a writing are inscribed without any of them being lost; a text's unity lies not in its origin but in its destination.[77]

The destination to which Barthes refers is the reader, whose birth, as Barthes announces in the final sentence of his essay, "must be at the cost of the death of the Author."[78] Within this key definition of the text lie the structural foundations of a comparable definition of intercultural avant-garde performance, which, like Barthes' notion of the text, is made of

multiple acts and drawn from many cultures, with "one place where this multiplicity is focused": the audience, "not, as was hitherto said," the producer. As with the case of the text, a performance's "unity lies not in its origin but in its destination." Likewise, the birth of the audience "must be at the cost of the death" of the producer.

It has been more than forty-five years since Brook made the following claim in his legendary prescription for the theater, that small book called *The Empty Space:* "No one seriously concerned with the theatre can bypass Brecht. Brecht is the key figure of our time, and all theatre work today at some point starts or returns to his statements and achievement."[79] To return to Brecht here in these considerations of Brook's adaptation of *The Mahabharata* is not only to affirm Brook's pronouncement from thirty years ago. It is also to argue that the path back to Brecht is a path that runs counter to the expressed intent of Brook's adaptation. For just as Brook's adaptation of *The Mahabharata* pivots on a notion of the death of the author, so too do the Brechtian undercurrents in Brook's production pivot on a notion of the death of the director. Significantly, the death of the director, inasmuch as it is intertwined in Brook's adaption with a latent Brechtian context, pivots on an avant-garde conception of the audience that coincides with Barthes' shifting of critical focus from the author to the reader. The Brechtian strategies of estrangement and interruption posit the audience as a diverse body "capable of thinking and of reasoning" and of adopting "a critical attitude," an audience capable, in short, of gradually recognizing that Brook's *The Mahabharata* has more to say about the processes of representation than it has to do with representation as such.[80]

CHAPTER 5

From Cutting Edge to Rough Edges

On the Transnational Foundations of Avant-Garde Performance

> Assume therefore that, as a result of specific historical
> circumstances, a theory or idea pertaining to those circumstances
> arises. What happens to it when, in different circumstances and
> for new reasons, it is used again and, in still more different
> circumstances again? What can this tell us about theory itself—
> its limits, its possibilities, its inherent problems—and what can it
> suggest to us about the relationship between theory and
> criticism, on the one hand, and society and culture on the other?
>
> EDWARD SAID, "TRAVELING THEORY"

I. 'In Advance of': An Introduction

While the Brechtian dimensions of Peter Brook's *The Mahabharata* may
cut across the grain of Brook's expressed intent, and while those dimen-
sions may highlight the unresolved tensions of an intercultural avant-
garde, the tensions are arguably much less unique than one might ini-
tially suspect. Indeed, they are commonplace enough in the history of the
avant-gardes that one might legitimately ask whether it is perhaps a bit
redundant to speak of an intercultural avant-garde as some sort of dis-
tinct subcategory of the avant-gardes. From their very inception, the
Western theatrical avant-gardes have consistently found themselves en-
tangled in the cultural politics of colonialism. Examples of this entangle-
ment are not difficult to find since they are often poorly masked beneath
aesthetic categories like primitivism or negritude, to name only the most
obvious, or even beneath a patronizing embrace of Asian performance
traditions as occurred in Russia, Germany, and France. In *Ubu Roi*, for
example, Alfred Jarry provocatively embraced a fashioned savage primi-

tivism that shocked William Butler Yeats, and that theater historians have consistently cited as "the beginning of the performative avant-garde."[1] In Zurich, the Dadaists displayed similar proclivities. As I noted in the opening pages of this book, Hugo Ball costumed himself in what he constructed to be a facsimile of a witchdoctor's headdress before reciting his *Lautegedichte* at the Cabaret Voltaire.[2] His friend and co-founder of the Cabaret Voltaire, Richard Huelsenbeck, followed the reading of his own fabricated "Negro poems" with a debate on their authenticity, and when Jan Ephriam, the owner of the Cabaret, gave Huelsenbeck examples of genuine African poems that he had collected as a sailor, Huelsenbeck recited them at the Cabaret but decided that they would be better (perhaps even more authentic) if, as in his fabricated poems, he added the sound "Umba" to the end of each line.[3] Even Antonin Artaud's intense fascination with Balinese dance theater was mediated, as is well known, by the Colonial Exhibition where he first encountered Balinese dancers.[4]

While these and similar moments in the history of avant-garde performance are indicative of the extent to which experimental artists were anxious to find alternatives to bourgeois cultural expression, they also remind us that the Western avant-gardes sustained European cultural prerogatives even amid its most vociferous assaults on bourgeois culture. The legacies of such an entanglement have left historians of the avant-gardes confronting a grossly *underplayed* dilemma. Either we contextualize the entanglement by arguing that the whole of the avant-garde is not contained within the particulars of its colonialist attitudes, and thus circumvent the problem, or we cite the entanglement as an example of the pervasive ideological corruption wrought by Western imperialism and begin the hard task of finding models of artistic expression uncontaminated by colonialist presumptions. Granted, my construction of this dilemma is polemical, but the stakes are higher than they might first appear. For the choice one makes here has a major impact on how we understand the legacies of the avant-gardes, especially with regard to how we understand the influence of the avant-gardes on the world stage, i.e., beyond the borders of Europe.

A profoundly neglected uncertainty looms over the question of whether we should consider the expanding influence of the avant-gardes to be an indication of a departure from their colonialist birthing or another example of imported Western cultural hegemony. With this latter concern in mind, the limits of our current theories of the avant-gardes and the need to revisit the colonialist underpinnings of avant-garde per-

formance become evident. Indeed, it is particularly appropriate to return to this matter now, at a time when a radical reassessment of the very concept "avant-garde" and its concomitant histories can be found in collections like *Refusal of the Shadow* (Verso, 1996), *Not the Other Avant-Garde* (Michigan, 2006),[5] *The Avant-Garde and the Margin* (Cambridge Scholars Publishing, 2006), and *Avant-Garde Performance and Material Exchange* (Palgrave, 2011), as well as in individual studies like Paul Mann's *Theory-Death of the Avant-Garde* (Indiana, 1991), Mike Sell's *Avant-Garde Performance and the Limits of Criticism* (Michigan, 2008), Kimberly Jannarone's *Artaud and His Doubles* (Michigan, 2010), and my *Cutting Performances: Collage Events, Feminist Artists, and the American Avant-Garde* (Michigan, 2010). Focusing on the avant-gardes' subtle entanglement in the politics of colonialism offers the possibility not only of fundamentally retheorizing the avant-gardes, but also of shifting their basic terrain. The argument here is very simple: if we turn a blind apologetic eye to that entanglement or if we see only the entanglement and dismiss the idea of an avant-garde as another ideological conduit for European cultural hegemony, then we have failed to recognize the extent to which the colonialist underpinnings of avant-garde performance mark the avant-gardes not as a particularly European cultural phenomenon, but rather, as a fundamentally global cultural phenomenon.

The arguments that follow do not downplay the contested intercultural exchanges and vexed negotiations that have shaped this phenomenon. Indeed, the shortest summary of this chapter's main assertion is that nothing more aptly characterizes the avant-gardes than the moments of contested intercultural exchange at their colonialist birthings. Those exchanges not only mark the avant-gardes, but culture itself, and in an effort to maintain the critical integrity of those contested moments, I have chosen to characterize the avant-gardes as a transnational phenomenon, first because the term highlights the global dimensions of the avant-gardes, and second because the term *transnationalism* is itself contested, signifying both the processes of global hegemony and the practice of counterhegemonic resistance.

II. Center-to-Edge/Edge-to-Center

Important opportunities for rethinking the history, indeed the very concept, of the avant-gardes can be found by considering whether the notion

of an edge (in this case, the cutting edge) presupposes a center or, at the very least, a point of origin from which one might plot a rectilinear course to the edge itself. With respect to the avant-gardes, the question of whether we can have an edge without a center is another way of asking whether we can have an advanced guard without some anchored sense of what is at its rear. Historically, scholars have presumed that the former necessitates the latter and have characterized this edge-to-center relationship dialectically, positioning the avant-gardes at the margins, hostile to the bourgeois center of society. While this critical paradigm is evident at least as far back as Renato Poggioli's *Theory of the Avant-Garde* (1962), some of the most important theoretical work along this line emerged in the early 1990s when Paul Mann rejected the notion that the avant-gardes occupy a stable site of resistance vis-à-vis society at large. Moving from a static to a more dynamic understanding of avant-garde gestures, Mann places the trajectory of the avant-gardes within an enduring continuum of negation and affirmation, or what he calls the "anti and its recuperation."[6] Recuperation, he argues, "is not simply the defeat of negation; rather both are functions of the same dialectal apparatus."[7] The avant-gardes, following Mann, are thus propelled forward in an ever-expanding process of innovation that is dogged by an inescapable and equally expanding process of appropriation. Indeed, according to this argument, the two processes are one. Hostile though they may be to bourgeois culture, the avant-gardes thus not only reaffirm the social mainstream in the authority that their rebelliousness tacitly acknowledges, they also revitalize the center of that exceptionally resilient mainstream by feeding it with fresh cultural expression.

Yet for all the significance of Mann's problematizing of the avant-gardes' anti-cultural or negating gestures, his argument still falls well within the established paradigm of conceptualizing the avant-gardes as an edge undulating outward from a center taken for granted. Indeed, Mann's argument meshes quite well with Michael Kirby's classic definition of the avant-gardes in *The Art of Time* (1969): "'avant-garde' refers specifically to a concern with the historical *directionality* of art. An advanced guard implies a rear guard or at least the main body of troops following behind."[8] There is a lot to be learned from the reaffirmation of this paradigm in Mann's argument, especially since the dialectic of "the anti and its recuperation," like the militaristic origins of the term "avant-garde" itself, bears a striking resemblance to the structures of Western bourgeois expansionism. This resemblance, while overlooked in Mann's

arguments, touches upon what is perhaps the most disturbingly familiar and resoundingly conservative note within the seemingly dissonant and radical chords of avant-garde expression. Indeed the very notion of a front guard feeding the vital center presents us with a discomforting reminder that the term "avant-garde" first emerged as a characterization of artistic practice in the heyday of nineteenth-century European colonial enterprise, when edge-to-center/center-to-edge relationships structured the hegemonic mechanisms of empire. The subtle affirmation of empire in Artuad's interest in Balinese dance theater (which he encountered at the Paris Colonial Exhibition in 1931) is but one example of the myriad ways that colonialist attitudes and European avant-garde proclivities could circulate with relative ease within the same conceptual economy. Indeed, they often converged. Certainly this was the case with Western modernism's fascination with appropriations from other cultures under the conceptual rubric of Artaud's problematic notion of "oriental theatre,"[9] or more generally, under the rubric of primitivism. This latter conceptual model of appropriation provided what subsequently became staple contours of European avant-garde expression.

The European construction of primitivism has far-reaching implications not merely for modernism in general but for the avant-gardes in particular. Any serious rethinking of the avant-gardes must at one point grapple with this latter example from the contested edges of empire, where an assumption of European cultural superiority and its ability to civilize "savage" cultures after its own Western image provided ideological cover for the widespread appropriation, on physical, intellectual, and aesthetic levels, of non-Western cultural artifacts. Significant steps toward precisely such a reassessment of the avant-gardes play an important role in the latter chapters of Rebecca Schneider's book *The Explicit Body in Performance*. In the preface to an eloquent exploration of how the notions of the primitive and the feminine were blurred in the Western modernist imaginary, she argues that the European avant-gardes positioned themselves within racist and contradictory constructions of the primitive. While assuming, on the one hand, that the "'primitive' practices and artifacts of 'other' cultures . . . [were] less evolutionarily developed" than European culture,[10] the avant-gardes simultaneously embraced, on the other hand, "the savage primitive" as a mode of "confrontation to the tenets of high modernism."[11] The context for these disparate inclinations, Schneider argues, was a nostalgia for the prelapsarian, which the Western avant-gardes first projected onto African and Oceanic cultures and then

embraced in a gesture that aimed at reestablishing a "connectedness to all that modernity had 'lost'."[12] Whatever opposition such gestures mounted against the modern institutions of Western bourgeois society, the characterizations of non-Western cultures as prelapsarian or as less evolutionarily developed were but two sides of a single coin purchasing European cultural prerogatives at the expense of a richer and more dynamic intercultural exchange among different peoples. Predictably, it was an expense paid for by non-Western cultures.

While nostalgia for the prelapsarian is a signature trope of modernist aesthetics, the flipside of this nostalgia has played a far more enduring role in the history and historiography of the avant-gardes. Indeed, there is a pressing need for scholars to rethink their understanding of the avant-gardes in such a way as to disentangle the idea of an art that is "in advance of" from a simultaneous reaffirmation of the hierarchical assumption that non-Western cultures were less sophisticated or less developed than their European counterparts. This is no easy task, especially since the idea of an art that is "cutting edge" or "in advance of" tends to imply, by its very definition, a hierarchy of evolution. So if we are to break from the Western cultural chauvinism of movements like primitivism, the obvious place to begin this task of retheorizing the avant-gardes is to disabuse ourselves of Eurocentric truisms about the cutting edge of art that have found their way even into important works like Richard Schechner's *The Future of Ritual.* When in the early pages of that work Schechner mentions in passing that the "historical avant-garde took shape in Europe during the last decades of the nineteenth century. . . . [and] soon spread to many places around the world,"[13] the chronology he endorses reminds us that the center-to-edge/edge-to-center framing of the avant-gardes in scholarship is as much a model for constructing an ideologically loaded and biased history of European artistic influence as it is a model for characterizing the forward-thinking and most advanced positions of artistic expression. Ironically, it is a model that places Europe simultaneously at both center and edge, privileging it as the center of innovation, while positioning it at the cultural frontiers as the harbinger of the new. Yet this truism propagates a myth, placing European expression at the cutting edge because European artists supposedly understood what non-Western artists were presumably incapable of comprehending about their own work. It is to erase the moments of exchange between European and non-European (e.g., African, Asian, Oceanic) cultures and to perpetuate the injustices that historically marked those exchanges by positing their con-

sequence as a point of origin rather than as a product of an earlier moment of appropriation, subordination, and conquest. In short, the model assumed by Schechner (and he is certainly not alone in this assumption) tacitly elides the contested exchange among cultures, privileging a representation that posits the repackaged return of looted intellectual and aesthetic property "to many places around the world" as examples of European originality, innovation, and enlightenment. The center-to-edge model underlying Schechner's chronology assumes a uniform, rectilinear historiography of aesthetic innovation that provides ideological cover for erasing a dubious and circular path of return.

III. From "the Cutting Edge" to "Rough Edges"

The one redeeming quality of this selective chronology of the avant-gardes is that it is merely a matter of scholarly convention to locate the foundations of avant-garde expression subsequent to the moments of intercultural exchange rather than in the exchanges themselves. Since colonial history reminds us that these exchanges were far from equitable, one can speculate that this historiographic convention is another example supporting Walter Benjamin's contention that history is seldom seen through the eyes of the vanquished—an issue that I will take up at length in the next chapter. But there is much more to be gained by breaking with convention and shifting our focus back to this earlier contested and largely erased moment. The idea here is not merely to offer some record of that moment, as Christopher Innes's chapter "The Politics of Primitivism" does in his book *Avant-Garde Theatre 1892–1992*. It is rather to finally see the aporia beneath the apology in Innes's ability to recognize, on the one hand, that "the whole artistic enterprise of interculturalism remains inherently problematic" because of its links to "nineteenth-century imperialism" while, on the other hand, he glosses over the implications of that recognition in claiming that "the attempt to reproduce the effects of 'primitive' or ritual theatre helps to explain avant-garde elements that might otherwise seem puzzling."[14] For not only does that moment of problematic intercultural exchange belong to the history of the avant-gardes, which, as Innes recognizes, is reason in itself for including it, but highlighting that moment of contested exchange provides us with a vantage point from which we might begin to retheorize the very concept of an avant-garde as a whole—something Innes does not do. To some ex-

tent, that vantage point sets three distinct theoretical areas into critical relief. Roughly speaking, those areas can be characterized as contested edges, simultaneous articulations, and apostate adaptations. But the individual titular categories are less important than the theorizing they facilitate.

Above all, a return to the site of cultural exchange and contestation among cultures gives us a very different vision of the center-to-edge/ edge-to-center relationship than that which heretofore has served as a paradigm for conceptualizing the avant-gardes. The most crucial revision of that paradigm, gained in the step back to the site of cultural contestations, is the recognition of a plurality of edges devoid of an identifiable center, a plurality that the rectilinear center-to-edge/edge-to-center convention in scholarship on the avant-gardes has obscured. Here, a rethinking of the avant-gardes can thus fruitfully begin with a move from a singular to a plural notion of the edge. In simplest terms, that move necessitates that we reconceptualize our notion of the vanguards within a theory of borders, and that we supplant *the cutting edge* with *the rough edges* of contestation, "struggle," and "negotiation," which as Michal Kobialka has noted, are implied in the "palimpsest quality" of borders "and the multifocal aspect of representational systems or practices used to narrate [them]."[15] Some justification for this turn to border theory as a segue into a reconceptualized vision of the avant-gardes can be found in the fact that, while two-sided, the border is, like the cutting edge, "a site of resistance or compliance."[16] It is, to echo once again Mann's theory of the avant-gardes, a site of "the anti and its recuperation." But more important still is the multi-sided nature of the border that moves us beyond the universalized notions of history and aesthetics implicit in the linear undercurrents of terms like *the cutting edge*. On this point, border theory reminds us that in culture(s) there is no such thing as a jagged edge protruding into an empty space. The cutting edge always cuts into its other, one edge not only going against another, but also assuming the authority to define or erase the other in the act of expansion. How rarely is this sense of expansion to be found in the existing theories of the avant-gardes! As of yet, scholarship has provided us with a notion of "the avant-garde" conceptualized in relation to its "rear guard" (Kirby) and characterized as "forward looking" (Schechner). Yet, conveniently, scholars have neglected to consider what the conventional conception of the avant-gardes displaces in its forward march and what those displacements say about the paucity of our existing theories.[17]

Arguably, these displacements are a product of a conceptual framing that has radically limited our ability to see the friction between conflicted edges that provided one of the more important igniting sparks of avant-garde activity—important because this spark ignited from a variety of cultural sources spreading simultaneously in a variety of cultural directions. Border theory can go a long way toward illuminating those conflicted edges beneath *the cutting edge*. Moreover, moving from the singular notion of *the cutting edge* to a notion of *borders* where each edge is always already (at least) two-sided, we encounter a profound reminder of the extent to which the implied singular in the notion of a *cutting edge* maintains an artificially constructed center that is forcefully imposed and that ironically seeks to dull the potential influence of its other, not by outpacing it, but by excluding and casting out that which, though positioned with the vanguard, is heterogeneous to the ideological order whose borders *the cutting edge,* as a concept, marks and regulates, no matter how cutting that edge might be. If, as Kobialka argues, the border can also be understood as "a wound,"[18] *the cutting edge* is not only conceptually a perpetrator of that wound, it also buries its victims beneath a historiography that has both elided the defining moments of cultural contestation at the founding of avant-garde practice and erected a European center in their stead.

It is in critical opposition to that fabricated European center that we can look to border theory for a decentered conception of the avant-gardes. In this respect, drawing upon the theory of the border in order to decenter the Eurocentric has not only conceptual but also widespread territorial implications for locating and (re)formulating the history of avant-garde expression. In a very literal sense, to decenter the avant-gardes is to reconceive their territorial domain and to look beyond the conventionally conceived borders of Europe for the convergence of artistic innovation and oppositional politics that so frequently has characterized avant-garde expression. Here the issue is as much how we conceptualize cultural borders as it is how we conceptualize the cutting edge. Indeed, how we conceptualize the former largely determines how we ultimately conceptualize the latter. For it is only possible to use *the cutting edge* as an arm of Eurocentric exclusions if one adheres to what border theorists have recognized to be an antiquated nineteenth-century definition of culture. Some of the more helpful thinking along this line has come from Alejando Lugo, who, in an important essay entitled "Reflections on Border Theory," argues that "the border region . . . can erode the

hegemony of the privileged center" by a process of "deterritorializing" our notions of culture.[19] A pivotal aspect of Lugo's argument that has direct bearing on how we choose to conceptualize avant-garde cultures is his recasting of "the border region" beyond the nineteenth-century notions of culture and the nation that enjoyed wide uncritical currency well into the late twentieth century, and that established borders by conceptualizing culture around notions of "harmony" and "shared patterns of belief,"[20] as well as around notions of homogeneity, "fraternity," and "imagined community."[21] By contrast, Lugo embraces more recent theoretical arguments that have advocated "the transformation of the nature of *the cultural* (from homogeneity to heterogeneity)."[22] Drawing upon the work of scholars like Renato Rosaldo and James Clifford, he posits a notion of culture not as that which is the "harmony" within borders, but rather as that which never emerges from the borderlands of contingency, fragmentation, and contestation, and which is at both center and edge, a borderland of ever-emergent, competing, and oppositional interests. Or, to translate Lugo's ideas into terms relevant to our own discussion, culture is that which, while potentially positing an ideological notion of *the cutting edge,* is nonetheless constituted by a multiplicity of emergent, conflicted edges. Following this line of argument, to speak of the cutting edge of culture is not to address the farthest points from the cultural center; it is rather, when pluralized, to speak of culture as such.

For our immediate purposes, the point of rehearsing Lugo's arguments is that if we move beyond an antiquated notion of a homogenous European culture (i.e., homogenous vis-à-vis the rest of the world) toward a notion of culture as that which is ever emergent, contingent, and contested, we find ourselves confronting a definition of culture that is not only profoundly exemplified in the contested moments of intercultural exchanges of primitivism, but that also suggests the clashing heterogeneous traditions of those moments are indicative of avant-garde cultures more generally. In the specific example of primitivism, we discover an instance of avant-garde expression that is conceptually constituted within a global constellation and that only as a result of the most blatant acts of erasure can be characterized as European. In the specifics of border theory, we discover a definition of culture that recommends the example of primitivism as a segue into what we can posit as the global dynamics that, although having largely gone unacknowledged in scholarship, have nevertheless always characterized the avant-gardes. The contrast here is between a definition of the avant-gardes centered, on the one hand, around

an imagined European cultural homogeneity that expanded in influence, or a definition of the avant-gardes, on the other hand, whose territorial coordinates were always already heterogeneous, dispersed, and diversely located in moments of contestation. More about these competing definitions will come momentarily.

IV. Beyond Linear Historiographies: Simultaneity

If border theory helps us to deconstruct and thus regulate the unchecked slippage between a notion of the cutting edge that signifies aesthetic innovation and a notion of the cutting edge that promotes a linear model of European cultural dominance and influence, it also leaves us with the subsequent task of theorizing the avant-gardes beyond the Eurocentric moorings that have substantially limited the parameters within which scholars have charted both the scope of the history of experimental aesthetics and the conceptual structure governing it. One course beyond those limitations involves some reflection on the fundamental role that the related notions of simultaneity and transnationalism can play in reframing the historiography of the avant-gardes. While the latter of these two notions is the more crucial and in fact is the one that helps us to negotiate between the two competing definitions mentioned above, the notion of simultaneity can serve as an important primer for our discussion of transnationalism because it helps clarify the notion of an avant-garde as a deterritorialized phenomenon. To this end, we can certainly get some bearing from the lessons of primitivism, which cannot be identified as either wholly European or wholly African because, even amid its problematic colonial undercurrents, it was a product of the borderlands and resulted in the kind of hybrid transcultural phenomenon that Diana Taylor has characterized in another context as that in which "both the dominant and the dominated are modified through their contact with another culture."[23] But the point here is not so much primitivism's hybrid expression as it is the simultaneity of the traditions that converge in its forms.

That simultaneity not only gives primitivism ambiguous territorial boundaries, it also suggests the need to look for a comparable territorial ambiguity in a wide range of avant-garde expressions, regardless of whether those expressions emerge in distinct instances of (inter)cultural hybridity. Indeed, even in areas where the aesthetic practices of the Euro-

pean avant-gardes were either not related to or ran counter to the colonial appropriations that mark primitivism, those practices have enjoyed a certain historiographic privilege that has eclipsed a register of the independent significance of often commensurate performative practices emerging outside of Europe. One case in point is the vociferously anti-colonial attitudes of the Parisian surrealists, who denounced the 1931 Colonial Exhibition in Paris as "colonial piracy," and "with the help of the Communist Party" staged "a counter-exhibition entitled 'The Truth about the Colonies'."[24] This well-known avant-garde provocation effectively coalesced aesthetic and radical political expression. But we still have yet to fully appreciate the implications that a comparable coalescence in the anti-colonial work of, say, Haitian artists (who were among the victims of colonialism) has for the historiography of the avant-gardes, and this despite the fact that within the ranks of the Surrealist avant-garde, we even come across clear acknowledgments not of *derivative* but of *independent* parallels between the politically engaged aesthetics of the Surrealists and those of their Haitian contemporaries.

Those acknowledgments can hardly be dismissed as a variation on the nostalgia for the prelapsarian that characterizes primitivism. Breton himself, in a 1946 visit to Haiti, paid homage to the Haitian "enthusiasm for liberty and its affirmation of dignity," both of which, according to Breton, were manifested in a "lyrical element" that, he argued, "emerges from the [political] aspirations of the entire people."[25] Combined with the traditions associated with voodoo, the politically charged Haitian lyricism to which Breton refers produced a volatile aesthetic cocktail that could compete with almost anything the surrealists had served up in their efforts to place their experiments with dreams, trance, and automatic writing "in service of the revolution." The point behind this short digression is less about precedent than it is about the presumption of European influence in the historiography of the avant-gardes—about techniques traditionally associated with the innovations of the European avant-gardes not only surfacing either earlier, simultaneously, or even later in cultures outside of Europe, but doing so as significant moments of innovation from within non-European traditions. In short, the convergence of aesthetics and politics in Haiti, a convergence that, in fact, was in service to an actual revolution, is but one small example of a vanguard beyond the pale of a scholarly reluctance to look past conventionally conceived European borders to find the narrative material for constructing the history of the avant-gardes. This reluctance is evident even

when that vanguard can be located in simultaneous temporal proximity to its European counterparts.

In light of such an example, it is tempting to conclude this rethinking of the avant-gardes with a legitimate and overdue call for scholars to break from their Eurocentric fixation and to finally acknowledge the global simultaneity of the basic forms of avant-garde expression. But there is the potential for the overly simplistic and reductive in such a call—that is, the potential for succumbing to a critical compromise that, while recognizing a global simultaneity in the emergence and forms of avant-garde expression, still inadvertently elides the crucial moments of contestation in the borderlands of the cutting edge. To conclude with a notion of simultaneity would thus leave us with an important deterritorialized conception of the avant-gardes, but, by the same token, the conclusion would never adequately grapple with the competing definitions of the avant-gardes mentioned earlier, and this would substantially diminish our understanding of the complex dynamics governing avant-garde cultures more generally. Far from merely presenting us with an either/or proposition, the competition between those two definitions arguably reflects a crucial irreconcilable antinomy within the avant-gardes, i.e., an enduring moment of contestation that constitutes avant-garde cultures as such and that offers us an important variation on Mann's argument that the avant-gardes always already contain "the anti and its recuperation." The issue thus is not whether one chooses a heterogeneous and dispersed notion of the avant-gardes over and above a notion centered around an imagined European cultural homogeneity, or, more simply put, whether one embraces the idea of global simultaneity over Eurocentricism, but rather whether one recognizes that in characterizing the avant-gardes, the two definitions cannot entirely be distinguished from one another.

V. Toward a Theory of the Transnational Avant-Gardes

To conceptualize the avant-gardes around a notion of global simultaneity does not in and of itself dispose of the problematic Eurocentric undercurrents of the "avant-garde" as a concept. Here we are not talking about specific modes of artistic practice that are identifiably international and comparable, but rather about an abstract category of cultural criticism that first emerged in discussions of cultural politics among European in-

tellectuals in the late nineteenth century and that, when applied internationally, provides us with a lens through which to perceive and assign (not an exhaustive but rather) a specific type of significance and worth to performance practices on a global scale. For better or worse, that lens casts a European conceptual hue across an amazing diversity of cultural traditions, and, to put it bluntly, the danger that this European lens presents is that it potentially distorts and filters as much as it magnifies and illuminates. This is not to say that the European origins of "the avant-garde" *as a category of cultural criticism* automatically disqualify it as a tool for understanding the significance of experimental performance beyond the borders of Europe. Indeed, to reject a category of criticism solely because of its European ties would be as problematic as pretending that those ties are irrelevant. But if the extension of this category is to circumnavigate the currents feeding a subtle perpetuation of European cultural hegemony, then the study of avant-garde practices as a global phenomenon must take conscious critical account of the European conceptual heritage structuring "the avant-garde" as an idea and as a conceptual tool for assigning cultural and political value. Otherwise, embracing the unacknowledged global simultaneity of avant-garde expression may ironically replicate the very Eurocentrism it seeks to avoid and devolve into something that, as Masao Miyoshi argues is the case with a poorly conceived multiculturalism, tends to look "suspiciously like another alibi to conceal the actuality of [repressive] global politics."[26]

Although there are conceivably other possibilities for avoiding this potential devolution, one important answer to the question of how to use the idea of an avant-garde as a lens that illuminates both the blindness and insight it brings to our understanding of global performance practices is to supplement, in the definition of the avant-gardes, the concept of simultaneity with what I would argue are the *transnational* foundations of avant-garde practice. Partly this argument pivots on the logic of analogy and capitalizes on a structural parallel between the perennially contested status of the avant-gardes and the contested status of the term *transnational* itself. More important, however, is the manner in which the conflicted historical referents of the term *transnationalism* set in critical relief the contextual historical dynamics governing the avant-gardes as global phenomena. Understanding the nature of that dynamic thus arguably necessitates a brief scrutiny of how the term *transnationalism* has reshaped our understanding of the political legacies of colonialism and European cultural hegemony.

As is frequently the case with terms that gain wide currency in scholarly discourse, the term *transnational*, and its variants are marked by often simultaneous and contradictory trajectories. These disparate trajectories are pronounced enough in the study of literature, for example, that prominent scholars like John Carlos Rowe consider a citation of both as a requisite part of defining the terms. Indeed, Rowe begins his *PMLA* article "Nineteenth-Century United States Literary Culture and Transnationality" by noting that the term *transnationalism* not only characterizes "a critical view of historically specific late modern or postmodern practices of globalizing production, marketing, distribution, and consumption for neocolonial ends," but that it also "is used to suggest counterhegemonic practices" that are comparable to "Homi Bhabha's privileging of 'cultural hybridity' as a way to resist global homogenization."[27] Arguably, these concurrent contradictory trajectories also mark a crucial dynamic that characterizes avant-gardism as a global phenomenon. If, on a geographical level, we finally acknowledge that the forms of avant-garde expression have always been dispersed and global, then, on a conceptual level, the contradictory trajectories of the term *transnationalism* help us to remain critically conscious of the extent to which we, in defining these expressions as avant-garde, always skirt the fence (that precarious balancing act on the border) between the neocolonial and the counterhegemonic.

Of these two trajectories, Rowe's characterization of the former is clearly indebted to the seminal work of theorists like Miyoshi, who in essays from the early 1990s like "A Borderless World? From Colonialism to Transnationalism and the Decline of the Nation-State" offered powerful arguments connecting the practices of eighteenth- and nineteenth-century colonialism with the repressive dynamics of late twentieth-century global capitalism (in the form of "multinational enterprises" and "transnational corporations").[28] The importance of this connection and especially of Miyoshi's concomitant discussion of the discursive ideology that (under the guise of "cultural studies and multiculturalism") easily masks a naive complicity with contemporary neocolonialist attitudes is that the path Miyoshi maps from colonialism to a neocolonial transnationalism provides an important arc for understanding the enduring legacies of the avant-gardes' cultural imbrications in the politics of colonialism.[29] The earliest manifestations of those imbrications are easy to recall. In my discussion of primitivism, I already noted the colonialist birthing of the European avant-gardes. But in this discussion, it is easy to

overlook the larger significance of the fact that throughout the twentieth century the European wing of the avant-gardes never quite successfully severed their vexed ties to the political and cultural interests that had spearheaded colonial expansionism in the first place. Even as far back as the very early 1960s, relatively traditional theorists like Renato Poggioli argued that, for all its seemingly radical sentiments, "the avant-garde" (the reference here is a presumed European avant-garde) could not "help paying involuntary homage to democratic and liberal-bourgeois society."[30] In other words, it could not help paying homage to the very society that was at the vanguard of colonial expansion and that, as Miyoshi so persuasively argues, subsequently, and rather undemocratically, gave rise to (and indeed provided tacit, if not explicit ideological sanction of) the later displacements and homogenizations of transnational global capitalism. While Poggioli's linking of the avant-gardes to bourgeois society arguably presages Mann's characterization of the avant-gardes as always already containing their own moment of recuperation, there is a much more important historical insight to be gained from recognizing that the bond cited by Poggioli was ultimately a bond to the social currents that laid the foundation for what Miyoshi characterizes as the neocolonialism of late twentieth-century global capitalism.

That insight hinges on an adaptation of Miyoshi's primary concern in tracing the origins of transnationalism back to colonialism and empire. The central argument to emerge from the connection that Miyoshi establishes between these two stages of global capitalism is, echoing the Marxist critique of postmodernity, his contention that the legacy of colonialism is constituted not in the move from colonialism to postcolonialism, but rather in an evolution from colonialism to the neocolonialism of transnational capitalism, which is far more elusive and ultimately more repressive. Although this summary does a disservice to the richness of Miyoshi's arguments, his more general questioning of the assumption that we have broken with colonialism and entered into an era of postcolonialism is, in its simplest expression, particularly important to our concerns here because of the avant-gardes' early conceptual entanglements in the cultural politics of colonialism. If, as Miyoshi claims, we have never truly departed from colonialism, then it behooves us to consider whether the colonialist birthing of the avant-garde was a mere aberration, i.e., a singular point of departure for a history quite distinct from its beginning (a history divorced from its colonialist beginnings)—or whether, following in the *geo-cultural sphere* what Miyoshi sees as the historical develop-

ment of Western neocolonialism in the geo-political sphere, that birthing was the beginning of a global dynamic that, though evolving, has always been a crucial aspect of the avant-gardes as phenomena.

This latter possibility is intriguing on a number of different levels. First and foremost, it offers a political historical context for my earlier assertion that *the rough edges of contestation,* i.e., the problematic moments of contested intercultural exchange that marked the beginning of the avant-garde as a cultural phenomenon, are characteristic of avant-garde expression throughout the twentieth century. More important, however, are the subtle ways in which Miyoshi's arguments help to clarify the shape of these contested exchanges. Perhaps the most significant of these clarifications only emerges from the admonishment with which Miyoshi closes his essay. Not only does Miyoshi caution in his final statement against "allowing ourselves to get absorbed into the discourse on 'postcoloniality,'" because by doing so we may inadvertently collaborate "with the hegemonic ideology" of neocolonialism, but he also argues that the same endorsement of neocolonialism results from allowing ourselves to be absorbed into the discourse on "post-Marxism."[31] It thus should come as no surprise that in linking the discourses of postcoloniality and post-Marxism, Miyoshi implicitly suggests that Marxism's historical role in the resistance to colonialism has continued relevance for maintaining sites of resistance to the processes of neocolonialism. But that relevance is particularly important here, in part because of the avant-gardes' long (if somewhat strained) historical affiliation with the Marxist Left, and in part because almost from its inception Marxism has functioned as an international movement. At one level, then, Marxism has provided an international political and structural link that has cut across cultural lines and that, in an amazing variety of forms, has captivated the attention of experimental artists on a global scale. Amid these historical currents, at least one strand of what we can identify as the transnational avant-gardes arguably takes shape as a by-product of the international politics of Marxism, rather than as a mere global extension of a European category of cultural criticism.

Marxism's impact on the experimental arts, by which I mean the specific forms of artistic expression it has precipitated, has varied widely from culture to culture, and that variation, along with its Marxist underpinnings, is a good example of the way that we might conceptualize the transnational foundations of the avant-gardes more generally. There is much to be learned from the example provided by the diverse appeal of

the political discourses of Marxism, especially because that appeal underscores a wide and simultaneous critical consciousness of global politics among artists internationally, and also because the application of that consciousness to experimental artistic expression frequently has taken the form of artists addressing specific and local concerns vis-à-vis the impact of colonial and neocolonial processes of globalization and homogenization. While these adaptations may be evidence of the amazing flexibility of Marxist thought, the proclivity demonstrated by an artistic tailoring of Marxist political sensibilities to local cultural concerns is by no means unique to experimental arts informed by the discourses of Marxism. The international response of experimental artists to Marxism is indicative of a kind of transnational consciousness that has consistently marked the attitudes of experimental artists across the globe.

Recognizing that Marxism created an international context to which experimental artists responded on a global scale is, in many respects, merely a reminder that theater practitioners and experimental performance artists, regardless of their geographical location, have seldom practiced their craft in a vacuum. Indeed, one of the central arguments for a transnational conception of the avant-gardes is that within the experimental arts, there are countless examples of significant figures outside of Europe who not only transformed the shape of theatrical expression and focus within their own cultures but who also had an intense awareness of and interest in the experimental work of their European counterparts. While this interest certainly impacted their aesthetics, it did so on their own terms. (A similar point, it is worth noting in passing, was probably the most decisive counter-argument that Schechner formulated in response to Rustom Bharucha's essay "The Collision of Cultures," which I discussed at the beginning of the previous chapter.) African, Asian, and Latin American experimental artists have been far from provincial in their aesthetic views, repeatedly displaying cosmopolitan sensibilities that demonstrate familiarity with European theatrical innovations. The problem is not with these artists' interest in Western experimental practices. It lies rather in the one-dimensional representations that Western scholars of the avant-gardes have offered in commenting on that interest.

The tendency has been to see that interest through the flat lens of an overly simplistic notion of influence. Scholars thus have confused interest with mere imitation rather than recognizing that the general interest in Western experimental forms by non-European artists not only possesses numerous dynamic moments of profoundly creative, independent, and,

above all, experimental adaptation but, more importantly, repeatedly leads to apostate adaptations, that is, to adaptations that owe no allegiance to the integrity of their European origins and that become experimental precisely because of that lack of allegiance. Diana Taylor has argued a very similar point in her discussion of how deceptively recognizable Latin American theater has seemed to theater historians versed in European theatrical traditions:

> The deceptive *familiarity* of Latin American theatre . . . has led to errors in criticism. As no indigenous theatre survived intact after the century following the conquest, it goes without saying that all the dramatic forms currently used in Latin America are derived *in some degree* from Western drama. While certain dramatic forms were forcefully imposed during the colonial period, since then Latin American dramatists have tended to "borrow" models. . . . Nonetheless, they do not borrow indiscriminately. Given a choice, people tend to take what they need.[32]

Certainly, Latin American theater is not unique in its consciously selective borrowing of theatrical models. Indeed, to place this and similar practices in a larger international context is one way to tease out the avant-garde propensities in the strategies mentioned by Taylor. First of all, the type of borrowing she refers to is, as a technique, a crucial aspect of theatrical experimentation and innovation. Thus it is hardly a leap to see in this strategy the nascent aesthetic practices that we deem avant-garde, and there is nothing particularly European about experimental borrowing. This point is only strengthened if one considers the implications of Taylor's statement that "given a choice, people tend to take what they need." If the needs cited by Taylor are not intended to coincide with or replicate European norms—and that is certainly what she is suggesting—there is a kind of random appropriation and adaptation to the practice of borrowing that also coincides with the aesthetics of the avant-gardes, in particular with the techniques associated with the *object trouve*. Here we discover a rather innovative, if not subversive, inversion of those very techniques. Rather than looking to Europe for models of experimental theatrical expression, experimental artists in areas as diverse as Latin America, Japan, and Francophone Africa have treated European experimental forms as found objects that can be appropriated and adapted to meet particular local needs.

Consistently, this phenomenon of experimental appropriation and adaptation has positioned global avant-garde expression in close proximity to what Rowe characterizes as the second dominant trajectory suggested by the term *transnationalism:* namely, the "counterhegemonic practices" that he likens to Homi Bhabha's notion of "cultural hybridity."[33] With regard to the avant-garde, much of the significance of this comparison derives from the fact that Bhabha posits hybridity as a mode of subversion standing in direct contrast to "theorists who engage in the battle for 'power' but do so only as the purists of difference."[34] Not only does Bhabha question whether such pure cultural difference exists (either as a site of opposition and resistance, or even as a site of absolute hegemonic authority), he also argues that hybridity is hardly tantamount to a capitulation to (European) cultural hegemony. On the contrary:

If the effect of colonial power is seen to be the *production* of hybridization rather than the noisy command of colonialist authority or the silent repression of native traditions, then an important change of perspective occurs. The ambivalence at the source of traditional discourses on authority enables a form of subversion, founded on the undecidability that turns the discursive conditions of dominance into the grounds of intervention.[35]

By positing a notion of hybridity, the subversive qualities of which are the direct result of an "undecidability" or a slippage in the signs of colonial authority, Bhabha offers us a conceptual dynamic whereby the symbols of cultural hegemony signify that hegemony even as they are simultaneously vulnerable to a "strategic reversal of the process of domination," i.e., even as they potentially and simultaneously signify their opposite.

There is a clear echo of Paul de Man in Bhabha's notion of hybridity, an echo that not only suggests a relevant cultural application for de Man's seminal poststructuralist characterization of textuality but that also provides a crucial passageway for Bhabha's notion of hybridity to enter into the discourses of the avant-garde. "The paradigm for all texts," de Man argues, "consists of a figure (or a system of figures) and its deconstruction. But since this model cannot be closed off by a final reading, it engenders, in its turn, a supplementary figural superposition which narrates the unreadability of the prior narration."[36] Of particular relevance to the project of rethinking the avant-gardes is de Man's concept of unreadability, which we might productively extend to the discourse of the avant-

gardes specifically because de Man uses it as shorthand for what he otherwise describes as a "model [that] cannot be closed off by a final reading." Presuming that de Man is correct in the paradigm he offers "for all texts," extending his concept of unreadability to the discourses of the avant-gardes (and particularly to the narrative history of the avant-gardes) acknowledges that only a matter of rhetorical convention keeps the conceptual parameters of the avant-gardes within Eurocentric boundaries, and if those parameters cannot be closed off, then the lack of closure offers an important opportunity for expanding our understanding of the conceptual dynamics of the avant-gardes themselves. The extension of de Man's concept to the avant-gardes thus takes a critical step toward opening up its discourses to new readings, both in the sphere of the textual and ultimately, via Bhabha, in the sphere of the cultural. Indeed, as we will see momentarily, the significance of this extension for our understanding of the avant-garde emerges in the intersection of the underlying notions governing de Man's concept of "unreadability" and those governing Bhabha's concept of "undecidability."

The parallel first between de Man's notion of "unreadability" and Bhabha's notion of "undecidability," and second between de Man's concept of "a supplementary figural superposition" and Bhabha's concept of "hybridity," is underscored by Bhabha's contention that the slippage between the symbols of colonial authority and their subversion never resolves the contestation between cultures. Like the discursive model that "cannot be closed off by a final reading," the slippage in the symbols of colonial authority leaves the symbols deconstructed and unreadable because of their contradictory trajectories. The irreconcilable cultural contestation underlying that deconstruction marks the hybrid itself. Hybridity, Bhabha argues, "is not a third term that resolves the tension between two cultures . . . in a dialectical play of 'recognition.'" It is rather a term that denotes the entrance of "other 'denied' knowledges . . . upon the dominant discourse," an entrance that "estrange[s] the basis of its authority—its rules of recognition."[37] Arguably, it is those "other 'denied' knowledges" that fill the space of de Man's "unreadability" and that culturally and subversively diversify the discourses of the avant-gardes. If de Man's "unreadability" is shorthand for discursive models that "cannot be closed off by a final reading," then Bhabha's argument here suggests that his concept of "undecidability," which serves as the backdrop for his concept of hybridity, refers to "other 'denied' knowledges," or to those cultural expressions that would at first appear to be elided by a dominant

discourse. In that subversive act of inversion, which gives voice to those "other 'denied' knowledges" and which emerge from the margins of discursive models like those of the avant-gardes that cannot be closed off, Bhabha's concept of hybridity emerges as a crucial concept for understanding the transnational avant-gardes.

In many respects, Bhabha's notion of hybridity returns us precisely to the colonialist moments of cultural contestation that mark the earliest phases of avant-garde expression, that is, to the site where the Eurocentric narrative authority of conventional histories of avant-gardes can be challenged if we recognize how *the rough edges* of that contestation mark a fundamental hybridity in the avant-gardes, a hybridity that changes the established "rules of recognition" for characterizing avant-garde performance. To some extent, I addressed this notion in chapter two, where I spoke of American hybrid vangardism. But with Bhabha's concept of hybridity, we thus segue into a definition of transnationalism and of transnational avant-gardes that rebuts the assumption that extending the conceptual lens of the avant-gardes internationally compromises our understanding of particular performance practices across the globe. Indeed, the idea of an avant-garde characterized first by strategies of adaptation and appropriation for local ends and second by strategies of subversion that change "the rules of recognition" (by reversing the processes of domination and hegemony) stands in marked contrast to the arguments of critics who, for example, would categorically reject the relevance of extending the idea of an avant-garde beyond Western theatrical traditions.

The immediate consequence of this shift in focus is to force a critical reassessment of the historical functions of the term "avant-garde" itself, and if the consequence of this shift and its reassessment is to have rendered "the avant-garde" an example of what Edward Said has called "traveling theory," I can offer in conclusion some response to his open question: "whether by virtue of having moved from one place and time to another an idea or a theory gains or loses in strength, and whether a theory in one historical period and national culture becomes altogether different for another period or situation."[38] If nothing else, the critical movement toward a notion of a transnational avant-garde would suggest that linking the term "avant-garde" with a specific historical lineage conceptualizes the term as being an unproblematic signifier of a particular history of European theatrical practice. By conceptualizing the term this way, scholars have entangled themselves in the rhetorical bind of having to argue that any discussion of a non-European theatrical avant-garde,

first of all, necessitates a severing of the term "avant-garde" from what implicitly amounts to an assumed "true" signified (i.e., the European experimental theatrical tradition of the early and mid-twentieth century). Any effort to maintain such a secure connection between signifier and signified is problematic, to say the least. More importantly, it misses the pivotal argument of this entire chapter: namely, that the connection between the term "avant-garde" and the European experimental theatrical tradition is an ideological construct rather than a historically unified moment of authentic signification. This ideological construct lays claim to and gives Europe credit for a whole range of political and stylistic theatrical practices. In the process it elides a recognition of the originality, and often simultaneous existence, of comparable political and stylistic innovations in the theater and performance practices of other cultures.

CHAPTER 6

Performing the Vanquished Vanguards

Nostalgia, Globalization, and the Possibility of Contemporary Avant-Gardes

I. Introduction: Contemporary Contexts /
Contemporary Avant-Gardes

Roughly a decade and a half ago, some of the most provocative attempts to rethink the cultural criticisms associated with the Frankfurt School focused on the rigid, surprisingly ahistorical, and ironically underdeveloped notions of capitalism that Theodor Adorno and Max Horkheimer used in their classic critique of the culture industry. Although these efforts to rethink the basic concepts governing Adorno and Horkheimer's critique of bourgeois society suggested that capitalism was not as uniformly oppressive as the two critics had presumed, the suggestion itself could hardly be counted among the chorus of voices joining the neo-conservative affirmation of capitalism that became a kind of deafening roar in the years immediately following the collapse of the Soviet Union. On the contrary, the argument made by critics like Albrecht Wellmar was that, however alluring Adorno and Horkheimer's critique might sound to critics at the end of the twentieth century, capitalism itself had evolved substantially since the publication of *The Dialectic of Enlightenment* in 1948, and if critical theory was to avoid a debilitating nostalgia, a much more historically dynamic understanding of capitalism and the culture industry was necessary.

A similar argument might be formulated with regard to the question of whether it is still feasible to speak of an avant-garde today. At the very least, the call to avoid a debilitating nostalgia is a call that scholars of the avant-gardes in particular would do well to heed. For the admonishment implicit in Wellmar's efforts to salvage critical theory pertains not so

much to a nostalgic fixation on a time and place but to a critical discourse that has become anachronistic because its points of reference have evolved and left it behind. What this warning means for studies of the avant-gardes, it seems to me, has less to do with the demise of the avant-gardes than it does with the criticism that frames its reception. I would suggest that here the call to avoid a debilitating nostalgia is ultimately a call for cultural historians not only to develop a more dynamic understanding of how the avant-gardes reconstitute themselves and evolve in new contexts but also to develop a more dynamic understanding of the ever-evolving cultural and political contexts to which the avant-gardes respond.

II. On Nostalgia, Death, and a History of the Vanquished Vanguards

At one level, the simplest way to avoid nostalgia would seem to be to abandon the term "avant-garde" as a descriptive for contemporary experimental performance. This is certainly part of the implicit logic behind numerous pronouncements of the avant-garde's demise and death. Since the 1950s, such pronouncements have come with such regularity that, ironically enough, they have a tradition all their own, which Mike Sell has aptly characterized as "the Eulogist School" of avant-garde studies.[1] One of the most prominent voices within that School—or at least within a closely related School—is Peter Bürger. While not specifically claiming that the avant-gardes are dead, he nonetheless does claim that art has "entered a post-avant-gardiste phase" because "the attack of the historical avant-garde movements on art as an institution [. . .] failed."[2] Since this claim is at the very crux of Bürger's distinction between the "historical avant-garde," which he champions, and the "neo-avant-garde," which he largely dismisses, it is worth pausing momentarily to consider its singularly peculiar logic—a logic that, I would argue, is not merely tainted by nostalgia but masks this nostalgia beneath rigid and deeply problematic historical categories.

There is, of course, nothing particularly unique in the logic that privileges success over failure. Most of Western cultural history is structured around this logic and the concomitant, problematic assumption that the spoils of victory and success include the privilege to dictate history's narratives. But if one is to speak of the avant-gardes' break with history, a rejection of such logic is arguably central to what constitutes an avant-

garde as such. Indeed, when one considers that conceptually the avant-gardes are embedded in notions of experimentation, provocation, and advocacy, it is difficult to understand how "failure" necessarily leads to a "post-avant-gardiste phase," rather than to subsequent avant-garde gestures. On the contrary, it is success rather than failure that would herald a "post-avant-gardiste phase" because success would have the best chance of rendering the need for an avant-garde obsolete. But even here, the notion of a success that is so absolute and comprehensive as to render the avant-garde obsolete is difficult to imagine. In this respect, Samuel Beckett's famous maxim from *Worstward Ho*—"Ever tried. Ever failed. No matter. Try again. Fail again. Fail better," is arguably more in line with the logic of the avant-gardes than Bürger's euphemistic eulogy.

Failure is not the death of the avant-gardes. It is part of their conceptual terrain, and until failure becomes part of the material, the substance, and the subject of the written histories of the avant-gardes—not as their death or termination but as part of their recognized processes and evolution—those histories will be forged in a Faustian bargain that sacrifices an actual elucidation of the dynamics of the avant-gardes in favor of a nostalgic fixation on individual formations of avant-garde expression. As with every Faustian bargain, the terms of this bargain are deceptive. Within them, the histories of the avant-gardes will subtly continue to side with the victors, despite a rhetoric that eulogizes the fallen and vanquished.

Euphemistic or not, eulogies for the avant-gardes incline more toward nostalgia than toward a dynamic understanding of the always provisional, transitory, and fluid nature of the avant-gardes as cultural phenomena. The danger of this kind of nostalgia is, to echo one of Adorno's favorite colloquialisms, that eulogies for the avant-gardes easily result in throwing "the baby out with the bath water."[3] But rather than tossing the vanguards out among the discarded and the dead, scholars might consider how consistently pronouncements of the avant-garde's death are, in fact, little more than nostalgic expressions of allegiance to a very specific avant-garde. As Mike Sell has noted, "most eulogies of the avant-garde are ultimately eulogies for the unity of truth and art embodied, supposedly, by a specific moment or movement."[4] While mourning the exhaustion of one form of avant-garde expression, they incline mistakenly toward a hasty generalization. Positing the particular for the universal, they turn a blind eye to the evolving versatility of the many that characterizes the avant-gardes of the past and the present and arguably the future as well. Ex-

amples of this tendency are numerous, and what is especially striking about them is how frequently they are couched in the success-failure logic employed by Bürger, and how frequently this logic involves a sleight of hand that equates failure with death, assessing the avant-gardes in terms of vague but conventional notions of success, and thereby thwarting a fuller exploration of the cultural and political dynamics of the avant-gardes more generally.

The force of this logic is compelling enough even to capture the critical imagination of performance scholars like Richard Schechner and David Savran. In fact, Schechner and Savran have a peculiar relationship within the Performance Studies wing of the Eulogist School. In his essay "The Death of the Avant-Garde," Savran prefaces his focus on what he calls "the last wave of the avantgarde (the one epitomized by the Wooster Group)," by noting how much he agrees with Schechner "that the avant-garde is effectively dead."[5] Aside from his apparent assumption that all the avant-garde is the Wooster Group, the irony of Savran's agreement with Schechner is that his focus on the Wooster Group is at odds with Schechner's own sense of the avant-garde's demise. If Savran really agreed with Schechner, he wouldn't need to eulogize the avant-garde as he does because Schechner's eulogy, if accurate, would have ended the avant-garde not only prior to what Savran sees as the Wooster Group's demise and failure but also prior to the Wooster Group's earlier successes, which Savran legitimately celebrates as avant-garde.

In the essay that he wrote at the beginning of the 1980s, Schechner promises an expansive assessment of the state of the American avant-gardes, but ultimately locates "The Decline and Fall of the (American) Avant-Garde"[6] primarily with the breakup of The Performance Group in 1980. Thus in a very literal sense, he dismisses the specific avant-garde (the Wooster Group) whose subsequent faltering some twenty-five years later Savran generalizes into a sweeping eulogy for the avant-garde as such. Yet even Schechner's assertion is not without its problems. As Arnold Aronson has noted, there is

> a slight aura of sour grapes in Schechner's broadside. Recognizing that his position of leadership within the avant-garde was under siege, if not completely routed, he declared the game over.[7]

Generally speaking, it is the bitterness of nostalgia (for those seemingly sweeter past days) that sours the grape. But however sour the grapes,

Aronson—with whom Savran ironically also agrees—ultimately argues that the problem with Schechner's declaration is not that it eulogizes the avant-garde, but that it "was perhaps a decade early."[8] What Savran's subsequent eulogy ultimately offers in its announcement of the avant-garde's death is in this respect little more than the next installment in a series of eulogies that seem roughly to be following a five-to-ten-year cycle in Performance Studies: Schechner locating the death of avant-garde performance at the beginning of the 1980s, Aronson implicitly locating it in the early 1990s, Savran locating it at the mid-point of the twenty-first century's opening decade, and—in a somewhat surprising move—Schechner echoing his 1980 arguments once again in 2010, in his article "The Conservative Avant-Garde."[9]

What one can garner from this cycle of eulogies are the inverted signs of a diverse collection of vanguards repeatedly regrouping and reconstituting, rather than succumbing to final defeat. Flipping those signs in order to render them legible, not as a sweeping epitaph but as the traces of an on-going evolution, is a crucial aspect of understanding the dynamics of the avant-gardes and also of understanding the continued viability of the avant-gardes today. As an alternative to these recurring eulogies, I thus want to suggest a different understanding of the "failures" of the avant-garde, an understanding that can be cultivated by looking to the margins of the Frankfurt School, where one finds the work of Adorno's friend, Walter Benjamin. Benjamin may be best known to scholars of the avant-gardes because of Bürger's interest in his theories of allegory, or, more directly, because of Benjamin's writings on Brecht, on Surrealism, and on art in the age of mechanical reproduction, but it is worth considering whether his value to those interested in the history and theory of the avant-gardes might lie elsewhere: in his theories of history, for example.

One might focus in particular on the seventh of Benjamin's fifteen "Theses on the Philosophy of History," where he famously argues, "there is no document of civilization which is not at the same time a document of barbarism."[10] There is much in Benjamin's assertion that overlaps with the often militant, anti-cultural sentiments of the European avant-gardes, especially sentiments like those coming from vanguard artists who were profoundly disillusioned by how impotent the great accomplishments of European culture proved to be in the face of the bellicose nationalisms that fueled the First and Second World Wars. Indeed, if that impotence did not signal a kind of direct cultural complicity with the destructive

forces of nationalism, it indicated a vulnerability to easy appropriation into the sustaining ideologies of those same nationalistic forces. From the perspective of the vanguards, that vulnerability, however indirect, amounted to complicity as well. In their radical rejection of the established cultural traditions of the literary and performing arts, the European avant-gardes thus laid the foundation for a wide range of provocations and gestures that, while now enshrined as (anti)art, originally had profound ideological affinities with Benjamin's own assertion linking the appearance of civilization with instances of barbarism. The anti-art gestures of the European avant-gardes implicitly rejected European art and culture as a candy-coating of the viciously militaristic, indeed barbarous, organization of society.

Despite this affinity with the anti-cultural sentiments of the avant-gardes, Benjamin's assertion about the barbarous undercurrent to the documents of civilization is not so much a critique of the impotence of established culture as it is an articulated concern about history's vanquished, and about the extent to which historians have tended to empathize with victors that "step over those who are lying prostrate," while carrying off "cultural treasures" as "spoils."[11] Though never explicitly stated, there is in Benjamin's lament a call for histories to no longer be written from the vantage point of the victors. Indeed, commenting on this same passage, Adorno suggests Benjamin was not only lamenting that "history had hitherto been written from the standpoint of the victor," but that he was also implicitly arguing that history "needed to be written from . . . [the standpoint] of the vanquished," and "address itself," Adorno added, to "what might be called the waste products and blind spots that have escaped"[12] the accepted narratives of history. Interestingly enough, when Benjamin finished writing his "Theses on the Philosophy of History" in 1940, most of the European avant-gardes could be counted among the vanquished—scattered as they were in exile, having fled Germany and Europe while the fascists shut down their performance spaces, burned their books, or exhibited their works as examples of "degenerate art." To some extent, the vanguards have never reemerged from the ranks of the vanquished. It is from these ranks that the vanguards are forced to reconstitute themselves. Among the vanquished, the vanguards have found vitality.

At one level, then, one might legitimately argue that Benjamin's call for a history written from the standpoint of the vanquished implicitly includes a call for a radically different history of the vanguards. I would

suggest that historians could revolutionize the extant histories of the avant-gardes by simply considering the spaces where the locus of the vanguards and the vanquished are very close to being one and the same. Such a consideration is all the more pressing, it seems to me, given the tendency among scholars to celebrate the artistic vanguards's successes at politically-inspired artistic innovation, while disregarding their failures to bring about actual artistically-inspired political change. The point here is simple: critical celebration of artistic innovation is a sorry consolation prize for political defeat—even when that celebration is ambivalent as it arguably is in Schechner's famous assertion from 1995 that the "'avant-garde' has become a style, a way of working, rather than a bellwether."[13] Despite Schechner's caveat that "the current avant-garde is not 'mainstream',"[14] I would suggest that a privileging of artistic innovation over and above political struggle tends to rehabilitate the vanguards into a palatable form for mainstream consumption, shifting focus away from actual political engagement and inscribing avant-garde expression to the conventional logic of celebrating success over failure.

Critical though this last observation may seem, it moves toward what I would argue are the defining, though largely unacknowledged, building blocks of the avant-gardes. Those blocks are always multi-sided: innovation is always tied to the experimental, which, in turn, is tied to risk, which, in turn is tied to potential failure. Even Allan Kaprow, speaking of the element of "chance" in the Happenings, states that rather than characterizing that element as "spontaneity," the use of the term "chance" implies "risk and fear" and the kind of "nervousness" that accompanies potential failure.[15] Indeed, it is difficult to imagine an adequate history of the experimental arts without some clearer and equitable accounting of experimental failure and defeat. Although it is easier to document that which is celebrated than it is to document that which fails to capture immediate critical attention, it is only in the juxtaposition of the two that critical scrutiny of the criteria for celebration is possible. Recognizing this basic disparity in the histories that cultural critics have constructed is the first step toward also recognizing some of the genuine value that Benjamin's seventh thesis on the philosophy of history has for conceptualizing the histories of the avant-gardes.

When seen through the critical lens of Benjamin's arguments, those histories heretofore not only have been decisively one-sided and biased toward the victors, but in this bias they arguably also betray a mentality both deferential to established authority and inclined toward a subtle

ideological affirmation, not of a vanguard sensibility but of a conceptual reaffirmation of the values embraced within the status-quo. And here one might follow Benjamin's own assessment: "empathy with the victor invariably benefits the rulers."[16] What radical history, we might ask by way of example, does Renato Poggioli elide in his classic *Theory of the Avant-Garde,* when he argues:

> When Fascism and Nazism fell, no avant-garde work created in secret and silence, through the years when the spiritual life of two great European nations was suffocated by the tyranny and oppression of those two regimes, came to light. From now on we cannot believe that other masterpieces exist, unless perhaps those once visible and misunderstood. [. . . In] the modern world we cannot help doubting the existence of manuscripts closed in chests, paintings hidden in attics, statues stashed away in kitchens.[17]

One may question whether the focus here on "masterpieces" is tantamount to "empathy with the victors." But at the very least, Poggioli's focus on masterpieces empathizes with the very traditional notions of art and accomplishment that the European avant-gardes opposed. Moreover, the focus on masterpieces eclipses the profoundly important work of those who toiled unsuccessfully amid tyranny and oppression, but who were vanguard nonetheless. Ironically, their erasure is history's own validation of their credentials among the anti-institutional currents of an avant-garde that shunned the deference to the author/ity implied in the embrace of author/ship, that rejected the institutions of art in favor of the strategic ephemerality of provocation and gesture, and that circumvented easy appropriation through the elusiveness of unscripted improvisation. Their failure to produce masterpieces—which I would suggest means their failure to conform to the dominant models of cultural production and hence to empathize with the victors—is not a failure to be avant-garde. It is a call for a history written from the standpoint of the vanquished vanguards.

Following this same line of thought, I would suggest that the radical histories of the vanguards will always remain unwritten until they too are written from the standpoint of the vanquished and of those who in daring to experiment have failed. On this note, it is worth recalling that at roughly the same time that Poggioli was penning his homage to masterpieces, Judith Malina and Julian Beck were actively courting Martin Bu-

ber's support in "their efforts to organize a General Strike for Peace."[18] Buber ultimately declined, stating, "I dread the enormous despair that must be the consequence of the inevitable failure."[19] Malina, on the other hand, ultimately situated her own work as a member of the vanguards squarely in the realm of what Buber dreaded as the consequence of failure: she gave her published diaries the title *The Enormous Despair.*[20] That title places The Living Theatre—the single most phoenix-like avant-garde theater in the history of the American avant-gardes—within a vanguard tradition whose history remains yet to be written.[21] In fact, to speak in one breath of The Living Theatre, and, say, also of Artuad's notion of "signaling through the flames" is to speak of a tenacity of political vanguard conviction that has enabled them repeatedly to rise from the ashes: vanquished but resolute—reconstituted, and certainly not dead. Almost fifty years after the IRS closed their theatre on Fourteenth Street, and Schechner announced that "The Living Theatre isn't living anymore,"[22] one can say with the certainty of hindsight, eulogies for the Living were wildly premature. If the tumultuous history of The Living Theatre might serve here as but one small example, then I would suggest that the radical histories of the vanguards will always remain unwritten until historians acknowledge that histories of the vanguards are by definition an always already incomplete account of ongoing struggles where victories have been no more decisive or final than failures, and where the very concept of "the vanguard" is not only always in progress (i.e., always "becoming") but is constantly evolving and divaricating within what, borrowing from Adorno, one might legitimately call a negative dialectic. Here the particular is not an instance of the more general universal idea; rather, the particular destabilizes and redefines the universal as such.

III. Radicalism, Vanguardism, and Militancy

Beneath the chorus of eulogies for the avant-garde, there is the opportunity for a critical excavation of the terms "radical" and "avant-garde" that arguably points toward the continued viability of "the avant-garde," particularly as a concept for understanding the blurring of radical art and radical politics. Beginning with the term "radical," it is instructive to recall that the connotations of this term that is associated with breaking with tradition, with being innovative, or even with advocating fundamental social or political reform, are all subordinate to the term's more

general meaning of a change that goes to the root. It is, I would suggest, to the roots of the avant-gardes that one must look to find their versatility and continued viability. To look to their roots is to look to their radicalism. At the level of metaphor (and here the term "root" is in fact a metaphor), arguably the single most constructive discussion of the roots of the avant-gardes came almost a decade and a half ago in an early essay by Stephen Bottoms entitled "The Tangled Flora of Goat Island: Rhizome, Repetition, Reality."

Though not speaking of the avant-gardes in general terms, Bottoms's discussion of Deleuze and Guattari's interest in "the rhizome" (from their book *A Thousand Plateaus*) in his study of Goat Island actually hints at a model for understanding the "radical" structures of the avant-gardes—structures that, like the system of roots called a "rhizome," spread "out in all directions on a horizontal plane just below ground level, with its shoots (or 'lines of flight') constantly tangling, overlapping, cutting back [. . . . and creating a system that is] inherently decentered." As Deleuze and Guattari note, the rhizome "connects any point to any other point, and its traits are not necessarily linked to traits of the same nature; it brings into play very different regimes of signs."[23] More important still, the death of one shoot, even the ostensible original shoot, does not jeopardize any of the other ones. The rhizome is profoundly non-hierarchical, and as a conceptual model for the avant-gardes it offers a powerful alternative to the eulogies that presume that the death of one avant-garde shoot signals the death of the avant-garde as a whole.

With regard to the broad histories of the vanguards, this image of a rhizomatic system suggests a very different way to consider the death of any individual avant-garde, but it also suggests the need to consider parallel forms of vanguardism that generally fall out of the purview of scholarly studies of the avant-gardes. In many respects, Sell attempts something along this line in his book *Avant-Garde: Race, Religion, War,*[24] particularly in his discussion of the profound debt the avant-gardes owe to the military structures from which the European avant-garde derived its name. Among other things, Sell's book provides a short history of military vanguardism that I do not want to rehearse here, primarily because that history is most interesting simply as a reminder that while cultural critics belabor the idea of the avant-garde's death, the vanguard—that is, the military's advance-guard, its small units of elite troops and "special ops" teams—is not only very much alive within the discourses and the actual operations of the military, but it has also been in a con-

stant state of evolution for well over a century. Both conceptually and literally, military vanguardism moves on the cutting edge, refining its techniques, methods, and effectiveness and playing an increasingly important role in military actions. In the so-called "war on terror," the vanguard is a central player, ironically enough. To put it bluntly, proclamations of the death of the avant-garde would come as a puzzling announcement to military planners who would likely dismiss the idea as naive and ill-informed.

Given the widely accepted genealogy that traces the Western origins of cultural vanguardism in military vanguardism (a genealogy that Sell himself traces), one might legitimately ask why cultural historians have located that crossover as a seemingly singular nineteenth-century event, as opposed to something much more dynamic, for example—something along the lines of the rhizome that includes multiple "lines of flight." Since the military's vanguardism is literally in a perpetual state of evolution, are there not, at least potentially, instances of what Deleuze and Guattari would call constant "lines of flight" or "offshoots" into spheres of cultural expression—instances, in short, where the vanguardism in the military serves as a model from which the cultural vanguards draw conceptual material for radical artistic expression? Could there be instances in which, to follow Deleuze and Guattari, the traits of cultural vanguard expression, while modeled after the military's vanguardism, are not necessarily "linked to traits of the same nature"? Rather than seeing the crossover from military vanguardism to cultural vanguardism as a one-time event, I would suggest that the rhizome offers a much more compelling model for understanding the dynamics of the avant-gardes, and in particular for understanding their global dimensions.

Two areas come immediately to mind where such a model for understanding the avant-gardes seems particularly appropriate: the first is exemplified in pieces like The Riot Group's *Pugilist Specialist,* which specifically engages the military's covert operations and the war on terror as part of its subject matter; the second is exemplified in the staging of terrorist acts themselves, which have forced the American military to rethink its basic understanding of the front lines of armed conflict. Both of these examples place avant-garde expression in a global context. Both also answer—however problematic those answers might be—the original concerns about the avant-gardes that Schechner voiced back in 1981, when he argued that the "big bang" of vanguardism from the early 1950s to the mid 1970s had succumbed to "entropy," and that the avant-garde

was in decline because the post-1970s performance landscape lacked "the experiments, the breaking of boundaries and conventions, the political action, the questioning, the multiplicity of staging options, [and] the sharing of primary creativity."[25]

The Riot Group's production of *Pugilist Specialist* premiered at the Pleasance Theatre during the 2003 Edinburgh Fringe Festival, roughly at the same time that David Savran was writing his eulogy for the avant-garde. *Pugilist Specialist* is the work of a self-described, "incendiary"[26] experimental ensemble, "fiercely committed" to sharing creative responsibility for their productions—productions that are political both in terms of content and in terms of the Riot Group's "confrontational acting style."[27] The production of *Pugilist Specialist,* which was written by The Riot Group's artistic director Adriano Shaplin, is especially noteworthy for its timeliness. John Peter of London's *The Sunday Times* singled it out as "the first play directly inspired by the 'liberation of Iraq.'" But I would suggest that the piece is less about the actual liberation of Iraq than it is about competing notions of vanguardism. Containing only vague allusions to Iraq at best, the piece focuses primarily on the internal dynamics of a special or "black" ops team. Ostensibly, the team is given the assignment to assassinate a Middle Eastern leader, who is only identified by the code names "Big 'Stach" and "The Bearded Lady."[28] There is some indication in the play that the target is Saddam Hussein. But by the end of the piece, enough ambiguity surrounds the team's actual assignment that it is no longer clear whether the code names "Big 'Stach" and "The Bearded Lady" even refer to the same person. I want to address that ambiguity momentarily, since it plays directly into the technique the piece employs in moments of self-reflection on vanguardism in general, but first a brief synopsis of the play's narrative is in order.

Pugilist Specialist begins with the meeting of three marine lieutenants and a colonel by the name of Johns, who apparently has been ordered to assemble and prepare the lieutenants for a covert operation (a "black ops" assignment) to assassinate a Middle Eastern leader. The lieutenants include a communications officer by the name of Studdard, a sniper by the name of Travis Freud, and a demolitions expert by the name of Emma Stein, who, it turns out, is notorious both for being the planner/supervisor of a legendary "remote ambush detonation"[29] and for being the probable "unnamed source" in an article on "the cover of the *New York Times*"[30] that has embarrassed the Marine Corps. In both instances, her "authorship" is officially not known, but it is widely recognized among her peers

and is certainly made known to those assembled for this new assignment. Much of the tension of the piece thus derives from the strong undercurrent of resentment leveled against Stein because of her superior operational skills, her willingness to be a whistle-blower to the press and to defy the unspoken code of loyalty to the Corp, and, not least of all, because of her gender.

The assignment the team receives positions the marines within the context of the Bush administration's break with a tradition that began in the mid-1970s with a Congressional Report by the Church Committee entitled "Alleged Assassination Plots Involving Foreign Leaders." That report sparked enough public outcry that President Gerald Ford issued Executive Order 11905 forbidding targeted assassinations of sovereign leaders.[31] It was not until George W. Bush's administration that official support for the original Executive Order from Ford ended. One can debate the wisdom of that break with tradition. But what makes the assignment to target a foreign leader peculiar, as it is represented in *Pugilist Specialist,* is that as the assignment itself unfolds and as it becomes increasingly clear that Stein will successfully assassinate "Big 'Stach," Col. Johns admits, "It wasn't supposed to get this far." He decides that he "can't let [Stein] finish this mission."[32] It becomes clear that the mission was actually designed to fail and to either totally discredit Stein or to dispose of her in a death that would never officially be acknowledged.

When it becomes evident that, despite expectations to the contrary, Stein will succeed in finishing the bomb that will lead to "Big 'Stach"'s death, Col. Johns (via his communications officer Studdard) orders Lt. Freud to shoot Lt. Stein, implying vaguely that if Freud doesn't kill her, he will be killed himself: ("Lieutenant, if you disobey this order it will be the last one you receive."[33]) The indication is that the stated assignment, which structures much of the action in the drama, was in fact a ruse to cover the tracks of another profoundly dishonest and more deeply disturbing covert operation, aimed at ridding the marines of a highly talented but independently minded and outspoken young female officer. Though this is never specifically stated in the play, Stein emerges as having been the real target of the operation all along. From sources that are never made known, from sources whose authorship remains anonymous, she has arguably been the point of reference, from beginning to end, for the code name the "Bearded Lady." As she falls among the vanquished, the piece's early refrain, "Victory forgives dishonesty,"[34] is a kind of distant but lingering and sordid echo.

Although *Pugilist Specialist* is at times more clever than accurate in its portrayal of military culture, the rhizomatic structures of its vanguardism are in part an outgrowth of the piece's fixation on military covert operations. In terms of the politics of military actions, the murder of Lt. Stein under the cover of a staged covert operation that will remain classified highlights the extent to which such operations readily constitute a significant threat to democratic processes, even though in the US they are frequently authorized in the name and defense of democracy itself. As Jennifer Kibbe has noted: "Because covert operations are hidden from the public, neither the thinking behind such missions nor their consequences can be publically debated," and they thus "lack the kind of accountability democracy requires."[35] Ironically enough, this problematic lack of accountability is in fact a major segue between the military and cultural vanguards that *Pugilist Specialist* implicitly explores.

This segue is evident in the fact that the piece focuses not on a simple clandestine operation but rather on a military assignment, one of the primary objectives of which—in classic avant-gardist form—is to obscure authorship and agency. The assignment that the marine unit takes on in *Pugilist Specialist* is at one level a clandestine operation, but it is also the kind of assignment that is designed not only to occur in secret in order "to preserve tactical surprise," but also so that is left untraceable even after it is finished. At a more general level, then, the unacknowledged specter looming in the background of the action is the American government, and the Riot Group's piece can thus be seen as a work of political theater that demands public debate and that uses experimental theater to call for accountability within a state-sanctioned vanguard that is structured conceptually around an exemption from accountability. Indeed, the official assignment portrayed in the piece is in sync with the dictates of US law. While targeting a head of state has only been restricted by Executive Order and not by actual legislation, covert actions themselves are called for in specific legislation (and hence laws) where they are viewed as a legitimate extension of US foreign policy:

"Covert Action" is defined by U.S. law as activity meant "to influence political, economic, or military conditions abroad where it is intended that the role of the United States Government will not be apparent or acknowledged publicly." Covert actions are thus distinct from clandestine missions: whereas the term "clandestine" refers to the secrecy of the operation itself, "covert" refers to the secrecy of its sponsor; the

action itself may or may not be secret. An operation conducted secretly in order to preserve tactical surprise, but then acknowledged by U.S. officials after the fact, would not be considered covert.[36]

Inasmuch as the assignment that the marines in *Pugilist Specialist* are given has less to do with influencing conditions abroad than it does with using global political conflicts as a veil to cover an act of vigilante justice directed against one of the marine's own, even the US government's status as the "secret sponsor" is little more than a vague diversion that further veils the sponsorship of the unofficial orders Col. John apparently is following. Even if Col. John has gone rogue and taken matters into his own hands in order to settle the score with a talented female lieutenant who threatens his traditional Corps values, the point is still very much the same. The potential for egregious abuse of the opportunities created by the laws governing covert operations is so great that such operations are both politically and morally suspect, regardless of their stated goals. Here the notion that "Victory forgives dishonesty" is not an anomaly. It is the norm. It provides the kind of self-justifying tripe that rationalizes countless *uncounted* crimes, all done in the name and defense of values that they fundamentally contradict and undo, and all possible because of the legal veil of secrecy governing covert operations. The criminal undercurrent to this kind of vanguardism should not be underestimated, for it provides a fundamental link with the vanguardism exemplified in the staging of terrorist acts. Indeed, there is much room for debate about whether the two are simply different sides of the same coin. At the very least, they would seem to be intertwined at the roots.

If there is a prevailing view that the vanguards today have lost the sense of global struggle or revolutionary fervor that Schechner associated with the avant-garde from the early 1950s to the mid 1970s, the Riot Group's production of *Pugilist Specialist* offers an important reminder of how one avant-garde (in this case a cultural avant-garde) can arise as a rhizomatic "line of flight"—indeed, a politically oppositional "line of flight"—from the global imperialistic aspirations of another avant-garde (in this case a military avant-garde). As a reminder, the rhizomatic line connecting the Riot Group with military vanguards points to other possibilities as well, for the Riot Group's work is certainly not the only "line of flight" extending from the global interventions of the US military's special operations teams. For the last decade, those interventions have played out in what Samuel Weber has called the "theatricalization" of the

"War against Terrorism," a theatricalization that is, according to Weber, the consequence of the "relatively new phenomenon" of linking war and terrorism "to *spectacle*"—the kind of spectacle nowhere better exemplified than in "the destruction of the World Trade Center and part of the Pentagon" on 9/11.[37] The "theater of operations" for the "War against Terrorism" spans "throughout the world."[38] Its global dimensions are embedded within the deadly "lines of flight" of competing vanguard factions.

To speak of that theater of operations as embedded within the rhizomatic structures of contemporary avant-gardes can hardly be dismissed as an abstract construct. Writing in the months directly following September 11, 2001, Frederic Jameson pointed to what in many respects was the most obvious "line of flight" between US covert operations in the late twentieth century and acts of terror at the beginning of the twenty-first century. In "The Dialectics of Disaster," he reminds readers that "the Americans themselves, with the help of the Pakistani secret police, invented bin Laden during our covert participation in the Soviet war in Afghanistan."[39] If that invention was part of a global political conflict, so too was the "dialectical reversal" that Jameson saw in bin Laden "turn[ing] on his creators."[40] Indeed, that reversal had multiple dimensions. Inasmuch as Weber observed "spectacle" and "theatricalization" in the "War against Terrorism," the converse has also proven to be true. Not only is terrorism itself embedded in spectacle and theatricalization, the kind of terrorism associated with the events of September 11, 2001 constitutes its own brand of vanguardism—one in which the "lines of flight" between the political and cultural vanguards blur and one in which, building on Mike Sell's recent work on the Arabic concept of *taliah*, a fuller sense of the rhizomatic structures of the avant-garde might be found.

Whereas Weber speaks of "spectacle" and "theatricalization," others have made bolder observations. Less than a week after the events of September 11, the German avant-garde composer Karlheinz Stockhausen, for example, famously provoked international condemnation by calling the attacks "the greatest work of art there has ever been."[41] All superlatives aside, a good part of the condemnation that followed arguably had to do with the untimeliness of Stockhausen's assertion rather than with its content. But that untimeliness itself was not only part of the problem. It was also part of a provocation. Coming from a recognized figure within the European avant-gardes, Stockhausen's comments fell within the vanguard traditions of *épater le bourgeois*. They were an avant-garde gesture.

Although the media certainly took Stockhausen's comments out of

context, the idea that on September 16th someone could passingly venture into the discourses of aesthetics and art criticism when talking about people who died in the destruction of the twin towers was taken by the press as an affront because of its casual insensitivity. Yet within a few months, Jameson could argue without controversy that "Stockhausen was [. . .] not wrong to insist on the essentially aesthetic nature of the act,"[42] and Weber could write of spectacle and theatricalization in an article that now seems almost quaint. Roughly a half decade later, Schechner penned an article for *PMLA* entitled "9/11 as Avant-Garde Art?" In Schechner's article, previous laments over the death of the avant-garde gave way to an effort to account for an avant-garde that had become a merchant of death and that was criminal, as Stockhausen himself had noted, "because those involved [i.e., those who were murdered] didn't consent."[43]

At the very least, Schechner's discussion of the events of 9/11, which I want to contrast with Sell's discussion of *taliah,* is noteworthy because it grapples with the ethical/moral dilemmas of positioning the attack on the twin towers within the discourses of aesthetics, even if those discourses belong to the anti-art traditions of the avant-gardes. But aside from this reflection on ethics, what is most striking about Schechner's discussion of 9/11 is not so much that he argues that those horrific events should "be understood as the actualization of key ideas and impulses driving the avant-garde,"[44] but that in conceptualizing 9/11 as "avant-garde art," he not only relies on a wholly Western sense of aesthetics but also on a one-dimensional, linear sense of the avant-garde's history—a sense in which avant-garde gestures are like roads, all presumably leading back to Rome and/or Europe. Indeed, even Schechner's reflections on ethics rely entirely on Western points of reference. There are compelling reasons to recognize the events of 9/11 as avant-garde, but to argue as Schechner does that "the 9/11 attack was in direct succession to futurist, anarchist, and other actions," like those orchestrated by "the Vienna Aktionists" or "Christo and Jeanne-Claude,"[45] is to seriously neglect the vanguard traditions to which Al-Qaeda belongs, traditions that encompass both the political and cultural dimension of vanguardism and that can hardly be seen as stemming from a linear tradition that begins in Europe with the Italian futurists.

In his article "Al Qaeda and the Avant-Garde: Towards a Genealogy of the *Taliah,*" Sell goes a long way toward correcting that neglect. Similar to Schechner's "9/11 as Avant-Garde Art?," Sell's "Al Qaeda and the Avant-

Garde" also argues that the events of 9/11 need to be understood as a calculated and well-coordinated avant-garde gesture. In his essay, Sell takes as his point of departure Osama bin Laden's own description of the 9/11 terrorists as "a blessed group of vanguard Muslims, the forefront of Islam."[46] This point of departure is telling, for the significance of Sell's argument in contrast to Schechner's is that rather than subordinating Al-Qaeda and 9/11 to a Western conceptual frame, Sell asks scholars to consider how the concept of *taliah* (the term in bin Laden's comments that on Al Jazeera television and later in the US press was translated as "vanguard") radically challenges prevailing notions of the avant-gardes as such. If Schechner does this implicitly, say for example, in the moral/ethical discomfort he expresses in discussing 9/11 as avant-garde art, Sell takes a far more historical approach, offering a detailed analysis of *taliah* and of the appropriateness of translating the term as "vanguard." Not only does the genealogy he provides affirm the appropriateness of this translation, but it points to a concept of vanguardism that, since the late nineteenth and early twentieth centuries, Middle Eastern intellectuals have been tracing back to "the *hijra,* the exile and insurgency of Mohammad and his followers" in the seventh century. Two of the most prominent twentieth-century intellectuals to espouse this notion of Islamic vanguardism are the Pakistani founder of Jamaat-e-Islami, Maulana Sayyid Abdul Ala Maududi, and the Egyptian theologian Sayyid Qutb, who, Sell notes, is "rightly considered the most important influence on radical Islamism today."

With regard to Qutb in particular, Sell focuses on a figure who, in the aftermath of the events of 9/11, has become well known in the West as a key intellectual informing the political and theological views espoused by Al Qaeda, and who is also known as a contradictory figure, caught between a pronounced antipathy toward Western culture and an equally pronounced debt to that same culture's influence on his own ideas. But Sell complicates this contradiction, placing Qutb's work within a larger Islamic tradition that has even exercised a profound influence on Western culture, an influence that goes back at least as far as early nineteenth-century romanticism, the cultural movement without which Sell (echoing Poggioli) argues the rise of the European avant-garde "is inconceivable." Noting the "extensive body of scholarship that shows Islam to be a deep and significant influence on romanticism," Sell places *taliah* within the generative cultural mix that produced twentieth-century avant-garde sensibilities, both in the West and, notably, in the East as well.

In constructing this genealogy, Sell does more than merely offer insight into why Al Jazeera was correct when they translated Osama bin Laden's praise for those who had destroyed the twin towers as "a blessed group of vanguard Muslims," or even why it is correct to call the destruction of the twin towers a political and cultural avant-garde event. Sell gives voice to an understanding of the avant-garde that is rhizomatic in structure. Indeed, he even mentions "the rhizome" in passing, as one of a series of models helpful for imagining the rough interconnectedness of "small group radicalism" that comprises not only the contemporary avant-gardes but also the divergent histories of all those whose radicalism might be deemed avant-garde. In this respect, Sell's discussion of *taliah* is an example of a much larger point, namely that "the avant-garde is not a substantive, unitary agent that follows a linear, developmental story, but is, instead, deployed as a critical concept, a marker that identifies and links situated domains of knowledge whose relationship to each other is motile and mercurial." It would be difficult to find a characterization more consistent with the notion that I have been forwarding here of the avant-garde as rhizome.

IV. The Vanquished, the Rhizome, and Globalization

It is worth pausing momentarily to reconcile the two seemingly divergent trajectories pursued in this chapter. On the one hand, I have argued for the need to understand the avant-gardes not only in terms of their successes but also in terms of their defeats. I have argued for an understanding of the avant-gardes that takes account not only of the victors but also of the vanquished. At the same time, I have also argued that pronouncements of the death of the avant-garde fundamentally misunderstand the structures of the avant-gardes more generally, structures that I have likened to the rhizome, with the demise of one avant-garde by no means amounting to the death of the avant-garde as such. While Sell's genealogy of *taliah* certainly moves discussions of the avant-gardes toward the notion of the rhizome that I have been advocating, one of the questions that looms over his analysis—at least within the larger context of the arguments I have been developing here—is where one might place this analysis in relation to the notions of the vanquished vanguards that I have also been advocating throughout this chapter. At first blush, one might speculate that, however morally repugnant their methods might be, bin Laden

and Al Qaeda ought to be counted among the vanquished who struggle against an expansive US empire and its questionable history. Although US foreign policy certainly merits this kind of criticism—particularly with regard to policy in the oil-rich Middle East—there is good reason to suggest that the vanquished do not lie on bin Laden's side.

If the portrait that Sell offers of bin Laden and Al Qaeda is problematic, I would suggest that the problem is two-fold. First of all, there is the temptation to position bin Laden, either directly or implicitly, within contexts where he does not necessarily belong, namely within the kinds of political impulses with which the Western avant-gardes have long had deep (albeit at times problematic) sympathies. With regard to figures like bin Laden, I would argue that what David LeHardy Sweet has argued is true of the Western avant-gardes in general is also true of Western scholarship about the avant-gardes, and of Western scholarship on 9/11 as an avant-garde event in particular: while "most elements of the avant-garde have shown themselves sympathetic to, if not actively supportive of, whatever attitudes, impulses, or ideas may have contributed to the struggle against Western imperial control," the Western avant-gardes—when they have been "attracted to the Near East"—have tended to be attracted to "everything that is eccentric and unfamiliar about it."[47] This kind of attraction is also true of the romantics. Although Sell is extremely careful to avoid this kind of exoticization, beyond the question of whether the events of 9/11 were "avant-garde" (art), and beyond the question of whether the structures of the avant-gardes are unitary and linear, or situated and rhizomatic, there is a larger question about what kind of avant-garde the events of 9/11, or, more specifically, the perpetrators of those events, represent. This question has at least as much to do with Benjamin's distinction between the victors and the vanquished—between the rulers and the ruled—as it does with the struggles between cultures. There is, in fact, substantial room for debate about whether beneath the rhetoric of Islamic vanguardism, bin Laden himself is really working at "the forefront of Islam" or simply borrowing the rhetoric of the vanguard—the rhetoric of *taliah*—in order to play a rich man's deadly game.

In discussions of the avant-gardes, the rhetoric of *taliah* is easy to romanticize since it unites the rhetoric of redemption and revolution. In no uncertain terms, that rhetoric is part of the exoticism that bin Laden played to his advantage on the world stage. Yet his access to that stage was purchased not by the currency of his rhetoric (borrowed or otherwise)

but literally, by his immense wealth and his status as a member of the classes of the ruling global elite. In this respect, one would still do well to heed the word of caution that Jameson offered early in 2002: "Exotic trappings aside, [bin Laden] is the very prototype of the accumulation of money in the hands of private individuals and the poisoned fruit of a process that, unchecked, allows an unimaginable autonomy of action of all kinds." Jameson argues furthermore that "Al-Qaeda [. . . thus] constitutes less a new and interesting party-organizational form for the new world of globalization than it does a rich man's private hobby."[48]

At the very least, Jameson's reference to "a rich man's private hobby"—a hobby enabled by the political economies of globalization—is a blunt reminder that scholars can ill-afford to limit themselves to questions of whether to designate the events of 9/11 as "avant-garde." Nor can they afford to use this designation merely as a provocative example to illustrate the point that the avant-gardes are diffuse and non-linear (i.e., rhizomatic). Both of these are important issues. Both of them attest to the fact that the avant-gardes are not dead. But the designation "avant-garde" is not a passport to an exceptional status; it is not an ethical or political exemption clause. It says nothing about whether any individual avant-garde functions on behalf of the rulers or the vanquished, whether any individual avant-garde is conservative or progressive, or whether any individual avant-garde is repressive or liberatory. For one avant-garde can be any of these, while another can be the opposite. In a manner of speaking then, the structures of the avant-gardes might best be described as being both horizontal and vertical. To speak of the avant-gardes as a rhizome is to speak of horizontal (i.e., parallel and coexistent) avant-gardes and avant-garde traditions. To speak of the vanquished vanguards is to speak of vertical avant-gardes (i.e., successful and failed, dominant and subordinate, or reactionary and subversive): of avant-gardes that are politically at odds and in competition with one another. To speak of the dynamics of the avant-gardes necessitates a scholarly discourse that takes both the horizontal and the vertical avant-gardes into account. Such a discourse, I would suggest, is also necessary for understanding how contemporary avant-gardes not only position themselves in relation to previous avant-gardes that have exhausted their viability, but how they also position themselves in relation to the processes of globalization that have transformed the social, political, and economic contexts to which the avant-gardes have historically responded.

Some sense of how one might position contemporary vanguards in

relation to the processes of globalization can be garnered by returning briefly to that moment mentioned at the beginning of this chapter when critics were searching for a more contemporary and dynamic understanding of capitalism than that which Adorno and Horkheimer provided in *The Dialectic of Enlightenment*. Indeed, the efforts to historicize critical theory's understanding of capitalism coincided, interestingly enough, with a wide range of studies theorizing the processes of globalization, processes that mark a historically distinct development in the structures of capitalist enterprise, and that, while perhaps foreshadowed in the work of Adorno and Horkheimer, are nevertheless not specifically conceptualized by them. The range of these studies is quite rich, but one study that, at a conceptual level, has striking relevance for studies of the contemporary avant-garde is Masao Miyoshi's important 1993 essay "A Borderless World? From Colonialism to Transnationalism and the Decline of the Nation-State,"[49] which I mentioned in the previous chapter. I single out Miyoshi's essay again not only because its account of the operative structures and historical rise of transnational corporations answers the call implicit in attempts to salvage the cultural criticisms of the Frankfurt School, but also because Miyoshi boldly asserts that the processes of globalization ultimately call into question the temporal linearity taken for granted in postcolonial studies, a temporal linearity that, at a comparable level, is generally taken for granted in studies of the avant-gardes as well.

While there is much in Miyoshi's analysis that pushes well beyond the notions of bourgeois society that not only dominated the Frankfurt School's criticism but also dominated the cultural criticism associated with the European avant-gardes, there are, with regard to the contemporary avant-gardes, important historiographic parallels one might draw from Miyoshi's understanding of how the processes of globalization necessitate a rethinking of the movement from colonialism to postcolonialism. Briefly stated, Miyoshi's central thesis is that the very idea of postcoloniality may blind us to "the actuality of global politics" and to the profound extent to which colonialism continues to thrive today "in the form of transnational corporatism."[50] Following the logic of Miyoshi's arguments, I want to suggest that the idea of post-coloniality may not only blind us to the actuality of global politics, as he argues, but also to the important ways in which contemporary experimental artists give voice to anti-colonial sentiment and resist the forms of colonialism that continue to thrive today in the processes of globalization. Returning to the opening reflections of this chapter, I would thus suggest that the idea

of a post-avant-garde—an idea that always accompanies pronounce-ments of the death of the avant-garde—functions in a manner compa-rable to Miyoshi's description of the effects of the idea of post-coloniality. The question, then, is how we might understand the avant-gardes in rela-tion to local communities that are increasingly regulated by global mar-ket interests. The answer to that question takes both the horizontal and vertical dimensions of the avant-gardes into account.

Rather than heralding the death of the avant-garde, the processes of globalization call for a rethinking of the contexts to which the avant-gardes respond. At the most basic level, those processes suggest the need to rethink stagnant notions of consumerism or of bourgeois society, such as those associated with the critical theory of the Frankfurt School, and those criticized and negated within some of the most famous avant-garde expressions of the early and middle twentieth century. But if there is a need to rethink the contexts to which the avant-gardes respond, the task of this rethinking is one that falls not to artists but rather to critics, theo-rists, and historians who have yet to take stock of the global structural contexts against which contemporary avant-garde performances emerge as sites of political-aesthetic resistance, opposition, or negation. The van-guards are already there. While understanding the attacks of 9/11 as an avant-garde event certainly moves toward a rethinking of the social, po-litical, and economic contexts to which the vanguards respond, there are much earlier examples one might turn to in order to facilitate the kind of rethinking that globalization requires, examples even among the work of American artists. A good case in point, in this regard, is the one provided by Suzan-Lori Parks's *The America Play*.

Although *The America Play* does not explicitly address the processes of globalization, it is remarkable for its un-nostalgic reflection upon Ameri-can history from the standpoint of the vanquished, a reflection that cul-tivates a rhizomatic sense of parallel avant-gardes and that subtly illus-trates the shift from an "administrative and occupational mode of colonialism" to the "economic version" that Miyoshi identifies as the neocolonial underpinning of globalization itself.[51] In this respect, *The America Play* points toward a very different trajectory within the Ameri-can avant-gardes than that suggested by critics like Aronson or Savran. Indeed, rather than exemplifying the sentiments of American avant-garde artists whom Savran describes as "look[ing] to their revolutionary fore-bears for inspiration,"[52] *The America Play* arguably moves in the exact opposite direction, mounting a substantial opposition to forebears whose

legitimacy it ultimately rejects, both aesthetically and politically, and whose death by no means signals a eulogy for the historical trajectories the play seeks to recover.

Written in the early 1990s, *The America Play*'s central conceit is an archeological reconstruction of the personal history of a fictional African American performer by the name of Bram Price—a reconstruction that plays out against the backdrop of a replica of a living history theme park called "The Great Hole of History." Often referred to as the "Foundling Father" or the "Lesser Known," Price is a former gravedigger whose history is so embedded in everyday performance practices like the rituals surrounding death itself (he and his wife, for example, "would build a mourning business"[53]) that his life blurs the lines between the historical and the histrionic, between life and art. Placing "the history of History [. . .] in question too,"[54] Bram Price becomes a catalyst for a history told from the standpoint of the vanquished. Much of that history focuses on the personal narrative that is buried beneath the gravedigger's peculiar resemblance to Abraham Lincoln.

Despite the fact that Price is black, his resemblance to Lincoln is pronounced enough that it ultimately allows him to leave the graveyard—that site of eulogies—and to venture into a new career, first reciting Lincoln's speeches for the public, and then ultimately venturing into something much more experimental. Price abandons the text-based performances of reciting Lincoln's speeches, and takes up a mode of performance that erases the boundaries that have traditionally defined the proscenium stage, separating audience and performers. Indeed, Price develops a mode of performance in which spectators become active participants. He plays the mortally wounded 16th American President for customers who pay to play the role of John Wilkes Booth and to shoot the President in improvisational reenactments of Lincoln's assassination at Ford's Theatre.[55] In many respects, the performance derives from a wildly provocative avant-garde conceit that troubles the foundational histories of the American avant-gardes, while binding Price ever deeper within economic structures that, out of dire necessity, he has no choice but to sustain and that perpetuate his own subjugation. Here the journey into experimental performance is not the product of revolutionary sentiment but of sheer financial despair. In *The America Play*, the linkage between avant-garde experimentation and economic subjugation thus raises fundamental questions about who the beneficiaries and who the disen-

franchised are—who the victors and who the vanquished are—in the most dominant conceptions of the avant-gardes.

Much, of course, can be made of the meta-theatrical allusions to Hamlet in Parks's decision to cast her main character as a gravedigger, that relatively obscure, one-dimensional Shakespearean figure who, in his minor and subservient role, merely facilitates Prince Hamlet's soliloquy on life, death, and the late court jester, Yorick. But more important, I think, are the implications of Parks's decision to single out that pivotal moment in American history when radical politics and theatrical practice converged in a bloody rupture of political order and theatrical decorum, leaving Lincoln with a gaping hole in his head—one of the truly great holes of history. Indeed, that moment, which is reenacted time and again in the play, situates Parks' main character in a violent cycle of death and resurrection, repeating what I would suggest the play implicitly but plausibly posits as the unacknowledged messy birth of the American avant-gardes. Unlike the standard narratives of the American avant-gardes, this is a birth with profoundly reactionary undercurrents. Moreover, it is a birth that, viewed from within its own historical context, is arguably on a par with the events of 9/11. In the absence of twenty-first century media technology, it would have been hard in the nineteenth century to find a more "theatrical" site than the theater itself for such a symbolic, albeit brutal, gesture like the assassination of a president. More to the point, it is hardly too much of a presumption to conclude that, if given the choice between taking down the twin towers or taking down the American president, Osama bin Laden would have opted for the latter. The death of a president has global implications.

One can wonder for some time about why the operative logic that would lead American critics like Schechner and Sell to characterize the attacks of 9/11 as an avant-garde event did not lead earlier to a similar assessment of events like the assassination of Lincoln—an assessment *The America Play* encourages, and that would demand a fundamental rethinking of the historical foundations of the American avant-gardes. Given the fact that the actions of John Wilkes Booth belong to some of the least progressive moments of American history, such an assessment would hardly cast American vanguard traditions in an auspicious light, but it would open the door to a serious consideration of the limited political spectrum within which historians have generally conceptualized the history of American vanguardism. The implications here are signifi-

cant. Following the line set by Parks in *The America Play*, such a rethinking of how limited the considered political spectrum of the avant-gardes has been would not only widen the horizontal scope of American vanguardism, it would arguably also shift its center of gravity significantly, to say the very least, toward center-to-right political traditions—the kind of traditions Parks breaks with in *The America Play*, rather than looking to them for inspiration.

More important still, I would suggest that the absence heretofore of such a rethinking bears a disturbing similarity to the kind of denials that tacitly or secretly give safe harbor to political affiliations that are dialectically opposite to that which is publically acknowledged. Perhaps the simplest way to illustrate this point is to note that amid *The America Play*'s Magruder-like repetitions of Lincoln's assassination, it is easy to lose sight of the possibility that the reenactments of the Lincoln assassination are a ruse, and are ultimately a lot less appalling than the dirty secret for which they provide cover. The opportunity to "shoot Mr. Lincoln" in a historical reenactment gives a whitewash of legitimacy to the fantasies of a racist public only too happy to pay a penny to shoot a black man and put him in his place. In this respect, Bram Price's "emancipation"—purchased at great price, according to historical narrative, through the martyrdom of Abraham Lincoln—ultimately amounts to little more than the contradictory opportunity to subject himself to daily executions, literally in order to step out of the grave. Lincoln is shot once, while for Price a pistol to the back of the head is a day-to-day economic reality as a black man. As Miyoshi argues is the case with the neocolonial structures of globalization, so too does emancipation (as depicted in *The America Play*) simply inaugurate a new structure of enslavement.

Moving from administrative to economic bondage, Price's plight echoes the processes of decolonialization that, according to Miyoshi, are now hallmarks of the racist and oppressive disenfranchisements of globalization: "Decolonialization," Miyoshi argues, "neither effected emancipation and equality nor provided new wealth or peace. Instead, suffering and misery [continue . . .] in an altered form, at the hands of different agencies."[56] In Miyoshi's study those agencies are best exemplified in transnational corporations, whose extra-national status has increasingly positioned them beyond democratic regulation, while allowing them to determine the material conditions of general populations whose "local culture and history," like "The Great Hole of History" theme park in *The America Play*, are reduced to the stuff of tourism and commodity.[57] Re-

gardless of whether such vertical political and economic structures are associated with the legacies of slavery in the US or with the neocolonial dynamics of globalization, they point to a global social stratification—a separation of the victors from the vanquished—where "local culture and history," where political ideals, and where the rhetoric of vanguardism and the vanquished themselves all become manipulable objects in the geo-political hobbies of the rich.

V. Post-9/11 Anthems from the Vanquished Vanguard

Situated within a larger global context, the image that *The America Play* presents of a black man daily confronting a pistol to his head brings me full circle in the contrast that I have been building between proclamations of the avant-garde's death and possibilities of a contemporary avant-garde, between a sense of the avant-gardes that empathizes with the victors and a sense of the avant-gardes that speaks from the perspective of the vanquished, and between a conception of the avant-garde as unitary and a conception of the avant-gardes as horizontal and vertical in structure. Bram Price teeters between death and phoenix-like survival. He is an elusive figure, dodging and improvising his way through daily threats of terror, and for this reason he offers a profoundly important model for understanding the multiple and problematic modes of vanguardism summoned into play by the events of 9/11—a model, I would argue, that a little over a decade later found a ready echo in Richard Montoya and Culture Clash's post-9/11 performance piece, *Anthems: Culture Clash in the District.*

Commissioned by Washington's Arena Stage, *Anthems: Culture Clash in the District* originally bore the title *Radio D.C.: Culture Clash in the District* and was intended to be a DC version of Culture Clash's successful Miami-based piece, *Radio Mambo,* which they brought to DC during the Arena Stage's 1999–2000 season. Like *Radio Mambo, Radio D.C.* was to be based on interviews that Montoya and the two other members of Culture Clash conducted throughout DC's various communities and neighborhoods and then distilled into a conceptual survey of the city's political and cultural landscape. But as the Arena Stage's artistic director Molly Smith notes, "Two years into the process, the events of September 11th changed our world and, of course, the project." The piece that ultimately became *Anthems: Culture Clash in the District* was written by

Montoya in the months following 9/11 and structured around his coinci-
dental encounter in the Houston airport with a grief counselor from Ar-
lington, Texas, "who was flying out east to help families devastated by the
events of 9/11," and who, in the course of the conversation that ensued
while they were waiting for their flights back east, encouraged Montoya
"to search the city for an 'anthem'."[58]

Played out against the backdrop of this patriotic grief counselor's re-
quest that Culture Clash provide an anthem to a stricken nation, *An-
thems: Washington D.C.* is clearly sensitive to the senselessness of the nu-
merous deaths on 9/11, yet it never loses sight of activism or of the shifting
paradigms of the vanguards. Indeed, *Anthems* is remarkable for its refusal
to let the call for unity, the call for an anthem, to become a sentimental
whitewash that elides a national history full not only of acts of aggression
on behalf of corporate interests abroad, but also of acts of terror against
the weak, the poor, and the minorities at home. Moreover, if *Anthems*
embraces a model comparable to that found in Parks's *The America Play,*
the model is evident in the only answer that Montoya is able, finally, to
propose to the grief counselor's call for an anthem that might unite the
US in troubled times: Billy Holiday's "Strange Fruit." In citing Holiday's
haunting tribute to those murdered by racist lynching mobs, Montoya
not only moves into the terrain summoned by the image of a pistol
pointed at the back of Bram Price's head, but he also provides a much-
needed reminder that for many Americans, brown and black Americans
in particular, the events of 9/11 were merely *another example of*—rather
than *an introduction to*—terrorism at home.

For those Americans there was no loss of innocence on 9/11. There was
little innocence left to lose. Like the families of those lynched and hang-
ing from the trees in Holiday's song, they have known intimidation and
terror all their lives. As Montoya tells the audience toward the end of the
Anthems, "sometimes the face of terror comes in forty-one bullets in a
vestibule, sometimes the face of terror wears a white sheet over its face
[. . .] sometimes terror kills transgenders in southeast D.C.," and "some-
times the face of terror looks like Timothy McVeigh."[59] All of these faces
participate in the combination of spectacle and theatricality that Weber
linked together in his discussion of 9/11. Similar faces of terror were pres-
ent in the early 1980s, when Schechner prefaced his discussion on "The
Decline and Fall of the (American) Avant-Garde" by expressing trepida-
tion about a future that portends "danger, even terror and doom,"[60] and
they were certainly present almost thirty years later, when he argued in

PMLA that "what 9/11 offered was a spectacle of cruelty in the Artaudian sense."[61] In this respect, it is a bit of a misnomer to speak of the events of 9/11 as avant-garde—unless, of course, one is willing at the same time to discuss the long history of terrorism against minorities in the US in similar terms.

Viewed from the perspective of America's vanquished, the characterization of 9/11 as avant-garde is selective at best. The question is what does this selectiveness say? There is no small irony to the fact that such characterizations come at the one historical moment when, after listing the many faces of terror that have been used to oppress people of color in the US, Richard Montoya tells his audience: "but right now the face of terror mostly looks like me."[62] Whether as a matter of coincidence, oversight, or bigotry, the designation of terrorism as avant-garde comes only when people of color look like the perpetrators of "danger, even terror and doom." Indeed, this blurring of identities in the face of terror marks a troublesome shifting of paradigms about the contemporary avant-gardes. It implies that vanguard artists who are black or brown are a moral and political threat to a supposedly liberal and tolerant cultural order. At the most subtle ideological level, then, the selectiveness in characterizing 9/11 as avant-garde thus expresses empathy with the rulers.

Among the truly great accomplishments of *Anthems* are the work's resistance to this selective characterization and its concomitant extension of the terrorist/vanguard logic to the long, troubled history of American extremism. Early in *Anthems,* we hear the loud crash of airliners. It is an unmistakable reminder of the death of many in September of 2001. But not the death of the avant-garde. Marking the heinous arrival of one vanguard, the replay of this abrupt and disturbing sound in *Anthems* signals one vanguard facing off with the actions of another—one vanguard seeking an alternative to carnage shrouded in spectacle or in patriotic displays that whitewash a violent history of aggression and bigotry.

Victims of History and the Ghosts of the Avant-Gardes

A Plausibly Deniable Conclusion

A theatre that is closed cannot raise money, a theatre that is
struggling can. Once dead everyone mourns, people don't try to
revive the dead but they do save the living.

JULIAN BECK

Perhaps it is a testament to the original timeliness of the work itself that
roughly forty years after its publication by Surkamp Verlag in 1974, Peter
Bürger's *Theory of the Avant-Garde* continues to haunt not only studies of
avant-garde performance but studies of the avant-gardes across the spec-
trum of the arts. If there is an irony to this haunting, it lies in the fact
that, as critical gestures, the constant refrains of Bürger's work are so very
un-avant-garde. Looking backward rather than forward, they possess lit-
tle of "the radical quality of the break with what had prevailed heretofore"
or "the historically unique break with tradition" that Bürger posited as
defining touchstones of "the historical avant-garde" as a mode of cultural
expression.[1] Obviously, there is no dictate that requires studies of the
avant-gardes to be avant-garde themselves. However much scholarship is
driven by a seemingly unending quest for the new, legitimacy in cultural
criticism is not contingent upon a break with tradition or with what has
prevailed heretofore—unless of course that break renders visible that
which existing scholarly discourse leaves invisible. In this latter respect,
there is significant irony in the haunting presence that Bürger's work has
in current studies of the avant-gardes. That haunting largely precludes
critical inquiry into another form of haunting that has everything to do
with how we might conceptualize the living legacy of the avant-gardes.
Indeed, while Bürger's theories lend a kind of life support to arguments
that grandly pronounce the death of the avant-garde, these same theories
discourage serious critical scrutiny of what one might call the ghosts of
the avant-gardes.

As a conclusion to this book, I would like to suggest that much of the significance and continued viability of the avant-gardes—whether one speaks of the avant-gardes of the past, the present, or the future—rests with those ghosts, and with what I would call vanguard ghosting. This is, of course, a metaphorical and not a metaphysical paradigm, and I posit it here as a counterweight to the often-overlooked fact that the "death" critics have frequently used to pronounce a finality, end, or termination to avant-garde gestures is itself a metaphor. As grand as those pronouncements of the death of the avant-garde might sound—and the function of metaphors is in part to aggrandize—they traffic in a conceptual impossibility. Every vanguard gesture leaves a trace, and those traces have an uncanny, haunting vitality that critics have been slow to consider—a vitality rich with previously unexplored meanings and new potential meanings as well. Indeed, avant-garde gestures frequently derive their initial vitality from the ghosts haunting the gestures that preceded them. At its most basic level, then, vanguard ghosting is the process whereby avant-garde gestures find and give voice to residual or untapped significance and meaning in previous gestures—significance and meaning that linger either because they were left unexplored or because new historical contexts bring them into play.

In terms of historiography, this notion of vanguard ghosting offers a conceptual flexibility that is vastly superior to the strict linearity and the far more restrictive notion of the avant-gardes and of history itself that Bürger assumes in *Theory of the Avant-Garde*. Indeed, some initial sense of the conceptual restrictions that Bürger's theories enforce can be garnered through a simple juxtaposition of his categorical dismissal of "the neo-avant-garde," on the one hand, and Marvin Carlson's more recent embrace, on the other, of the characteristic feature of theater, which he calls "ghosting." Bürger's arguments discount almost the entire post-war American avant-gardes, and they carry a surprising hostility toward performance—avant-garde or otherwise. In one of his more dismissive references to the work of Andy Warhol, for example, Bürger argues that "the neo-avant-garde, which stages for a second time the avant-gardiste break with tradition, becomes a manifestation that is void of sense and that permits the positing of any meaning whatever."[2]

There is no small irony in the fact that that the strict sequential linearity of Bürger's anti-theatrical rejection of the "neo-avant-garde" is itself haunted by the legacy of avant-gardists like Antonin Artaud. In many respects, in fact, Bürger's rejection rehearses (i.e., "stages for a second time")

Artaud's own arguments in *The Theatre and Its Double* "that an expression does not have the same value twice, does not live two lives; that all words, once spoken, are dead and function only at the moment when they are uttered, [and] that a form, once it has served, cannot be used again and asks only to be replaced by another."[3] Not only does this rehearsal of Artaud situate Bürger conceptually in what one might call a "neo-modernist aesthetic." It also links his arguments to what Rosalind Krauss has famously identified as the avant-gardes' discourse of originality.

According to Krauss, that discourse perpetuates an "organicist metaphor" that equates vanguard expressions with "a literal origin, a beginning from ground zero, a birth," and ultimately a death, and it thus refers "not so much to formal invention as to sources of life."[4] Bürger's allegiance to this anti-theatrical discourse is evident in the fact that he equates repetition (e.g., staging "for a second time") not only with an absence of sense, but, inasmuch as repetition supposedly allows for "any meaning whatever," he also equates it with the loss of a presumed authentic meaning available only in an unprecedented event. Krauss counters such notions with her now famous assertion that "the actual practice of vanguard art tends to reveal that 'originality' is a working assumption that itself emerges from a ground of repetition and recurrence."[5] In short, the very concept of "originality" is always already haunted by the ghosts of the avant-gardes.

Although Marvin Carlson speaks little of the avant-gardes in his book *The Haunted Stage,* his notion of "ghosting" as a characteristic feature of theater highlights the extent to which Krauss's argument subtly acknowledges avant-garde theatre and performance. For the phenomenon to which Carlson gives "the name *ghosting*"—the phenomenon that he argues is central to theater itself—involves a process of staging and re-staging, and of appearance and re-appearance. Playing off Marcellus's question in *Hamlet,* "What, has this thing appeared again tonight," Carlson argues that "ghosting" occurs in the theater when spectators confront "the identical thing that they have encountered before, although now in a somewhat different context."[6] If, as Krauss suggests, repetition and recurrence are the ground from which the avant-gardes's notion of "originality" emerges, it is no small matter that this ground is also the very substance of theater and performance. Krauss's implicit critique of Bürger's embrace of the discourse of originality thus segues into a performative space where, echoing Carlson, I would like to suggest the ghosts of the avant-gardes begin to take visible form.

To some extent, these ghosts coincide with the broad implications of Carlson's arguments not only about the haunted stage but in particular about what he calls "the haunted text." It is not difficult, for example, to see some correspondence between Julian Beck's account in "Storming the Barricades" of the effect that Artaud's *The Theatre and Its Double* had on The Living Theatre, and Carlson's more general assertion that in the relationship between a "preexisting dramatic text and its enactment onstage" it is possible to speak of a "'haunting' that lies close to the structure of the theatrical experience."[7] Indeed, recalling the moment in the summer of 1958 when M. C. Richards' translation of *The Theatre and Its Double* arrived in the mail, Beck says that he and the other members of The Living Theatre read the book "again and again" until "the ghost of Artaud became [. . . their] mentor."[8] That ghost transformed their theater. But what is significant about Beck's reference to "the ghost of Artaud" is that, as a mentor, this ghost led The Living Theatre not into the haunting baggage of theater history that Carlson explores in his book, but rather, into an altogether different haunting, where the ghosts of history—the vanquished, the repressed, and the victims of injustice—cry out in accusation against those whom Beck describes as:

> the heartless monsters that wage wars, that burn and gas six million Jews, that enslave blacks, that plan bacteriological weapons, that annihilate Carthage and Hiroshima, that humiliate and crush, that conduct inquisitions, that hang men in cages to die of starvation and exposure [. . .], that wipe out the Indians, the buffalo, that exploit the peon, that lock men in prisons away from natural sex, that invent the gallows, the garrote, the block, the guillotine, the electric chair, the gas chamber, the firing squad, [and] that take young men in their prime and deliberately teach them to kill.[9]

It may be a politically idiosyncratic reading of Artaud to suggest, as Beck does, that "Artaud believed that if we could only be made to feel, really feel anything, then we might find all this suffering intolerable [. . . and] put an end to it."[10] But inasmuch as Beck's reading of Artaud somehow leads to this conclusion, I would like to suggest that it is a near-perfect example of vanguard ghosting. For in this reading, it is not only the ghost of Artaud who haunts Beck and the other members of The Living Theatre.

It is clear from Beck's comments that he is haunted by the specter of the suffering he detailed in the passage I just cited. This haunting is not

unlike that which Alice Rayner describes in her book *Ghosts: Death's Double and the Phenomena of Theatre*. In the introduction to that book, Rayner argues that "ghosts hover where secrets are held in time: the secrets of what has been unspoken, unacknowledged; the secrets of the past, the secrets of the dead. Ghosts wait for the secrets to be released into time."[11] Such ghosts haunt Beck's reading of *The Theatre and its Double*, and in a very literal sense, they are the ghostwriters of the political activism that Beck derives from Artaud's visionary prescription for the theater. At one level, then, we might use Beck's reading of Artaud to supplement Carlson's concept of ghosting. Vanguard ghosting is not merely an instance of "encountering the identical thing" that one has encountered before in a now "somewhat different context," and recognizing in turn that this reappearance of the familiar is haunted by the previous contexts where one first encountered it. New and different contexts are populated with ghosts as well—ghosts that press for a revised understanding of the familiar objects one encounters. Ghosts make the familiar *"unheimlich,"* uncanny . . . strange. As we will see momentarily, those ghosts, while giving form to that which "has been unspoken" or "unacknowledged," may carry with them not just "the secrets of the past" but also the secrets of the present and the haunting possibilities of the future. In this respect, Beck's idiosyncratic yet politically creative reading of *The Theatre and Its Double* offers us insight into how texts are always already haunted by any number of potential readings.

This latter haunting is a call to experimentation and innovation, a call that is forward-looking and that cultivates vanguard expression. Despite Bürger's anxieties that repetition or staging "for a second time" allows for "any meaning whatever," I would suggest that Beck's idiosyncratic reading of Artaud exemplifies the radical vanguard potential of the very tendency Bürger discounts. Far from being a liability that, as Bürger suggests, is devoid of "sense," the possibilities of "any meaning whatever" are limited only by the level of courage one has to improvise those possibilities into significance. Indeed, the radical exploration of those possibilities can reorient ghosting itself. Whereas Carlson sees the haunted stage as a memory machine, Beck's mentor apparently opened the eyes of The Living Theatre to the ghosts of the present and the future, as well as the past. In a manner reminiscent of the darkest moments of Charles Dickens's Christmas narrative, these ghosts haunt the present with the unseen, the unforeseeable, and the overlooked, and the morally disastrous potential consequences that attend them.

The odd temporal conceit of the ghosting implied in Beck's reading of Artaud provides a vivid metaphor for the conceptual structures of the visible and the invisible that I want to explore first in my discussion of The Living Theatre's productions of Kenneth Brown's *The Brig*, and then in a concluding discussion of vanguard ghosting and Artaud's *The Theatre and Its Double*. It is not a matter of coincidence that I have prefaced these discussions with reflections on Beck's own reading of Artaud, for both *The Brig* and vanguard ghosting more generally are foreshadowed in Beck's reading. The Living Theatre's production of *The Brig* in the spring and summer of 1963 was conceptualized as a realization of Artaud's "Theatre of Cruelty." Moreover, Beck's essay "Storming the Barricades" has a historical tie to Brown's play, having first been published as a preface to the 1965 Hill and Wang edition of *The Brig*,[12] which followed The Living Theatre's original production of the play and which, it is worth noting, appeared in print after the IRS had closed The Living Theatre's Fourteenth Street theater in October 1963, and Beck and Judith Malina were themselves incarcerated on contempt-of-court charges.[13]

Whether those charges were politically motived has always been a matter of debate. Beck and Malina certainly believed that mixing Artuad's "Theatre of Cruelty" with Brown's radical critique of military culture was capable of producing a politically subversive enough spectacle—a kind of theatrical Molotov cocktail—that a backlash was a genuine possibility. Malina claimed as much in a now legendary interview conducted while the members of The Living Theatre had re-occupied the Fourteenth Street theater temporarily after the IRS had locked them out and shut down their production of *The Brig*. Yelling answers from the third-floor office window to Richard Schechner, who was posing questions to her via a megaphone from the street, she told him "that the kind of plays" they produced had "a lot to do with" the closing of the theater.[14] Yet in the same issue of *TDR* where that interviewed appeared, Charles Mee argued it was inevitable that the "creditors would eventually close in," calling it the height of "stupidity" for Beck and Malina to believe that incurring massive debts and running up "a tax bill of thousands of dollars" was not a prescription for closing a theater.[15] If the political activism of The Living Theatre's work was subversive enough to provoke a backlash—and it is debatable whether it was—their seeming disregard of financial responsibilities was nothing short of an invitation to the authorities to take action against the group.

For his part, Beck tended to frame the closing of the Fourteenth Street

theater as yet another example of the repressive mechanisms of an increasingly authoritarian society. *The Brig* had only exposed the crudest militaristic forms of that society. Judith Malina echoed this framing by arguing that *The Brig* is merely "a structure" and that "the Immovable Structure is the villain" regardless of "whether that structure calls itself a prison or a school or a factory or a family or a government or The World As It Is."[16] Nowhere was this framing more evident than when in an act of resistance to the IRS's demand that they quit the building, the members of The Living Theatre symbolically turned the significance of the set design for *The Brig* on its head. With the IRS pressing them to vacate, Beck and the other members of The Living Theatre "all went into the inner compound of the brig and announced [. . . they] would not go until . . . allowed to perform."[17] That inner compound was a cage, complete with a mesh of barbed wire to separate the performers and the stage from the audience, thereby foregrounding the brutal realities of incarceration within the penal system of the armed services. In performances of *The Brig*, the inner compound of the set was a site of discipline, constraint, and detention. Above all it represented what it felt like to be brutally cut off from society at large. But at the moment when the IRS began closing in for eviction, Beck, Malina, and the other members of The Living Theatre recognized in the inner compound a radically opposite potential: a site of staged resistance and a last bastion of artistic freedom within a society where, from their perspective, the repressive apparatus of the state had become all-pervasive and was literally closing in. In this respect, the inner compound was not devoid of sense but was open to "any meaning whatever"—for those who had the courage to improvise it into a new significance.

Despite the IRS's efforts to evict The Living Theatre and to keep the public out of the building, enough people found their way in through windows and openings in the roof that an audience formed, and shortly before 10:00 pm on October 19, 1963, The Living Theatre began their last performance of *The Brig* at the Fourteenth Street theater. From within the cage—that site of brutal discipline and authority—they mounted what Beck ironically but legitimately called "a performance which was in and of itself an act of civil disobedience" and an "act on the part of individuals who were saying we want the freedom to create, we want a society in which the inhibitions of the state and/or money do not dominate."[18] Kenneth Brown stood with them, as did the roughly forty members of the audience, many of whom along with Brown were later arrested with

The Living Theatre on charges of "Impeding a Federal Officer in the Performance of his Duties."[19]

Among the ghosts of this moment were Brown's companions from the Third Marines with whom, roughly five years earlier, as a 19-year-old recruit, he had done thirty days hard labor in Camp Fuji, the marine corps brig close to Mount Fujiyama in central Japan. The brutalization he and the other prisoners endured there largely provided the substance of his deeply disturbing drama. In many respects, the play itself is haunted by those experiences. Indeed, it is difficult to imagine how Brown, or anyone else who was arrested on that October night in 1963, could avoid drawing haunting parallels between the potentially violent prospect of prison time and the state-sanctioned brutalities of time in a military brig. The act of civil disobedience—i.e., the performance itself—and the ensuing arrests established an otherwise inaccessible affinity with those marine prisoners. Malina gave voice to that affinity in the parallels she drew between the month she had previously spent "in the Women's House of Detention" for her acts of civil disobedience and hearing "the familiar metal scraping prison sounds and the stamp of the booted foot on concrete"—a sound that she acknowledges "will haunt [. . . her] forever as they will haunt all of us who have been prisoners."[20]

From the perspective of the state, this is the haunting that is most desirable, a haunting that is most frightening because, like ghosts themselves, it is only vaguely discernable. As Avery Gordon argues in his book *Ghostly Matters,* the possibility of disappearing into the hands of the state is not a matter that the state wants to keep entirely "hidden away, but rather [it] must be discernible enough to scare 'a little bit of everyone' into shadows of themselves, into submission."[21] On the other hand, the haunting parallels between a prison and a military brig established the kind of affinity that is ultimately necessary to bring about social change. Drawing in part upon the work of Michael Taussig, Gordon argues that "haunting is [. . .] the mode by which the middle class needs to encounter something you have to try out for yourself, feeling your way deeper and deeper into the heart of darkness until you do feel what is at stake"[22]—in other words, until you know that the choice is between becoming a submissive shadow of yourself or refusing the shadows.

Ironically enough, the harsh, dismissive criticism of The Living Theatre's unlicensed performance of *The Brig* that subsequently came from theater practitioners like Herbert Blau and Jules Irving only further established this haunting affinity between the evicted and soon-to-be ar-

rested performers and the prisoners within *The Brig* whom they portrayed. Blau and Irving admonished readers of *TDR* to avoid "spooky speculation" and not to confuse "civil disobedience" with what they considered to be "an inexplicably dumb show" that amounted to little more than "the most adolescent kind of law-breaking."[23] Yet adolescent law-breaking and a disproportionate, heavy-handed response to it by civilian or military authorities is precisely what linked the performers at the Fourteenth Street theater to the actual prisoners who had been subjected to the sadistic physical brutalities and psychological humiliations that constituted punishment at Camp Fugi. As a young marine, after all, Kenneth Brown had received thirty days in the Brig merely for being late for an assignment.[24] What was possible within the marine corps—what Brown bitterly described as "being treated inhumanly by people who were supposed to be [. . . his] fellow countrymen"[25] for mere adolescent irresponsibility—was now a specter that potentially loomed over any social non-conformist at any point.

Blau's and Irving's dismissals notwithstanding, the final Fourteenth Street performance of *The Brig* was by almost any measure a germinal moment in the history of American avant-garde performance. Though perhaps naively idealistic, it combined a brinkmanship style of improvisation with political activism, radically redefining the space of theater. It liberated performance from subservience to the authority of the dramatic text, and provoking the civil authorities into action, it blurred the boundaries not only between performers and spectators, but between life and art. Even its more puerile moments of "acting out" were consistent with the frequently juvenile preoccupations of the Dadaists and of Alfred Jarry before them. The ghosts of the avant-gardes were with this performance, but to understand how profoundly haunted this performance really was, it is necessary to backtrack momentarily so as to reconsider Kenneth Brown's bitterness toward fellow countrymen who treated him inhumanely—and to consider this bitterness in light of Beck's allusions (in his idiosyncratic reading of Artaud) to the dispossessed and to the victims of injustice, those ghosts of history who cry out in accusation.

Brown's bitterness is all the more striking because it implicitly equates the expectation of humane treatment with a shared nationalism (e.g., "being treated inhumanly by [. . .] fellow countrymen"). This is not to suggest somehow that Brown was a latent nationalist, extending notions of humanity only to those who march under the stars and stripes. In fact, Brown categorized his play in universalized existentialist terms, as an ex-

ploration of the "human condition."[26] The issue is rather that beneath his bitterness, there lies a haunting that would point us to something deeper than the fear that what happens in *The Brig* could happen at home. This haunting points us into the shadowy and more disturbing realms of clandestine operations and ghost wars, where CIA operatives are routinely called "spooks," and where the ghosts of the voiceless, the repressed, the disappeared, the tortured, and the murdered reside. This is a haunting in the shape of the simple question—a question that Brown himself echoed in a 2007 interview.[27] If Americans are willing to treat their fellow countrymen inhumanly within the structures of their own penal system, what are they willing to do to non-citizens who do not enjoy the ostensible protections of the law, and who, like the prisoners at Abu Ghraib, are viewed by their guards "as culturally alien, as enemies, as inferior—as Other"?[28] At the time when Brown was locked up in the brig at Camp Fugi in the late 1950s—roughly at the same time Beck and Malina were put in jail for "participating in an anti-nuclear demonstration"[29]—this was a question that few wanted answered. John Prados has noted, for example, that the then Chairman of the Senate Armed Services Committee, Senator Leverett Saltonstall, once commented: "It is not a question of reluctance on the part of CIA officials to speak to us. Instead it is a question of our reluctance, if you will, to seek information and knowledge on subjects which I personally, as a Member of Congress and as a citizen, would rather not have."[30] One does not need to ponder such statements for long to recognize the culpability involved in being aware of something that appears morally suspect and yet consciously deciding not to look into the particulars of it.

Morally repugnant though Saltonstall's selective ignorance may sound—especially coming from a Chairman of the US Senate Armed Services Committee—it is consistent with the policy of "plausible deniablity" that has governed US covert operations since their inception during Harry Truman's presidency at the beginning of the Cold War.[31] This is a policy that multiplies the mechanisms of power and authority of the state through a calculated ignorance that obfuscates and leaves those mechanisms unchecked by the rule of national and international law. Ironically enough, this notion of plausible deniability might also be used to describe the status in which all ghosts exist, regardless of whether those ghosts are the covert agents of the state, the restless victims of repression and injustice, or simply the stuff of supernatural fancy. Whether paramilitary or paranormal, ghosts are plausibly deniable because they are

both visible and invisible. If nothing else, the shadowy spaces of plausible deniability remind us that the haunting world of ghosts is a terrifying realm in which anything can happen. It is the locus of those who have been "ghosted" and/or "disappeared." It is the dominion of "ghost planes" and extraordinary rendition. It is that "parallel world" of black sites and secret prisons that exist, like Alexander Solzhenitsyn's descriptions of the Gulags, "within physical reach of everyday life but yet [. . .] unseen to ordinary people."[32] At the same time, however, the realms of plausible deniability are not the realms of absolute deniability. Despite the unleashed state-sponsored terror facilitated by such politically sanctioned evasiveness, its restless victims—those ghosts of history past, present, and future—appear again and again to press their case.

At an abstract level, the extent to which the very appearance of such restless victims is enough to press their case is arguably the focal point of plays like Harold Pinter's *Party Time*. In the closing scene of that play, which takes place against the backdrop of a brutal police action in the streets, there is a particularly good example of this point, particularly with regard to the character Jimmy, whose noticeable absence from a social gathering of political elites is a politically sensitive and thus consciously avoided topic. Earlier, at this same party, Jimmy's sister Dusty inquired about her brother's sudden disappearance and was met with feigned ignorance, chilling indifference, and ominous rebuffs. Her husband Terry warned, "Nobody is discussing this [. . .] Do you follow me? Nothing happened to Jimmy."[33] When Jimmy arrives at the door at the end of the play, it is not clear whether he is alive or dead, but either way he is a ghost of his former self. Disoriented and uncertain about where he is or what has happened to him, he speaks cryptically of the violence of which he is a victim. Like Jimmy's ambiguous status in this final scene, Pinter's entire play is strategically ambiguous with regard to time and place. *Party Time*'s dramatization of Jimmy's return is thus arguably more of a theoretical reflection calling attention to ghosting than it is an actual example of a drama or performance haunted by ghosts. Indeed, the temporal and spatial ambiguity of the play functions like a script for the audience, rhetorically encouraging them to seek a historical point of reference for the simulated repressiveness enacted on the stage.

When the ghosts of the avant-gardes appear, however, their appearance is always unscripted and radically improvisational. Julian Beck was a conduit for their voices when, from within the pages of *The Theatre and Its Double,* he somehow discovered echoes of the cries of murdered Jews,

enslaved Africans, and dead citizens of Hiroshima. These are cries that haunt the text, but, unlike the appearance of Jimmy in Pinter's *Party Time,* they are without direct textual warrant. You will not find them in the pages of Artaud's visionary book. They haunt from the periphery and the margins, where they press their case amid plausible deniability, visible but invisible, in the text but not of the text. Moreover, their presence cannot be discounted as the product of Beck's profoundly creative abilities as a poet, artist, and reader. The ghosts of history haunt artist and audience alike in the work of the living.

Fifty years after The Living Theatre received M. C. Richards' translation of *The Theatre and Its Double* in the mail, their 1963 Artaud-inspired production of *The Brig* continues to haunt them. That haunting hovered about their 2001 "collaboration with local theater artists in Lebanon" in the creation of a "play about the abuse of political detainees in the notorious former prison at Khiam."[34] It also hovered about the opening of their new theater on Clinton Street in New York's lower east side in April 2007, which they inaugurated with a re-staging of *The Brig.* While, to echo Bürger once again, some might consider this re-staging of *The Brig* for a second time a gesture that is "void of sense," the members of The Living Theatre argued that "a play about brutality inside a US military prison seems more to the point today than ever."[35] In 2007, they were hardly alone in seeing the play's new relevance—a relevance that was clearly the result of the radical potential of a play that was far from being "void of sense" precisely because it lent itself to interaction with and was haunted by profoundly disturbing forces of history. The potential of this rich context of relevance echoed through the press. Writing for *The Village Voice,* for example, Michael Feingold suggested that if the new production of *The Brig* "makes you think of Abu Ghraib, of Guantánamo, of secret CIA prisons in Eastern Europe, or of a US government that claims the right to hold its own citizens incommunicado for months on end without criminal charges," The Living Theatre is not to blame.[36]

But neither is the text of Brown's play to blame. The victims of Abu Ghraib, of Guantánamo, of secret CIA prisons and of the US government's willingness to incarcerate its citizens (and others) without charging them, are only present in the performance of *The Brig* as ghosts. They haunt the margins of a text to which they do not belong. In a very literal sense, they are there in spirit rather than in the letter. In this respect, I would suggest, to speak of the ghosts of the avant-gardes is to speak also of a sensibility for the haunted spaces where they plausibly reside. It is to

speak of a sensibility capable of improvising those spaces into perceptible and plausible legitimacy—a sensibility that, among other things, improvises invisibility into visibility and works thus against plausible deniability. At one level, such improvisations result from an opportunistic and subversive misreading of the written word. In substance, however, such improvisations are crucial performative gestures of the avant-gardes. Far from being the products of a senseless void, they are the haunting antithesis of the death of the avant-garde. As such, they are a vital dimension of the avant-gardes' continued relevance today.

Such improvisations may be easy with a piece like *The Brig* in 2007, but the improvisations go much further than an ability to draw an analogy between the unjustifiable brutality dramatized in *The Brig* and the unjustifiable brutality played out in an Abu Ghraib, a Guantanamo, or a secret CIA prison. They touch upon a profound understanding of the combative relation that experimental performance has with textual authority—an understanding that not only informed Malina's decision to do a new production of *The Brig*, but was central to the decision in the early sixties to do a production of *The Brig* in the first place. That understanding was on display in an interview Malina did shortly after the opening of the new production. There she explained that the play is "about torture, the torture consists of living [. . .] by the book and doing everything in an exact way."[37] Malina's immediate point of reference was obviously *The Guidebook for Marines,* which dictates the code of conduct by which Marines must abide. All the prisoners in *The Brig* are made to read this book incessantly. At the same time, it is the book whose authority and legitimacy are radically subverted by the sheer physical brutality for which it provides cover and which The Living Theatre's productions of *The Brig* expose.

Although the members of The Living Theatre have long held profound moral reservations about the military, Malina's pointed reference to *The Guidebook for Marines* and the role that it plays in The Living Theatre's productions of *The Brig* have less to do with the military per se than with the need to question "living by the book," whatever that book might be. This admonishment, which pivots in part on a classic avant-garde contrast between text and performance, is arguably grounded in a deep-seated belief that improvisation is a passageway into the haunted spaces where the ghosts of the past, present, and future can be heard beyond the lines of textual and political authority and are no longer invisible. This is an admonishment that would coax us into the margins of

textuality and into the radical potential of improvisation. It touches the pulse of a living legacy and the continued viability of the avant-gardes.

Keeping Malina's admonishment in mind, it is worth recalling that a continent, a quarter of a century, and a brutal world war—not to mention a language—separated the original publication of Artaud's *The Theatre and Its Double* and the ghosts that Julian Beck found in his subsequent reading of this visionary book prior to The Living Theatre's 1963 production of *The Brig*. Given this distance, Beck's initial idiosyncratic reading of Artaud is in many respects already a model of the continuing viability of the avant-gardes and of their ability to reconstitute themselves in subsequent improvised readings of literary texts and cultural artifacts. This is, in fact, what Beck's reading of Artaud exemplifies. A similar sense of that viability is evident in The Living Theatre's 2007 revival of *The Brig*, which not only populated the margins of Brown's drama with a new community of ghosted victims, but, with the CIA's practice of disappearing juridically inconvenient people, it also added a whole new layer to the very notion of "ghosting" as such. But what connects these two moments in The Living Theatre's history beyond the initial and subsequent productions of *The Brig* are the improvised readings that aim at the margins of textual authority, and that move from the conventionally visible toward those who are historically the dispossessed and the invisible. As a praxis, those readings preface what I have called vanguard ghosting.

While it is true, as I mentioned at the beginning of this chapter, that no dictate compels studies of the avant-gardes to be avant-garde themselves, I would suggest that the difference between seeing the ghosts of the avant-gardes and seeing the death of the avant-garde may very well pivot on one's ability, indeed on one's willingness, to venture into experimental reading as a praxis. It may depend, in other words, on one's willingness to improvise and to look to the margins—especially when reading the artifacts of the avant-gardes' own histories. Beck himself gives a cue for such a praxis in the record of his response to Artaud, a response that identifies many ghosts but that in its relation to *The Brig* ultimately led to a hearing for only a few. One might query those that remain and in doing so extend the processes of vanguard ghosting to a more sustained reading of the visible and invisible in Artaud's *The Theatre and Its Double*. To summon one example here, it is worth asking how one might read Artaud in response to the ghosts Beck identifies as "men [locked] in prisons away from natural sex" by "heartless monsters." In this final section of this chapter, I want to turn to this question.

Anyone familiar with the sexual politics of The Living Theatre and of Julian Beck in particular will recognize that his reference to "natural sex" has little to do with reinforcing heterosexual norms. On the contrary, the reference points toward an unrestricted sphere of sexual experimentation and exploration—a sphere in which, to borrow a phrase from Malina, sexuality is no longer practiced "by the book." In this respect, even the notion of locking men "in prisons" is as figurative as it is literal. It refers as much to the codified social mores that close the minds of men and women to a more radical understanding of sexuality as it does to the institutions that close them behind locked and guarded doors. Indeed, Beck's reference to prisons conjures the ghosts of those who have been incarcerated and persecuted behind bars because of their sexual identity and because of the threat that it presumably poses to the dominant social order. I would suggest that for Beck, "natural sex" thus refers to an understanding of sexuality that is so fundamentally diverse and fluid that it is anarchistic and threatening to the heteronormative economy of the body politic. It is radically performative and subversively visceral in ways that not only have profound parallels with Artaud's vision of the theater but that arguably bring the ghosts haunting that vision out of the closet and into visibility.

Since this notion of "natural sex" may seem far afield from The Living Theatre's productions of *The Brig,* and from the ghosts that haunt those productions, it is worth pausing briefly to remember that the most grotesque moments of that haunting—at least with regard to the 2007 production—are manifested not in vague references to Abu Ghraib but in the particulars that the vague references politely avoid and that thus largely remain invisible. Those particulars are documented in the deeply disturbing photographs the public saw for the first time in April of 2004. What the public saw in those photographs not only was foreshadowed by Beck's reference forty years earlier to the "heartless monsters" who "lock men in prisons away from natural sex." The photographs, while perhaps reminiscent of the system of humiliation recounted in *The Brig,* also document a strategy of calculated humiliation that uses physical and psychological torture grounded specifically in a vicious form of homophobia. Among other things, the photos that surfaced in 2004 show Iraqi men stripped of their clothing and forced to assume sexually suggestive positions with one another or with the guards who threatened them with physical violence and attack dogs. Time and again, the decisive subtext of these photos is written in the attempt to humiliate and degrade prisoners

specifically by associating them with homoerotic tendencies. This subtext, which is nothing less than a viciously authoritarian reinscription of compulsory heterosexuality, is based as much upon the profound homophobia that permeates US society as it is upon a corresponding homophobia in Iraqi society.

Amid the bewildering effects of the brutality recorded in these photos, it is easy to lose sight of the fact that the victims who haunt them are multiple and hard to identify because they reside in differing degrees of invisibility. First and foremost, the anonymous victims of torture populate the photographs themselves—victims robbed of their identities, who have been "disappeared" and "ghosted" and who only surfaced by chance in photos leaked to the media. There are also the un-photographed prisoners: victims who remain invisible ghosts in almost every sense of the word. But beyond the immediacy of these horrific instances of torture and abuse, other ghosts hover even further in the margins of the photographs: those whose sexual identity presumably is so threatening and is such a source of anxiety within Iraqi society, for example, that the potential release of a coerced photograph suggesting an association with them was enough to blackmail Iraqi prisoners into submission and cooperation. Then there are also people whose sexual identity is presumably so threatening and such a source of anxiety that the US military deemed it "unspeakable" and closeted it into invisibility with policies like "Don't Ask, Don't Tell."

These are the ghosts that the US military has forced into disparaged margins and shadows where they do not belong. This is the same US military that in its tacit approval of the abuses at sites like Abu Ghraib all too willingly links the display of homoerotic desires with the most degrading forms of humiliation. There is nothing natural about such a linkage. People forced into the shadows because of the sexual bigotry of Iraqi society or that of the US military and other US social institutions also haunt Abu Ghraib: they are the victims of policies that cultivate and sustain a deeply homophobic culture, both in and outside of the military. It is these ghosts who unite The Living Theatre's productions of *The Brig* with the specter of "natural sex" that haunts *The Theatre and Its Double*.

Some sense for that haunting can be found in the fact that Artaud's own resistance to the authority of the written word—his resistance, so to speak, to doing things "by the book"—is premised upon an embrace of a "physical knowledge" of theater[38] that is charged with erotic and anarchistic undercurrents. Describing a theater no longer beholden to the

"deaden[ing]" effects of what Artaud calls a "superstitious valuation of texts,"[39] he celebrates an anti-textual notion of performance conceptualized as "the encounter upon the stage of two passionate manifestations."[40] Indeed, Artaud calculates this celebration according to the degree to which the encounter—and hence performance itself—can be compared with a physical sensuality so intense that it eclipses one's allegiance to established civil and moral authority. In its opposition to literary works that are "fixed in forms that no longer respond to the needs of the time,"[41] performance thus becomes "something as entire, true, even decisive, as, in life, the encounter of one epidermis with another in a timeless debauchery."[42]

Artaud's use of an erotically charged metaphor to characterize the "physical knowledge" of theater and performance that he posits in opposition to literary authority is hardly unique as an image in *The Theatre and Its Double*. Nor is the image of "debauchery" the most provocative of those linking a "physical knowledge" of the theater with an intense, even desperate, sensuality. More provocative still—and more problematic—is the analogy Artaud draws between this physical knowledge of the theater and the image of someone in the time of the plague casting all rational caution to the wind, experiencing a "surge of erotic fever" and "trying to wrench a criminal pleasure from the dying or even the dead, half crushed under the pile of corpses where chance has lodged them."[43] If debauchery suggests a passionate, wild abandon, the suggestion here is to a force so extreme that it arguably begins to collapse under the weight of its own rhetoric. Indeed, I would suggest that however provocative this image of the dying and the dead piled together and sexually defiled may be as a characterization of an intense theatrical immediacy, the rhetoric of this image pushes far enough toward an extreme that the ghosts of the avant-gardes move once again from invisibility to visibility and press their case.

This erotically charged image segues back into Beck's original encounter with the ghosts who haunt Artaud's text. But more to the point, the image of someone wrenching "a criminal pleasure from the dying [. . . and] the dead" gives the ghosts haunting The Living Theatre's 2007 production of *The Brig* passage into *The Theatre and Its Double* as well. Puzzling though Beck's earlier idiosyncratic reading of Artaud might be, his reference to Holocaust victims (the "six million Jews" burned and gassed by "heartless monsters") bears some conceptual semblance to Artaud's image of the dying and the dead violated while "half crushed under [. . . a] pile of corpses" during the 1720 plague of Marseille. Indeed, I would suggest that this conceptual semblance establishes a connection where the traffic of ghosts moves not merely between the lines of textual author-

ity but also across generations and historical periods. It is worth remembering in this regard that among the most haunting and disturbing images from the Holocaust are the photographs of naked and emaciated victims left in piles to rot by heartless monsters. It does not take much to imagine how difficult it would have been in the early 1960s for Beck to read Artaud's graphic allusion to the victims of the plague without being reminded of the recent victims of those fascists who took criminal pleasure in murdering so many. If those horrifying photographs documenting the Holocaust haunt Beck's reading of Artaud, so too do the victims in those photographs and the victims of Artaud's graphic descriptions of the plague haunt The Living Theatre's revival of *The Brig*.

While this haunting is in part the kind of haunting of one production by another that Carlson discusses in *The Haunted Stage,* it also extends beyond the margins of the 1963 and 2007 productions of *The Brig.* Just as Beck could not read Artaud in the early 1960s without being haunted by the ghosts of those incarcerated, tortured, and murdered in Nazi concentration camps, so too do the ghosts of those incarcerated, tortured, and murdered in Abu Ghraib haunt *The Brig* after 2004. Here is an instance of vanguard ghosting that one might call "ghosts by association." It involves a haunting facilitated by the kind of associative logic that has been a staple of the avant-garde since the invention of collage: a radical juxtaposition of seemingly disparate elements that bring forth an unexpected meaning and significance out of a new and different context. But here is a place of vanguard ghosting that arises less from the collagist's constructions than from the uncanny momentary correspondences of history, such as the haunting parallels between Artaud's account of Marseille in 1720, Beck's knowledge of Buchenwald in 1945, and the leaked photographs from Bagdad in 2004.

If the chilling similarity to photographs of piled up Holocaust victims in 1945 haunt the photographs of piled up, abused, and potentially dead and dying Iraqi prisoners at Abu Ghraib, so too do Artaud's descriptions of the "surge of erotic fever" and of "criminal pleasure" wrenched from those "half crushed under [. . . a] pile of corpses" render the brutal sexual undercurrent of the Abu Ghraib photos visible. The ghosts who convene in the space of this haunting to press their case link Artaud's graphic description of the dying and the dead "half crushed under [. . . a] pile of corpses" not just with the photographs of piles of dehumanized Holocaust victims but also with the photographs of naked Iraqi prisoners stacked in piles in front of smirking US soldiers like Army Specialists Charles Graner, Lynndie England, and Sabrina Harman—smirking with

the erotically charged, sadistic, criminal pleasure that they apparently derived from "readying" the prisoners for interrogation. But how much credibility should scholars give to the associative logic of this case and this kind of historiography? How much validity can be found in the experimental reading that they entail—an experimental reading that as a critical practice has solid precedent in Beck's own idiosyncratic reading of Artaud? The question that looms over the haunting parallel between Marseille, Buchenwald, and Baghdad is thus a question of whether to acknowledge the parallel's legitimacy and give it voice and visibility in critical discourse, or whether to embrace its plausible deniability and thereby relegate its ghosts to silence and invisibility. In terms of historiography, the choice is between improvising and doing things "by the book." In terms of theory, the choice is between recognizing the radical potential lurking within Artaud's statement that "an expression does not have the same value twice"[44] or buying into Bürger's assertion that staging for a "second time" results in "a manifestation that is void of sense."[45] In terms of the legacy of the avant-gardes, I would suggest that the choice is between the ghosts of the avant-gardes and the death of the avant-garde.

It is, of course, a long journey from Marseille in 1720 through Buchenwald in 1945 and the Marine Brig at Mount Fujiyama in 1957 to Baghdad in 2004, but it is precisely the kind of logic that fuels this journey that is at the core of what I have been calling vanguard ghosting. This logic, I would suggest, is a crucial strategy for seeing beyond the death of the avant-garde to discover the meanings that linger like ghosts in avant-garde gestures because they have been left unexplored or because new historical contexts bring them into play. At one level, that logic and the historical leaps forward and backward that it enables are foreshadowed in Beck's own reading of Artaud—a reading in which the "heartless monsters [. . .] that burn and gas six million Jews" are the same "heartless monsters [. . .] that enslave blacks," "wipe out the Indians," and "lock men in prisons away from natural sex." If the ghosts of the avant-gardes haunt Beck's reading of Artaud, if they haunt The Living Theatre's 1963 production of *The Brig*, they also haunt The Living Theatre's 2007 production of *The Brig*. Indeed, they and other ghosts—unseen and unforeseen ghosts of the past, present, and future—haunt *The Theatre and Its Double* as well. In this respect, the broad license that Beck took as a reader of Artaud was not only in the spirit of Artaud's own anti-textualism. It exemplifies a critical practice that one might extend to the cultural artifacts and the legacy of the avant-gardes more generally.

Notes

INTRODUCTION

1. Mel Gordon, *Dada Performance* (New York: PAJ Publications, 1987), 15.
2. Hugo Ball, *Flight Out of Time: A Dada Diary,* trans. Ann Raimes, ed. John Elderfield (Berkeley: University of California Press, 1996), 70.
3. Ball, *Flight Out of Time,* 70.
4. Mike Sell, *Avant-Garde Performance and Material Exchange (New York: Palgrave MacMillan,* 2011), 9.
5. Ronald Murphy, *Theorizing the Avant-Garde* (Cambridge: Cambridge University Press, 1999), 35.
6. Sell, *Avant-Garde Performance and Material Exchange,* 10.
7. Sell, *Avant-Garde Performance and Material Exchange,* 10.
8. T. J. Demos, "Zurich Dada: The Aesthetics of Exile," in *The Dada Seminars,* ed. Leah Dickerman (Washington DC: Distributed Art Publishers, 2005), 7–8.
9. Ball, *Flight out of Time,* 70.
10. Ball, *Flight Out of Time,* 71.
11. Hugo Ball, "Gadji BeriBimba," in *Dada Performance,* ed. Mel Gordon (New York: PAJ Publications, 1987), 41.
12. Ball, *Flight Out of Time,* 67.
13. John Elderfield, introduction to *Flight out of Time* (Berkeley: U of California Press, 1996), xxvii.
14. Ball, *Flight Out of Time,* 67.
15. Ball, *Flight Out of Time,* 25.
16. Greil Marcus, *Lipstick Traces* (Cambridge: Harvard UP, 1989), 215.
17. Theodor Adorno, "Reconciliation Under Duress," *Aesthetics and Politics* (London: Verso, 2007), 176.
18. Jonathan P. Eburne and Rita Felski, "Introduction," *New Literary History* 41 (2010): vi.
19. Eburne and Felski, "Introduction," vi.
20. Eburne and Felski, "Introduction," ix.
21. Eburne and Felski, "Introduction," vii.
22. Mike Sell, "Resisting the Question, 'What is an Avant-Garde?'," *New Literary Critique* 41 (2010): 754.
23. Peter Bürger, "Avant-Garde and Neo-Avant-Garde: An Attempt to Answer Certain Critics of Theory of the Avant-Garde," *New Literary History* 41 (2010): 703.

24. For a thorough discussion of Bürger's anti-theatrical bias, see James Harding and John Rouse's introduction to *Not the Other Avant-Garde* (Ann Arbor: University of Michigan Press, 2006), 1–6.

25. Hans-Thies Lehmann, *Postdramatic Theatre* [1999] (London: Routledge, 2006), 48.

26. Lehmann, *Postdramatic Theatre*, 57.

27. In Germany, for example, reaction was so strong that an entire volume of criticism was published shortly afterwards by Martin Lüdke under the title *Theorie der Avantgarde: Antworten auf Peter Bürgers Bestimmung von Kunst und bürgerlicher Gesellschaft* (Surkamp, 1976). As is often the case, controversy did more to institutionalize the status of Bürger's arguments than it did to lay them to rest.

28. Richard Schechner, "The Conservative Avant-Garde," *New Literary History* 41 (2010): 896.

29. Eburne and Felski, "Introduction," ix.

30. Lehmann, *Postdramatic Theatre*, 90.

31. Paul Mann, *Theory-Death of the Avant-Garde* (Bloomington: Indiana University Press, 1991), 3.

32. Robert Radin, "The Recuperation of 'The Theory-Death of the Avant-Garde'," *Diacritics* 28, no. 2 (1998): 43.

33. Roland Barthes, *The Pleasure of the Text*, trans. Richard Miller (New York: Noonday Press, 1975), 54–55.

34. Radin, "The Recuperation," 42.

35. Benjamin Buchloh, "The Primary Colors for the Second Time: A Paradigm Repetition of the Neo-Avant-Garde," *October* 37 (1986): 42.

36. Renato Poggioli, *Theory of the Avant-Garde* (Cambridge: Harvard University Press, 1968), 52.

37. See Mike Sell, "Al Qaeda and the Avant-Garde: Towards a Genealogy of the *Taliah*," *Modernism / Modernity* 18, no. 2 (2011): 395–404.

38. Poggioli, *Theory of the Avant-Garde*, 50.

39. Roland Barthes, "The Death of the Author," in *Image / Music / Text*, trans. Stephen Heath (New York: Hill and Wang, 1978), 147.

CHAPTER I

1. Christopher Innes, "Modernism in Drama," in *Cambridge Companion to Modernism*, ed. Michael Levenson (Cambridge, UK: Cambridge University Press, 1999), 131.

2. All subsequent references will be to *The Trial*.

3. Matthew S. Witkovsky, "Dada Breton," *October* 105 (2003): no. 136.

4. Frederick Busi, "Dada and the 'Trial" of Maurice Barrès," *Boston University Journal* 23, no. 2 (1975): 67.

5. Busi, "Dada and the 'Trial' of Maurice Barrès."

6. George Hugnet, "Dada in Paris," in *The Dada Painters and Poets*, ed. Robert Motherwell (Cambridge: Harvard University Press, 1979), 184.

7. Gunter Berghaus, *Theatre, Performance and the Historical Avant-Garde* (New York: Palgrave, 2005), 164.

8. Hugnet, "Dada in Paris," 185.

9. Tristan Tzara, *L'Affaire Barrès,* ed. Marguerite Bonnet (Paris: José Corti, 1987), 38.

10. Tzara, *L'Affaire Barrès,* 39.

11. Annabelle Melzer, *Dada and Surrealist Performance* (Baltimore: Johns Hopkins University Press, 1994), 154.

12. Tzara, *L'Affaire Barrès,* 38.

13. Gérard Durozoi, *History of the Surrealist Movement* (Chicago: University of Chicago Press, 1997), 24.

14. Durozoi, *History of the Surrealist Movement.*

15. Cited in Mark Polizzotti, *Revolution of the Mind* (New York: Farrar, Straus and Giroux, 1995), 157.

16. Karl Marx and Friedrich Engels, "Manifesto of the Communist Party," *The Marx-Engels Reader,* 2nd ed., ed. Robert Tucker (New York: Norton, 1978), 476.

17. Cited in Polizzotti, *Revolution of the Mind,* 158.

18. Polizzotti, *Revolution of the Mind,* 170.

19. Polizzotti, *Revolution of the Mind,* 169

20. Polizzotti, *Revolution of the Mind,* 170.

21. Cited in Arnauld Pierre, "The 'Confrontation of Modern Values': A Moral History of Dada in Paris," *The Dada Seminars,* ed. Leah Dickerson (Washington, DC: National Gallery of Art, 2005), 242.

22. Pierre, "The 'Confrontation of Modern Values.'"

23. Hugnet, "Dada in Paris," 187.

24. Cited in Hugnet, 188.

25. Maurice Nadeau, *The History of Surrealism,* trans. Richard Howard (Cambridge: Harvard University Press, 1989), 66.

26. Nadeau, *The History of Surrealism.*

27. Polizzotti, *Revolution of the Mind,* 170.

28. Polizzotti, *Revolution of the Mind,* 157.

29. Melzer, *Dada and Surrealist Performance,* 159.

30. Polizzotti, *Revolution of the Mind,* 170–71.

31. Witkovsky, "Dada Breton," 136.

32. Polizzotti, *Revolution of the Mind,* 171.

33. Matthew Josephson, *Life Among the Surrealists* (New York: Holt, Rinehart and Winston, 1962), 148–49.

34. Josephson, *Life Among the Surrealists,* 149.

35. Josephson, *Life Among the Surrealists.*

36. Polizzotti, *Revolution of the Mind,* 171.

37. Mike Sell, "Race," Unpublished Manuscript. Used with permission of the author. This manuscript is part of Sell's forthcoming book on key concepts in the avant-garde.

38. Josephson, *Life Among the Surrealists,* 149.

39. Polizzotti, *Revolution of the Mind,* 171.

40. Polizzotti, *Revolution of the Mind.*

41. Polizzotti, *Revolution of the Mind.*

42. André Breton, *Conversations: The Autobiography of Surrealism,* trans. Mark Polizzotti (New York: Paragon House, 1993), 55.

43. Polizzotti, *Revolution of the Mind,* 157.

44. Josephson, *Life Among the Surrealists,* 149.

45. Josephson, *Life Among the Surrealists*.

46. Roger Cardinal, "Review," *The Burlington Magazine* 132 (October, 1990): 726.

47. Tristan Tzara, "Lecture on Dada. (1922)," in *The Dada Painters and Poets*, ed. Robert Motherwell (Cambridge: Harvard University Press, 1979), 247.

48. Tzara, "Lecture on Dada," 246.

49. Tzara, "Lecture on Dada," 251.

50. Cardinal, "Review," 726.

51. Josephson, *Life Among the Surrealists*, 149.

52. Pierre, "Moral History of Dada," 242.

53. Josephson, *Life Among the Surrealists*, 149.

54. Polizzotti, *Revolution of the Mind*, 185–86.

55. Polizzotti, *Revolution of the Mind*, 171.

56. Tzara, *L'Affaire Barrès*, 38.

57. Annabelle Melzer, *Dada and Surrealist Performance* (Baltimore: Johns Hopkins University Press, 1994), 159.

58. Polizzotti, *Revolution of the Mind*, 185.

59. André Breton, "After Dada," in *The Dada Painters and Poets: An Anthology*, 2nd ed., ed. Robert Motherwell (Cambridge: Harvard University Press, 1981), 204.

60. Mike Sell, *Avant-Garde Performance and the Limits of Criticism* (Ann Arbor: University of Michigan Press, 2005), 13.

61. Sell, *Avant-Garde Performance and the Limits of Criticism*, 37.

62. Paul Mann, "The Afterlife of the Avant-Garde," *Masocriticism* (Albany, NY: SUNY Press, 1999), 4.

63. Paul Mann, *The Theory-Death of the Avant-Garde* (Bloomington: University of Indiana Press, 1991), 38.

64. Tzara, "Lecture on Dada," 246.

65. Mann, *Theory-Death*, 39.

66. Mann, "Afterlife," 3.

67. Breton, "After Dada," 206.

68. Breton, "After Dada," 204–5.

69. Breton, "After Dada," 204.

70. Tristan Tzara, "manifesto on feeble love and bitter love," in *The Dada Painters and Poets: An Anthology*, 2nd ed., ed. Robert Motherwell (Cambridge: Harvard University Press, 1981), 86.

71. Cited in Melzer, *Dada and Surrealist Performance*, xvi.

72. George Ribemont-Dessaignes, "History of Dada," in *The Dada Painters and Poets: An Anthology*, 2nd ed., ed. Robert Motherwell (Cambridge: Harvard University Press, 1981), 102.

73. Breton, "After Dada," 204.

74. See for example Robert Motherwell, introduction to *The Dada Painters and Poets: An Anthology*, 2nd ed., ed. Robert Motherwell (Cambridge: Harvard University Press, 1981). xxxi.

75. George Ribemont-Dessaignes, "Artichauts Nouveaux," *Le Coeur à barbe* (April, 1922): 2

76. Pierre, "Moral History of Dada," 249.

77. Indeed, Michel Sanouillet, whose 1965 study *Dada à Paris* is the definitive study of the Parisian Dadaists, notes that although there is some vagueness about the

precise publication date of *Le Coeur à barbe*, certain allusions to the article "Lâchez tout" situate the journal's publication after Breton's article, which appeared on April 1. See Michel Sanouillet, *Dada à Paris* (Paris: Jean-Jacques Pauvert, 1965), 344.

78. Polizzotti, *Revolution of the Mind*, 175.
79. Cited in Polizzotti, *Revolution of the Mind*, 175.
80. Tristan Tzara, "manifesto on feeble love," 92.
81. Anonymous, "Lâchez tout," *Le Coeur à barbe* (April 1922): 5.
82. Anonymous, "Lâchez tout."
83. Polizzotti, *Revolution of the Mind*, 167.
84. Ruth Brandon, *Surreal Lives* (New York: Grove Press, 1999), 167.
85. Brandon, *Surreal Lives*, 167–68.
86. Brandon, *Surreal Lives*, 167.
87. Sanouillet, *Dada à Paris*, 383.
88. Josephson, *Life Among the Surrealists*, 152.
89. Polizzotti, *Revolution of the Mind*, 192.
90. Polizzotti, *Revolution of the Mind*.
91. Sanouillett, *Dada à Paris*, 386.
92. Witkovsky, "Dada Breton," 136.

CHAPTER 2

1. John Cage, Interview with Michael Kirby and Richard Schechner, in *Happenings and Other Acts*, ed. Mariellen R. Sanford (New York: Routledge, 1995), 55.
2. Paul Mann, *The Theory-Death of the Avant-Garde* (Bloomington: Indiana University Press, 1991), 81.
3. Yvonne Rainer, "Looking Myself in the Mouth," *October* 17 (1981): 66.
4. Rainer, "Looking Myself in the Mouth," 67.
5. Rainer, "Looking Myself in the Mouth," 67; Richard Kostelanetz, *John Cage* (New York: Praeger Publishers, 1970), 51.
6. Rainer, "Looking Myself in the Mouth," 67–68.
7. Rainer, "Looking Myself in the Mouth," 67.
8. One example of this optimism can be found in the attitude with which the American press received the anti-cultural sentiments of avant-garde artists after fascist Germany publically disavowed the avant-garde in the infamous 1937 Entartete Kunst exhibit. As Stephanie Barron has noted in her "European Artists in Exile,"

> The reception accorded the artists whose work was banned by the Nazis was directly related to American attitudes toward Germany and the National Socialists. The American press responded with appropriate invective to the 1937 *Entartete Kunst* show in Munich. Thereafter, the meaning of modern art in America changed, and it was equated with the art of democracy. See Stephanie Barron, "European Artists in Exile: A Reading between the Lines," in *Exiles + Emigrés: The Flight of European Artists from Hitler*, ed. Stephanie Baron and Sabine Eckman (Los Angeles: Los Angeles County Museum of Art, 1997), 26.

9. Mann, *Theory-Death*, 81.
10. The classic argument in this regard comes from Irving Sandler, who in *The New York School: The Painters and Sculptures of the Fifties* (New York: Harper and

Row, 1978) devotes a chapter to the influence of what he specifically dubs "The Duchamp-Cage Aesthetic." See Sandler, chapter 8.

11. Sandler, *New York School,* 164.

12. Though examples of such views are widespread, it is worth citing Richard Kostelanetz, who has long been one of Cage's most ardent supporters. In his influential *Theatre of Mixed Means* (New York: Dial Press, 1968), Kostelanetz notes that "in America, among the greatest influences shaping the Theatre of Mixed Means are the ideas and examples of John Cage, who in the early fifties made the intellectual leap that connected all performed music with the theatre" (19). Among the more significant examples of this leap is Cage's work at Black Mountain, which is the primary focus of this study.

13. Though scattered and fragmented translations of Artaud's writing began to appear earlier, it was not until 1958 that Grove Press first published a complete translation of *The Theatre and Its Double.* In fact, it was Cage who, while at Black Mountain College, brought Artaud's writing to the attention of Mary Caroline Richards, who became the English translator for the Grove Press edition of *The Theatre and Its Double.* See Martin Duberman, *Black Mountain: An Exploration in Community* (New York: Dutton, 1972), 350. Schwitter's work, as well as that of other Dadaists, gained a substantial new audience when Robert Motherwell published *The Dada Painters and Poets* anthology in 1951 (Cambridge, MA: Harvard University Press, 1981), the year directly prior to Cage's untitled piece at Black Mountain College.

14. As is well known, it was at The New School that Cage taught the legendary courses on composition, and the students in those courses became a virtual who's who list for the Happenings and Fluxus movements. But even these courses arguably would not have become what they were without Cage's prior involvement with Black Mountain, both as a faculty member and a performing artist. It is also worth noting the significance of these two specific institutions in the American cultivation of a transplanted European intelligentsia. These schools were the first to open their doors to the "intellectual refugees from Nazi Germany" (Barron, "European Artists in Exile," 24).

15. Michael Kirby, *Happenings* (New York: Dutton, 1965), 31.

16. Interestingly enough, Cage's own recollection does not always coincide with that of others who attended the event. Cage told Michael Kirby and Richard Schechner, for example, that he too gave his lecture on a ladder (Cage, "An Interview with Michael Kirby and Richard Schechner," 53).

17. RoseLee Goldberg, *Performance Art: From Futurism to the Present* (New York: Abrams, 1988), 126; Mary Emma Harris, *The Arts at Black Mountain College* (Cambridge: MIT Press, 1987), 226.

18. Quoted in Duberman, *Black Mountain,* 351. Duberman's *Black Mountain: An Exploration in Community* (1972) is the definitive study of Black Mountain College. Though Duberman's concerns are primarily historical rather than aesthetic, his account of Cage's untitled piece at Black Mountain is one of the very few accounts to emphasize how diverse and inconsistent are the recollections not only of those who participated but also of those who attended the event. Unfortunately, Duberman doesn't consider these inconsistencies in terms of their artistic implications, but rather only in terms of the problems they present to the historian.

19. Duberman, *Black Mountain,* 351.

20. John Cage, *Silence* (Hanover, NH: Wesleyan University Press, 1961), 12.

21. In this respect, both the institutional structure of Black Mountain and the intentional structure of Cage's untitled performance piece coincide with the concluding sentiments that Herbert Marcuse expressed a decade later, albeit with the increasingly militant tone of the time, in *One Dimensional Man:* "To liberate the imagination so that it can be given all its means of expression presupposes the repression of much that is now free and that perpetuates a repressive society" (Boston: Beacon Press, 1964), 250.

22. Duberman, *Black Mountain,* 102.

23. Cage, *Silence,* 12.

24. John Dewey, *Democracy and Education* (New York: Free Press, 1997), 205.

25. Dewey, *Democracy,* 195, 85.

26. John Dewey, *Art as Experience* (New York: Perigee Trade, 2005), 42.

27. Dewey, *Art,* 62.

28. On this point, see Peter Bürger, *Theory of the Avant-Garde* [1974] (Minneapolis: University of Minnesota Press, 1984), 57.

29. This tendency was widespread and by no means limited to the theatrical community. In the introductory essay "Considering (and Reconsidering) Art and Exile" that Sabine Eckmann wrote for the anthology *Exiles + Emigrés: The Flight of European Artists from Hitler,* she notes how many of the European Exiles arriving on the American shores went through a process of "deradicalization" (a term she borrows from Martin Jay). See especially pages 34–35 of her article. Sabine Eckmann, "Considering (and Reconsidering) Art and Exile," in *Exiles + Emigrés: The Flight of European Artists from Hitler* (Los Angeles: Los Angeles County Museum of Art, 1997), 30–42.

30. Quoted in Renato Poggioli, *The Theory of the Avant-Garde* (Cambridge: Harvard University Press, 1968), 62.

31. Flippo Tommaso Marinetti, "The Founding and Manifesto of Futurism," in *Modernism,* ed. Vassiliki Kolocontroni, Jane Goldman, and Olga Taxidou (Chicago: University of Chicago Press, 1998), 251.

32. Marcel Duchamp, *The Writings of Marcel Duchamp* (New York: Da Capo Press, 1973), 140.

33. Quoted in Richard Kostelanetz, *Conversing With Cage* (New York: Limelight, 1989), 22.

34. Clement Greenberg, "Avant-Garde and Kitsch," in *Perceptions and Judgements, 1939–1944,* ed. John O'Brian (Chicago: University of Chicago, 1986),12.

35. Clement Greenberg, "Counter-Avant-Garde," in *Marchel Duchamp in Perspective,* ed. Joseph Masheck (Englewood Cliffs, NJ: Prentice Hall, 1975), 124, 127.

36. Mann, *Theory-Death,* 81.

37. Those trappings were the trappings of all aesthetic negation: namely, the tendency to inadvertently reinscribe the very cultural structures one seeks to negate.

38. Roger Reynolds, "Interview with John Cage," in *John Cage,* ed. Robert Dunn (New York: Henmar Press, 1962), 47.

39. Poggioli, *Theory,* 61–62.

40. Matei Calinescu, *Five Faces of Modernity* (Durham: Duke University Press, 1987), 146.

41. Though it is a bit of a stretch, it might well be worth considering the extent to which Cage's comments reflect the enduring image in the American cultural mentality of the ever-present frontier waiting to be cultivated. Interestingly enough, this

image of abundance, however false and ideologically charged it may be, stands in marked contrast, say, to the Nazi rallying call for the creation of *Lebensraum*, a call that openly sought the creation of "German" space at the expense or negation of other peoples and cultures.

42. Cage most clearly associates avant-garde aesthetics with alternative spaces in his "Lecture on Nothing," where he specifically attributes his own status as a member of the "avant-garde" to his engagement not with tonality but with the intervals between tones, i.e., with the silences that, historically, have been defined negatively as the absence of tone and/or sound. In an echo of Dewey's positive reconceptualization of the negative view of play within the logic of capitalism, Cage—who admits, "I never liked tonality"—reconceptualizes these intervals affirmatively as the presence of sounds and/or noises that a regressive mode of hearing fails to "intellectualize," or, in other words, fails to perceive (*Silence*, 116). He notes, furthermore: "I found that I liked noises even more than I liked intervals" (117). This discovered preference leads Cage down a path, in his art, of accentuating what he then can assume always already exists, but which historically has been neglected—hence his predilection for the affirmative and his affinity with Dewey. For like Dewey's affirming embrace of play, Cage's aesthetic path is a counter-affirmation to the negative deafness of tonality. But as is the case with his accentuation of the affirmative, Cage's struggle is not directly with or against tonality. It is rather with the aesthetic harnessing of the overlooked presence of noise in what we perceive as silence.

43. Kostelanetz, *Mixed Means*, 54.

44. Asserting the relation of Cage's aesthetics to Dewey's is, in fact, not without precedent. In the midst of the flurry of American avant-garde performance activities that were taking place in 1968, for example, Van Meter Ames published a short study entitled "From John Dewey to John Cage," in which he argues that "Cage out-does Dewey in bridging the difference between life and art" (Van Meter Ames, "From John Dewey to John Cage," in *Proceedings of the Sixth International Congress of Aesthetics*, ed. Rudolf Zeitler [Uppsala, 1972], 738). Unfortunately, Ames neither draws connections between Dewey's philosophies of education and art, nor does he address experimental communities like Black Mountain College, which, as I argue here, provides the clearest connection between Dewey and Cage.

45. Moira Roth, "The Aesthetics of Indifference," *Artforum* 16 (1977): 49.

46. David K. Johnson, *The Lavender Scare: The Cold War Persecution of Gays and Lesbians in the Federal Government* (Chicago: University of Chicago Press, 2004), 2–3.

47. Duberman, *Black Mountain*, 346.

48. Amelia Jones, *Postmodernism and the En-Gendering of Marcel Duchamp* (Cambridge: Cambridge University Press, 1995), 30.

49. Roth, "Indifference," 49.

50. Reynolds, "Interview with John Cage," 47.

51. Quoted in Kostelanetz, *Mixed Means*, 57.

52. Dewey, *Democracy and Education*, 84.

53. Dewey, *Art as Experience*, 52.

54. Dewey, *Art as Experience*, 45; *Education and Democracy*, 140.

55. The French exile Amédéé Ozenfant, for example, who was "the founder of the Purist movement in France," and who lectured at the college in the summer of 1944, noted both the college's anomalous status in American society and its role as a refuge for displaced members of the German avant-garde. He "described the college

as 'a petite university, isolated in nature like a Benedictine abbey,'" and "as 'one of the new centers of German culture' in America" (quoted in Harris, *Arts at Black Mountain*, 96). The new center of German culture to which Ozenfant referred was the product of an affiliation with exiled members of the Bauhaus that dated back to the college's founding.

56. Cage was in fact quite familiar with Bauhaus. Prior to the summer of 1952 when he orchestrated his untitled piece, Cage already had established contacts with exiled members of the Bauhaus, having taught "music at László Moholy-Nagy's Chicago Bauhaus" in 1942 and having developed a fairly good rapport with Josef Albers when Albers invited him to be part of the summer faculty at Black Mountain in 1948. See Richard Kostelanetz, *John Cage* (New York: De Capo Press, 1991), 4; Harris, *Arts at Black Mountain*, 146.

57. Richard Kostelanetz, *Dictionary of the Avant-Gardes* (Chicago: Cappella Books, 1993), 23.

58. Kostelanetz, *Mixed Means*, 13.

59. Harris, *Arts at Black Mountain*, 15.

60. Josef Albers, "Art as Experience," *Progressive Education* 12, no. 6 (1935): 391.

61. Bürger, *Theory of the Avant-Garde*, 53.

62. Duberman, *Black Mountain*, 324.

63. When Cage and Cunningham visited the college for the first time in 1948, for example, Albers and Cage agreed considerably on questions of aesthetics. But as Mary Harris notes, Cage had not yet discovered the *I Ching* or incorporated chance operational procedures into his work, developments "which were anathema to Albers's emphasis on discipline and control." See Harris, *Arts at Black Mountain*,146.

64. Harris, *Arts at Black Mountain*, 10; Cage, Quoted in Marjorie Perloff, "'A Duchamp Unto My Self': 'Writing Through' Marcel," in *John Cage: Composed in America*, ed. Marjorie Perloff and Charles Junkerman (Chicago: University of Chicago, 1994), 113.

65. When Schawinsky arrived at Black Mountain, he already had a long list of Bauhaus experimental theatrical productions behind him at Weimar, Berlin, and Dressau, and the courses he offered in the late thirties at Black Mountain in "Stage Studies," which he listed as "not intended as training for any particular branch of the contemporary theatre but rather as a general study of the fundamental phenomena: Space, form, color, light, sound, music, movement, time, etc.," might very well be characterized as precursors to the courses that Cage subsequently taught in composition at the New School in the fifties (Xanti Schwinsky, "From the Bauhaus to Black Mountain," *TDR* 15, no. 3 [1971]: 44).

66. Schawinsky "From the Bauhaus to Black Mountain," 39.

67. Oskar Schlemmer, "Man and Art Figure," in *The Theater of the Bauhaus*, ed. Walter Gropius and Arthur Wensinger (Baltimore: Johns Hopkins, 1996), 32.

68. Harris, *Arts at Black Mountain*, 40.

69. Natalie-Crohn Schmitt, "'So Many Things Can Go Together': the Theatricality of John Cage," *New Theatre Quarterly* 11, no. 41 (1995): 72.

70. Schawinsky, "From the Bauhaus to Black Mountain," 43.

71. Benjamin Buchloh, "Theorizing the Avant-Garde," *Art in America* 72, no. 10 (1984): 19.

72. Miklos Szabolcsi, "Avant-Garde, Neo-Avant-Garde, Modernism: Questions and Suggestions," *New Literary History* 3, no. 1 (1971): 60.

73. Szabolcsi, "Avant-Garde," 63–64.

CHAPTER 3

1. Glenna Syse in the *Chicago Sun Times*, January 11, 1966, cited in Donald Glut, *The Frankenstein Legend: A Tribute to Mary Shelly and Boris Karloff* (Metuchen, N.J.: Scarecrow Press, 1973), 51–52.

2. *The Village Voice*, September 12, 1968, p. 38.

3. Arthur Danto, *Encounters and Reflections* (New York: Farrar, Straus, and Giroux, 1990), 289.

4. Andy Warhol, *The Philosophy of Andy Warhol* (San Diego: Harcourt Brace & Company, 1975), 11.

5. For the seminal theoretical discussion of these ties, see Renato Poggioli, *Theory of the Avant-Garde* [1962], trans. Gerald Fitzgerald (Cambridge: Harvard University Press, 1968), 43–59. Echoes of Poggioli's arguments are to be found in Matei Calinescu's *Five Faces of Modernity* (Durham: Duke University Press, 1987), 100–108; and, more recently, in the opening chapter of Richard Murphy's *Theorizing the Avant-Garde* (New York: Cambridge University Press, 1999).

6. In an amusing allusion to Shelley's novel, the Baron's wife (played by Monique van Vooren) is also the Baron's blood sister. They have two children who haunt the film as they wander the castle unsupervised. In the novel, of course, Elizabeth, killed by the creature on the night of her wedding to Victor Frankenstein, is Victor's un-officially adopted sister. Incest is thus only indirectly implied, and Victor and Elizabeth have no children.

7. Joan Hawkins, *Cutting Edge: Art Horror and the Horrific Avant-Garde* (Minneapolis: University of Minnesota Press, 2000), 192.

8. Margaret Croyden, *Lunatics, Lovers and Poets* (New York: McGraw Hill, 1974), 97.

9. Saul Gottlieb, "The Living Theatre in Exile: *Mysteries, Frankenstein*," *TDR* 10, no. 4 [T32] (1966): 145.

10. *We, the Living Theatre* (New York: Ballantine Books, 1970), 112.

11. Paracelsus had served as a source of inspiration to Victor Frankenstein in Shelley's novel. Historically, he was a transitional figure involved in modernizing medicine by treating illnesses with chemicals, while nonetheless embracing notions drawn from alchemy and mysticism. Indeed, Paracelsus believed that alchemy could actually create humans.

12. Gottlieb, "Living Theatre in Exile," 148.

13. Croyden, *Lunatics*, 99.

14. Accounts by Biner and Neff indicate Frankenstein, rather than the creature, as the instigator of the prison revolt. But the implications for the body politic are the same. See Pierre Biner, *The Living Theatre* (New York: Horizon Press, 1972), 137–38; Renfrew Neff, *The Living Theatre: USA* (New York: Bobbs-Merril Co., 1970), 71–72.

15. Croyden, *Lunatics*, 101.

16. Croyden, *Lunatics*.

17. Antonin Artaud, *The Theatre and Its Double*, trans. Mary Caroline Richards (New York: Grove Weidenfeld, 1958), 13.

18. Artaud, *The Theatre and Its Double*, 110–11.

19. Hawkins, *Cutting Edge*, 171. Hawkins notes that unlike other films Morrissey made while associated with Warhol, *Frankenstein* did not literally carry Warhol's name as producer. There is a kind of playfulness here that Hawkins overlooks. The

film, which is full of allusions to other Frankenstein films, subtly associates Warhol himself with the Frankenstein creature in the absence of Warhol's name in the credits. (Boris Karloff's name was absent in Whale's *Frankenstein* as well.) The list of characters includes the reference to "the Monster," but that reference is followed by question marks, as if to suggest that any number of people could be the Monster.

20. Hawkins, *Cutting Edge.*

21. Julian Beck, "3 Stages in the Genesis of *Frankenstein:* A Drama Spectacle Created by the Living Theatre Company," *City Lights Journal, Number Three* (San Francisco: City Lights Books, 1966), 58.

22. Beck, "3 Stages in the Genesis of *Frankenstein.*"

23. Brown was the playwright who penned the script for the Living Theatre's infamous production of *The Brig.*

24. Kenneth H. Brown, "*Frankenstein* and the Birth of the Monster," *City Lights Journal, Number Three* (San Francisco: City Lights Books, 1966), 51.

25. Gottlieb served as the Living Theatre's agent and representative in New York during their exile.

26. Gottlieb, "The Living Theatre in Exile," 145.

27. Gottlieb, "The Living Theatre in Exile," 137.

28. It is worth noting in this regard that Beck had already published poetry in *City Lights Journal, Number Two,* which Ferlinghetti had published in 1964. To this earlier second issue of the journal, Beck had contributed an anti-war poem entitled "Daily Life."

29. Arthur Danto, *Encounters and Reflections* (New York: Farrar, Straus, and Giroux, 1990), 292, 289.

30. Danto, *Encounters and Reflections,* 289.

31. Danto, *Encounters and Reflections.*

32. Albert LaValley, "The Stage and Film Children of *Frankenstein:* A Survey," in *The Endurance of Frankenstein,* ed. George Lavine and U.C. Knoepflmacher (Berkeley: University of California Press, 1979), 282.

33. This description is drawn from a variety of accounts of the performances (including the footage that was broadcast on German television in 1966), but it is primarily indebted to Saul Gottlieb's account in "The Living Theatre in Exile." See his essay in *TDR* 10, no. 4: 147.

34. Pierre Biner, *The Living Theatre,* 208 [italics mine].

35. Renato Poggioli, *Theory of the Avant-Garde* [1962], trans. Gerald Fitzgerald (Cambridge: Harvard University Press, 1968), 46.

36. Poggioli, *Theory of the Avant-Garde,* 50.

37. Poggioli, *Theory of the Avant-Garde.*

38. Marlon B. Ross, "Romantic Quest and Conquest," in *Romanticism and Feminism,* ed. Anne K. Mellor (Bloomington: Indiana University Press, 1988), 29.

39. LaValley, "Stage and Film Children," 246.

40. Anne K. Mellor, "Possessing Nature: the Female in *Frankenstein*" in *Romanticism and Feminism,* ed. Anne K. Mellor (Bloomington: Indiana University Press, 1988), 221.

41. There is pretty clear documentation of this decision. Johanna Smith, for example, has noted that Shelley expressed deep anxieties in her letters about the biased reception her work might receive if her name stood as author directly beneath the title. Indeed, as an author, Shelley labored in a period where the "spheres of writing

and literacy" and the production of what Shelley called "print-worthy dignity" were presumed to be "the product[s] of a public-school and university education, available at this time only to men." See Johanna M. Smith, "'Cooped up' with 'Sad Trash': Domesticity and the Sciences in *Frankenstein*," *Frankenstein* 2nd ed. Johanna M. Smith (New York: Bedford, 2000), 316.

42. In this regard, it is helpful to rehearse the clichéd banter between two visitors to a museum. One responds to Warhol's Campbell soup cans by saying, "I could have done that." The other, in an implicit acknowledgment of Warhol's brilliance, replies, "Yes, but you didn't."

43. Donald Drew Egbert, *Social Radicalism and the Arts* (New York: Alfred A. Knopf, 1970), 404.

CHAPTER 4

1. Rebecca Schneider, "Reactuals: From Personal to Critical and Back," in *The Rise of Performance Studies: Rethinking Richard Schechner's Broad Spectrum,* ed. James M. Harding and Cindy Rosenthal (London: Palgrave Macmillan, 2011), 137.

2. Richard Schechner, *The Future of Ritual* (New York: Routledge, 1993), 5, 18.

3. Schechner, *The Future of Ritual,* 17.

4. Rustom Bharucha, "A Collision of Cultures: Some Western Interpretations of Indian Theatre," *Asian Theatre Journal* 1, no. 1 (1984): 14.

5. Bharucha, "A Collision of Cultures."

6. Rustom Bharucha, "Reply to Richard Schechner," *Asian Theatre Journal* 1, no. 2 (1984): 256.

7. Richard Schechner, "A Reply to Rustom Bharucha," *Asian Theatre Journal* 1, no. 2 (1984): 247.

8. Schechner, "A Reply to Rustom Bharucha."

9. Schechner, "Reply to Rustom Bharucha," 250.

10. Schechner, "A Reply to Rustom Bharucha," 252.

11. Richard Schechner, "From Ritual to Theatre and Back: The Structure / Process of the Efficacy-Entertainment Dyad," *Educational Theatre Journal* 26, no. 4 (1974): 476.

12. Bertolt Brecht, "The Street Scene," in *Performance Analysis: An Introductory Coursebook,* ed. Colin Counsell and Laurie Wolf (New York: Routledge, 2001), 47.

13. Schechner, "Reply to Rustom Bharucha," 252.

14. Bharucha, "Reply to Richard Schechner," 255.

15. Brook's travels in India and his dealings with his Indian hosts are infamous for their destructive disregard for the particular individuals involved and for the general lack of respect Brook showed for the cultural traditions and theater practices that his hosts were kind enough to arrange for him to observe. The two most thorough accounts of Brook's rather arrogant dealings with Indian culture are Phillip Zarilli's "The Aftermath: When Peter Brook Came to India," *TDR* 30, no. 1 (1986): 92–99, and Alf Hiltebeitel's "Transmitting Mahabharatas: Another Look at Peter Brook," *TDR* 36, no. 3 (1992): 131–59.

16. With regard to the uniting of poststructuralist and Brechtian theories, I am thinking particularly of the work of Janelle Reinelt and Elin Diamond. Their com-

plementary projects of merging poststructuralist thought with Brechtian aesthetics are specifically aimed at establishing a critical feminist discourse for theater studies. In citing their work in this context, I am implicitly suggesting that the combination of poststructuralism and Brechtian aesthetics has wide-sweeping political implications for the work that we do as theater scholars.

17. Una Chaudhuri, "Working Out (of) Place," in *Staging Resistance*, ed. Jeanne Colleran and Jenny S. Spencer (Ann Arbor: University of Michigan Press, 1998), 77.

18. Chandhuri, "Working Out (of) Place," 78. It is worth noting that Chaudhuri's call to move beyond a "personal denigration" of Brook coincides with long-standing ways of regarding Brecht and the gross contrasts between his personal and artistic politics. Elizabeth Wright, for example, argues forcefully against dismissing Brecht based upon *ad hominem* attacks that note "the contradictions between his life and his art." Indeed, Wright argues that Brecht's "undoubted opportunism" ought not "be held indiscriminately against him when a critical survey of his achievements as a writer is being conducted." See Elizabeth Wright, *Postmodern Brecht* (New York: Routledge, 1989), 9.

19. Chandhuri, "Working Out (of) Place," 94.

20. Wright, *Postmodern Brecht*, 19.

21. Fredric Jameson, *Brecht and Method* (New York: Verso, 1998), 38.

22. Leonard C. Pronko, "Los Angeles Festival: Peter Brook's *The Mahabharata*," *Asian Theatre Journal* 5, no. 2 (1988): 220.

23. Peter Brook, foreword to *The Mahabharata: A Play*, by Jean-Claude Carrière, trans. Peter Brook (New York: Harper and Row, 1987), xvi.

24. Schechner, "Reply to Rustom Bharucha," 248.

25. This is in fact precisely the point Liza Henderson attempted to underscore in 1988 when she argued "far from transcending the socio-political structures of history, Brook reflects one of its more regrettable trends, once again selling the East to the West." See Liza Henderson, "Brook's Point," *Theater* 19, no. 2 (1988): 37. This same sentiment is echoed in Gabrielle Cody's polemical assertion that "in the spirit of the British Raj, Brook views Hinduism through the generosity of a conqueror's eyes, admiring its spirituality, naively reveling in its exoticism." See Gabrielle Cody, "Art of Awe's Sake," *Theater* 19, no. 2 (1988): 32.

26. This is the underlying assumption, for example, in Una Chaudhuri's discussion of the "mission" of Brook's production: "But Brook's mission was inevitably framed by his own philosophical vision, which for all its intercultural investments, is a Western humanist one. At its heart lies the belief that Truth is universal and singular, and that this Truth can be recovered from certain stories of other cultures—no matter how strange and unfamiliar their outer form." See Chaudhuri, "Working Out (of) Place," 83.

27. Gautam Dasgupta, "*The Mahabharata*: Peter Brook's Orientalism," in *Interculturalism and Performance*, ed. Bonnie Marranca and Gautam Dasgupta (New York: PAJ Publications, 1991), 80.

28. Indeed, Margaret Eddershaw argues that unusual linguistic structures are a staple of Brechtian techniques to attract the attention of the audience: "The Brechtian performer's playing . . . is aided not just by the text's wholesale changes in dramaturgical style but by, for example, the detailed distancing effects created through the use of unusual vocabulary and linguistic structures that are designed to catch the specta-

tor's ear and make them take special note." See Margaret Eddershaw, *Performing Brecht* (New York: Routledge, 1996), 15.

29. Peter Brook, "Talking with Peter Brook: Interviews by Richard Schechner, Mathilde La Bardoniie, Joël Jouanneau, and George Banu," *TDR* 30, no. 1 (1986): 61.

30. Janelle Reinelt, *After Brecht: British Epic Theater* (Ann Arbor: University of Michigan Press, 1994), 90.

31. Walter Benjamin, *Understanding Brecht* (London: New Left Books, 1977), 11.

32. David Williams, "Theatre of Innocence and of Experience," in *Peter Brook and the Mahabharata,* ed. David Williams (New York: Routledge, 1991), 23.

33. Quoted in Martine Millon, "Talking with Three Actors," *TDR* 30, no. 1 (1986): 85.

34. Glenn Loney, for example, recalls Brook's own sense of surprise at Frank Rich's specific disappointment in this regard: "To cap his condemnations, Rich observed: 'For all the Eastern exotica, the stagings and the script still end up accentuating the common ground shared by "The Mahabharata" and the West'. For Peter Brook, this was an astonishing comment, primarily because it is couched as a quibble, an objection, an evidence of a shortcoming, even of a failure in the production. And yet, what Rich perceived was in fact what Brook had hoped would be intuited." See Glenn Loney, "Myth and Music: Resonances Across the Continents and Centuries," *Theater* 19, no. 2 (1988): 23.

35. Maria Shevtsova, "Interaction-Interpretation: *The Mahabharata* from a Socio-Cultural Perspective," in *Peter Brook and the Mahabharata,* ed. David Williams, 222.

36. Bertolt Brecht, *Brecht on Theatre* (New York: Hill and Wang, 1964), 137.

37. Rustom Bharucha, "Peter Brook's *Mahabharata:* A View from India," *Theater* 19, no. 2 (1988): 8.

38. Some sense of this inability is evident in Gary Williams' rather pithy and to my mind accurate characterization of the Western registers working within Brook's adaptation: "*The Mahabharata* offers a Western existentializing of Eastern mythology at the same time that it is fleeing from the spiritual poverty of the West. It comes with Greenpeace warnings against the dangers of seeking 'pasupata,' the ultimate weapon, together with intimations that the best human kind may hope for is an endless cycle of meaninglessness in the garden of Godot." See Gary Jay Williams, "From *The Dream* to *The Mahabharata:* or, Draupadi in the Deli," *Theater* 19, no. 2 (1988): 31.

39. Dasgupta, "*The Mahabharata:* Peter Brook's Orientalism," 79, 78.

40. Loney, "Myth and Music," 26.

41. Janelle Reinelt, "Rethinking Brecht: Deconstruction, Feminism and the Politics of Form," *The Brecht Yearbook* 15 (1990): 100.

42. Bharucha, "Peter Brook's *Mahabharata,*" 9, 10.

43. Brecht, *Brecht on Theatre,* 181.

44. Jacques Derrida, "The Theatre of Cruelty and the Closure of Representation," *Writing and Difference,* trans. Alan Bass (Chicago: University of Chicago Press, 1978), 235.

45. W. B. Worthen, "Disciplines of the Text / Sites of Performance," *TDR* 39, no.1 (1995): 22.

46. Bharucha, "Peter Brook's *Mahabharata,*" 8.

47. Bruce McConachie, "Towards a Postpositivist Theatre History," *Theatre Journal* 37, no. 4 (1985): 478.

48. Worthen, "Disciplines," 22.

49. Worthen, "Disciplines."

50. In this respect, the critique of Brook's production falls in line with notions of performance belonging to a long-standing tradition within literary criticism that considers meaning to reside in text rather than in performance. As W. B. Worthen has argued "literary engagements with performativity tend to focus on the performative function of language as represented in literary texts, and much performance-oriented criticism of drama, for all its invocation of the theatre, similarly betrays a desire to locate the meanings of the stage in the contours of the dramatic text." See W. B. Worthen, "Drama, Performativity, and Performance," *PMLA* 113, no. 5 (1998): 1093.

51. Dasgupta, "*The Mahabharata*: Peter Brook's Orientalism," 76.

52. Benjamin, *Understanding Brecht*, 19.

53. Chaudhuri, "Working Out (of) Place," 82–83.

54. It is worth noting how this Brechtian notion of *interruption* coincides with the evolution of the concept of performance that Dwight Conquergood traces in "Of Caravans and Carnivals." Interestingly enough, according to Conquergood, the Brechtian notion of *interruption* finds an echo in the postcolonial theories of Homi Bhabha. "Now, the current thinking about performance constitutes a shift from poiesis to kinesis. Turner's important work on the productive capacities of performance set the stage for a more poststructuralist and political emphasis on performance as kinesis, as movement, motion, fluidity, fluctuation, all those restless energies that transgress boundaries and trouble closure. Thus, postcolonial critic Homi K. Bhabha deployed the term 'performative' to refer to action that incessantly insinuates, interrupts, interrogates, antagonizes, and decenters powerful master discourses, which he dubbed 'pedagogical'. From Turner's emphatic view of performance as making not faking, we move to Bhabha's politically urgent view of performance as breaking and remaking." See Dwight Conquergood, "Of Caravans and Carnivals," *TDR* 39, no. 4 (1995): 138.

55. Chaudhuri "Working Out (of) Place," 85.

56. Bharucha, "Peter Brook's *Mahabharata*," 8.

57. Chaudhuri, "Working Out (of) Place," 93.

58. Indeed, Kent Devereaux notes that "what is [perhaps] most striking about Peter Brook's *The Mahabharata* is its purposeful abstention from psychological drama." See Kent Devereaux, "Peter Brook's Production of *The Mahabharata* at the Brooklyn Academy of Music," *Asian Theatre Journal* 5, no. 2 (1988): 230.

59. Jameson, *Brecht and Method*, 53.

60. This quotation comes from Brook's 1988 film of the play, *The Mahabharata*, directed by Peter Brook (1988, Parabola Films).

61. Cited in Bharucha, "Peter Brook's *Mahabharata*," 9.

62. Cited in Chaudhuri, "Working Out (of) Place," 89.

63. Chaudhuri, "Working Out (of) Place," 89.

64. Just one among the many examples of this tendency is Roger Long's complaint: "I was disappointed in that I was not more intensely involved in the emotions of the individual characters." See Roger Long, "Peter Brook's *The Mahabharata*: A Personal Reaction," *Asian Theatre Journal* 5, no. 2 (1988): 233.

65. This is in fact where some of Brook's most famous defenders leave the matter. Patrice Pavis, for example, in his defense of Brook has called attention to the "universal transcultural factors" that in Brook's production supposedly convey "the symbolic terrain of humanity as a whole." See Patrice Pavis, *Theatre at the Crossroads of Culture*, trans. Loren Kruger (New York: Routledge, 1992), 187.

66. Bharucha, "Peter Brook's *Mahabharata*," 8.

67. In this respect, Brook's behavior ironically echoes the character of Śakuni, whose cheating at dice has lasting and devastating consequences. Śakuni's cunning manipulation of the dice is one of the few unambiguous moments of villainy in *The Mahabharata*. Defying the random possibilities of the game, Śakuni's manipulations of the dice have ramifications well beyond whatever personal gain he may hope to obtain. Indeed, Śakuni's cheating is so despicable precisely because his actions not only destroy his direct relations with those whom he cheats, but they also destroy the Pāndavas's relations with their family (e.g., with Dhritarashtra and the Kauravas), their colleagues (e.g., Drona) and their community (e.g., the Pāndavas's kingdom).

68. Cited in Bharucha, "Peter Brook's *Mahabharata*," 19. This is but one aspect of Meduri's blunt critique of Zarrilli's piece. Maduri criticizes Zarrilli for focusing too exclusively on matters of courtesy and form when larger economic and political issues are at stake: "The article [Zarrilli's "Aftermath: When Peter Brook Came to India"] does not address the deeper, larger philosophical issues of self-responsibility and of the part in relation to the whole. Neither does it acknowledge the capitalistic vested interest of the West in coming to the East and vice versa. It chooses instead to focus on the external manifestations of form, courtesy, and consideration that Peter Brook and his company ignored." See Avanthi Meduri, "More Aftermath After Peter Brook," *TDR* 32, no. 2 (1988): 14.

69. John Rouse, "Brecht and the Question of the Audience," *The Brecht Yearbook* 15 (1990): 113.

70. Brook, "Talking with Peter Brook: Interviews," 62, 63.

71. Though without regard to his Brechtian function, Vyasa's pivotal significance in the narrative of *The Mahabharata* has been recognized before. Nora Alter, for example, has noted the following: "Like any omnipotent author, he [Vyasa] has the ability to intervene as a character in his own story. . . . He redirects the action, and intervenes on several occasions when the poem does not follow what he considers to be its proper course, interjecting authorial remarks." See Nora Alter, "Peter Brook's *Mahabharata*: Orality and Literacy," *Theater Three* 6 (1989): 161.

72. This quotation comes from Brook's 1988 film of the play. *The Mahabharata*, directed by Peter Brook (1988, Parabola Films).

73. Worthen, "Disciplines," 15.

74. Derrida, "The Theatre of Cruelty," 235.

75. Derrida, "The Theatre of Cruelty," 234.

76. Worthen, "Disciplines," 17.

77. Roland Barthes, "The Death of the Author," *Image / Music / Text*, trans. Stephen Heath (New York: Noonday Press, 1977), 148.

78. Barthes, "The Death of the Author."

79. Peter Brook, *The Empty Space* (New York: Atheneum, 1968), 72.

80. Brecht, *Brecht on Theatre*, 79, 78.

CHAPTER 5

1. Rebecca Schneider, *The Explicit Body in Performance* (New York: Routledge, 1997), 139.

2. Hugo Ball, *Flight Out of Time: A Dada Diary*, trans. Ann Raimes, ed. John Elderfield (Berkeley: University of California Press, 1996), 70.

3. Richard Huelsenbeck, *Memoirs of a Dada Drummer*, trans. Joachim Neugroschel, ed. Hans J. Kleinschmidt (Berkeley: University of California Press, 1991), 9.

4. Antonin Artaud, *The Theatre and Its Double*, trans. Mary Caroline Richards (New York: Grove Press, 1958).

5. The original version of this chapter was in fact the lead essay in that collection.

6. Paul Mann, *The Theory-Death of the Avant-Garde* (Bloomington: Indiana University Press, 1991), 81.

7. Mann, *The Theory-Death of the Avant-Garde*.

8. Michael Kirby, *The Art of Time* (New York: E.P. Dutton, 1969), 18.

9. While far less polemical than his critique of Schechner, Rustom Bharucha's discussion of Artaud in "The Collision of Cultures" provides an especially helpful commentary on Artaud's notion of "oriental theatre." See Bharucha, "A Collision of Cultures: Some Western Interpretations of Indian Theatre," *Asian Theatre Journal* 1, no. 1 (1984): 3-4.

10. Schneider, *Explicit Body*, 129.

11. Schneider, *Explicit Body*, 134.

12. Schneider, *Explicit Body*, 129.

13. Richard Schechner, *The Future of Ritual: Writings on Culture and Performance* (New York: Routledge, 1993), 6.

14. Christopher Innes, *Avant-Garde Theatre 1892–1992* (New York: Routledge, 1993), 18.

15. Michal Kobialka, *Of Borders and Thresholds* (Minneapolis: University of Minnesota Press, 1999), 3.

16. Kobialka, *Of Borders and Thresholds*.

17. Mike Sell has taken scholarly steps to redress this problem in his recent book *Avant-Garde: Race, Religion, War* (Segull, 2011), which takes a sociological approach to the avant-garde as a broad historical phenomenon rather than as a specific kind of artistic movement.

18. *Kobialka, Of Borders and Thresholds, 3.*

19. Alejandro Lugo, "Reflections on Border Theory," *Border Theory: the Limits of Cultural Politics*, ed. Scott Michaelsen and David E. Johnson (Minneapolis: U of Minnesota Press, 1997), 45.

20. Lugo, "Reflections on Border Theory," 49.

21. Lugo, "Reflections on Border Theory," 54.

22. Lugo, "Reflections on Border Theory," 50.

23. Diana Taylor, "Transculturating Transculturation," in *Interculturalism and Performance*, ed. Bonnie Marranca and Gautam Dasgupta (New York: PAJ, 1991), 63.

24. Michael Richardson, introduction to *Refusal of the Shadow: Surrealism and the Caribbean* (London: Verso, 1996), 4.

25. Paul Laraque, "Andre Breton in Haiti," *Refusal of the Shadow*, 212.

26. Masao Miyoshi, "A Borderless World? From Colonialism to Transnationalism and the Decline of the Nation-State," *Critical Inquiry* 19, no. 3 (1993): 728.

27. John Carlos Rowe, "Nineteenth-Century United States Literary Culture and Transnationality," *PMLA* 118, no. 1 (2003): 78.

28. Miyoshi, "A Borderless World?," 734.

29. Miyoshi, "A Borderless World?," 751.

30. Renato Poggioli, *Theory of the Avant-Garde* (1962), trans. Gerald Fitzgerald (Cambridge: Harvard University Press, 1968), 106–7.

31. Miyoshi, "A Borderless World?," 751.

32. Taylor, "Transculturating Transculturation," 67.

33. Rowe, "Literary Culture and Transnationality," 78.

34. Homi Bhabha, *The Location of Culture* (New York: Routledge, 1994), 111.

35. Bhabha, *The Location of Culture,* 112.

36. Paul de Man, *Allegories of Reading* (New Haven: Yale University Press, 1982), 205.

37. de Man, *Allegories of Reading,* 113–14.

38. Edward Said, "Traveling Theory," *The World, The Text and the Critic* (Cambridge: Harvard University Press, 1983), 226.

CHAPTER 6

1. Mike Sell, *Avant-Garde Performance and the Limits of Criticism* (Ann Arbor: University of Michigan Press, 2005), 13.

2. Peter Bürger, *Theory of the Avant-Garde* (Minneapolis: University of Minnesota Press, 1984), 57.

3. Theodor Adorno, *Minima Moralia,* trans. E. F. N. Jephcott (New York: Verso, 1974), 43.

4. Sell, *Avant-Garde Performance,* 37.

5. David Savran, "The Death of the Avant-Garde," *TDR* 49.3 (2005): 12.

6. Richard Schechner, "The Decline and Fall of the (American) Avant-Garde: Why It Happened and What We Can Do about It," Part 1, *Performing Arts Journal* 5, no. 2 (1981): 48–63; "The Decline and Fall of the (American) Avant-Garde: Why It Happened and What We Can Do about It," Part 2, *Performing Arts Journal* 5, no. 3 (1981): 9–19. Schechner republished the essay in *The End of Humanism: Writings on Performance* (New York: Performing Arts Journal Publications, 1982).

7. Arnold Aronson, *American Avant-Garde Theatre: A History* (New York: Routledge, 2000), 181.

8. Aronson, *American Avant-Garde Theatre: A History.*

9. See Richard Schechner, "The Conservative Avant-Garde," *New Literary History* 41, no. 4 (2010): 895–913.

10. Walter Benjamin, "Theses on the Philosophy of History," in *Illuminations,* ed. Hannah Arendt, trans. Harry Zohn (New York: Schocken Books, 1968), 256.

11. Benjamin, "Theses on the Philosophy of History."

12. Theodor Adorno, *Minima Moralia,* trans. E. F. N. Jephcott. (New York: Verso, 1974), 151.

13. Richard Schechner, *The Future of Ritual* (New York: Routledge, 1995), 8.

14. Schechner, *The Future of Ritual.*

15. Allan Kaprow, "Happenings in the New York Scene," in *The Blurring of Art and Life,* ed. Jeff Kelley (Berkeley: University of California Press, 1993), 19.

16. Benjamin, "Theses on the Philosophy of History," 256.

17. Renato Poggioli, *Theory of the Avant-Garde* (Cambridge: Harvard University Press, 1968), 100–101.

18. Erika Munk, "Only Connect: The Living Theatre and Its Audiences," in *Restaging the Sixties,* ed. James Harding and Cindy Rosenthal (Ann Arbor: University of Michigan Press, 2006), 46.

19. Munk, "Only Connect," 46.

20. Judith Malina, *The Enormous Despair* (New York: Random House, 1972).

21. With regard specifically to the Living Theatre, one notable exception is Cindy Rosenthal's recent article, "The Living Theatre's Arrested Development in Brazil: An Intersection of Activist Performances," in *Avant-Garde Performance and Material Exchange,* ed. Mike Sell (New York: Palgrave Macmillan, 2011).

22. Richard Schechner, "Who Killed Cock Robin?," *Tulane Drama Review* 8, no. 3 (1964): 11.

23. Passage from Bottoms as well as quote from Deleuze and Guattari are taken from Stephen Bottoms, "The Tangled Flora of Goat Island: Rhizome, Repetition, Reality," *Theatre Journal* 50, no. 4 (1998): 434.

24. Mike Sell, *Avant-Garde: Race, Religion, War* (Dehli: Seagull Press, 2011).

25. Schechner, "The Decline and Fall," Part 1, 49.

26. See the description of The Riot Group's mission on their website: http:// www.theriotgroup.com/?page_id=11, accessed December 11, 2010.

27. Statement on The Riot Group in Adriano Shaplin's *The Riot Group: Pugilist Specialist.* (London: Oberon Books, 2003), 4. In that same statement, The Riot Group explains: "All Riot Group performance texts are written by Adriano Shaplin with roles tailored to each individual actor. Each production is collaboratively directed and designed by the cast."

28. Shaplin, *Pugilist Specialist,* 26.

29. Shaplin, *Pugilist Specialist,* 22.

30. Shaplin, *Pugilist Specialist,* 20.

31. Catherine Lotrionte, "When to Target Leaders," *The Washington Quarterly* 26, no. 3 (2003): 74. Lotrionte notes that Presidents Carter and Reagan both issued executive orders reaffirming Ford's original executive order. The policy was rejected by President George W. Bush. Unlike his Father, President George H.W. Bush, who rejected the idea of directly targeting Saddam Hussein, the younger Bush opened the second Gulf War with bombing raids that specifically set out to eliminate Hussein.

32. Shaplin, *Pugilist Specialist,* 78, 80.

33. Shaplin, *Pugilist Specialist,* 81.

34. Shaplin, *Pugilist Specialist,* 14, 17.

35. Jennifer D. Kibbe, "The Rise of the Shadow Warriors," *Foreign Affairs* 83, no. 2 (2004): 104.

36. Kibbe, "The Rise of the Shadow Warriors."

37. Samuel Weber, "War, Terrorism and Spectacle: On Towers and Caves," *The South Atlantic Quarterly* 101, no. 3 (2002): 449.

38. Weber, "War, Terrorism and Spectacle."

39. Frederic Jameson, "The Dialectics of Disaster," *South Atlantic Quarterly* 101, no. 2 (2002): 301.

40. Jameson, "The Dialectics of Disaster."

41. Karlheinz Stockhausen, "'Huuuh!' Das Pressegespräch am 16. September 2001 im Senatszimmer des Hotel Atlantic in Hamburg," *Musik Text 91* (2001): 76–77. The original German reads: "das größte Kunstwerk, was es je gegeben hat."

42. Jameson, "Dialectics of Disaster," 303.

43. Stockhausen, "'Huuuh!'," 77. The original German reads "Der Verbrecher ist es deshalb, das wissen Sie ja, weil die Menschen nicht einverstanden waren."

44. Richard Schechner, "9/11 as Avant-Garde Art?" *PMLA* 124, no. 5 (2009): 1825.

45. Schechner, "9/11 as Avant-Garde Art?"

46. All citations are taken from the manuscript of Mike Sell's forthcoming article, to be published by *Modernism / Modernity.* The quote is from comments that bin Laden made on Al Jazeera television (via video) within hours of the US invasion of Afghanistan, and which were later published in an article the *New York Times,* "The Sword Fell," October 8, 2001.

47. David LeHardy Sweet, "Edward Said and the Avant-Garde," *Alif: Journal of Comparative Poetics* 25 (2005): 171.

48. Jameson "Dialectics of Disaster," 303.

49. Masao Miyoshi, "A Borderless World? From Colonialism to Transnationalism and the Decline of the Nation-State," *Critical Inquiry* 19, no. 4 (1993): 726–51.

50. Miyoshi, "A Borderless World?," 728.

51. Miyoshi, "A Borderless World?"

52. Savran, "Death of the Avant-Garde," 10.

53. Suzan-Lori Parks, *The America Play and Other Works* (New York: Theatre Communications Group, 1995), 163.

54. Parks, *The America Play and Other Works,* 4.

55. Parks, *The America Play and Other Works,* 164.

56. Miyoshi, "A Borderless World?," 729.

57. Miyoshi, "A Borderless World?," 747.

58. Molly Smith, "Introduction to *Anthems: Culture Clash in the District," Culture Clash in AmeriCCa* (New York: Theatre Communications Group, 2003), 154.

59. Richard Montoya and Culture Clash, *Anthems: Culture Clash in the District, Culture Clash in AmeriCCa* (New York: Theatre Communications Group, 2003), 211.

60. Schechner, *End of Humanism,* 13–14.

61. Richard Schechner, "9/11 as Avant-Garde Art?," 1821.

62. Montoya and Culture Clash, *Anthems,* 211.

CHAPTER 7

1. Peter Bürger, *Theory of the Avant-Garde,* trans. Michael Shaw (Minneapolis: University of Minnesota Press, 1984), 60.

2. Bürger, *Theory of the Avant-Garde,* 61.

3. Antonin Artaud, *The Theater and Its Double,* trans. Mary Carol Richards (New York: Grove Press, 1958), 75.

4. Rosalind Krauss, "The Originality of the Avant-Garde: A Postmodern Repetition," *October* 18 (Autumn 1981): 53

5. Krauss, "The Originality of the Avant-Garde," 53–54.

6. Marvin Carlson, *The Haunted Stage: The Theatre as Memory Machine* (Ann Arbor: University of Michigan Press, 2001), 6–7.

7. Carlson, *The Haunted Stage*, 16.

8. Julian Beck, "Storming the Barricades," in *The Brig*, ed. Kenneth H. Brown (New York: Hill and Wang, 1965), 24.

9. Beck, "Storming the Barricades," 24–25.

10. Beck, "Storming the Barricades," 25

11. Alice Rayner, *Ghosts: Death's Double and the Phenomena of Theatre* (Minneapolis: University of Minnesota, 2006), x.

12. The Hill and Wang edition of Kenneth Brown's *The Brig* was a shorter version of the play based specifically on the Living Theatre's production. In the spring of 1964, the *Tulane Drama Review* (*TDR*) published the complete text of the play. See *TDR* 8.3 (1964): 222–57.

13. Charles Isherwood, "Keeping the Old Off Off Broadway Spirit Alive," *New York Times*, April 27, 2007.

14. Richard Schechner, "Interview with Judith Malina and Kenneth Brown," *TDR* 8.3 (1964): 208.

15. Charles L. Mee, Jr., "Epitaph for the Living Theatre," *TDR* 8.3 (1964): 220.

16. Judith Malina, "Directing the Brig," in *The Brig*, ed. Kenneth H. Brown (New York: Hill and Wang, 1965), 83.

17. Julian Beck, "How to Close a Theatre," *TDR* 8, no. 3 (1964): 189.

18. Beck, "How to Close a Theatre."

19. Beck, "How to Close a Theatre," 190.

20. Malina, "Directing the Brig," 84.

21. Avery Gordon, *Ghostly Matters* (Minneapolis: University of Minnesota Press, 1997), 126.

22. Gordon, *Ghostly Matters*, 131.

23. Herbert Blau and Jules Irving in "The Living Theatre and Larger Issues," *TDR* 8, no. 3 (1964): 195.

24. Richard Schechner, "Interview with Judith Malina and Kenneth Brown," *TDR* 8, no. 3 (1964): 212.

25. Ibid.

26. C. W. E. Bigsby and Kenneth Brown, "The Violent Image: The Significance of Kenneth Brown's *The Brig*," *Wisconsin Studies in Contemporary Literature* 8, no. 3 (1967): 429.

27. Kenneth Brown, "*The Brig*: A Revival with Modern Themes," interview by Lu Olkowski, National Public Radio, April 27, 2007.

28. Cindy Rosenthal, "In Living Color: Re-viewing *The Brig* after Abu Ghraib," unpublished manuscript of paper presented at the American Society for Theatre Research Conference, November 2007. Used with Permission of the author.

29. Ibid.

30. Cited in John Prados, *Safe for Democracy* (Chicago: Ivan R. Dee, 2006), 152.

31. Ibid., 642.

32. Stephen Grey, *Ghost Plane* (New York: St. Martin's Griffin, 2007), 16.

33. Harold Pinter, *Party Time and The New World Order* (New York: Grove Press, 1993), 5.

34. Living Theatre website, accessed August 16, 2008, http://www.livingtheatre .org.

35. Ibid.

36. Michael Feingold, "Prisoners of the Past," *The Village Voice,* April 24, 2007.

37. Judith Malina, "*The Brig:* A Revival with Modern Themes," interview by Lu Olkowski, National Public Radio, April 27, 2007.

38. Antonin Artaud, *The Theatre and Its Double,* 80.

39. Ibid., 78.

40. Ibid., 75.

41. Ibid.

42. Ibid.,79.

43. Ibid., 24.

44. Ibid.

45. Bürger, *Theory of the Avant-Garde,* 61.

Index

9/11, 3–4, 174, 175–76, 178, 179, 181, 183, 185–97

Abstract Expressionism, 17, 62, 76
Abu Ghraib, 197, 199, 200, 202, 203, 205
Adorno, Theodor, 9, 161, 163, 164, 167; *The Dialectic of Enlightenment*, 159, 180
Albers, Josef, 82–85, 86, 215n56, 215n63; *Art as Experience*, 83
Al Jazeera, 176, 177, 226n46
Aragon, Louis, 34, 38, 39, 49, 57
Arena Stage, 185
Artaud, Antonin, 14, 27, 63, 97–98, 99, 100, 101–2, 103, 109, 140, 187, 189–90, 196; Balinese dance theater, 137; non-literary theater, 108, 133, 202; "oriental theatre," 223n9; "surface of fact," 97, 100, 102; *The Theatre and Its Double*, 190, 191–92, 193, 196, 198, 199, 201, 203–6, 212n13; "Theatre of Cruelty," 102, 193; "truth in excess," 101, 104
avant-gardes: beyond linear historiographies, 146–48; center-to-edge/edge-to-center, 138–41; contemporary, 159–60; cutting edge to rough edges, 142–46; decentering the narrative history, 86–89; discursive economy, 16–19, 20, 22, 26, 27, 52, 53, 59; gendered genealogies of the artist as producer, 20–25; historiographies, 1, 12–20, 26; militancy, 163, 213n21; operative as-

sumptions, 102–10; pluralities, 1–27; post-9/11; radicalism, 40, 58, 168, 177; rhetoric, 28–58; strategies, 97–102; transnational, 23, 138, 146, 148–58; vanquished, 160–67

Bahun-Radunovic: *The Avant-Garde and the Margin*, 138
Ball, Hugo, 1–2, 3, 4, 26; "Gadji Beri Bimba," 5, 6, 8; "Karawane," 5; *Lautegedichte*, 137; sound poems, 5–7
Barcelona Dada Group, 49, 51
Barrès, Maurice, 30, 31, 35, 42, 46. See also *The Trial and Sentencing of Maurice Barrès by Dada*
Barron, Stephanie: "European Artists in Exile," 211n8
Barthes, Roland, 133; death of the author, 24, 25, 26, 134–35; *The Pleasure of the Text*, 17, 18
Bauhaus, 81–86, 87, 214n55, 215n56, 215n65
Beck, Julian, 22, 27, 95–96, 98–100, 102, 103, 166, 188, 191–94, 196, 198–99, 201–2, 204–6, 217n28; arrested, 197; "Daily Life," 217n28; *Frankenstein*, 22, 95–96, 98–100, 102, 103; "Frankenstein Poem," 99; "Munich Scenario," 99; "natural sex," 202; reading of Artaud, 192–93, 196, 198–99, 201–2, 204–6; "Storming the Barricades," 191, 193; "Venice Synopsis," 99. *See also* The Living Theatre